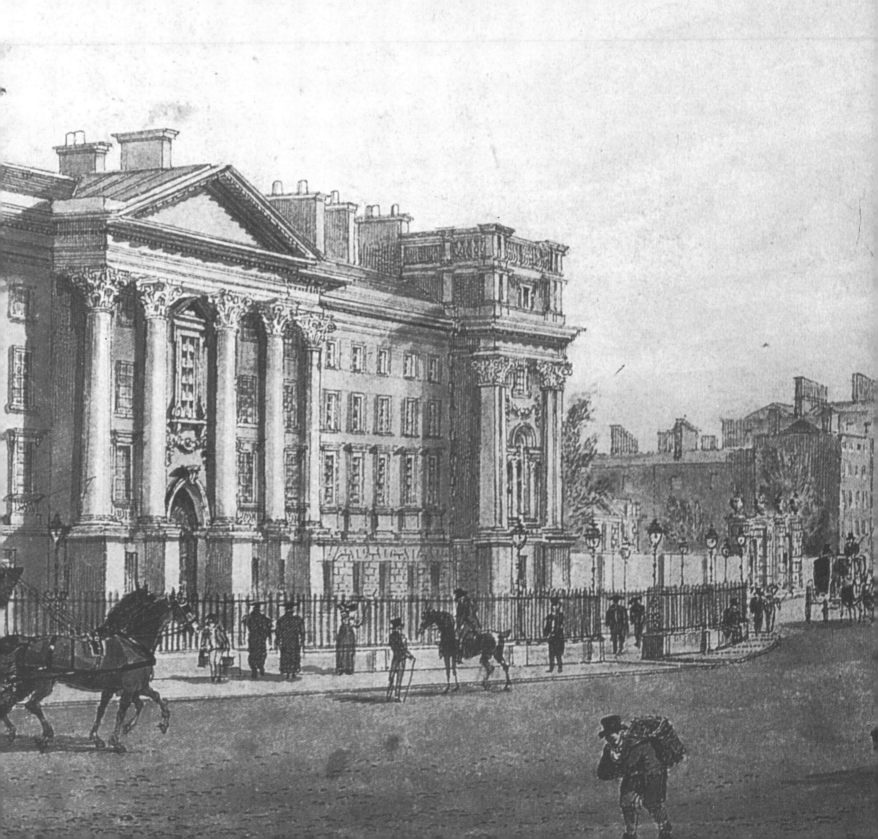

THREE HUNDRED YEARS OF
IRISH WATERCOLOURS
AND DRAWINGS

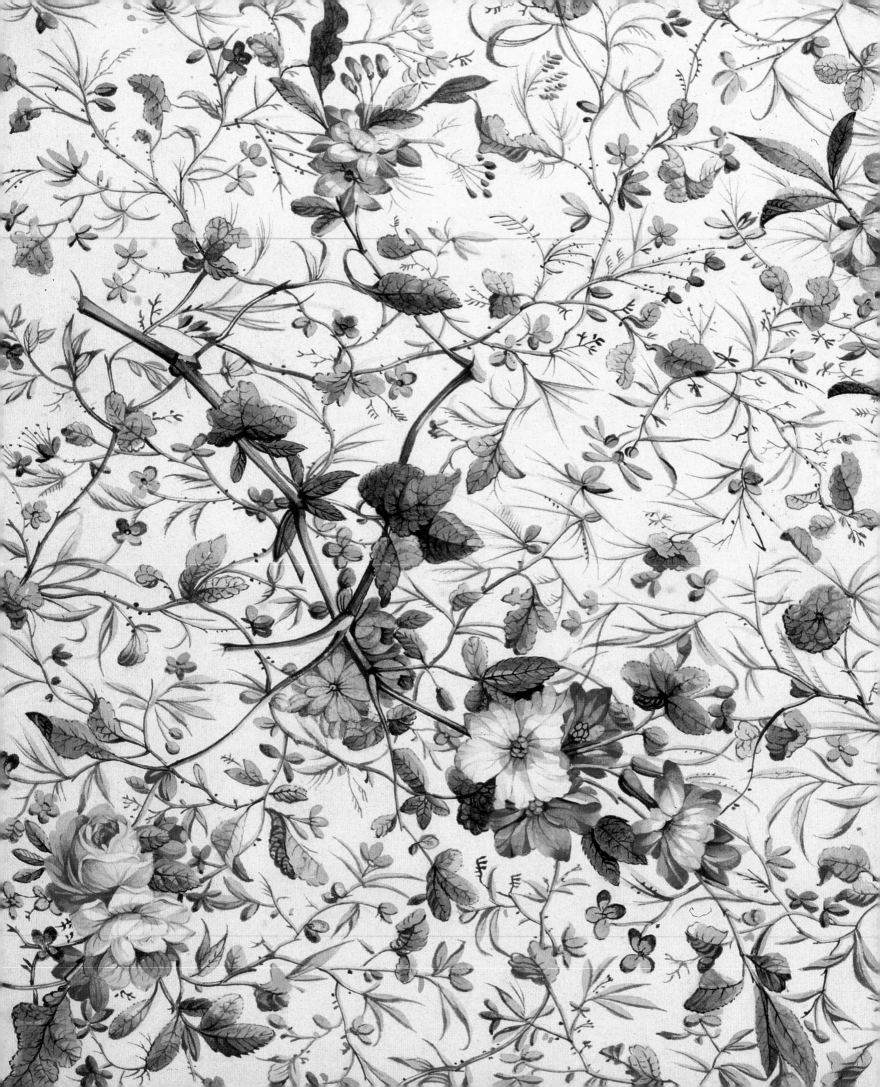

THREE HUNDRED YEARS OF
IRISH WATERCOLOURS AND DRAWINGS

Patricia Butler

Foreword by Raymond Keaveney

WEIDENFELD AND NICOLSON

LONDON

TO THE MEMORY OF PATRICK
AND FOR OUR CHILDREN, CHARLES AND VANESSA
WITH LOVE

First published in Great Britain in 1990
by George Weidenfeld & Nicolson Limited
91 Clapham High Street
London SW4 7TA

British Library Cataloguing in Publication Data
Butler, Patricia
An introduction to three hundred years of Irish
watercolours and drawings
1. Irish paintings, history
I. Title
759.2915

ISBN 0 297 83055 4

Designed by Trevor and Jacqui Vincent

Typeset by Keyspools Ltd, Golborne, Lancs
Colour separations by Newsele Litho
Printed in Italy by Printers SRL, Trento
Bound in Italy by L.E.G.O., Vicenca

ENDPAPERS
Trinity College and College Green, Dublin.
Samuel Frederick Brocas (1792–1847). (See illus. 39)

HALF-TITLE PAGE
An illustration to Moonshine Fairy Stories by E. Knatchbull.
William ('Billy') Brunton (1833–1878).

FRONTISPIECE
Design for chintz.
William Kilburn (1745–1818). (See illus. 70)

Contents

The publishers and author
are particularly grateful to
The Investment Bank of Ireland
for its generous support.

ACKNOWLEDGEMENTS

In particular, I wish to express my gratitude to Prof. A. Crookshank, Mr & Mrs C. M. Esdon, Mr A. Figgis, Guinness Peat Aviation, Mr & Mrs P. Jacob, Mr R. Keaveney, Mr & Mrs P. Markham and The National Gallery of Ireland for their generous support and help.

I would also like to thank all the galleries and institutions who have provided me with information, illustrations and assistance, and the following people without whose co-operation and help this book would not have been possible: Mr M. Anglesea; Mr & Mrs B. Arnold; Mr C. Ashe; Mr D. Bell; the late Miss E. M. Booth; Dr N. Gordon Bowe; the late Baron B. de Breffny; Lady Melissa Brooke; Senator & Mrs E. de Buitléar; Ms S. Burke; Mr C. Butler; Mrs L. Butler; Dr J. Campbell; Ms S. Chappell; Mr M. Colgan; Mr T. M. Coulter; Mr F. Cullen; Mr & Mrs S. Wingfield Digby; Ms E. Dawson; Mr & Mrs C. Downes; Ms A. Elliott; Dr E. Fitzpatrick; Miss A. Fitzsimmons, Sir R. Brinsley Ford; Mrs D. Foskett; The Hon. Mr & Mrs C. S. Gaisford St. Lawrence; Mr J. Gibbs; Ms F. Gillespie; Mrs F. Goodbody (née Figgis); Miss A. Gore-Booth; Mr & Mrs J. Gorry; Mr C. Guinness; The Hon. D. Guinness; Mrs E. Guinness; Major & Mrs C. R. F. Hamilton; Mr A. Le Harivel; Mr J. Harvey; Ms P. Hicks; Mr & Mrs A. Hobart; Miss K. Hudson; The Countess of Iveagh; The Earl of Iveagh; Mr O. Jennings; the late Mrs Brooke Johns; Dr E. Kane; Ms F. Kelly; Dr S. B. Kennedy; The Lord Killanin; Mr L. Lambourne; Lady R. Langham; Mr H. Mallalieu; Mrs P. McCabe; Mr. G. McCaw; Prof. S. T. McCollum; Mr J. McCurrie; Mr C. MacGonigal; Miss R. McGuinness; Mrs P. McKenna; Mrs E. Mackeown; Mrs P. McLean; Mrs M. Mason (née Byrne); Mrs K. Middleton; Dr C. Mould; Mr P. Murray; Mr O. Nulty; Mr A. O'Brien; Mr R. L. Ormond; Mr H. Potterton; Dr & Mrs M. Purser; Mr & Mrs Jobling Purser; H.M. The Queen; Mrs A. Reihill; Dr & Mrs J. Reynolds; Ms M. Rooney; Mr & Mrs J. Ross; Ms C. Ryan; Ms R. Ryan; Dr T. Ryan; M. J. F. Scannell; Mrs R. Senior; Mr & Mrs J. Shackleton; Mr & Mrs D. Shaw-Smith; Ms J. Sheehy; Dr G. Simms; Mr A. Sisley; Mr A. Smith; Dr M. Smurfit; Dr J. Stafford; Miss L. Stainton; Mrs A. Stewart (née Miller); Mrs L. Suber; Mr J. Taylor; Captain & Mrs A. Tupper; Mr J. Turpin; Mr C. Waetzig; Miss M. Ward; The Marquis of Waterford; Dr J. White; Mr I. A. Wilson; Mr & Mrs P. Wingfield; Mr K. Wood; Mr R. Wood; Dr Patrick Wynne; Senator M. Yeats.

A special word of appreciation to photographer, Stuart Smyth, and to the team at Weidenfeld including Michael Dover, Suzannah Gough and designers, Trevor and Jacqui Vincent. Finally, without the patience, dedication, and sense of humour of my editor, Coralie Hepburn, this book would not have seen the light of day; my heartfelt thanks to her for splendid support throughout.

FOREWORD

The definitive reference book on Irish Art is Stricklands's *A Dictionary of Irish Artists*, first published in 1913. Strickland, who at the time of the publication of his two volume survey was Registrar at the National Gallery of Ireland, later served for a short period as acting-Director, following the death of Sir Hugh Lane in 1915. Since that time progress has been slow in building up a more informed and comprehensive image of the development of Irish Art. Particularly lacking was the provision of a wide-ranging, well-illustrated study. In some respects this defect was put right with the publication of Anne Crookshank and the Knight of Glin's volume published in 1978. It has taken over ten years for a similar survey to be produced to serve those with a deep interest in the discipline of watercolours and drawings.

As with most schools of painting, the availability of information and documentation on watercolours is more limited than for oil paintings. Indeed, it is not simply the availability of published information but also the accessibility of the watercolours themselves which poses awkward problems for those with a deep, or for that matter, simply a passing interest in the medium. Executed for the most part on paper and sensitive to light, these fragile creations need to be stored and exhibited in a well-controlled environment if they are to be conserved in optimum condition.

It is not surprising, therefore, that it has taken so long for someone to explore the development of this aspect of Irish art. Nor is it surprising to find out that having embarked upon such a task, one discovers that there is a great deal more material worthy of investigation than one originally would have thought. Most of us are aware of the compositions of Nathaniel Hone the Elder, a founding member of the Royal Academy and an artist who first made his reputation as a miniature painter. In the mid-nineteenth century Andrew Nicholl produced many fine, popular views of Irish beauty spots, and closer to our own time Jack B. Yeats made his early reputation with his book illustrations and watercolours. Behind these better known names lies a whole host of lesser known or virtually anonymous artists who supplied the market with their compositions, either in the traditional manner as subject painters or more simply as providers of illustrations for publications on travel, natural history or various types of reference manual.

A volume which has as its ambition a comprehensive illustrated survey of virtually the complete spectrum of Irish watercolour production, ranging from fine art to humble, but beautifully accomplished, illustration, is greatly to be welcomed. Such a publication will prove of immense value both to the scholar and the amateur alike, who heretofore have had few sources to refer to when seeking information, especially with regard to the lesser-known artists. The many reproductions which illustrate this volume will provide a visual resource of immense value, greatly enhancing the usefulness of a text which, in abbreviated form, provides all the salient details regarding the artistic output of a whole host of artists, ranging from the famous to the forgotten to the rediscovered.

Raymond Keaveney
Director
National Gallery of Ireland

AUTHOR'S PREFACE

In the following pages I have given a fuller survey of the subject than originally intended. The reasons for this are many, but one of the principal ones was to provide information on a subject which, to the best of my knowledge, has not been covered from an Irish standpoint in any great detail. Numerous publications exist giving valuable information on the British watercolour tradition, most notably Martin Hardie's valuable *Water-colour Painting in Britain*. However, this vacuum has yet to be filled in Ireland, with little real information being available to the reader or collector interested in this relatively unexplored and exciting area of Irish art.

At the same time, the point should be made that this is an *introduction* to the subject of Irish watercolours and drawings. No attempt has been made to include every single known painter who worked in watercolour or any other medium (excluding oil). This would have been a virtual impossibility. However, attention has been paid throughout to include a reasonable balance of both minor and well-known painters with over 200 being included.

No subject can be treated satisfactorily in a vacuum and although the theme of the book is *Irish* watercolours and drawings, I have included many English watercolourists and draughtsmen who visited and painted in Ireland and thereby contributed generously to our cultural heritage down through the centuries. The front runners were, of course, the landscape, portrait and topographical draughtsmen; but the charm of the specialists, such as the botanical illustrator and flower painter, the caricaturist and black-and-white illustrator, and the miniature painter, all contributed in their own unique and fascinating ways to this great tradition.

The purpose of the book is not primarily biographical but to indicate to the reader the sources from which further information may be found. There is much research to be done on the lives as well as the work of Irish watercolourists and draughtsmen, and I trust this book will serve as a stepping stone in that direction.

This book is the result of almost twenty years of collecting and admiring watercolours and drawings. I hope the reader will find it useful and informative, but above all amusing and enjoyable.

Patricia A. Butler St Patrick's Day 17 March, 1990

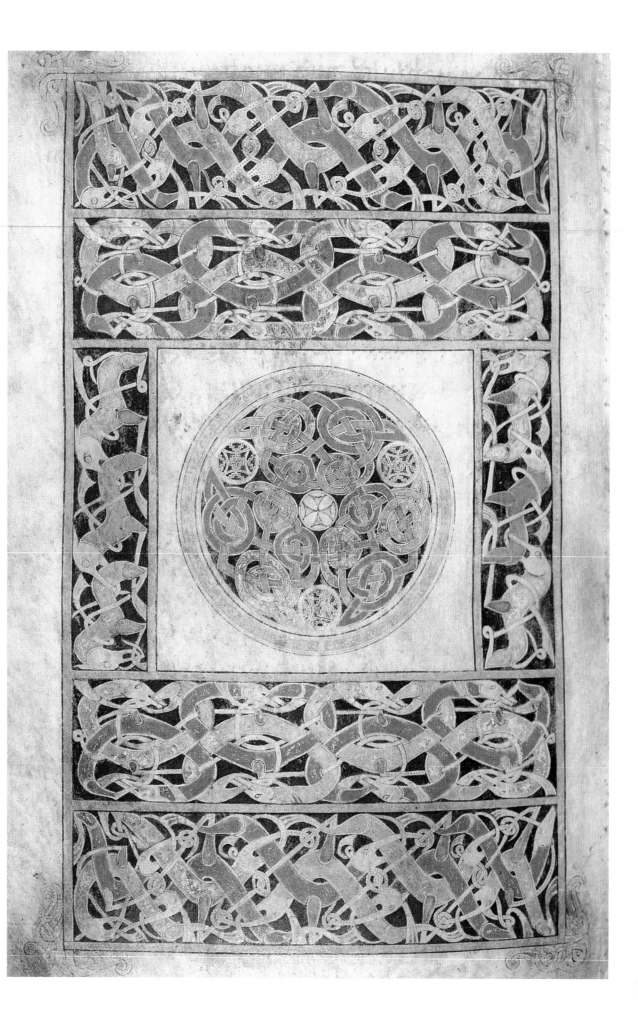

I

MANUSCRIPT TO MINIATURE

THE origins and roots of watercolour painting in Ireland can be found in the pages of our medieval illuminated manuscripts, from the brilliant and creative period between AD 650 and 800. These include such works as the Book of Dimma, a pocket gospel book, and the well-known Book of Kells. The illuminators worked with devotional patience and diligence in the scriptoria, or manuscript rooms, of Irish monastic foundations both at home and abroad.

An outstanding example from this period is the Book of Durrow (AD 650–680). Small in size,[1] it contains the text of the four Gospels together with some introductory material and is written in Irish majuscule (large letter) script. Decoration is elaborate, as can be seen from the carpet-page[2] facing the beginning of St John's Gospel (illus. 1), and the opaque colours stand out clearly against a black/brown background, or occasionally one of an ivory colour, on the vellum pages.

In a remarkable state of preservation, but perhaps less well known, is a little Irish psalter, the Psalter of Cormac[3] (illus. 2) belonging to the second half of the twelfth century, which was bought in Munich in 1904 by the British Museum Library. Colours throughout include variable tones of red, yellow, green and purple. The drawings have a remarkably vivacious quality which illustrates so well the extraordinary vitality to be found in Irish illumination right up to the time of the Norman invasion.

The link between the medieval illuminator and later work in watercolour is supplied by portrait miniatures, at first known as limnings, from the word 'illumination'. Those who executed them were called miniators. This term, like the later word 'miniature', is derived from the Latin *minium*, red lead, a pigment frequently used for the attractive, large initial letters found in these illuminated manuscripts. A good example may be seen in the *Portrait of Saint Matthew* taken from the Saint-Gall gospel (believed to date from the middle of the eighth century). This is one of several Irish miniatures to be found in the Abbey Library of Saint-Gall in Switzerland.

It may be seen that in such miniatures little attempt has been made to produce an accurate sense of draughtsmanship, but rather that the figures are employed as a form of decoration. These small paintings, or limnings, were also

2] A page from the Psalter of Cormac
(AD 1150–1200).

1] Carpet-page facing the beginning of St John's Gospel.
Book of Durrow (AD 650–680).

known as 'paintings in little'. It was not until the seventeenth century that the term 'miniature' came into use. As the centuries went by, illuminators decorated documents, bibles and books with designs which began to include representations or likenesses of persons. A portrait miniature on manuscript dating from *c.*1500, *Bernard Saint John André, the blind poet, presents Prince Arthur with a Manuscript*, is exquisitely separated and detached from the text by a little border or frame. It was only a short step before this type of illustration was removed from the sanctity and security of the bound book and transferred into a miniature as it is understood today.

Just when this happened has never been firmly established but there is no evidence to suggest that miniatures were painted before the sixteenth century. Like their medieval predecessors, the early miniaturists preferred gouache, grinding down their colours which included a white pigment and then mixing them with a solution of powdered gum arabic, sometimes adding sugar and white of egg, the entire mixture being dissolved in hot water. The colours produced by this method have survived remarkably well, retaining their brilliance to this day.

The early miniatures were painted on card or vellum. It was not until the late seventeenth century that an Italian artist, Rosalba Carriera (1675–1757),[4] discovered a method of painting miniatures on ivory.

The first miniaturist to introduce this method to England was Bernard Lens (1682–1740). However, it was not until the arrival of RICHARD COSWAY, RA (1742–1821) that the whole technique of, and approach to, miniature painting began to undergo radical changes.

Although Cosway was an Englishman, it is necessary to mention his name here in order to demonstrate the background to the development of miniature painting both in this country and in England. Born in Devon, the son of a headmaster of a school in Tiverton, Cosway studied at Shipley's drawing school in London and entered the RA Schools, becoming ARA in 1770 and RA a year later. At the beginning of his career he tended to concentrate on painting large portraits in oil, but as time went on he turned his hand towards miniature painting, being fortunate enough to enjoy the patronage of George, Prince of Wales.

Cosway was an extraordinarily hard worker; he claimed he could get through twelve or thirteen sittings in one day. He began to experiment with painting in watercolour using transparent pigments which he floated on to the ivory surface beneath, frequently allowing its natural luminosity to show through, particularly in the area of the face. As a result, the sitter's complexion acquired a warmth and delicacy which no other base could produce. This is beautifully demonstrated in his delicate portrait miniature of the Princess Amelia. Cosway used thin sheets of ivory, heating them between sheets of paper with an iron to remove their grease. He then rubbed them with a pumice stone until, in his own words, they adopted 'a dead grave effect'. His methods were to be adopted by countless miniaturists throughout Ireland and England. The National Gallery of Ireland is fortunate in having his *Self-Portrait* (illus. 3). Here Cosway portrays himself in Elizabethan costume, hatless and wearing a ruff. The finely-drawn miniature is

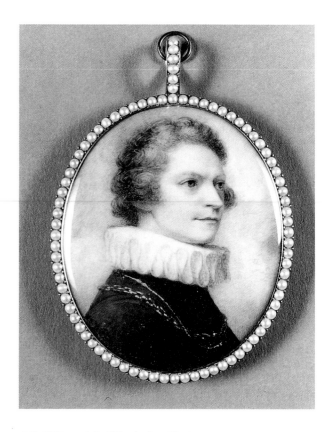

3] *Self-Portrait in Elizabethan Costume.* Richard Cosway (1742–1821).

set in an exquisite mother-of-pearl frame.

Watercolour miniatures became highly popular, as did plumbago miniature painting, particularly in the seventeenth century. The artist used a sharp piece of graphite and executed his work on vellum or paper. Plumbago miniature painting was generally of a high standard, as seen for example in the work of Thomas Forster (*c.*1677–*c.*1713) who may have spent some time working in Ireland. His miniatures are in the V&A, London, several other galleries and private collections.

Miniature painting on enamel was also practised, one of the principal advantages being that the miniatures were able to withstand changes in temperature.

The shape and size of the miniature varied considerably. The earliest known were circular, but towards the end of the sixteenth century the upright oval was introduced. Rectangular shapes were also in use, becoming fashionable in the nineteenth century. Dimensions could extend from thumbnail size up to 25 cm deep. Subject matter also varied. It could include mythological scenes, life portraits or copies of paintings. Frequently, miniatures were worn in lockets, rings and brooches. They might also be hung on the wall in rectangular or oval frames. Such paintings became known as 'cabinet miniatures'.

The brushes used by miniaturists were frequently made from squirrel tail, a favoured material being 'hair of Caliber', a type of squirrel hair imported from the Continent, originally from Calabria. Cosway, for example, used this type of brush, believing it to be the most suitable for miniature work. He burned off the tip so that he might dot or streak in the colour with the

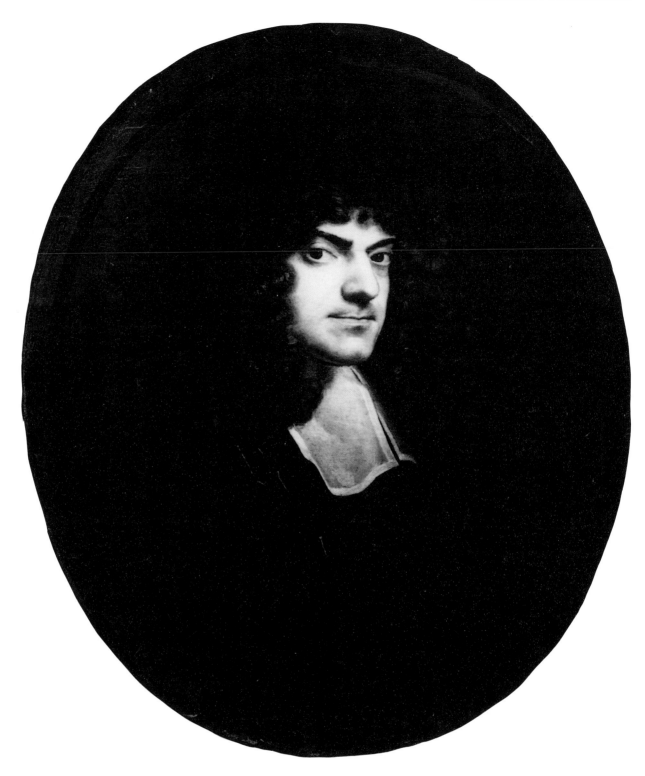

4] *Simon Digby, Bishop of Elphin* (fl. *1668–1720*) .
Unidentified Artist.

blunted point. The easel or desk of the miniaturist
generally contained a box with drawers in which to hold
colours and brushes. A baize-covered hinged board at
the top could be raised to different angles.

The origins of the portrait miniature in Ireland can be
traced to the seventeenth century and, in particular to
the work of SIMON DIGBY, Bishop of Elphin (fl.
1668–1720), who painted portraits of many of his
distinguished contemporaries, including Archbishop
Narcissus Marsh and John Tillotson, Archbishop of
Canterbury (1630–94), whose miniature portrait is in the
NGI.

Digby was the son of the Bishop of Dromore. It is not
known where he learned the art of miniature painting
but Bishop Downes, writing in 1720 to Archbishop
Wake, said that he was 'a great master of painting in little
watercolours and by that quality recommended himself
to men in power and ladies, and so was early made a
bishop'. Simon Digby died at Lacken, Co. Roscommon
and was buried in 'the Church of Tosara (Mt. Talbot) in

the said county, together with his Lady who died a few days after him'. Examples of his work exist in the family of his descendants, the Wingfield Digbys of Sherborne Castle, Dorset.

The Flemish artist GASPAR SMITZ (d. *c*.1707), who settled in Ireland and died there, is also known to have painted miniature portraits, as did his younger contemporary the portrait painter CHARLES JERVAS (*c*.1675–1739).

LUKE SULLIVAN (1705–1771) also belongs to this early group of pioneers. Born in Co. Louth, he went to England early in his life when his father became groom to the Duke of Beaufort. It was the Duke who later assisted him to obtain instruction in engraving, probably from Jacques-Philippe Le Bas (1707–1783). His earliest known miniatures, dating from 1750, had existed in the form of engravings since 1746. He assisted Hogarth and engraved his *March to Finchley*. However, one of his weaknesses seems to have been his addiction to the opposite sex, Pasquin remarking that 'his chief practice lay among the girls of the town; and indeed he resided almost entirely at taverns and brothels.'[5]

Despite these distractions he succeeded in producing miniatures which possess a strong sense of colour harmony and an attractive style reminiscent of the French school of Fragonard. Five of his miniatures are now in the Victoria and Albert Museum, London and include one of *An Unknown Woman* (illus. 5), signed and dated 1767.

The career of THOMAS FRYE (1710–1762) might be said to represent the struggle for survival of many Irish painters in the eighteenth century.[6] Frye was not only able to turn his hand to portraiture but also became a miniaturist and a superb and well-known mezzotint

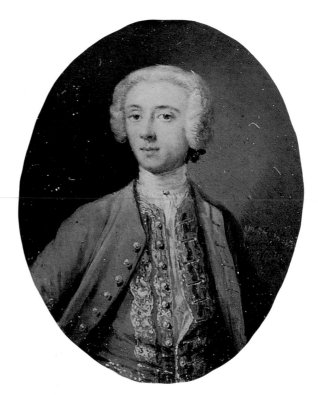

6] *Hiliary Turriano.*
Thomas Frye (1710–1762) .

engraver. He was also involved in the founding and running of the Bow Porcelain works at West Ham in Essex from 1744–1759. Relatively little is known about his early life and training, Strickland[7] remarking that he was born 'in or near Dublin'.[8] In London, he quickly established his reputation with a full-length portrait of Frederick Prince of Wales, executed in 1736. One of his earliest miniatures was executed a year later. His fine oil miniature of *Hiliary Turriano* (illus. 6) is in the V&A collection and reveals the possible influence of such Irish painters as James Latham (1696–1747).[9] Frye's watercolour miniatures reveal the use of delicate modelling combined with a sensitive touch. These are aptly demonstrated in his two miniatures of *A Lady* and *A Gentleman*, signed and dated 1761. Frye died in London of consumption, which was 'brought on by intense application'.

Apart from these early beginnings, a specifically Irish school of miniature portrait painting did not become firmly established until the middle of the eighteenth century. Its development may have been encouraged by visits to Dublin by one of these best-known exponents of the art, PETER PAUL LENS (*c*.1714–*c*.1750), son of the miniaturist BERNARD LENS III (1682–1740).

While in Dublin, Lens became a leading member of the Blasters Club. The Blasters became the subject of a report in the Irish House of Lords in 1738, when it was reported that Lens was a 'votary of the devil and that he hath offered up prayers to him and publicly drunk to the devil's health'. His prosecution was ordered, and Lens had to return somewhat hastily to London.

His miniatures are mostly small in size, the sitter usually being painted full face with the head occupying a considerable proportion of the ivory.

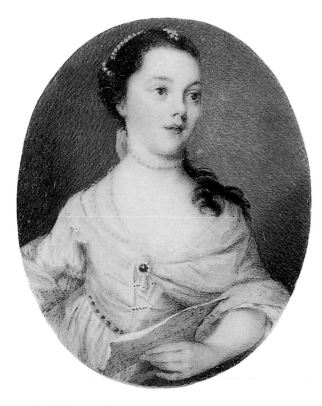

5] *An Unknown Woman.*
Luke Sullivan (1705–1771) .

Rather more is known of the life and career of NATHANIEL HONE THE ELDER (1718–1784), who by the age of thirty had established himself as the leading painter of portrait miniatures in London. Described by J. T. Smith in his life of Nollekens as a 'tall, upright large man with broad-brimmed hat and a lapelled coat buttoned up to his stock',[10] Hone was born in Wood Quay, Dublin, the son of another Nathaniel whose forebears had come from the Netherlands in the seventeenth century. The family was reasonably prosperous, and Protestant thrift and self-discipline seems to have stood the artist in good stead all his life.

Very little is known about his early training in Dublin, though Crookshank and the Knight of Glin suggest that he may have been a pupil of Robert West (d.1770).[11] His miniatures are usually small, direct, sparkling and full of vivacity, as can be seen from the portrait of his brother Samuel.

It was around 1748 that Hone began to develop a distinct style of his own. During this period he was living in London with his first wife Mary Earle, whom he had met and married in York in 1742. After visiting Paris and Dublin in the 1750s, he became a founder member of the RA, being fully aware that in order to gain wider recognition he could not afford to confine himself merely to miniature painting, copying other artists' work, or studying from nature. He exhibited at the Academy from 1769 to 1784 despite one or two notorious disputes with Sir Joshua Reynolds.

Hone signed his miniatures with a simple monogram NH, in which the last stroke of the N forms the first stroke of the H. The majority are dated, 1770 being the date of the latest known. His little miniature of *Sarah Sophia Banks* (illus. 7), executed two years before this date, reveals his more romantic, gentle style of the 1760s with the sitter set against a dark background which serves to highlight the delicacy of her features, and in particular the translucency of her pearl necklace and earrings. When faced with painting lace on his sitter's costume, as in his portrait of the writer and statesman *Edmund Burke* (illus. 10), Hone used opaque white. Frequently he shaded the face of his sitters with soft diagonal hatching.

Two of Hone's ten children became well-known miniaturists in their own right, JOHN CAMILLUS HONE (1745–1836) coming to Ireland around 1790 after working in India. He painted both in miniature and as a full-size portraitist in oil.[12] Another son, HORACE HONE (1756–1825), also had a successful practice at Dorset Street, Dublin, and became miniature painter to the Prince of Wales in 1795. His portrait of the actress *Mrs Sarah Siddons* (illus. 8) is inscribed on the back 'Painted in Dublin by Horace Hone, ARA, 1784'. It shows an elegant style where a fairly liberal amount of stippling is used to model and shade the face. Nathaniel Hone's descendant, Nathaniel Hone the Younger, will be dealt with in chapter VI (see p. 150).

Nathaniel Hone's work was not so highly thought of by his contemporaries as was that of his fellow Irishman, JAMES BARRY, RA (1741–1806). In fact, in a new edition

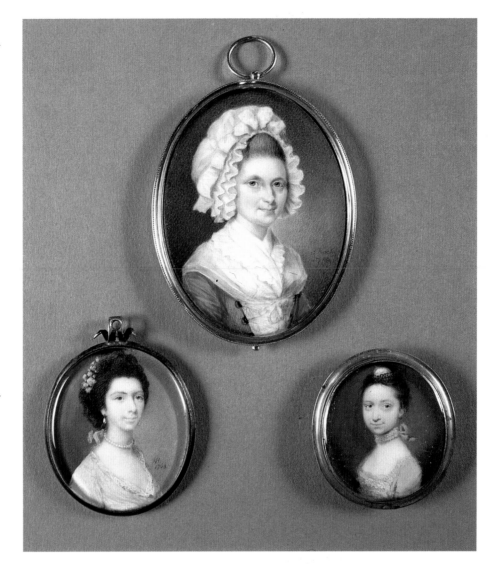

7] TOP *Sarah Sophia Banks.*
Nathaniel Hone the Elder (1718–1784) .
LEFT *Mrs Morgan.*
Sampson Towgood Roch (1759–1847) .

RIGHT *Portrait of a Lady in a Pink Dress.*
James Reily (*fl. c.* 1750–1880/88) .

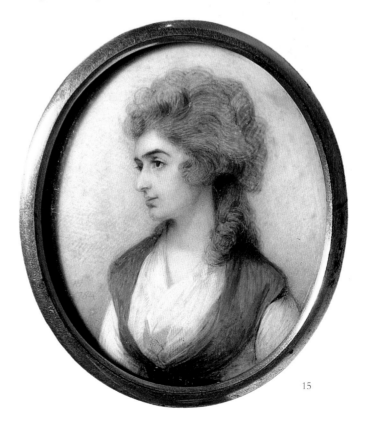

8] *Mrs Sarah Siddons (1755–1831), Actress.*
Horace Hone (1756–1825) .

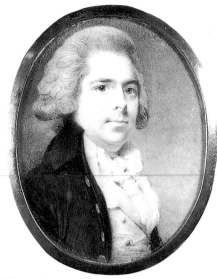

9] *Self-Portrait.*
Horace Hone (1756–1825) .

of *Pilkington's Diary* (1798) which set out to include 'the latest and most celebrated Artists', we find his name omitted altogether. However, Hone's miniatures whether executed in enamel or watercolour did receive respect and admiration both during his lifetime and subsequently.

Several miniaturists, who were later to become well-known in Dublin were employed by SAMUEL DIXON (*fl.*1748–1769) (see chapter IV, p.73). These included GUSTAVUS HAMILTON (*c.*1739–1755), JAMES REILY (or REILLY; *fl. c.*1750–1780/88) and DANIEL O'KEEFE (or KEEFFE; 1740–1787). Both Gustavus Hamilton and Daniel O'Keefe studied under Robert West at the Dublin Society Drawing School sited in George's Lane, and both became pupils of Samuel Dixon. Hamilton was the son of the Revd Gustavus Hamilton, Vicar of Errigal in the diocese of Clogher and Rector of Gallen in Co. Meath. On completion of his apprenticeship with Dixon he set up his own studio, attracting a fashionable clientele. His work is signed in a variety of ways: with his initials, with the abbreviated signature 'Ham.' followed by a date, and occasionally 'Gus. Hamilton' with or without a date. Draughtsmanship was not always of a high standard and the shading of the face of his sitters tended to be somewhat bluish. He exhibited at the Dublin Society of Artists from 1765 to 1773. Daniel O'Keefe left Dixon's employment to establish himself as a miniaturist in Temple Bar, Dublin, and later went to London, exhibiting at the Free Society of Artists in 1769 and 1783 and the Royal Academy from 1771 to 1786. He was known as Daniel Keefe until 1775, when he added the 'O' to his name. He died of consumption in Brompton on 22 June 1787.

HENRY PELHAM (1749–1806), unlike the miniaturists mentioned above, was born neither in Ireland nor in England, but in Boston. He was the son of Peter Pelham, mezzotint engraver, and Mary Singleton, widow of

Richard Copley and mother of the well-known American painter John Singleton Copley, RA (1738–1815). Pelham worked with, and was to a large extent influenced by, his half-brother. After he came to London he exhibited several miniatures at the RA in 1777 and again the following year. It was at about this time that he arrived in Ireland to become agent to Lord Lansdowne. His work included not only miniatures but engraving and mapmaking. He was also responsible for a number of illustrations for Grose's *Antiquities of Ireland* (see chapter II, p. 32).

A medium which was proving particularly popular with miniaturists during this period was pastel. Two of its earliest exponents had been Dublin-born, EDWARD LUTTRELL (or LUTTERELL; *c.*1650–1710) and HENRIETTA DERING (*fl.*1694–1728/29), part of whose work in pastel, dating from between 1704 and 1709, is now in a private collection in Ireland. Henrietta studied in 1707 with Simon Digby (illus. 4) who was a friend of her second husband, Gideon Johnston (1668–1716), an Anglican clergyman. (She had previously been married in 1694 to Robert Dering, son of Sir Edward Dering, 2nd Baronet, of Surrenden Dering, Kent.) Largely a portrait painter, her earliest known work in miniature dates from *c.*1703 when she began to establish herself as a fashionable miniaturist in Dublin. Shortly after her second marriage, she and her husband applied for missionary service in Charleston, North Carolina, arriving there in 1708. In America she continued to paint portraits largely in pastel and watercolour. After her husband was drowned in an accident, she went to live in New York where she continued to paint. Her work may be seen in the Museum of Early Southern Decorative Arts, Winston-Salem, North Carolina.

The establishment of the Dublin Society Drawing Schools and the high standard of drawing being taught by its first master, ROBERT WEST (d.1770), combined with the popularity of the work of such pastellists as Italian-born Rosalba Carriera all contributed to the rise in popularity of pastel drawing.

One of the greatest exponents of pastel, and an artist who represents the first generation of pupils to emerge from the Dublin Society Drawing Schools, was HUGH DOUGLAS HAMILTON (1740–1808), who is remembered for his miniatures executed in this medium and using the oval format. Hamilton worked almost exclusively as a pastellist from the 1760s for almost twenty years, this work culminating in his superb oil portrait of *Antonio Canova in his Studio with Henry Tresham*, executed in mid-1788 and late 1789 in Rome.

His early small pastel miniatures, executed on grey paper in black and white chalk with coloured chalks added, reveal the influence and training of Robert West at the Dublin Society Schools, but the artist is obviously somewhat restricted by the use of the small oval format as seen in his *Denis Daly of Dunsandle, MP* (illus. 11), one of a collection of pastel miniatures by Hamilton in the National Gallery of Ireland. His later pastels, such as his portrait of the well-known eighteenth-century collector, *Frederick Augustus Hervey* (which shows the Earl-

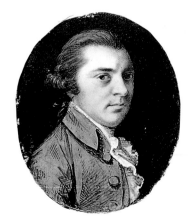

10] *Edmund Burke (1729–1797), Writer and Statesman.*
Nathaniel Hone the Elder (1718–1784) .

11] *Denis Daly of Dunsandle, MP (1747–1791) .*
Hugh Douglas Hamilton (1740–1808) .

Bishop seated on the Janiculum Hill overlooking the 'Eternal City'), reveal a more disciplined approach combined with a greater level of technical competence. His earlier pastels, in both Dublin and London, had tended to be marred by being somewhat unfinished. This may have been due to the fact that the artist constantly found himself in such demand that 'he could scarcely execute all the orders that came in upon him, and the writer has heard him declare, that in the evening of each day, a part of his occupation was picking and gathering up the guineas from amongst the bran and broken crayons, in the several crayon boxes into which, in the hurry of the day, he had thrown them.'[13]

In Dublin Hamilton had a thriving studio. 'His portraits in crayons, generally speaking, were rather crayon drawings than crayon pictures.... They appeared to have been very slightly executed, laid on with very few colours, the prevailing tone of which was grey, and then finished with red and black chalk. They were marked with great skill and truth. The features, particularly the eyes, were expressed with great feeling, but as pictures, they were not sustained by those depths either of colour or of shadow, which alone confer pictorial effect.'[14]

In 1764 he left Dublin for London and found no problem in attracting sitters and selling his work. He exhibited at the Free Society of Artists and sent his work back to the Society of Artists in Dublin.

In Rome, where he arrived with his daughter in 1779 and spent the next thirteen years, he began to concentrate on working as a painter in oil. He gained much from the study of the antique, travelling to Florence in January 1784 and studying antique statuary at the Uffizi Gallery.[15]

Hamilton left Italy in 1792 and returned to Dublin, where his output as a portrait painter continued on as large a scale as ever. A year later in May he wrote to Canova saying that he had finally decided to abandon pastel and was now concentrating on oil.[16]

Two other artists whose work belongs to the second half of the eighteenth century are CHARLES BYRNE (1757–c.1810) and SAMPSON TOWGOOD ROCH (or ROCHE; 1759–1847). Byrne was both pupil and interpreter to Roch, who had been born deaf and dumb into a well-to-do family who lived close to the Blackwater on the Waterford–Cork border.[17] Both practised as painters in miniature, Byrne being employed by a jeweller named Hutchinson to paint miniatures for his customers. He is known to have exhibited at the RA in 1800. Roch left Dublin for Bath in 1792 and remained there until 1822, when he retired and returned to Ireland. Byrne's *Self-Portrait* is in the NGI and several examples of Roch's work can also be seen there, including his portrait of *Mrs Morgan* (illus. 7).

ADAM BUCK (1759–1833), perhaps best known for his engravings of young ladies in high-waisted, flowing white dresses and low-heeled slippers, produced miniatures of a very high standard. His technique, however, varied greatly, the flesh colours in many instances being rather too pink. He used long and short strokes for the shading, and on a number of occasions used a scraper in the hair and in the background. He always painted in watercolour on ivory, displaying his gift for careful and very fine drawing.

12] *Portrait of a Young Lady seated on a Sea-wall.* Adam Buck (1759–1833).

13] *Major Conyngham Ellis (1783–1815).* Adam Buck (1759–1833).

Buck had been born the son of a Cork silversmith and had spent the first thirty-six years of his life in his native city, without exhibiting in Dublin. His first exhibition at the RA in London was in 1795, when he submitted two marine views. From the time of his arrival in London, and with the exception of the year 1800, he exhibited at the RA for a total of thirty-seven years, but he is believed to have exhibited only once in Dublin, in 1802. A successful teacher and a book illustrator (Sterne's *Sentimental Journey*), he is perhaps best known for his fanciful subjects which were generally done for engraving, and some of which were worked in watercolour. Much of his time was devoted to a book concerned with Greek vase painting, in connection with which he issued, on 1 June 1811, a prospectus: 'Proposals for Publishing by Subject 100 Engravings from Paintings on Greek Vases which have never been published drawn and etched, by Adam Buck. From private collections now in England. Dedicated to the Earl of Carlisle'. Sadly, public interest must have been slight as the book was never published.

His brother, FREDERICK BUCK (1771–*c*.1839/40) was also a miniaturist but frequently his work did not attain the high standard of Adam, the features of his sitters being badly modelled and drawn.

An artist, whose work included miniature painting and who enjoyed a somewhat erratic, if colourful career was GEORGE CHINNERY (1774–1852). Around 1794 he arrived in Ireland to stay with a relative, Sir Frederick Chinnery (whose portrait he later painted), and during this period became acquainted with another well-known miniaturist in Dublin, JOHN COMERFORD

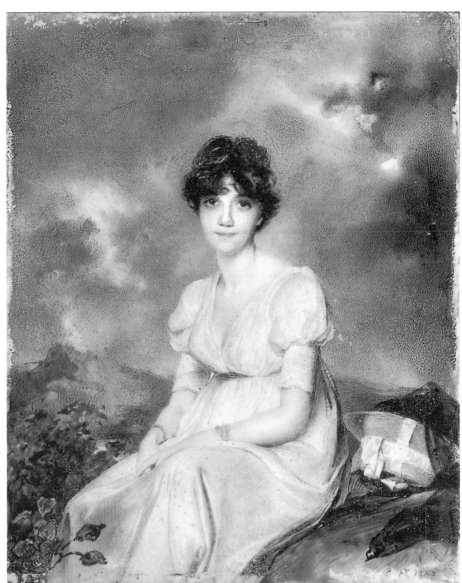

15] *Mrs Robert Sherson (1780–1858)*.
George Chinnery (1774–1852).

(*c*.1770–1832). Probably Comerford influenced to some extent Chinnery's method of miniature painting, which reveals a free-flowing, broad style similar to that of his Irish counterpart.

Chinnery's career had begun in London where, as a contemporary of Girtin, Constable and Turner and hailing from a family which already had an artistic tradition (his father had been a calligraphist and an amateur painter), he studied at the RA under Reynolds and at the age of seventeen was successful in having his work accepted for exhibition at the Academy. From then on he enjoyed a reputation as a landscape and miniature painter. Shortly after his arrival in Ireland he married his landlady's daughter, Mariann Vigne; but the marriage did not seem to be very successful, for in 1802 he left his wife and two children for London with the intention of sailing for India, where his family had a well-established firm in Madras. In 1807 he moved on to Calcutta and then to Dacca. In order to escape from his

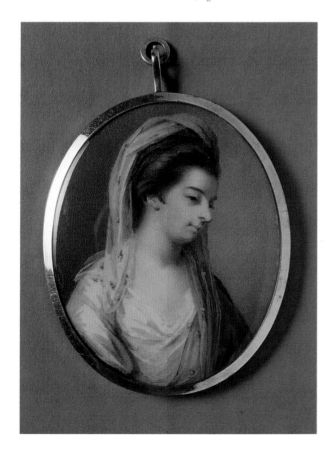

14] *Charlotte Walpole, Countess of Dysart (d. 1789)*.
Attributed to George Chinnery (1774–1852).

Journal on 29 June 1793, stating that he was now a 'Portrait Painter in Oil'. Four years later in the same *Journal* he announced that he was now specialising in 'Likeness in Oils and Miniature' and it is fair to assume that 'he must have started painting miniatures at that time'.[19] He lived with Chinnery and his wife at 27 Dame Street, College Green in Dublin for fifteen years. As his reputation increased as a miniaturist, he tended to concentrate less and less on full-scale portraiture. As with Chinnery's miniatures, his brushstrokes are in many instances loose and free and he quite frequently used a scraper and a little brownish shading on the flesh parts, darkening it in places with a small amount of blue. He never became a member of the RHA. His opposition to its foundation was genuine and well known. He firmly believed that all painters should gain their knowledge from nature as he himself had done. His pupils included political caricaturist John Doyle (1797–1868), commonly known as 'H.B.' (see chapter v; p. 103), and the grandfather of Sir Arthur Conan Doyle.

SAMUEL LOVER, RHA (1797–1868), was also a pupil of Comerford and greatly influenced by him. He had a wide-ranging career, for not only was he to become an accomplished miniaturist under the careful guidance and encouragement of Comerford, but he was also a songwriter, novelist, painter and illustrator. His father wished him to pursue a career as a stockbroker but he was determined to become a painter and, much against his father's will, turned to painting, giving drawing lessons from the age of seventeen. He exhibited both

16] *Self-Portrait*; squared for the National Portrait Gallery, London. George Chinnery (1774–1852).

debts and his wife, who had rejoined him in 1823, he travelled further eastwards to Macao, Hong Kong and Canton. At that time no European women were allowed in Canton. This enabled him to evade his poor, long-suffering spouse who, undeterred, had yet again made an attempt to pursue her wayward husband.

During his lifetime Chinnery was highly regarded as a portrait painter both in oil and miniature. The miniatures were frequently unsigned and often revealed quite a variation in style.

Chinnery's Dublin friend John Comerford was born in Kilkenny, the son of a flax-dresser. Comerford attended the Dublin Society School[18] and also acquired considerable knowledge copying paintings in Kilkenny Castle, at Carrick-on-Suir and in Waterford. His return from Dublin to his native city was marked by an advertisement which appeared in Finn's *The Leinster*

17] *Henry Sheares (1753–1798), Barrister.*
John Comerford (c. 1770–1832).

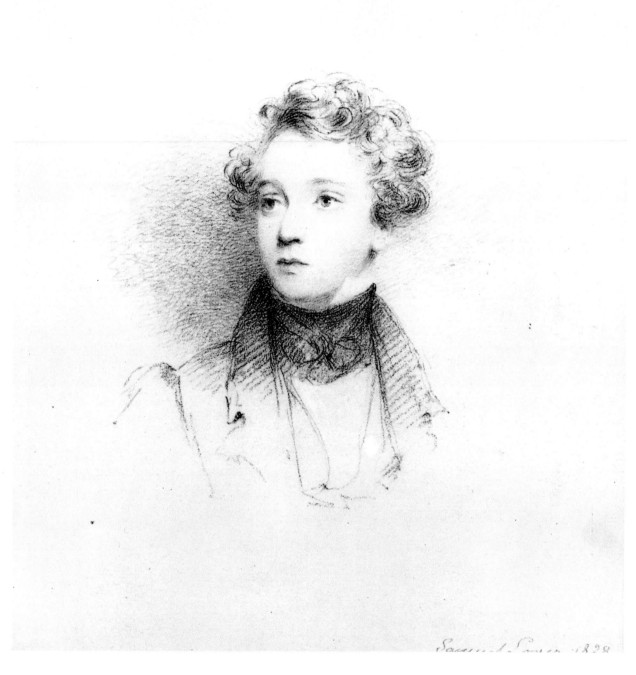

18] *Self-Portrait.*
Samuel Lover (1797–1868) .

miniatures and landscapes at the RHA from 1826 to 1835 being elected ARHA in 1828 and RHA in 1829. Before going to London in 1834 Lover helped to found and set up the *Dublin University Magazine* in 1833, contributing a large number of illustrations.

Until photography began to reduce the demand for miniatures, he had a successful practice in London, ceasing to paint in 1844. Two years later he set off for the

United States and Canada to present his 'Irish Evenings', monologues of stories, songs and poetry. Then, returning to London, he exhibited a series of landscapes at both the RA and the RHA, before retiring to live in Jersey for the last four years of his life.

In his miniature painting the quality of the work varies, and in many cases the colours are mixed with rather a lot of gum and tend to be too pink.

SIR FREDERIC WILLIAM BURTON, RHA, RWS, RSA (1816–1900) (see chapter VI; p. 147), records in a notebook Lover's remarks with regard to the ancient art of 'limning': 'The great difficulty in the manipulation is

19] *Portrait of a Young Girl.*
Samuel Lover (1797–1868) .

to avoid harsh and dry lines.' Burton, in his response, gives a hint of his critical approach to the whole area of art technique: 'It is a great difficulty, almost an impossibility but Lover certainly has overcome it – his hair especially is exquisitely blotted in, if I may say so, and he seems even to use his pencil [an obsolete term for brush] very full of wet colour. He masses well, I remember he also said that from the minute touching acquired in miniature painting, one is apt to forget to pay attention to the breadth so necessary in all works of art.'

During the early part of his career, Burton depicted small-scale representations of the human figure in relation to the background. His miniatures were always executed in watercolour, classical in feeling, using creamy flesh tones and tending to understate rather than emphasize the features of his sitter. This can be seen in his miniature of *Mr Blood* (painted on ivory), now in a private collection in Ireland.

An artist who possessed a style very similar to that of John Comerford was Belfast-born THOMAS CLEMENT THOMPSON, RHA (*c.*1780–1857), who entered the Dublin Society Schools in 1796 and, unlike his more famous predecessor, did become a founder member of the RHA. His practice was wide and his output prolific. He worked in both Dublin and Belfast and exhibited in Dublin between the years 1801 and 1854. Despite this, in 1817 he went to live in London and finally settled in Cheltenham around 1848.

Working slightly earlier than Thompson was JAMES REILY (or REILLY; *fl. c.*1750–1780/88) whose miniatures are well drawn and often expressive. After leaving the Blue Coat School, Oxmantown, he was, as already mentioned, apprenticed to Samuel Dixon, who pro-

duced flower and bird miniatures in bas-relief, which were then hand-coloured in body colour. Reily's task was to colour the prints. During his apprenticeship Reily showed a remarkable aptitude for drawing. He enrolled at the Dublin Society Drawing Schools, and when he had completed his training set up his own practice as a miniaturist in Capel Street, Dublin, later moving to Grafton Street where he was to remain for the rest of his life. Between 1765 and 1779 he exhibited at the Dublin Society of Artists.

Two miniatures in the NGI by ELIZABETH McAUSLAND (*fl.*1806–1807) demonstrate the skill of an artist who was rather more than an amateur. The first, of Charlotte Edgeworth aged twenty-four and executed in 1807 (the year of her death), demonstrates a delicate and fluid style coupled with a subtle sense of colour. The second, again of Charlotte Edgeworth, is somewhat less formal in tone. Both are painted in watercolour on ivory. Sadly, little is known of this artist's training or family.

Before becoming a miniature painter, Dublin-born CHARLES ROBERTSON (1760–1821) had exhibited 'designs in hair' at the tender age of nine.[20] Son of a jeweller

20] *Christine Noletor (née Jaffrey), the Artist's Wife.*
Charles Robertson (1760–1821) .

21] *Walter Robertson* (fl. c. *1768–1801*)*, Miniaturist and the Artist's Elder Brother.* Charles Robertson (1760–1821) .

who had lived at Ormond Quay, Dublin, Robertson practised in Dublin, exhibiting his miniatures for the first time in 1775. Ten years later he moved to London and remained there for almost nine years, contributing works to the RA. On his return to his native city, he became Secretary and eventually, in 1814, Vice-President of the Hibernian Society of Artists. Besides being a fine painter in the miniature style, he also painted flower pieces and small portraits in watercolour.

His daughter, CLEMENTINA ROBERTSON (MRS JOHN SIREE; 1795–c.1853), was trained by her father and like him became a miniature painter in her own right. However, his unsentimental and exact approach was somewhat less rigid when practised by his daughter, examples of whose work in miniature may be seen in the NGI. Charles Robertson's brother, Walter, also became a miniature painter, dying in India in 1801.[21]

HENRY KIRCHOFFER, RHA (1781–1860), was descended from a Swiss surgeon who had served in Ireland under William III. Strickland suggests that Kirchoffer was born in Dublin.[22] He entered the RDS Schools in 1797, first exhibiting in the city in 1801. He then practised in Cork for a number of years before returning to Dublin in 1816, where his portrait of *Charles Robertson* (illus. 22) is now in the National Gallery of Ireland. He was an original associate of the RHA and, from 1826 to 1835, a member. In 1835 he went to live in London, and later settled in Brighton.

Examples of MARJORIE ANN ROBINSON'S (1858–1924) miniatures can be found in the NGI and the Ulster Museum. A talented and gifted artist, she decided to specialize in miniature painting, training under Alyn Williams, PRMS (1865–1955) in London, and subsequently in 1912 became an associate member of the Royal Society of Miniature Painters. Born in Belfast, from an early age she showed a considerable aptitude for drawing and decoration. She studied illumination under John Vinycomb, head of the art department of Marcus Ward's publishing firm. She later attended the Belfast

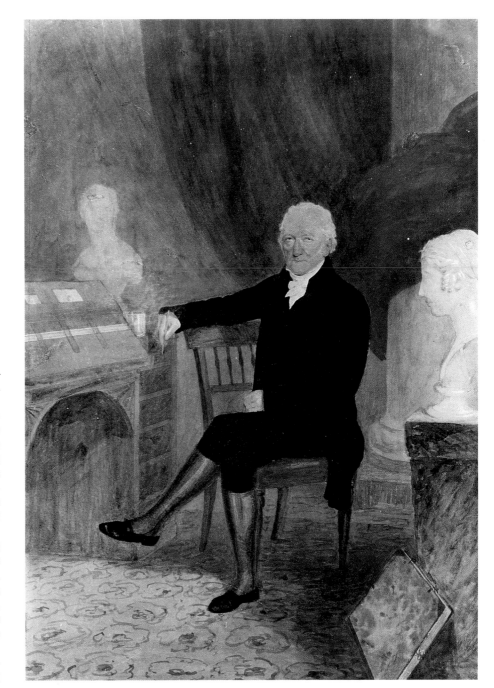

22] *Charles Robertson (1760–1821), Miniaturist.*
Henry Kirchoffer (1781–1860) .

Government School of Art and began working as an illuminator. After spending seven years in London, she returned to Belfast and exhibited her work regularly with the Belfast Art Society, Royal Academy and the RHA. She was elected an Associate of the Society of Women Artists in 1917.

Towards the middle of the nineteenth century, the spread of photography sounded the death-knell for the ancient art of limning. To try to keep abreast, the limners enlarged their work so that their portraits could stand alongside photographs, but the camera proved to be such an accurate and cheap method of reproduction that the older art could no longer command the field, and by the beginning of the twentieth century only a small group of miniaturists remained.

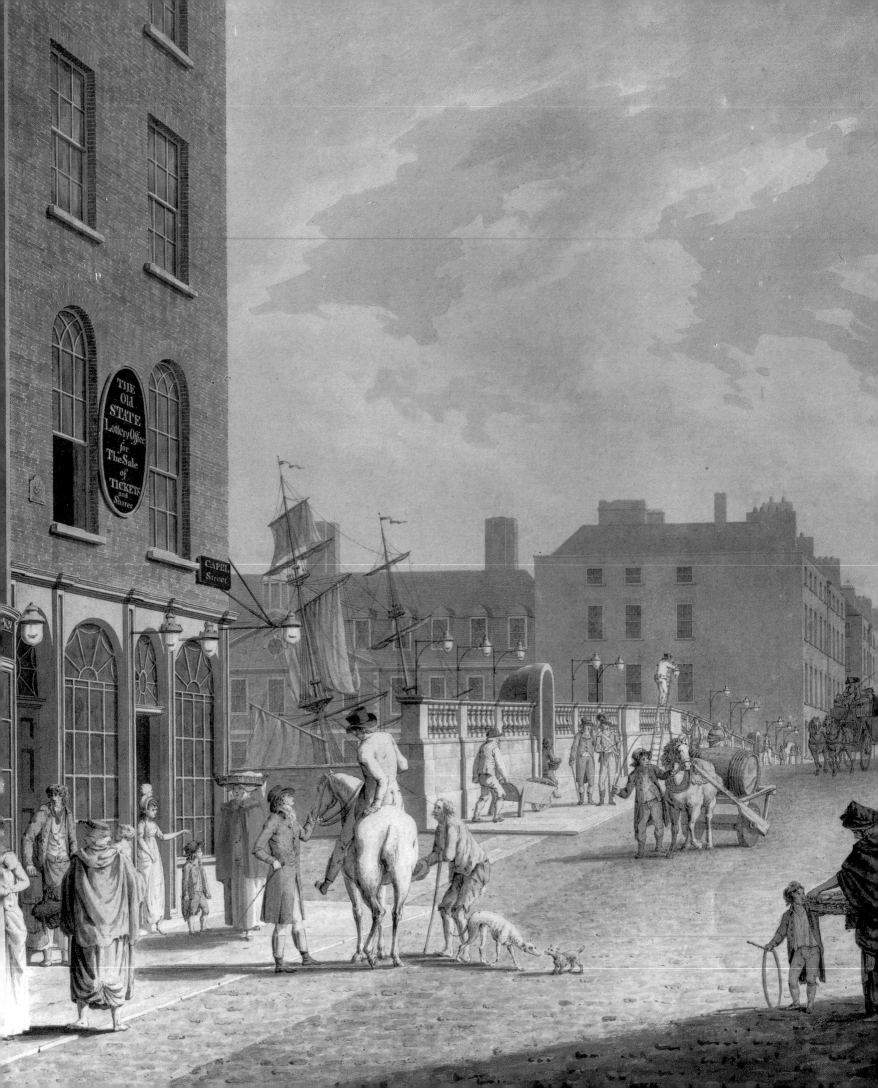

II

THE PLEASING PROSPECT:
THE TOPOGRAPHICAL TRADITION

THE appearance of the earliest landscape painters in watercolour in Ireland could perhaps be compared with the grafting of a new branch on to the none-too-healthy tree that constituted Irish art of the seventeenth century. This branch did not bear much fruit until the following century, then culminated in paintings and watercolours by such artists as George Barret, RA, William Ashford, PRHA, and T. S. Roberts RHA. By the time that period had been reached, the branch had forked in two very different directions with the ideal, classical landscape on the one side and the topographical depiction on the other. In tracing the early development of landscape watercolour, the topographical branch is best pursued first.

In the strictest sense topography means the portraiture of places, the topographer's task being primarily to gather information and, in doing so, to produce a drawing which records the view for posterity. The artist was thus a literal transcriber from nature, with little or no opportunity to introduce his personal interpretation of the scene before him.

Topographical painting in watercolour in Ireland began in the seventeenth century, the first topographical watercolourists coming from widely varying backgrounds. An interesting example was THOMAS PHILLIPS (c.1635–1693), a military engineer, who arrived in the winter of 1685 with strict instructions from the Master of the King's Ordnance, Lord Dartmouth, 'to take an exact view of the several forts, castles and garrisons of the said kingdom'. Phillip's origins are somewhat obscure but he seems to have progressed rapidly from being a ship's gunner to becoming an expert on bombardment and fortification, and spent the larger part of the 1680s drawing up plans and prospects of harbours in the Channel Islands. The volume relating to this survey was recovered from the wreck of the *Gloucester* in 1682 and is in the National Maritime Museum, Greenwich. It was also mentioned by Samuel Pepys in his correspondence from Tangier during an expedition of 1683.

On arrival in this country, Phillips found it miserably lacking in defence and immediately set about drawing up clear, concise and accurate maps. Macauley[1] refers to his map of Belfast as being 'so exact that the houses may be counted'. One of the most exciting features of his

report was the group of nine beautifully-executed 'Prospects' or views of various harbours and towns around the country which probably date from around 1685. These are now preserved in the National Library, Dublin. They form the nucleus of some of the very earliest topographical watercolour painting executed in Ireland. They show the scene in a highly recognizable manner, and are executed in a light colour wash. For the age in which they were painted, when the majority of drawings were so tight and concise, they demonstrate an astonishingly free style with a strong feeling for space in the rendering of cliffs, clouds and sea, as in *Duncannon, Co. Wexford*, or where storm clouds hover threateningly over Ben Bulben in *Sligo Town*, or float effortlessly across the sky as in *Limerick City* (illus. 24), reflecting the buildings of that once beleagured garrison.

Phillips was only one member of a talented trio of English artists who came to Ireland in the last quarter of the seventeenth century and recorded what they saw.

THOMAS DINELEY (or DINGLEY; c.1664–1695) was another important contributor, being described by his friends as 'very ingenious in drawing with his pen'. Dineley had the good fortune to be educated by the dramatist James Shirley at Whitefriars, London. He paid his first visit to Ireland in 1680, recording pen-and-ink sketches of towns and towerhouses, an example being the *View of the City of Youghal* contained in his *Observations* (1681). His work was of considerable topographical importance.

However, the most outstanding member of the group was without doubt FRANCIS PLACE (1647–1728),[2] who was to devote the greater part of his life to landscape painting and whose ability to record scenes with extraordinary accuracy gave his work a particular historical importance, combining topographical and aesthetic interest.

Born in Dinsdale, Co. Durham, he was articled as an attorney and admitted to Gray's Inn around 1665; but he soon showed, much to his father's regret, that he possessed no particularly strong feeling for the legal profession. He became a personal friend of the famous artist and engraver Wenceslaus Hollar (1606–1677) and, while always maintaining that 'he was a person I was intimately acquainted withal, but never his disciple', nevertheless did begin to model his style on that of the great illustrator and topographer.

Place came to Ireland in 1698, arriving in Drogheda to spend a year travelling, sketching and visiting such places as Dublin, Kilkenny and Waterford. Before

23] ABOVE *Dublin from Donnybrook Bridge* (now rebuilt), *on the River Dodder*. Francis Place (1647–1728) .

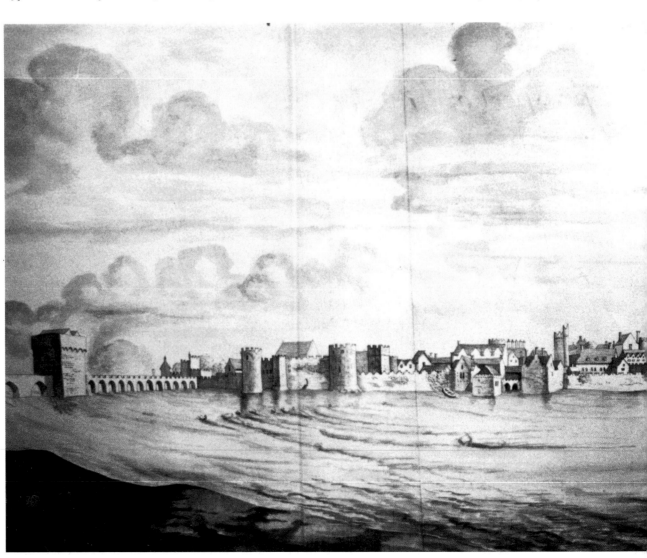

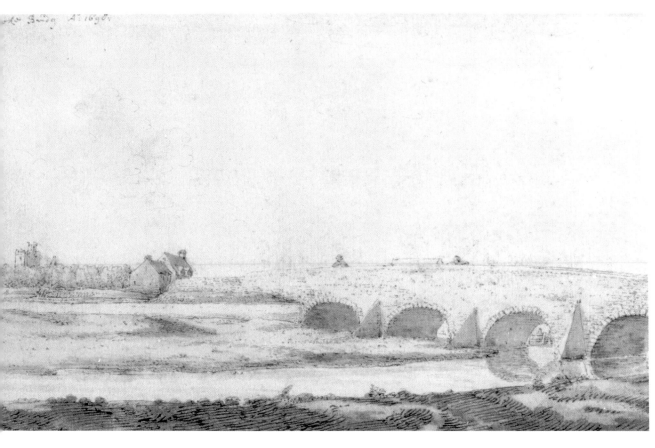

24] BELOW *Limerick City*; from the artist's *Military Survey of Ireland*, 1685. Thomas Phillips (*c.* 1635–1693).

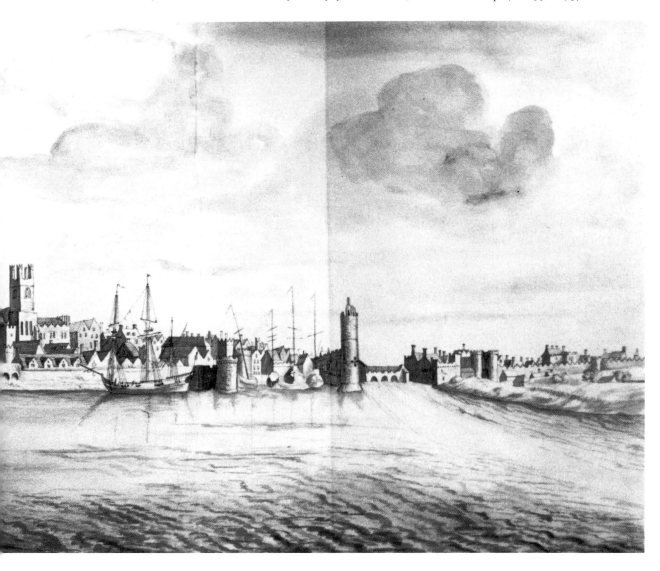

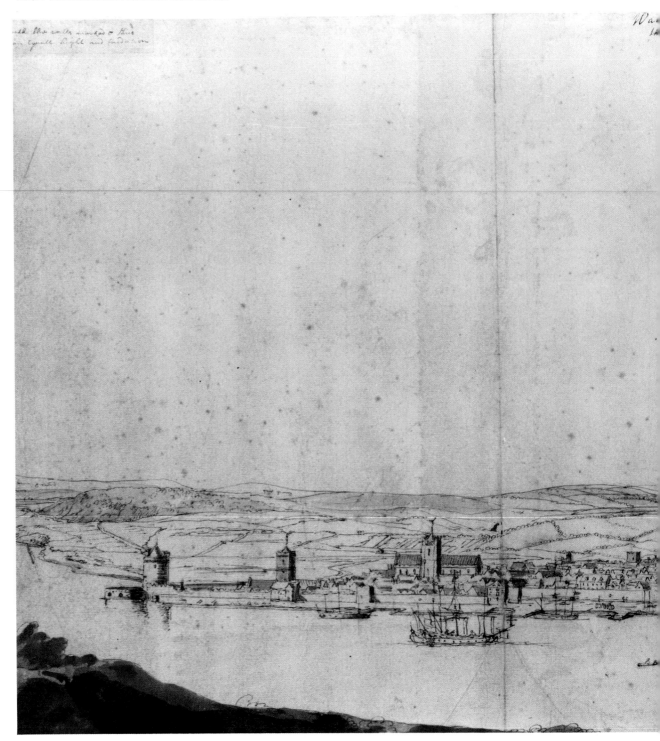

25] *View of Waterford from across the River Suir.*
Francis Place (1647–1728).

leaving England, his style had been characterized by sharp pen outlines combined with light, even washes of colour. In Ireland for the first time he began to use watercolour in its own right, beautifully and delicately, as is demonstrated in his drawing *Drogheda from the West with St Mary's Abbey*, a watercolour and wash on paper. Travelling on to Dublin, he recorded the *Bay of Dublin towards Dunleary*; *Dublin from Donnybrook Bridge* (1698) (illus. 23); and also a fascinating panorama of the city looking south which showed the two cathedrals, Christ

Church and St Patrick's; the old Tholsel (built from 1676 onwards); the old Four Courts; and a collection of churches including St Michael and All Angels as well as St Audoen's.

His travels through Ireland ended in Waterford, and the series is summed up in his *View of Waterford* (illus. 25). Here, in ink and wash on paper, he manages to combine a strong feeling for atmosphere with meticulous detail of the city encompassed by its medieval walls. Attached to the picture is a little note which reads: 'Let boath the walls marked be of an equall hight and fondation.' This note is on a separate piece of paper pasted to the corner of the drawing, which might suggest that Place proposed to make a set of Irish

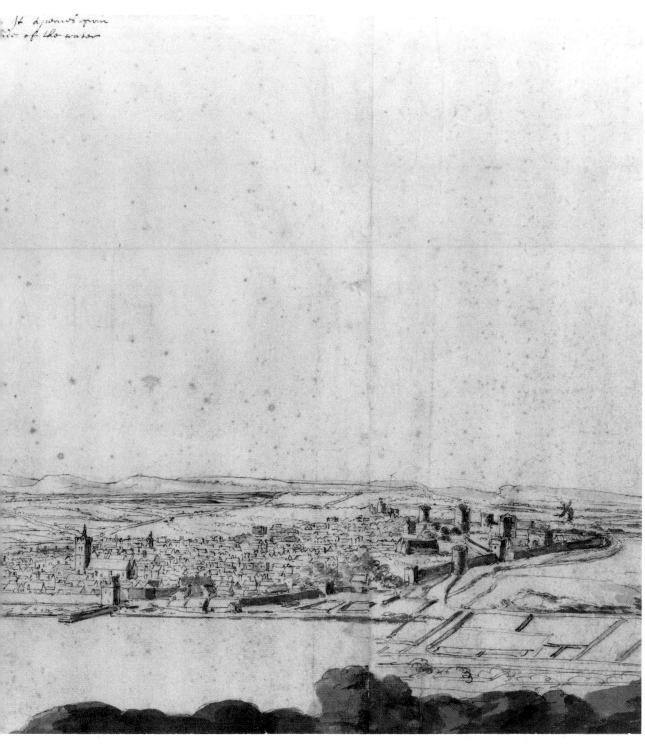

engravings from these drawings but never carried out the intention.

The 'ingenious Mr Francis Place', as he was known to many of his friends, was to end his days in the city of York, dying there in 1728 and leaving behind him an important nucleus of Irish work, much of which can be seen today in the National Gallery of Ireland.

Watercolours such as those executed by Phillips, Dineley and Place hold the key to the basic conception of early watercolour landscape painting in Ireland. They are characterized by the long, flat prospect executed in pen and wash, and occasionally in watercolour only. The early recorders of landscape possessed few aspirations to high art but were more concerned with making a detailed record of appearance – possibly with the exception of Place, who did manage to capture atmosphere.

The Dublin Society played an important role in this topographical tradition.[3] The influence on Irish artists of the Dublin Society, particularly in the eighteenth century, was of considerable significance. It offered a number of premiums and awards, and also acted as a vital focal point for painters, where their work might be exhibited and sold, or new commissions obtained.

SUSANNA DRURY (*fl.*1733–1776) was very much part of this topographical tradition and represents the first generation of Irish-born artists who were actively encouraged by the newly-founded Dublin Society.

Very little is known about this somewhat obscure Irish painter, whose views of the *Giant's Causeway, Co. Antrim* (illus. 26) executed in gouache on vellum and later engraved by François Vivarès (1709–1780) won her a premium from the Dublin Society in 1740.[4]

Susanna Drury came from a well-established Anglo-Irish family which lived largely in Dublin and had been established in Ireland since Elizabethan times. The Dublin side of the family was first mentioned in the seventeenth century when John Drury of Harold's Cross married Ann Leeson in 1675 (the Leesons, brewery and property speculators, later became Earls of Milltown). Their son, Thomas Drury, married the daughter of a Norfolk rector, Rebeckah Franklin, and they produced five children. One of their sons became, for a time, Vicar of Powerscourt, Enniskerry, Co. Wicklow, and another, the well-known miniature painter Franklin Drury, died at Powerscourt in 1771. They also had three daughters, Mary, Elizabeth and Susanna, none of whose dates of birth and death are recorded. Susanna is believed to have married a man named Warter, although exactly when and where the marriage took place still remains uncertain. She appears to have married quite late in life: Mrs Delany, in 1758, is still referring to the painter as 'Miss Drury'. Biographical details and any record of Susanna's training are hard to come by. As there was no established art school before the mid–1740s, it is possible that she was influenced by such landscape painters as William van der Hagen (d.1745) who was believed to have been working in Ireland from the early 1720s onwards.[5] Joseph Tudor

26| *East Prospect of the Giant's Causeway, Co. Antrim.* Susanna Drury (*fl.* 1733–1776) .

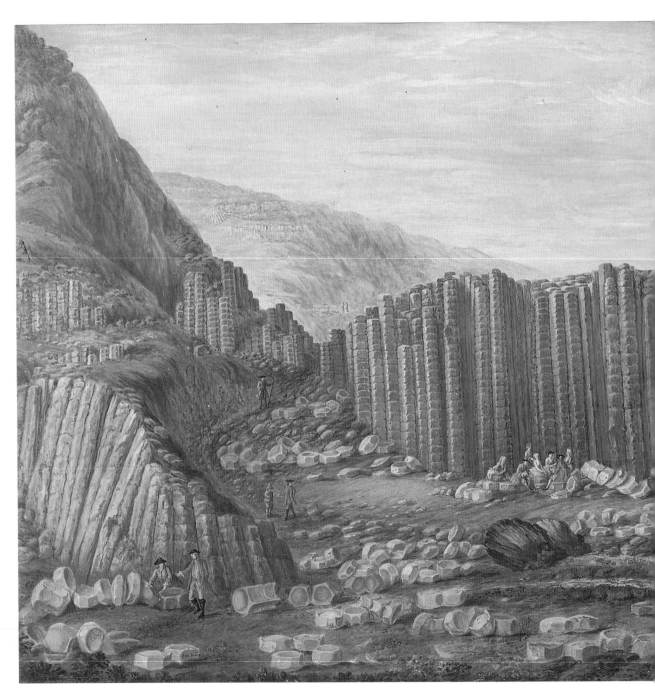

(c.1695–1759), a contemporary who was also a recipient of an award for landscape painting from the Dublin Society between 1740 and 1746 and described by Strickland as 'one of the principal landscape painters of that period in Dublin',[6] may also have been influential. However, one of her few known works, a London view entitled *One Tree Hill, Greenwich Park*, signed and dated 1733 and executed in gouache on vellum, suggests the possibility that she may have received some training in London.[7]

Whatever her artistic background and whatever her influences were, she was a remarkable recorder of landscape, as her two splendid gouache drawings of the Giant's Causeway amply demonstrate. Her acute sense of observation, draughtsmanship and obvious interest in the intrinsic structure of the rock formation are acutely conveyed.[8] Detailed descriptions are given on the back

of the Vivarès engravings. These are anonymous but may have been written by Susanna herself or by her brother. It is unfortunate that so little of this painter's work has survived.

Around this period in the 1730s and '40s, a significant and important school of engravers led by John Brooks and Andrew Miller was beginning to emerge in the capital. Brooks had learned the art of engraving in Dublin and had then set out for London, where he met Miller. Both returned to Dublin to set up a business publishing views and portraits.

Engraving was now a distinct and positive form of encouragement for the watercolourist. It could bring the artist's work into every home at a moderate cost and in many cases was the only means by which a painter could have his work appreciated and known by more than just a select few. Two hundred prints from an engraver

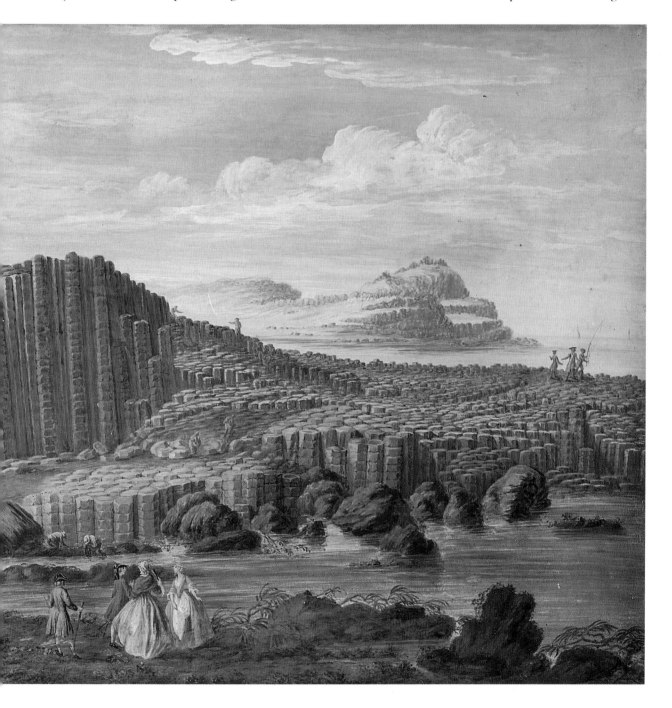

would make an artist's fame and name. Publishers now began despatching painters all over Ireland to record drawings of cathedrals, castles, country seats, mountains and lakes, the artists, in many cases having to make the arduous journey on foot.

One of the most intrepid travellers and recorders of information during this period was FRANCIS GROSE, FSA (1731–1791), an enormously corpulent but most likeable and generous man, about whom a Dublin butcher soliciting his custom was heard to remark, 'Only say you buy your meat of me and you'll make my fortune!'

His father, a jeweller, originally came from Berne and

27] *Portrait of Francis Grose (1731–1791)*; a plate from *A Dictionary of Irish Artists*, 1913, by W. G. Strickland.

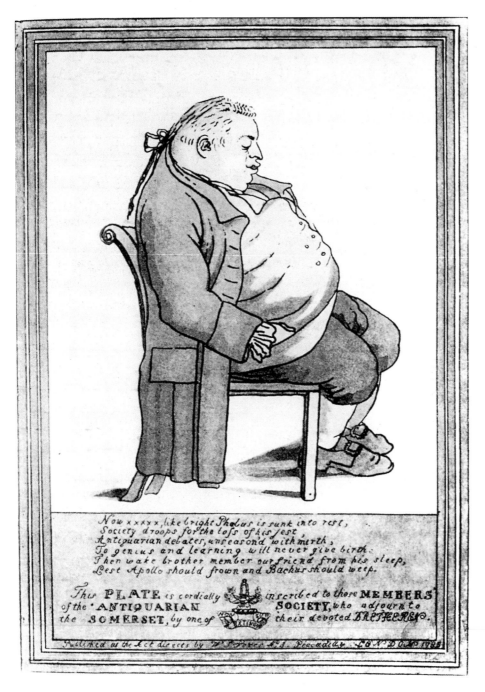

had the distinction of making the crown for George II. Grose was born in Greenford, Middlesex. He studied at Shipley's School and became a member of the Society of Artists. He exhibited architectural views there and at the RA from 1769 to 1777. Fortunate enough to have independent financial means, he drifted into the post of Richmond Herald in the College of Arms, where he remained until 1763. Resigning his tabard, he became Adjutant and Paymaster of the Hampshire militia and afterwards joined the Surrey militia.

A lover of antiquities, he set out in 1789 to tour Scotland collecting material for his *Antiquities of Scotland* (1789–91). In May 1791 he came to Ireland to embark on a similar work. On his arrival here, he immediately set off on tour accompanied by his assistant, Thomas Cocking (*fl. c.*1783–1791), but suddenly, in the middle of a visit to his friend the Dublin miniaturist Horace Hone, he was seized by an apoplectic fit and died. He had, as he often said himself, 'been going it too hard for three or four days'. He was buried in Drumcondra Church.

Grose's drawing of this building includes a rear view of himself, complete with pigtail, hat, stick and boots. He stands on what was to be his own grave amid the waist-high weeds in the overgrown graveyard, his back to the spectator (illus. 28).

After his death the completion of his *Antiquities of Ireland* was carried out by his nephew Lieut. D. Grose (d.1838) and by the Revd E. Ledwich, who continued the descriptive letterpress. In addition to the work in watercolour already carried out by Francis Grose, drawings by Barralet, Bigari, D. Grose, J. Gandon, A. Chearnely, F. Wheatley and others were also engraved in this well-known recording of Ireland's antiquities.

Like Francis Grose, GABRIEL BERANGER (1729–1817) and JOHN JAMES BARRALET (1747–1815) were part of a large and enthusiastic group of amateur and professional painters who travelled extensively throughout Ireland during this period, producing a vast collection of watercolours of Irish antiquities.

Beranger, like Barralet, was of Huguenot extraction. He came to Dublin from Rotterdam in 1750 to teach drawing, and also painted birds and flowers, exhibiting with the Dublin Society of Artists, and ran a small not too profitable print-selling business.

Barralet was a native of Dublin and had studied at the RDS, being awarded a premium in 1764 and establishing himself as a formidable master of drawing before leaving for London around 1770. There he founded, within a short space of time, two drawing schools, one in James Street off Golden Square and the other in St Alban's Street, Pall Mall, and also found time to exhibit at the RA and the Society of Artists.

In 1779 he returned to Dublin and the following year joined forces with Beranger, journeying through Wexford and Wicklow making drawings for Grose's *Antiquities of Ireland* and Milton's *Views of the Seats in Ireland*. Throughout these journeys his companion proved himself a keen and close observer of the people among whom he travelled, and gives in his diaries vivid descriptions of the scenery and places he sketched and visited. Beranger kept a careful itinerary of these tours, illustrated with watercolour sketches ready for publication. In a clear and firmly defined view of the Three Rock Mountain, he describes the scene:

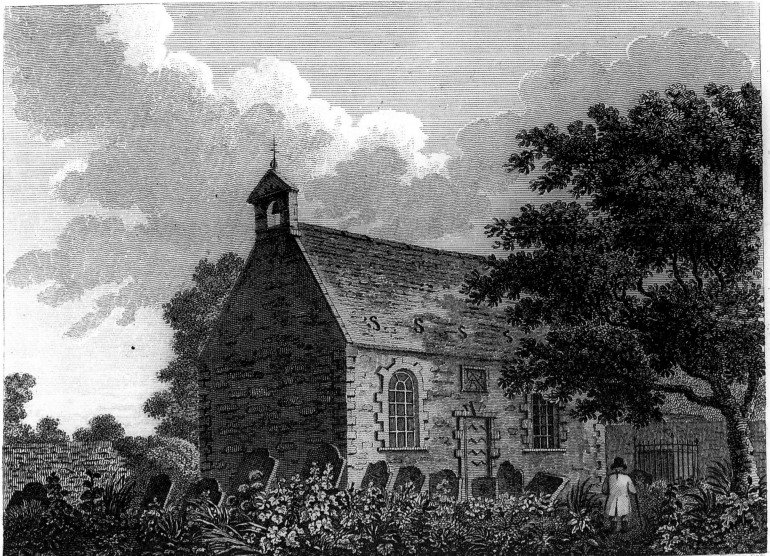

To JAMES GANDON, & SAMUEL WALKER Esq.rs M.r HORACE HONE & RICH.d EDW.d MERCIER who attended the funeral of the late FRANCIS GROSE Esq.r to the Church of DRUMCONDRA near DUBLIN where his REMAINS were deposited 18 May 1791. This View is inscribed by their Humble Servant SAMUEL HOOPER.

28] *Drumcondra Church; from* The Antiquities of Ireland, 1791–5; engraving after the drawing by Francis Grose (1731–1791).

This mountain has on its summit three huge heaps of rocks, piled one on another and seen at some miles distance from which the mountain takes its name. I take them to be altars on which sacrifices were offered. . . . I have copies of every stone as they are fixed and the regularity which is observed in piling them convinces me that they are the work of men, as they could not grow in that position. The sea is seen, though more than six miles off. The extensive summit of this mountain, the parched ground and its solitude made it the most awful spot I had ever seen.

Both artists were encouraged in their work by such eighteenth-century antiquarians as Col. Vallancey, map-maker of the Board of Ordnance and Engineers, and William Burton Conyngham, patron of the arts and architecture. The latter offered Beranger the post of assistant ledger-keeper in the Exchequer Office in 1783, a position he held until 1789.

Barralet worked chiefly in watercolour and gained a considerable reputation as a teacher. He is said to have been responsible for the invention of a machine for engraving on copper. Unfortunately, providence had not smiled on him in the matter of looks. Born lame, he was strikingly ugly and also had an irritable, eccentric and passionate personality. Unlike Beranger, he did not end his days in his native Dublin but emigrated to America in 1795, finally settling in Philadelphia where he worked as a book illustrator and watercolourist until his death in 1815.

Over a period of thirty years MARY DELANY (1700–1788) sketched and recorded 'wild, pretty places'. These drawings, some of which consist of loose draw-ings, are now in the National Gallery of Ireland's

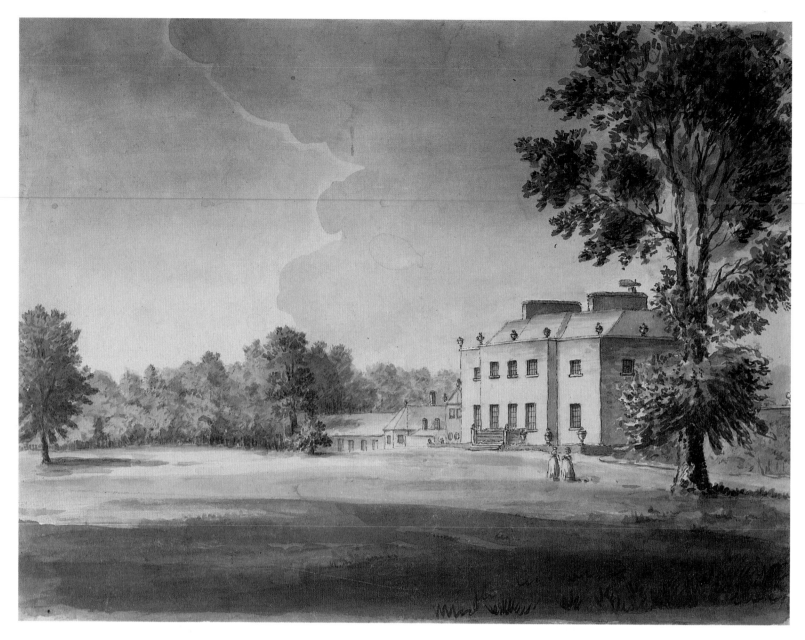

29] *The Lord Lieutenant's Residence* (Áras an Uachtaráin), *Phoenix Park, Dublin.* John James Barralet (1747–1815).

collection. They indicate a style which could be highly competent and pictorial, revealing the influence of such well-known artists as Hogarth and Francis Hayman. Originally taught by Goupy, she received encouragement from her second husband, the Revd Patrick Delany – a close friend of Jonathan Swift – whom she married in 1743. Interested in all aspects of the arts, her botanical work *Hortus Siccus* in the British Museum, consisting of almost one thousand flowers cut from paper, was begun at the age of seventy-two.

Mrs Delany's friend, LETITIA BUSHE (*fl.*1731–1757), reveals in her *View of the Village of Bray* (1736) (illus. 30) that she was an attractive, accurate and competent topographical watercolourist. This is one of the earliest known views of this Co. Wicklow seaside town and records several buildings which are still in existence today, most notably St Paul's Church (built in 1609 and

currently being used as an organ works). Letitia's drawings are generally handled with delicacy and lightness of touch, but at the same time great attention is paid to detail. It is not known where this 'gay, good-humoured, innocent girl …' (in the words of Mrs Delany) learned her art. However, it has been suggested that Bernard Lens (1682–1740) and possibly his son, Peter Paul (*c.*1714–*c.*1750), who have been mentioned in chapter I (see pp. 12 and 14), may have been influential judging by her close affinity to their style.

WILLIAM ASHFORD, PRHA (1746–1824), was born in Birmingham but was to spend sixty years of his life in Ireland. His straightforward, well-ordered topographical scenes reveal a good sense of colour which is combined with an elegant freedom of execution. While watercolour never became his primary medium, it nevertheless formed an important and integral part of his *oeuvre*, as seen in his twenty-four watercolour views of Lord Fitzwilliam's estate at Mount Merrion, Co. Dublin (illus. 31). These are now in the Fitzwilliam Museum, Cambridge.

It has never been firmly established just why he came to Ireland. Pasquin, commenting on this, remarks, 'He was appointed to a lucrative situation in the Ordnance Office in 1764.'[9] Ashford began exhibiting as a flower painter as early as 1767 at the Society of Artists. After 1772 he began to concentrate on landscape, possibly due to his involvement with the mapmaking activities of the Ordnance Office. A comment on a landscape work exhibited by him at the RA in 1775 notes: 'We don't remember this artist's name before in any exhibition not withstanding this, he is so far from being a novice in his profession that if he is young and attentive, he may well expect to reach the first form in this department of painting.' Indeed, Ashford was to prove that he was fully capable of doing just that, for in 1823 he became the first President of the RHA, a distinction for a painter of landscape in a period when this aspect of art was still being looked on as a poor relation.

Ashford never severed his links with England, contributing at intervals to the Society of Artists and the British Institution. In a catalogue dated 22 and 23 April 1790, J. T. Serres (1759–1825) son of the well-known marine painter Dominic Serres, RA (1722–1793), sold a number of paintings which belonged to him and to other artists including five views by William Ashford of scenery in both Wicklow and Killarney.[10]

For the last years of his life Ashford lived at Sandymount, County Dublin. 'His noble friend, Viscount Fitzwilliam ... gave him a lease of ground, on very moderate terms but strongly urged him to erect a villa upon it for himself which he did in a very appropriate style and with considerable taste, for which his friend, Mr Gandon gave him a suitable design.'[11] After the Act of Union, Ashford and his contemporaries suffered a decline in demand for their work as many of their clientele withdrew to England, deserting their estates. Nevertheless his lush views of well-cared-for parks and farmlands executed in watercolour or oil have continued to prove immensely appealing to collectors.

In the late eighteenth century a new type of print was introduced: the aquatint (see Glossary; p. 216). Unlike engraving, this can suggest convincingly the delicate wash qualities of watercolour.

Well-known publishers such as Ackermanns would

30] *View of the Village of Bray, Co. Wicklow.* Letitia Bush (*fl.* 1731–1757).

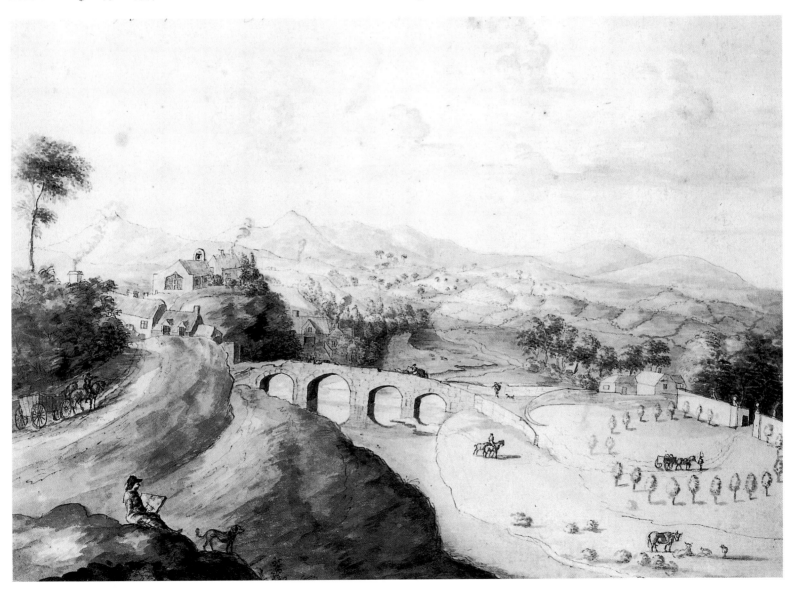

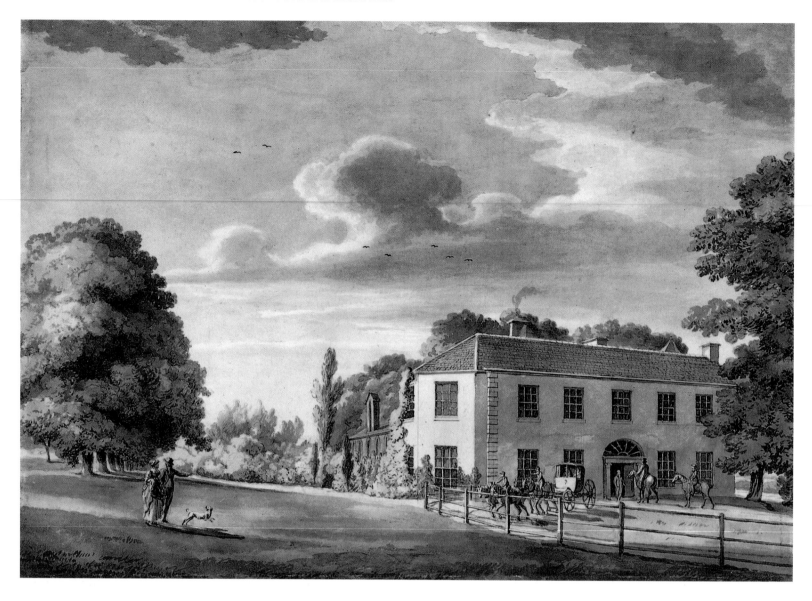

31] *Mount Merrion. The Lodge seen from the Lawn.*
William Ashford (1746–1824) .

employ a whole team of engravers. It was common for the plate to be printed in two or three colours, for example blue for the sky and brown for the foreground. This was achieved by using a soft paper, which was specially sized to stop the colours blotting. A number of trained colourists (generally women) were then employed to hand-colour the prints. After many years of experience, they could lay tints in even washes with a high degree of proficiency.

The increase in popularity of the aquatint was swift, and by the end of the eighteenth century it had been used in many important publications including James Malton's famous and valuable pictorial record of the City of Dublin in the late eighteenth century.[12] Before discussing the life of this artist, it is necessary to give a brief account of the less well-known members of his family.

James's father, THOMAS MALTON THE ELDER (1726–1801), first visited Dublin as early as 1769 and from then on paid several visits to the capital, mainly to

try to obtain support for his treatise on perspective[13] and for a new 'perspective machine', a drawing aid he had recently invented. However, financial difficulties forced him to leave London finally in 1785 and settle in Dublin, where he earned a precarious living as a professor of perspective and geometry, whilst at the same time paying frequent visits to England.

His son THOMAS MALTON THE YOUNGER (1748–1804) accompanied his father to Dublin in the year 1785, but apart from this brief visit he seems to have preferred to live in London, and also spent a short period in Bath in 1780. At Conduit Street, London, in the 1780s he held evening drawing classes, and numbered amongst his pupils two of England's most eminent watercolourists, Thomas Girtin (1775–1802) and J. M. W. Turner, RA (1775–1851), the latter being brought by his father to learn the art of perspective. William, another son of Thomas Malton the Elder, worked as an architectural draughtsman, but there is no record of him as an artist.

JAMES MALTON (c.1760–1803), the best known of the family, was like his father a professor of perspective and geometry. Two watercolours dating from 1789, entitled *A View of Castle Durrow* (illus. 32) and *A View of*

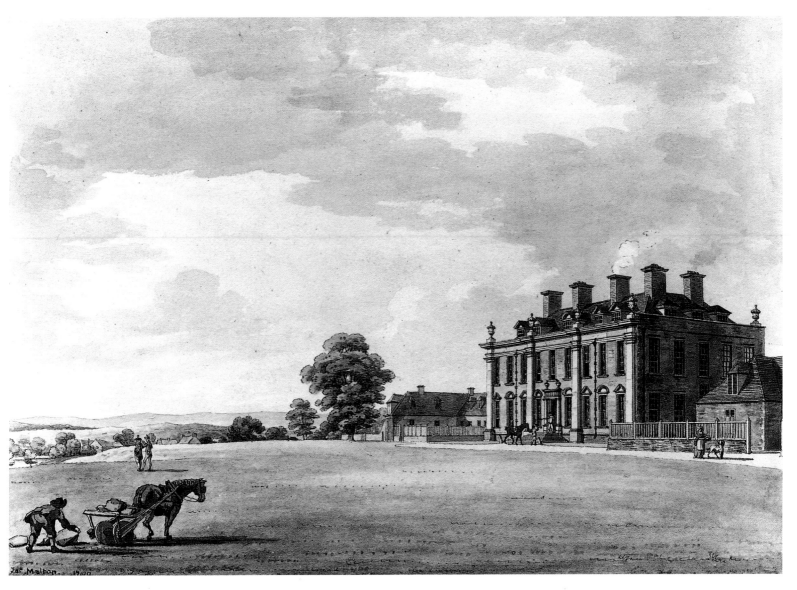

32] *View of Castle Durrow*.
James Malton (*c.* 1760–1803) .

Heywood, are amongst his earliest known works in this medium and were sent from Dublin to London to be exhibited at the Society of Artists in 1790. Having arrived in Dublin with his father five years previously, he had spent a period working as a draughtsman in the office of the architect JAMES GANDON, RHA, FSA (1743–1823). His *Picturesque and Descriptive View of the City of Dublin* was to be published in parts from 1792 until 1799 and is one of the earliest books with colour aquatints. The plates were worked from watercolour drawings executed by Malton, twenty-five being reproduced in etching and aquatint, with the work carried out by the artist himself. Publication by Malton began in London in 1792. Originally the views were to have been issued in four numbers of six views each, the subscriber being charged the princely sum of a guinea and a half for each number. However, this was altered to six numbers with four views each, the charge to be a guinea per number, and in this form they finally appeared – though the second number contained five plates, the *Interior of*

the College Library being offered as an extra plate. Each plate was accompanied by descriptive text, headed by a dedication and vignette in aquatint done by Malton, and all were inscribed 'James Malton del. et fecit'. The plates proved to be so popular that printing continued right into the 1820s. A highly important pictorial record of Dublin's principal buildings at that time, they are enlivened by groups of figures and little scenes which add character and charm to these superb topographical views. Two of these views are illustrated here, namely *View of Capel Street, Dublin, with the Royal Exchange in the Distance* (illus. 35) and *The Customs House, Dublin* (illus. 33).

Apart from this well-known work, Malton exhibited at the RA between the years 1792 and 1803 a total of fifty-one drawings of architectural subjects, seventeen of which were views of Dublin executed in Indian ink and watercolour. The majority were of the same subjects as his engravings, but in most cases were on a larger scale and carry dates later than the prints. The figures vary considerably from those found in the published views.

Before the actual publication of his *Views of Dublin* Malton left for London, where he was to spend the rest of his life completing such diverse works as *The Young*

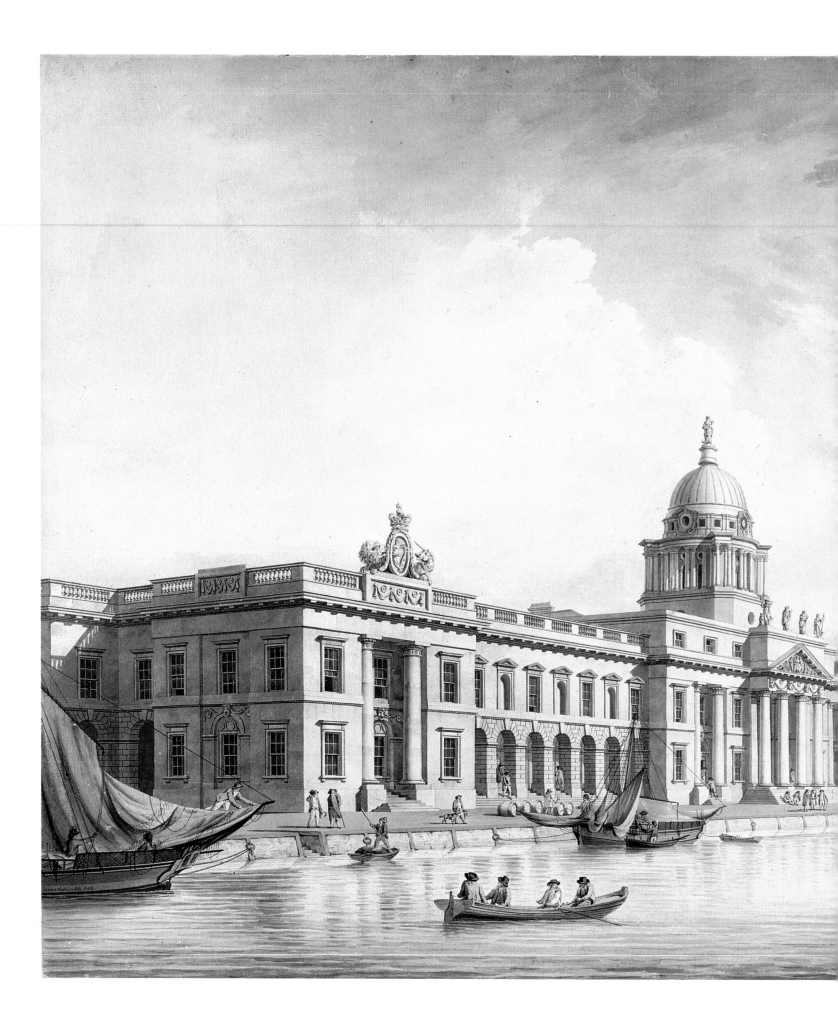

33] *The Customs House, Dublin.*
James Malton (*c.* 1760–1803) .

34] *A Description of the Lakes of Killarney, Co. Kerry*; from *Scenery of Ireland*, 1796; drawn and engraved by Jonathan Fisher (*fl. c.* 1763–1809) .

Painter's Mahlstick and book plates for the Earl of Charlemont. He continued to exhibit at the Incorporated Society of Artists and at the RA until his death on 28 July 1803. This may have been brought about by a 'brain fever' or, according to some, he may have taken his own life in Marylebone Fields.

The Maltons were, as Hardie[14] refers to them, 'street-artists', making accurate and lively records of Dublin's elegant buildings and city life. They displayed a remarkable ability to capture the character of its bustling streets and slow-moving horse-drawn traffic.

JONATHAN FISHER (*fl.* 1763–1809) did not confine himself to recording city scenes but travelled extensively throughout Ireland, striving to complete a comprehensive coverage of Irish scenery. This resulted in the publication in 1796 of his famous *Scenery of Ireland*, with sixty plates aquatinted by himself. Before setting out to become a painter he had been a prosperous woollen draper in the Liberties of Dublin, and as far as is known did not have any conventional training, being largely self-taught, although he may have received some tuition

when he visited England early in his career. His topographical works, in the words of Strickland, were 'lifeless, cold and mechanical',[15] and perhaps this was one of the main reasons for their lack of popularity. In 1778 he was forced to take a post in the Stamp Office as Supervisor of Stamps. His topographical landscapes contained in his *Six Views of Killarney* (1770), and a folio volume entitled *A Picturesque Tour of Killarney* (1789), which he dedicated to his friend and patron, John, Earl of Portarlington, are somewhat contrived and cold in appearance and did not prove to be nearly as successful as the engravings and aquatints made after his drawings, as seen in *A Description of the Lakes of Killarney* (illus. 34).[16]

WILLIAM HINCKS (or HINKS; *fl.* 1773–1779), an 'ingenious and indefatigable gentleman',[17] was like Fisher entirely self-taught, having been apprenticed at an early age to a blacksmith. His name first appears in 1773 when he was living in York Street, Dublin, and exhibiting at the Society of Artists in William Street. A painter and an engraver who also worked as a book illustrator, Hincks completed, before setting out for London, an interesting series of drawings of the process of linen manufacture. These he engraved and published in London in 1782. The series was made up of twelve plates and represented the various stages in the manufacture of linen from the sowing of the flax to the

35] *View of Capel Street, Dublin, with the Royal Exchange in the Distance*. James Malton (*c.* 1760–1803) .

exportation of the finished article at Linen Hall, Dublin.

Like the Maltons before them, the Brocas family in the nineteenth century made a considerable contribution to topography, in particular that of Samuel Frederick Brocas, whose views of Dublin are well known.

This highly-artistic family descended from a Robert Brocas, a native of Derbyshire, who had come to Ireland in the time of Cromwell, as a 'cornet of horse'. HENRY BROCAS SENIOR (1762–1837) had four sons, all of whom were destined to enter the art profession. A master engraver, though most of his work was in watercolour, he was appointed Master of the Landscape and Ornament School at the RDS in 1801. He, and later his son HENRY BROCAS JUNIOR (1798–1873), were to be in charge of teaching in this area for the entire first half of the nineteenth century. He executed topographical views, portraits and political caricatures and contributed numerous engravings as illustrations of articles in magazines and periodicals.

Following his father, JAMES HENRY BROCAS (1790–1846) studied at the RDS and became a portrait and landscape painter. He was also a particularly fine animal painter, as is revealed by studies of cattle and horses which he submitted to exhibitions held in Dublin between 1801 and 1816. He also exhibited in Cork, where he finally settled in 1834.

Henry's third son, WILLIAM BROCAS, RHA (1794–1868), was also a portrait and landscape painter, submitting works to the RHA between 1828 and 1863 and becoming President of the Society of Irish Artists.

Of Henry's four sons, perhaps the best known today is SAMUEL FREDERICK BROCAS (1792–1847), who studied art at the RDS where he distinguished himself by being awarded medals for flower painting, etching and drawing. His twelve famous street views of Dublin, dating from 1817, are filled with interest and vitality. These were later to be engraved by his younger brother, Henry Junior, and published between 1818 and 1829 by J. Le Petit, Dublin, as part of a more ambitious project, a *Book of Views of Ireland* which, sadly, never found a publisher. A fine watercolourist, as his *Trinity College and College Green, Dublin* (illus. 39) reveals, Samuel Frederick also worked in Limerick, and exhibited at the RHA between 1828 and 1847. He was, like his brother, a member of the Society of Irish Artists.

Henry also taught his fourth son Henry Brocas Junior who, true to family tradition, became a landscape painter and engraver and as already mentioned, suc-

41

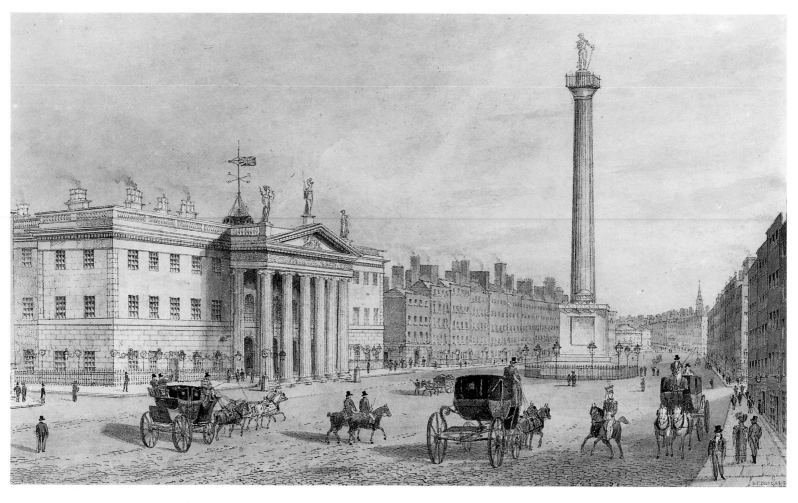

36] *The Post Office and Nelson's Pillar, Sackville Street* (now O'Connell Street), *Dublin.*
Samuel Frederick Brocas (1792–1847) .

37] *Old Bael's Bridge, Limerick* (now rebuilt) .
James Henry Brocas (1790–1846) .

ceeded his father in the RDS and was elected Master of the Landscape and Ornament School, from which he retired in 1854. An engraver, he etched some copies of Hogarth's works and his *Portrait of Richard Kirwan*, chemist and natural philosopher, engraved in stipple, was used as the frontispiece of the *Proceedings of the RIA* between the years 1847 and 1850.

Like the Brocas family, GEORGE PETRIE, PRHA, LL.D (1790–1866), was widely known during his lifetime for his work in watercolour, and prints of his graceful drawings illustrated many Irish guidebooks in the early part of the nineteenth century. He was the first watercolour painter to become a full member of the RA in 1828.

An extraordinarily accomplished man in many fields, he became not only an artist but also an archaeologist, musician and man of letters, making a valuable contribution to the RIA. Among the many manuscripts he secured for the Academy were the Annals of the Four Masters and the Book of the Dun Cow. Between 1835 and 1842 he was head of the topographical and historical department of the Ordnance Survey of Ireland and collected valuable material on the antiquities, place-names and local history of various counties in Ireland. Possessing a deep interest in Irish music, he gathered together a large collection of Irish airs, some of which he published in 1855 as *The Petrie Collection of the Native Music in Ireland*.

His artistic ability had to some extent been inherited from his father, the Dublin-born miniaturist JAMES PETRIE (1750–1819), and at an early age he had shown a talent for landscape painting, being awarded the Dublin Society Schools silver medal when he was only fourteen. His first sketching trips took him to Wicklow and Wales, and in 1813 to London in the company of fellow artists Francis Danby and James Arthur O'Connor. In a gentle topographical watercolour such as *Pilgrims at St Brigid's Well, Liscannor, Co. Clare* (illus. 40) he reveals his ability to place his figures in a romantic setting. He was also very interested in antiquities and wrote an essay on *The Round Towers of Ireland* which earned him a gold medal and prize in 1803. His work proved immensely appealing to book publishers, and he illustrated such books as G. N. Wright's *Historic Guide to Ancient and Modern Dublin* (1821), Brewer's *Beauties of Ireland* (1825) and Wright's *Ireland Illustrated* (1831).

WILLIAM FREDERICK WAKEMAN (1822–1900) and GEORGE VICTOR DU NOYER (1817–1869) were both pupils of Petrie. They were topographical draughtsmen and both, through their teacher's influence, gained positions in the Ordnance Survey.

In the 1840s du Noyer became a drawing-master at St Columba's College, Stackallan, and afterwards left to work with the Geological Survey of Ireland, with which he was connected until his death. Between 1841 and 1863 he exhibited at the RHA, and was also a member of the RIA and Kilkenny Archaeological Society.

When the topographical department of the Ordnance Survey closed, Wakeman worked as a drawing-master in Dublin and later taught at both St Columba's College and at Portora Royal School. A prolific archaeological writer and illustrator, he also illustrated works including Hall's *Ireland: its Scenery and Character* (1841–1843) and *Handbook of Irish Antiquities* (1848). Both Wakeman and

38] *The Fountain, James's Street, Dublin.*
Ascribed to George Petrie (1790–1866) .

du Noyer are represented in the RIA.

Like Wakeman and Du Noyer, HENRY O'NEILL (1798–1880) worked with Petrie, collaborating with him and Andrew Nicholl for such works as *Picturesque Sketches of some of the finest landscapes and Coast Scenery of Ireland* published in 1835. Born in Clonmel and orphaned while still young, he was brought up in Dublin by his aunt, entering the RDS Schools in 1815. His first entry at the RHA is recorded as taking place in 1835 and two years later he became ARHA. He resigned in 1844. He then worked as an illustrator before leaving for London in 1847. The move proved to be a mistake and he soon returned to Dublin where he resumed exhibiting with the RHA until 1879. A prolific topographical illustrator and lithographer, he contributed to such works as Hall's *Ireland: its Scenery and Character*

39] *Trinity College and College Green, Dublin.*
Samuel Frederick Brocas (1792–1847) .

(1841–43). Also an ardent nationalist, his interesting series of nineteen watercolours depicting various scenes of the Richmond Bridewell Prison, in which O'Connell and other Repeal Association prisoners were held in 1844, are now in the collection of the National Museum of Ireland.

To demonstrate how far the interpretation of a view or prospect had progressed by 1839 it is interesting to compare, for example, an illustration found in G. N. Wright's *Ireland Illustrated*[18] published in 1831 with N. P. Willis's *Scenery and Antiquities of Ireland* published in 1844.[19] Both views are by WILLIAM HENRY BARTLETT (1809–1854). In the later scene, drawn in 1839, the buildings seem to form a much more integral part of the landscape and possess charm, with the artist employing light and shade to enliven his picture. There is now a far more sensitive approach to the scene than the earlier, somewhat dry architectural drawing dating from 1829, which has been replaced by an aesthetically attractive picture of the same scene ten years later.

Bartlett was a competent topographical and architectural draughtsman who, while still in his teens, had been apprenticed to John Britton, FSA (1771–1857), a leading antiquarian and topographer. During seven years' apprenticeship with Britton, he completed thirty-three sketches for *Ireland Illustrated*, the engravings being based on his drawings. An intrepid traveller, and working on commission for the historical writer Dr W. Beattie, he made a Continental tour in 1830, going on to visit Syria, Egypt and Palestine. He also made several visits to the United States and Canada. After another journey to the East in 1842 he wrote: 'My publisher continued to employ me for some years on the same class of publication . . . but this branch I had taken up never

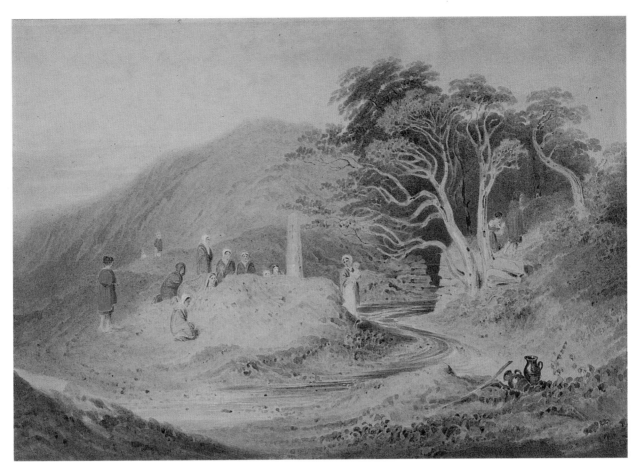

40] ABOVE *Pilgrims at St Brigid's Well, Liscannor, Co. Clare.* George Petrie (1789–1866).

41] BELOW *Hanging Washing in Lord Portlester's Chapel, St. Audeon's Dublin.* George Petrie (1789–1866).

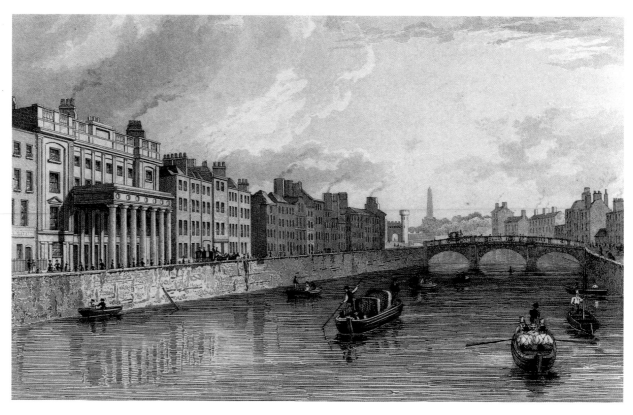

42] *The Cloth Mart, Home's Hotel and Queen's Bridge, Usher's Quay, Dublin*; from *Ireland Illustrated*, 1831; engraving after the drawing by W. H. Bartlett (1809–1854).

43] BELOW *The Quay, Waterford*; from *The Scenery and Antiquities of Ireland*, 1844; engraving after the drawing by W. H. Bartlett (1809–1854).

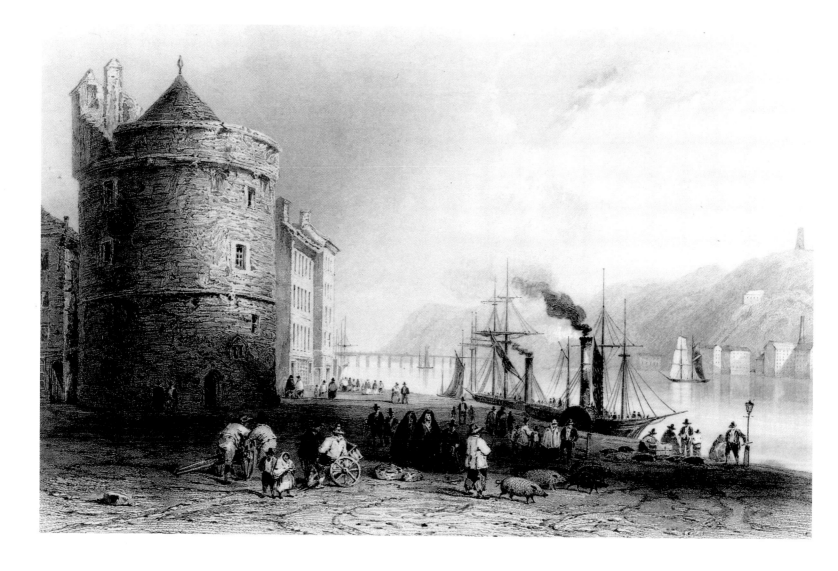

gave me enough to lay by even the smallest independence and I was unable successfully to enter upon any other branch of the profession.' From then on Bartlett wrote his own travel books as well as illustrating them. Though not to be compared with Turner (he had a poor technique in delineating human figures and trees), he had a fine and accurate style when it came to conveying buildings, towns, harbours and monuments, as may be found in his *Scenery and Antiquities of Ireland*. A constant traveller, journeyman artist and prolific recorder, he died at sea in the year 1854.

Numerous other artists of this period extended the visual exploration of Ireland, many watercolourists like Bartlett journeying further afield in search of new material. By the 1840s the truth was evident of what had been said in a work published as early as 1792, that 'the art of sketching is to the picturesque traveller what the art of writing is to the scholar'.[20]

III

THE EIGHTEENTH-CENTURY LANDSCAPE

As has already been mentioned in chapter II topography is the portraiture of places, the topographer's role being to produce a drawing which records the view for posterity. The artist becomes a literal transcriber of nature with little or no opportunity to introduce his personal interpretation of the scene before him.

By the middle of the eighteenth century this somewhat cold, workmanlike world began to experience changes brought about by an impetus from Italy towards idealization. This was to raise Irish topographical landscape to the level of a highly-sophisticated and romantic art form.

The principal influence stemming from Rome was to be found in the work of artists such as Claude Lorrain (c.1600–1682). Claude's compositional methods are clearly set out in his oil painting *Juno Confiding Io to the Care of Argus*, which today hangs in the National Gallery of Ireland. Here the main focus of interest lies in the middle distance with the eye being carried across the foreground to it and beyond it to the sky, the area of strongest light, lying immediately above the distant horizon. This classical or ideal type of composition was to prove immensely popular with painters, whether Italian or Irish. Claude's landscapes are filled with a soft, gentle light combined with a deep knowledge of nature, characteristics which may be adapted with ease from the Italian Campagna to the Wicklow hills.

In the middle of the eighteenth century another influential factor in the development of painters' styles, particularly of those residing in Rome, was that of the work of Welsh-born artist RICHARD WILSON (1713/14–1782) who was active in Italy from 1750 to late 1756 or early 1757. Although Wilson rarely worked in watercolour (the majority of his drawings are in black chalk, sometimes heightened with white), his work was to have a considerable importance and influence on watercolour in general. It was Wilson who was to impart an entirely new way of looking at landscape to his many pupils and followers, including several from Ireland. While he was an admirer of the draughtsmanship of Claude Lorrain, Wilson was principally interested in nature. In the words of Joseph Farington,

> *His admiration of the paintings of Claude could not be exceeded but he contemplated those excellent works and compared them with what he saw in nature to refine his feelings and made his observations more exact and although the drawings have certain links with other artists working in Rome in the eighteenth century, the Roman drawings of Wilson have an individuality and effectiveness that makes them a considerable achievement in their own right.*[1]

Wilson's works, whether in oil or chalk, were attractive and influential to painters, including a sizeable number of Irish artists who were working in Rome in the mid-eighteenth century.[2]

ROBERT CRONE (c.1718–1779) was an artist described by Edward Edwards as being of 'remarkably good temper and most excellent character'.[3] Having worked with Wilson he arrived in Rome around 1755, and suffered continuously from bad health, Edwards remarking that 'This person's progress in art, was greatly impeded by the melancholy state of his health.'[4] Before setting out for Rome, Crone had gained several prizes in

44] *The Arbra Santa on the Bank of Lake Nemi.*
Richard Wilson (1714–1782).

View near Killarney.
Francis Danby (1793–1861). (Detail of illus. 54)

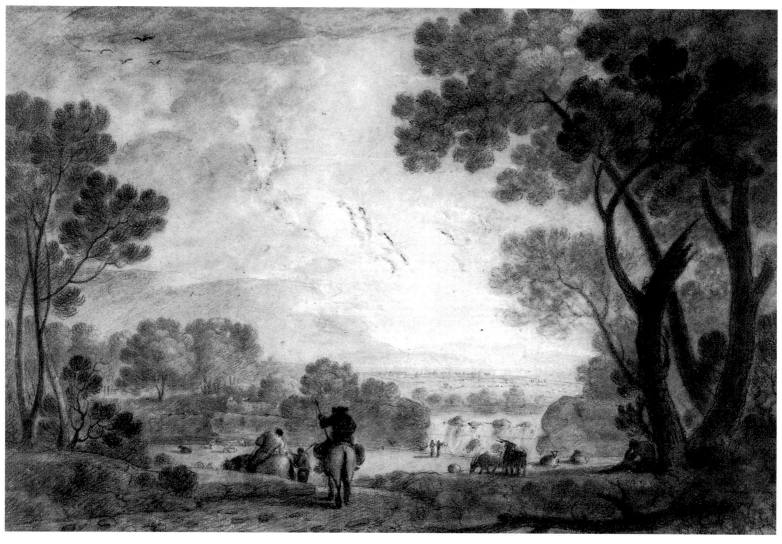

47] ABOVE *Ariccia*.
James Forrester (*c.* 1730–1776) .

45] OPPOSITE, ABOVE S. *Agnese Fuori le Mura and
S. Constanza, Rome, in a Capriccio with the so-called
Sarcophagus of Constantine*. Richard Wilson (1714–1782) .

46] OPPOSITE, BELOW *Landscape in the manner of Richard
Wilson*. Robert Crone (*c.* 1718–1779) .

St George's Lane School in Dublin.

As far as is known he painted few large-scale works, preferring instead to turn his hand to drawing. Here he showed a remarkable air of tenderness and gentleness in his handling of the Italian landscape, as may be seen in his *Landscape in the manner of Richard Wilson* (illus. 46). Between 1770 and 1778 Crone exhibited some thirty-seven works at the RA of which eighteen were drawings and nineteen were paintings. His speciality, in which he showed remarkable dexterity, was drawings in black and white chalks on blue-grey Roman paper.

JAMES FORRESTER (*c.*1730–1776), sometimes known as the 'Irish Sandby'[5] was, like Crone, a pupil of Robert West at St George's School, Dublin, in 1752 gaining first prize there for drawing. He arrived in Rome in 1755. A fellow artist and friend, Jonathan Skelton, describes him in a letter dated 20 August 1758: 'We have at Rome some very good young men among the students from Great Britain and Ireland. One of them is my very particular Friend, his name is Forrester, I have larn'd many excellent things from him in private Life. He studied Painting in my own way and is very ingenious.'[6]

Forrester's drawings, like Crone's, reveal Richard Wilson's influence. They include a series of eight drawings bought by William Henry Dawson, First Earl of Portarlington (d.1779), who himself practised as an amateur artist. Two of these are now in the V&A, London, and a third, *Ariccia* (illus. 47), in a private collection. All are executed in Indian ink and bistre washes heightened with white, on either grey, blue or buff-coloured paper. Sadly, the whereabouts of the remaining five is unknown.

Forrester also worked as an etcher, designing the frontispiece of Peter Stephen's *150 Views of Italy* (1762), and as a painter in oil. Several of his works reveal his fondness for depicting moonlit scenes. Two of these, bought by the Fourth Earl of Fitzwilliam in Rome in

48] *The Harvest Wagon*.
George Barret (1728/32–1784) .

1767, reappeared at a sale in London on 19 July 1985. Forrester spent roughly twenty years in Rome, the date of his death being recorded as 31 January 1776. The Latin inscription on his memorial stone at Santa Maria del Popolo reads, in translation, 'James Forrester from Dublin/eminent in the skills of painting pleasant things/lies'.

Among Wilson's many pupils was another Irish painter often known as the 'Irish Claude',[7] HUGH PRIMROSE DEAN (1746–1784). Thomas Jones gives an account of the young Irishman's reputation: 'Mr Dean … made himself so conspicuous in Italy … where no person as I was told that ever went from this country to that, had had the Address to excite so much curiosity and attention – his fame flew before him where ever he went – From Florence to Rome – From Rome to Naples and so back again – *Ecco viene il gran pittore inglese* was the cry.'[8]

On 17 July 1777 Dean was elected, as his fellow Irishman Solomon Delane was to be, to the Florentine Academy. His adventures in that city are described by Edwards, who remarks: 'He left a wife and son in England, of whom he became totally negligent.'[9] However, in 1776 his patron, Lord Palmerston, who was to become father of the famous 'Pam' of Victorian politics, sent them to Italy in pursuit of the wayward young painter. The meeting of the parties was amusing, for Dean happened to be standing at the door of an inn in Florence where he was living and, seeing a woman approach who looked as if she was in difficulties, offered to help. But when he found out the lady was his wife, he fled to Vallombrosa 'where he staid some days to recover his spirits'. Two years later he returned to England, having lost the support and patronage of Lord Palmerston. Because of his roguish behaviour and bad conduct he did not receive the recognition he thought he deserved as a painter, so instead he became a Methodist preacher – a move which proved, like his other adventures, to be unsuccessful. The last account of him was 'that he sunk into the oblivious, but useful situation of a Mechanick in one of our English Dockyards'.[10]

GEORGE BARRET, RA (1728/32–1784), never went to

49] *Ullswater, Cumberland.*
George Barret (1728/32–1784) .

Rome, but enjoyed the distinction of becoming for a brief period one of the leading landscape painters in Europe, even going so far as to rival Richard Wilson who, according to Sir W. Beechey, was very rarely out of humour 'except when talking of Barret, who was then the great favourite and universally patronised, so that he rode in his carriage while Wilson could scarcely get his daily bread. He used to call Barret's work spinach and eggs.'

Barret, son of a tailor and born in the Liberties of Dublin, began his career as apprentice to a stay-maker, but then branched out into colouring engravings for a publisher named Silcock. He also managed to find the time to attend classes at the Dublin Society Schools under Robert West and James Mannin, being awarded a first prize in 1747. During this period Barret was displaying a wide variety of styles in his work, seen for example in a series of panels and overdoors for Russborough House which depict Italianate landscapes and

Roman ruins. His work was also greatly encouraged by his friend and famous contemporary Edmund Burke, Barret absorbing many of the latter's ideas about the 'sublime' and the 'beautiful'; thoughts that Burke was later to expand and develop in his famous *Philosophical Enquiry into the Origins of our Ideas on the Sublime and the Beautiful* (1756).

The young Irish painter was to spend almost ten years painting examples of this romantic 'wild' scenery in and around the counties of Wicklow and Dublin. He frequently painted 'into' the light to create a dramatic and highly romantic effect, as seen in his gouache composition entitled *The Harvest Wagon* (illus. 48).

Why Barret left Dublin for London has never been firmly established. Strickland suggests that he left in 1762, his departure being hastened when he failed in an attempt to issue a set of engravings of his views of the River Dargle (advertised in 1762 but never published). However, it has been suggested that he may not, in fact, have gone until early 1763.[11] On 19 February of that year he is known to have been signing documents in Dublin in connection with some property and was described as 'of the city of Dublin, Landskip painter'.[12]

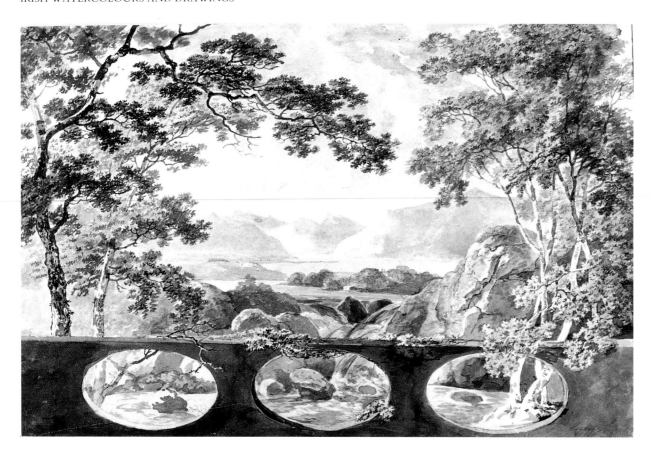

50] *Study for Norbury Park.*
George Barret (1728/32–1784).

Shortly after his arrival in London Barret launched his career by exhibiting a view of the River Dargle and Powerscourt Waterfall at the Society of Artists and at the Free Society. This won him almost instant recognition. By 1773 he had opened his first drawing school in James Street off Golden Square, and four years later a second followed in Pall Mall. In 1768 he became a founder member of the RA and was heavily involved in its establishment. Early success had, however, begun to blunt his style, making it somewhat conservative and conventional in approach and often lacking in the originality which had been so much a feature of his period in Ireland. Nevertheless, in the painting of a room at Norbury Park in Surrey for William Locke around 1780, in collaboration with Sawrey Gilpin POWS (1762–1843), Giovanni Cipriani (1727–1785) and Benedetto (Benedict) Pastorini (fl.1775–1810), he produced a decoration which was considered by many to be his masterpiece. A study for this, delicately executed in watercolour, is in the Courtauld Institute (illus. 50).

Primarily an oil painter, whose romantic representation of both English and Irish landscape had a wide appeal, Barret was not a prolific watercolourist. Martin Hardie, commenting on his style in this medium, describes it as that of one who 'possessed a fine sense of drawing combined with fluency'.[13]

51] *Self-Portrait.*
George Barret (1728/32–1784).

He also produced a number of fine drawings and gouaches which are brilliant in colour and appear to revert to his early Italianate manner, as may be seen in a work such as *Ullswater, Cumberland* (illus. 49).

His three children all became talented watercolourists. However, as they were born and worked in England, their careers lie outside the scope of this book. Suffice to say that George Barret Junior became one of the original members of the Old Watercolour Society and published *The Theory and Practice of Watercolour Painting* (1840), while his sister Mary became a pupil of Romney and was elected a member of the Society of Painters in Water-colours in 1823, exhibiting pictures of flowers, fruit and other still-life subjects. Barret's eldest son James painted landscapes both in oil and watercolour and in a style similar to that of his father, exhibiting at the RA from 1785 until 1819.

FRANCIS DANBY, ARA (1793–1861), was one of the most interesting and gifted artists of the Romantic period, becoming one of the principal exponents of poetic or romantic landscape painting. In his view of *Conway Castle*, he deliberately sets out to construct a scene in the romantic manner with the countryside melting into the far distance, whilst the castle itself stands silhouetted against a burst of evening sunshine. Danby's early watercolours, painted during his student days in Ireland and Wales, give very little indication of this distinctive style which was later to emerge and mark him out from so many of his contemporaries. His watercolour *Castle Archdale on Lough Erne, Co. Fermanagh* (illus. 52) is an accurate and painstaking drawing, but the details are rendered with no real power of imagination, and a definite system of perspective and design is absent.

During the 1798 rebellion Danby's family had moved to Dublin from Wexford, where he had been born in 1793. Shortly after the death of his father in 1807 Danby began his art training in the Dublin Society Schools, completing his studies in 1813. It was at art school that he made friends with two young landscape painters, James Arthur O'Connor (see below) and George Petrie (see chapter II), with whom he was to remain on good terms throughout his life.

Lacking patronage and needing to complete his education, Danby, together with Petrie and O'Connor, set out for London during the first week of June 1813. Shortly afterwards, Danby ran out of cash and was reduced to walking to Bristol.[14] He decided to remain there, no doubt being attracted by a lucrative and ready market for his watercolours – there was no landscape

52] *Castle Archdale on Lough Erne, Co. Fermanagh.* Francis Danby (1793–1861) .

53] *Ancient Garden*. Francis Danby (1793–1861).
This watercolour was engraved for A. A. Watt's
Literary Souvenir, 1835.

painter of any real talent living in the city at that time –
and by the fact that he had met a local girl, whom he was
later to marry in secrecy.

The young painter settled down, eking out a living by
giving lessons in drawing and by painting watercolours
such as *The Avon at Clifton*. This is an open composition
and, with its strong, dark colouring, it creates a mood of
romantic contemplation combined with an accurate
rendering of topographical detail. By way of compa-
rison, his watercolour *On the Avon, near Bristol* is almost
Turneresque in feeling, with many of the scenic devices
being deliberately borrowed from the techniques of
watercolourists such as Cotman and Turner. Danby's
pencil and watercolour *View near Killarney* (illus. 54),
painted *c.* 1817, demonstrates his enthusiasm for the
seventeenth-century classical landscape tradition and in
particular the influence of Claude Lorrain. Determined
to take London by storm, in 1820 he submitted a
dramatic oil painting at the British Institution, *The Upas
Tree or Poison Tree in the Island of Java*. The critics of the
London Magazine commented that 'the very large canvas
appeared amidst the gauds and gaieties of the collection

like the darkness of a thundercloud'. In this work his
concentration on details has been exchanged for a
broader execution coupled with an atmospheric effect.

In 1824 he moved from Bristol to London. Visits to
Norway and Scotland around 1825 heightened his
interest in the grandiose effects of sublime nature, as is
clearly shown in two watercolours dating from this
period, *Cascade in Norway* and *Lake in Norway*. Both are
fairly straightforward recollections of places seen on his
travels.

In 1825 Danby was elected ARA, and was John
Constable's chief rival for full status as an academician in
1829, being defeated by just one vote. His popularity
reached great heights during this period in London and
was even greater than that of Constable. However, after
his separation from his wife and his subsequent departure
for Paris in 1829, with a young girl, Helen Evans, his
career took a downward turn.

Very little is known of Danby's first years abroad, but
from the small evidence available it is known that they
were not easy or successful ones for the young painter.
By the end of 1831 he was in Switzerland, where he
settled in Geneva. He spent the next three and a half years
supporting himself and his growing family by the sale of
watercolour drawings through the aid of kind friends
such as Domenic Colnaghi (1790–1879) and the water-
colour painter George Robson, POWS (1788–1833). By

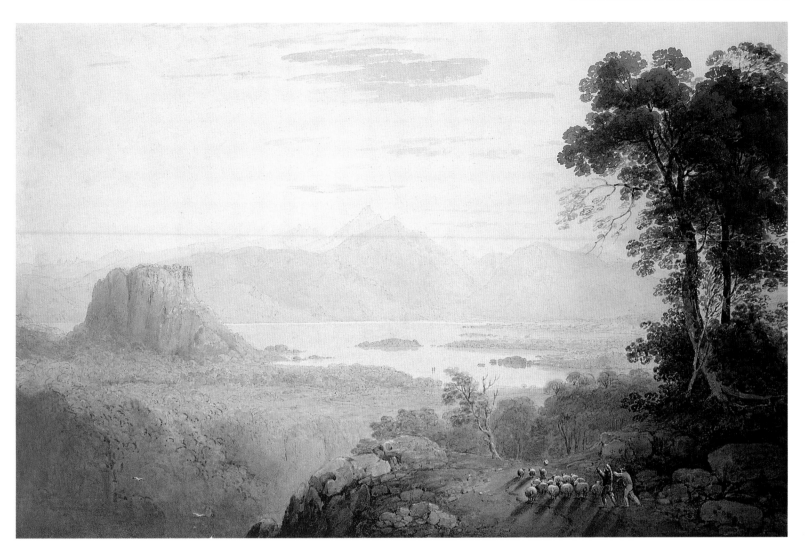

54 | *View near Killarney.*
Francis Danby (1793–1861) .

the spring of 1837 he had moved back to Paris, submitting to the RA such works as a scene illustrating a subject from Moore's *Irish Melodies*. Sadly, the painting was ignored by the critics, and as a result Danby avoided the Academy for the next three years.

Worse misfortunes followed: a disease killed three of his children. By the end of 1838 he had decided to move back to London. On his return he quietly set about reconstructing his broken career, exhibiting once again at the Academy and in Ireland at the RHA (1844). His work was also represented at the famous International Exhibition held in Paris in 1855, where critics once more began to acknowledge him as one of the great champions of the English school. However, he was still excluded from becoming a full member of the RA, an honour which was never to be bestowed upon him. On a visit to Bristol at Christmas 1860 to see a friend, he died suddenly. Both of his sons, James Francis Danby (1816–1875) and Thomas Danby, RHA, RWS (c.1818–1886), became painters; the latter was a prolific watercolourist, being elected a full member of the OWS in 1870.

Danby's scene from *A Midsummer Night's Dream*

(illus. 55) dated 1832, which is an illustration to the passage in act II scene I in which Titania refuses Oberon's claim to her changeling boy, makes a fascinating comparison with a watercolour and bodycolour dating from 1834 *Ancient Garden* (illus. 53). The former is a highly finished drawing; in the words of David Bogue, 'Some of these drawings partook of all the fancy and careful finish of his important pictures.'[15] However, the other watercolour, dating from the last ten years of his painting career, shows a curious resemblance to some of his very earliest works, with its purity of colouring and aerial delicacy.

During Danby's student days in Dublin he had been a close friend of JAMES ARTHUR O'CONNOR (1792–1841), a painter who specialized largely in landscapes in oil, although he also made occasional watercolours. Several of his drawings, now in the British Museum, are preparatory studies for a series of major works in oil commissioned by the Second Marquess of Sligo and Earl of Clanricarde of Westport House, Co. Mayo. O'Connor worked on these during the years 1817 to 1819.

A born romantic, O'Connor had little difficulty in transferring his feelings to the rugged, lonely surroundings of Westport; yet his technique always remained precise and careful, as seen in his drawing *Delphi Lodge, Co. Mayo* (illus. 56). O'Connor was largely self-taught.

55] *Scene from 'A Midsummer Night's Dream': act II, scene 1.* Francis Danby (1793–1861) .

He may have taken lessons from William Sadler Jr, a landscape painter who specialized in painting small scenes in oil, although John Hutchinson claims that 'there is little evidence for this traditional assumption'.[16] O'Connor's earliest sketches were, like Barret's, made on the River Dargle, his first works being exhibited in 1809. Among his earliest drawings are two works in Jupp's Interleaved Catalogues in the RA, both of which are signed and dated: 'J.A. O'Connor London, 1813'. These must have been drawn the year he and his two friends George Petrie and Francis Danby set out on their ill-fated visit to London. His sketchbook in the NGI, which dates from 1822 – the year he finally left Dublin for London – illustrates the young painter's thoughts as he journeyed through the South of England. The sketches include a number of watercolours, together with pencil and ink drawings, all of which are treated in the typically tight and linear manner of the eighteenth century.

It is interesting to compare O'Connor's work with that of John Constable's sketch books of 1813 and 1814, which make O'Connor's outlook seem somewhat old-fashioned and deliberate in relation to the light, delicate, spontaneous sketches of his more famous English contemporary. The watercolours contained in O'Connor's sketchbook are attractive and highly finished, the artist obviously devoting a great deal of care and attention to them, possibly because they were to be used as preliminary sketches for his larger works carried

out in oil. A simplicity and love of accuracy characterizes the ink drawings.

During his first year in London, O'Connor exhibited not only at the RA but also at the British Institute and the Society of British Artists. In 1826 he went to Brussels, and between the years 1832 and 1833 he also visited Paris, Belgium and Germany. An eclectic artist, he borrowed many of his ideas from a wide variety of sources. In the words of Hutchinson, 'His distinction lies . . . in his pivotal position as an Irish Romantic landscape painter.'[17]

The influence of Italy, coupled with a sense of romanticism, were not the only factors affecting Irish landscape painting in the eighteenth century. A taste for Dutch and Flemish art was making itself felt amongst collectors, and it is interesting to observe that in many eighteenth-century Irish sales catalogues names such as Cuyp, Ruysdael and Brueghel constantly occur. The essential characteristics of Dutch seventeenth-century landscape are clearly demonstrated in an oil painting by Meindert Hobbema (c.1638–1709) in the NGI. Here the distant outline of trees occupies practically all of the horizon. They are painted almost exclusively in light tones. The sky is a liquid blue with only a few stray clouds which, by their diagonal sweep, serve to define and add emphasis to the sky's width. The calm water in the foreground reflects the graceful group of trees while to the left are grouped two fishermen, their silhouettes serving as points against which the vast distance may be measured. No attempt at embellishment has been made in this very simple, laconic composition, yet here may be seen the complete programme of Dutch seventeenth-century landscape clearly set out; features which were to

Finloch with Delphi Cottage the Fishing seat of the Marquiss of Sligo. C° Mayo

56] ABOVE *Delphi Lodge, Co. Mayo.*
James Arthur O'Connor (1792–1841).

57] BELOW *Mount Browne, Co. Mayo.*
James Arthur O'Connor (1792–1841).

Mount Browne the seat of the Right Hon^ble Denis Browne. C°: Mayo.

absorb and influence both Irish and English landscape painters of the period.

This Dutch and Flemish style is evident in the oil paintings of Cork-born JOHN BUTTS (c.1728–1764). Unfortunately, little of his work has survived. However, a charming drawing in the NGI of a group of trees reveals that he was a capable performer when using crayon, ink and pencil, a strong compositional sense of harmony and poetic feeling being very much evident in this work. Butts died while still quite young. In the words of his friend and fellow Irish painter, JAMES BARRY, RA (1741–1806),[18] he was so fine a painter that it was 'almost a desperate undertaking to touch a landscape after him'. Despite his short life, his influence on mid-eighteenth-century landscape painting in Ireland was to be considerable.

One of his most outstanding pupils was THOMAS ROBERTS (1748–1778), a distinguished landscape painter in oil. His younger brother, THOMAS SAUTELLE ROBERTS, RHA (c.1760–1826), was 'studying at the Academies of landscape, painting and architecture in Dublin and does not know which of them he will pursue', according to his elder brother John.[19] Thomas Sautelle's father was one of the leading architects in the City of Waterford and after leaving the RDS Schools, his son was apprenticed to Dublin architect Thomas Ivory, a position he was soon to abandon in favour of painting. His links with architecture were never com-

pletely severed, however, for when handling an architectural scene he did so with confidence and skill. Mulvany, remarking on this in a memoir of the artist in the *Citizen*: 'Roberts's acquirements in architecture, although he did not like the pursuit, were of immense value to him as a painter, enabling him whenever he introduced buildings to give them a proportion and a grandeur, very imposing.'[20]

Precise information on Roberts's movements between the years 1779 and 1791 is hard to establish. Pasquin[21] and Strickland[22] both refer to him as working and living in London, while Crookshank and The Knight of Glin state that 'it seems more likely that he travelled regularly to and fro'.[23] However, he did exhibit both Irish and English views at the RA from 1789 to 1811 and in 1818, and at the British Institute from 1807 to 1818.

Roberts was fortunate to be patronized by the Viceroy, Lord Hardwicke, between the years 1801 and 1806. In Dublin Castle State Paper Office there is a letter from the artist dated 18 December 1801, to the Chief Secretary, the Rt. Hon. Charles Abbot,[24] seeking permission to exhibit the drawings of Irish scenery which Roberts had made for the Lord Lieutenant (the Third Earl of Hardwicke) and the Chief Secretary. Permission was obviously granted. The *Freeman's Journal* dated 12–19 January 1802 refers to the exhibition which was about to take place on Wednesday 13 January at Parliament House being 'Landscapes. . . . Chiefly executed for His Excellency the Lord Lieutenant and The Rt. Hon. Charles Abbot'. The drawings, all executed in watercolour, formed part of an ambitious

58] *Trees above a Valley*.
John Butts (c. 1728–1764) .

59] *View of Powerscourt with the Golden Spurs to the right* (the Small and Big Sugar Loaves) *with Bray Head Beyond.* Thomas Sautelle Roberts (*c.* 1760–1826) .

project entitled *Illustrations of the Chief Sites, Rivers and Picturesque Scenery of the Kingdom of Ireland.* In connection with this, Roberts had already issued twelve aquatints between 1795 and 1799.

In the RIA there is an entry in an anonymous diary[25] for 25 January 1802 stating that the artist had accompanied the Lord Lieutenant on his 'Wicklow Excursion in order to sketch such views for him as he should select . . . they are yet, striking and valuable pieces – the scenes mostly chosen amongst the more unfrequented parts of the Co. Wicklow, through which the inspection of the *via militaris* led his Excellency and suite – There are also some fine designs of the Dargle Scenery.'[26]

The fruits of that 'excursion' are illustrated by Roberts's fine watercolour *View of Powerscourt with the Golden Spurs to the right* [the Small and Big Sugar Loaves] *with Bray Head beyond* (illus. 59). In this picture the Chief Secretary, the Rt. Hon. Charles Abbot, is shown in the foreground mounted on his horse inspecting work on

the *via militaris* and being saluted by a soldier wearing a kilt. Two other men are busily engaged working on the new road. It would appear that the view was taken just south of the Glencree barracks. In a second watercolour, *View with Valley of Glencree*, a military officer is seen pointing out the proposed site of the Military Barracks to the Chief Secretary.

A critic who attended the exhibition in which these two views were shown gives a fascinating account of the artist's watercolour style:

This painter has two manners very widely different from each other and both faulty – one appears to be an imitation of the effect of oil, dashing careless touches, bright colours, dark shades and frequent prominent lights, the pieces which are executed in this style, please at the first view but on a longer observance convey the idea of having been scraped and the paper by that means making its appearance – his other manner is just the reverse – softness nearly fuzzy, dead colouring, and always autumnal, browns, reds, dusky yellows and sickly olives.[27]

Roberts did not devote his career entirely to watercolour. Like so many landscape painters before him, he

spent a great deal of his time painting the scenery of Wicklow and the Dargle valley and, according to Mulvany, it was his love of nature which induced him to abandon watercolour and to devote himself exclusively to oil. He enjoyed a high reputation in Dublin's artistic circles, and was one of three artists chosen to select the first members of the RHA. He contributed two watercolours and five oils to the opening exhibition in 1826. But before then a fall while travelling to London in 1818 had rendered his right hand useless. This caused him increasing misery and finally resulted in his becoming incapacitated before his death in 1826.

In the latter half of the eighteenth century Dublin was still regarded as the second capital of the three kingdoms. Prosperous, and thriving with expansion taking place in all directions, the city could hold her own with any other in western Europe. Music and literature flourished. Leading Irish nobles, such as Charlemont and Milltown returning from the Grand Tour, created a sophisticated taste and atmosphere for collecting, which in turn encouraged craftsmen in silver, glass and furniture to reach new standards of the highest excellence. Therefore it was not surprising that many English artists chose to visit, and in many cases to settle, in this elegant city.

FRANCIS WHEATLEY, RA (1747–1801) known among his contemporaries as 'a handsome man, of excellent manners and generally a favourite in genteel company who understood his art, [and] spoke with great taste on every branch of it' arrived in Dublin in 1779, hotly pursued by his creditors and accompanied by a handsome young woman named Mrs Gresse (wife of the artist J. A. Gresse (1741–1794) drawing-master to the Royal Princesses) with whom, we are told, he had 'the folly to enter into an intrigue'.[28] Wheatley had been born in the heart of London at Covent Garden. He had studied at Shipley's, and the Incorporated Society with which he first exhibited in 1765 and of which he was appointed a Director in 1772. In 1769 he entered the RA Schools and by the time he was twenty had carried off three premiums from the Society of Artists.[29]

Wheatley's years in Ireland were perhaps his busiest.[29] Apart from embarking on such impressively large canvases as his *View of College Green with a Meeting of the Volunteers on the 4th November, 1779 to commemorate the birthday of King William* (now in the NGI), he also turned his hand to watercolour compositions, largely scenes of Irish fairs and amounting to some twenty in all. These attractive and amusing scenes were an immediate success and brought him much-needed income. However, it was not enough. His debts began to mount up and, having unsuccessfully tried to pass off Mrs Gresse as his wife, it became clear to him that a change of scene was desirable, if not essential.

On his return to England, probably towards the end of 1783,[30] Wheatley produced his famous *Cries of London*, by which perhaps he is best known today. He began to exhibit once again on a regular basis at the RA from 1784 until his death. He was elected ARA in 1790 and RA in 1791. The latter part of his life was spent in considerable poverty, and in trying to persuade members of the RA to help him financially, which they did from time to time. By July 1800 his health had deteriorated to such an extent that 'he was so crippled in his hand that he can only use his right thumb and the finger next to it'. He died on 28 June 1801 in London.

One of the best known of all English watercolour painters of the eighteenth century was WILLIAM PARS, ARA (1742–1782)[31] who visited Ireland in the 1770s. Having studied under his brother Henry (1734–1782) in the Duke of Richmond's gallery and at St Martin's Lane Academy, he began his career as a portrait painter, exhibiting at the RA and the Incorporated Society and Free Society throughout the 1760s. Not very happy

60] *Portrait of Francis Wheatley (1747–1801)*.
George Dance (1741–1825).

March 17th 1793 . Geo Dance

61] *Buying Ale at Donnybrook Fair, near Dublin*.
Francis Wheatley (1747–1801).

62] *Killarney from the Hills above Muckross*.
William Pars (1742–1782).

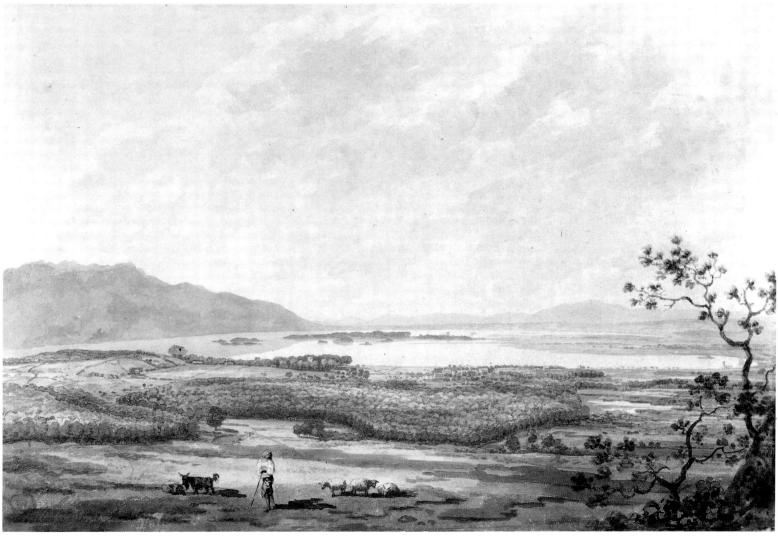

working as a portraitist, he gained employment as a draughtsman of 'little-known places', travelling to Greece in 1764 on behalf of the Society of the Dilettanti, and in the company of the painter and architect Nicholas Revett (1720–1804). His drawings made during this journey, in which he also visited Asia Minor, were used for Revett and Stuart's *Antiquities of Athens* (1789 and 1795) and later aquatinted by the watercolourist Paul Sandby (see p. 66). On a second journey, undertaken in the company of Lord Palmerston, he visited Switzerland and Austria. Before leaving for Rome in 1775 Pars visited Ireland, also with Lord Palmerston, and six scenes now in the V&A, London, are the fruits of that journey. His views of Killarney (illus. 62) and Derry are of a high standard. Here he works largely in grey tones with warmer tints of colour intermingling in the distance. He uses little penwork, only employing it to give form and accent after the drawing is finished. His figures are elegantly portrayed and placed with great skill.

In Rome, where he lived from 1775 until his death in 1782, Pars's style in watercolour matured, being considerably strengthened by his feeling for old buildings, which form the subject of several of his best watercolours. A beautiful softness and harmony pervades many of these scenes, as for example, in his *View of the Palazzo Chigi, Ariccia nr. Albano*.

CHRISTOPHER FAITHFUL PACK (1750–1840) was another artist who, like Wheatley and Pars, was born in England, but he too spent some time working in Ireland, beginning in 1787. From an early age he showed an interest in art and in 1781 was sent to London as a student of John Hamilton Mortimer, ARA (1740–1779). Pack was also fortunate enough to have the opportunity of working for a year in the studio of Sir Joshua Reynolds, 'whose portraits', according to Pasquin, 'he attentively copied for some time'.[32] It was Reynolds who introduced him to the Duke of Rutland, Lord Lieutenant of Ireland.

After spending some time in Liverpool practising as a portraitist, he came to Ireland working both in Dublin and Cork, specializing largely in portraiture. As a result, his landscapes are very few. One of his scenes in watercolour shows a view painted in 1836 of Kilmallock, Co. Limerick a town full of Norman buildings and made famous by a speech delivered by Charles Stewart Parnell in 1877. During his visit to Dublin, Pack became President of the Dublin Society of Artists in 1812, and Vice-President of the Hibernia Society in 1814.

Son of the distinguished English watercolour painter Francis Nicholson, OWS (1753–1844), a founder member of the Old Watercolour Society and a fashionable drawing-master,[33] ALFRED NICHOLSON (1788–1833) lived and worked in Ireland between 1813 and 1816, painting in a style very similar to that of his famous father. Born in Whitby, he had spent his early life in the Navy, eventually leaving to become a full-time painter. After his return from Ireland in 1816 he worked as a drawing-master in London, but returned to Ireland once more in 1821. Both of his daughters and his nephew became artists.

Contemporary with this group of painters were several Irish-born artists who made watercolour their main medium: N. C. Grogan, T. Walmsley, J. G. O'Brien (or Oben) and G. Grattan.

N. C. GROGAN (*c*.1740–1807) was a Cork man, who worked for his father as a wood-turner but spent a good deal of his time drawing. In the words of Pasquin he became 'acquainted with Butts and imitated his pictures'.[34] His interest in art angered his father and he was forced to leave home. Entering the Army, he served through the American War and in the West Indies, returning around 1780 to settle in Cork. Here he worked as a landscape, genre and decorative painter, specializing in 'apt delineation of humorous subjects in which he correctly represents the manners and customs of the Irish Peasantry'.[35] Crookshank and the Knight of Glin suggest that he may well have visited England,[36] as his attractive watercolour *The Old Bridge and Blarney Castle, Co. Cork* (illus. 63) reveals a knowledge of the English painter George Morland (1763–1804). In this delightful scene the castle is framed by the central arch of a ruined classical bridge, which has now sadly vanished. Grouped at the base of one of the piers of the bridge are local people watching a young couple dancing to the music of the uilleann pipes. Despite his lack of conventional art training, it is clear from this work that Grogan was a superb figure painter who injected his figures with great humour and vitality. In 1782 he exhibited at the Free Society of Artists in London, and after his death seventeen of his works and a self-portrait, were included in the Cork Exhibition of 1852. Two of his sons became painters.

Grogan was not the only artist to quarrel with his father. Dublin-born THOMAS WALMSLEY (1763–1806), whose family originated in Rochdale, fell out with his relatives and went to London to work as a scene-painter, gaining employment at the King's Theatre and Covent Garden. In 1788 he returned to his native Dublin, where he was employed as a scene-painter at the Crow Street Theatre, but he again went to England two years later. He was busily employed working for engravers and his coloured scenes, *Picturesque Views in Wales* and *Views on the Lakes of Killarney* were engraved by F. Jukes (1746–1812), an aquatint engraver. These proved to be immensely popular. He exhibited at the RA from 1790 to 1796, then spent the last ten years of his life in Bath. His favourite medium appears to have been bodycolour, as seen in *Twilight on the Shore of a Lake*, and many of his Irish and Welsh views were executed in this medium. His colours often appear overdramatic and harsh, perhaps influenced by his theatrical links.

Like so many of their Irish contemporaries, JAMES GEORGE O'BRIEN (or OBEN; 1779–1819) and GEORGE GRATTAN (1787–1819) were the products of the Dublin Society Drawing Schools. Grattan obtained a medal for landscape in 1779, and O'Brien in 1801 when he exhibited at Parliament House. He had changed his name from O'Brien to Oben, finding it more fashionable to be German, but causing great confusion among viewers and contributors. He left Dublin for London in 1798 but returned to his native city three years later, exhibiting views of Ireland, Wales and the North of England. After an exhibition held in 1809 at 49 Marlborough Street, to which he contributed landscapes, he once more left for London where he exhibited at the RA between 1810 and 1816. Two of his watercolours, *A Ferry Boat at Fennor Rock on the River Boyne, Co. Meath* and *Mountainous Landscape*, are in the NGI. He also

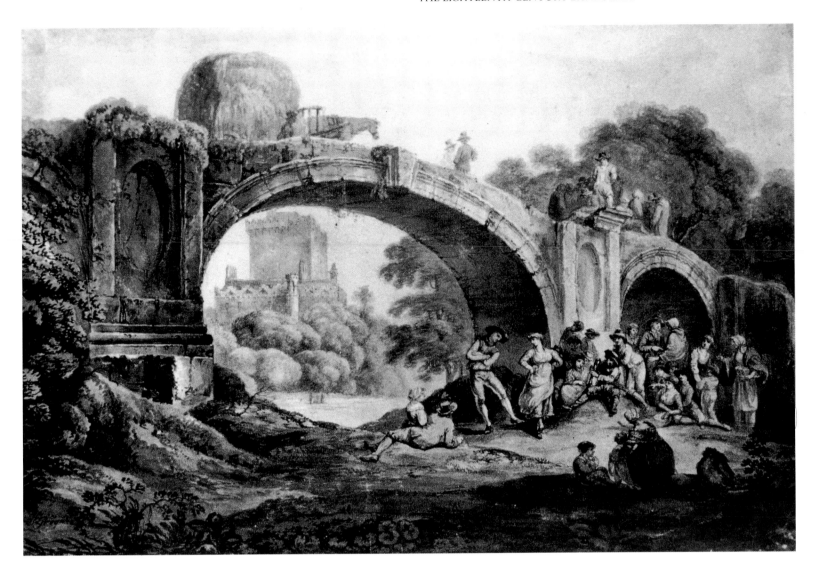

63] *The Old Bridge and Blarney Castle, Co. Cork.*
Nathaniel C. Grogan (*c.* 1740–1807) .

contributed a number of drawings to Grose's *Antiquities
of Ireland* (1791–95).

George Grattan, like O'Brien, was a successful pupil
at the Dublin Society Schools. In 1800 he was awarded a
gratuity of ten guineas 'as an encouragement to his
genius' and, while still a student, he sent a number of
portraits and landscapes to an exhibition in Parliament
House. In 1803, the Society awarded him a first prize for
a landscape 'from nature'. Grattan found it difficult to
obtain patronage until Colonel Vallancey, an anti-
quarian and mapmaker of the Board of Ordnance,
introduced him to Lord Hardwicke, the Lord Lieuten-
ant, for whom he painted several portraits and land-
scapes in watercolour. An attractive example of his work
in watercolour is his *South View of Christ Church
Cathedral*, now in the V&A, London.

COUNTESS CHARLEVILLE (CATHERINE MARIA;
1762–1851) reveals an Italianate romantic sensibility in
her gentle and unobtrusive observations of nature,
particularly when it came to depicting pencil studies of
trees. Examples of her work, in gouache, watercolour

and pencil can still be seen in the Gothick Revival castle
which she and her second husband, Charles William
Bury, Baron Tullamore (1801–51) built near Tullamore,
Co. Offaly. Respected for her intellectual tastes, she was
educated at the College Royal, Toulouse between
1778–81. Six years later, she married James Tisdall in Co.
Louth. Her second husband, whom she married in 1798,
became a Fellow of the Royal Society and President of
the Royal Irish Academy.

Two families who were to make a distinguished and
notable contribution to watercolour painting were the
Campbell and Nairn families. JOHN HENRY CAMPBELL
(1757–1828) is represented here by *Ringsend and Irishtown
from the Grand Canal, Dublin* (illus. 64), which succeeds
by a skilful use of undulating line in creating an
atmosphere of relaxation in what is primarily a topo-
graphical work. This is particularly evident in the
decorative detail of the large foreground tree. The
colour is controlled yet delicately varied to enhance the
charm of the whole design.

Campbell's work was largely confined to landscape
painting in watercolour (although some oils do exist)
and he was trained in the Dublin Society Schools,
becoming an exhibitor in the Opening Exhibition of the
RHA in 1826 and again in 1828, the year of his death. As

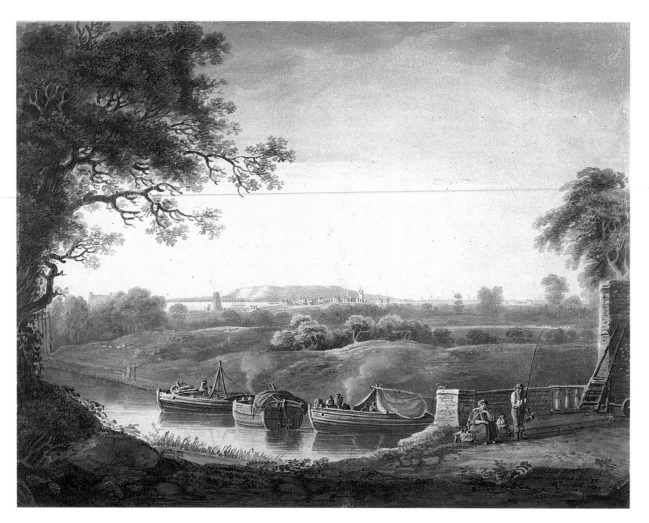

64] *Ringsend and Irishtown from the Grand Canal, Dublin.*
John Henry Campbell (1757–1828) .

far as is known, he never worked or exhibited outside
Ireland but spent all his life in Dublin, concentrating
largely on scenes in the Dublin and Wicklow areas.

His daughter CECILIA MARGARET CAMPBELL
(1791–1857) was taught by her father and began exhibit-
ing landscapes, both in oil and in watercolour, in Dublin
from 1809 onwards, contributing to the RHA exhi-
bitions between 1826 and 1847. In 1826 she married
George Nairn, ARHA (1799–1850), an animal painter in
oil. A number of her watercolours are in the Ulster
Museum including her *View of the Giant's Causeway*,
which makes an interesting comparison with Susanna
Drury's two gouache views of the same subject,
executed roughly eighty years earlier. Their daughter
ANNA LANGLEY NAIRN (*fl.*1844–1848) also became an
artist and was actively involved in design work for the
Belleek Pottery, Co. Fermanagh.

John Henry Campbell copied and admired the work
of the leading English watercolourist PAUL SANDBY,
RA (1725–1809). Sandby, as far as is known, never
visited Ireland and therefore an account of his life and
work lies outside the scope of this book,[37] but perhaps it
should be mentioned that the *Virtuosi's Museum* (1781),
which included views not only in England and Scotland
but also in Ireland, contained thirty-six scenes 'drawn on

the spot'. The majority of these views were credited to
amateur artists such as 'Mr Dawson' (John Dawson,
Second Viscount Carlow and First Earl of Portarlington,
1744–1798), whose original sketches served as the basis
for drawings which Sandby executed for the engraver.
The link between Ireland and Sandby lies in the architect
James Gandon, who had been a close friend of the
English watercolourist since the mid-1760s.[38] After
Gandon came to Ireland in 1781, the two men continued
to correspond with one another until Sandby's death in
1809. However, no mention is made in their correspon-
dence of any possible visit to Ireland by the English
watercolourist. The original sketch for Sandby's *Fall of
the Polufuca on the River Liffey* (illus. 65) was supplied by
John Dawson, and Gandon acted as the intermediary
between the artist and the Dawson family.

Unlike Sandby, CORNELIUS VARLEY (1781–1873)
did visit Ireland in 1808. He was the brother of John
Varley, OWS (1778–1842), a leading and influential
figure for English watercolourists. However, Cornelius
never became a full-time professional painter. He was
very different in looks from his 'broad, bluff brother
being small, dapper, and as sharp as a needle'. He was
brought up by an uncle who made watches and designed
scientific instruments, and most of his life was devoted to
instrument-making. In the Great Exhibition of 1851 he
received a prize for his Graphic Telescope, more than
forty years after he had invented it. Recently a large and
exciting collection of his watercolours has come to light,

65] *The Fall of the Polufuca on the River Liffey.*
Paul Sandby (1725–1809) .

66] *Castles on the Liffey*.
Richard Sass (1774–1849) .

most of them dating from the years 1800 to 1825. They reveal a landscape watercolourist of considerable ability, whose style is characterized by a naturalism and lightness of palette, uninhibited by the rules of composition. In many cases his informal views are only partially tinted pencil drawings, but they possess a great freshness and flair which makes them particularly appealing to twentieth-century taste. His airy, fresh watercolours such as *Sunset over a Wide Plain*, in the Birmingham Art Gallery, reveal a style which is essentially poetic in

quality and full of feeling. A collection of his pencil drawings, largely of scenes in and around Armagh, is in the Armagh County Museum and shows a sketching style of unusual directness, as seen in *Markethill, Co. Armagh* or *The Kennel near Markethill*.

Considered to be something of an eccentric – he always insisted on his children wearing green – Varley became one of the ten founder members of the Society of Painters in Watercolour and an original member of the Sketching Society. After 1808 he exhibited less and less with the Society, ceasing altogether when he resigned in 1820 after the second reorganization of the Society. His *Ruins of Kerry Castle* was made from a sketch done 'on the spot' in 1808.[39]

RICHARD SASS (or SASSE; 1774–1849) was also working in Ireland at about this time, preparing a series of etchings of Irish views which were to be published in 1810. Sass's style reveals the influence of many leading watercolourists of the period, notably that of Francis Nicholson, OWS (1753–1844), Thomas Girtin (1775–1802) and Thomas Barker of Bath (1769–1847). Redgrave, describing Sass's style, commented, 'He tried many manners without succeeding in finding any of his own.'[40]

Sass made his living largely by giving private drawing lessons. He became a landscape painter in watercolours to the Prince Regent. Between 1791 and 1813 his works were seldom absent from the walls of the RA, but after 1813 they vanished abruptly from the annual exhibitions. Ten years later, it was learnt that he had settled in Paris, Frenchifying his name to Sasse. Strangely, when he died his name was not even mentioned by the usually conscientious and observant *Art Journal*. His watercolours are competent and attractive, as can be seen from his *Castles on the Liffey* (illus. 66) or the *Falls of Powerscourt near Bray*.

IV

BOTANICAL ILLUSTRATION
AND FLOWER PAINTING

IN the earliest-known flower drawings the main objective of the flower painter was to assist the search for medicinal plants and herbs, and this has remained an important purpose of botanical illustration. Realism was obviously desirable, as it was necessary to distinguish with accuracy those herbs and plants which were poisonous from those which might be beneficial. A Greek herbal dating from the sixth century AD has paintings of plants depicted in watercolour, conveyed with extraordinary naturalistic accuracy and energy.

The symbolic meaning of flowers in a religious context was also of vital importance, particularly when so few could read and write. An altarpiece by Hugo van der Goes (d.1482), commissioned by the Medicis' agent at Bruges, Tommaso Portinari, is a splendid example. Here the flowers, executed in a lifelike manner, occupy a prominent position in the painting and are laden with

religious significance, the scarlet lily signifying the blood of the Passion, and the spray of columbines the sorrow of the Virgin.[1]

Later artists such as Leonardo da Vinci (1452–1519) and Albrecht Dürer (1471–1528) were interested in drawing flowers for 'their intrinsic interest in the spirit of scientific curiosity that marks the High Renaissance and leads directly to the spirit of the specialist flower painters a century later'.[2] In two marvellously lively botanical studies (illus. 67) dated by Sir Kenneth Clark to between 1505 and 1508, Leonardo reveals a thorough understanding in his approach to the plant's structure, and they must be considered 'to be among the first truly modern botanical drawings ever made'.[3] His German counterpart Dürer also reveals a remarkable ability for observation through the medium of watercolour in the field of botanical painting as seen in his superb *Das grosse Rasenstück*.

Design for chintz.
William Kilburn (1745–1818) . (Detail of illus. 74)

67] *Wood Anemone (Anemone nemorosa) and Marsh Marigold (Caltha palustris)* Leonardo da Vinci (1452–1519) .

corum ꞇ ᴏ ᴍ ᴠ ꞩ Primus. 217

A

B

Kuchenſchell. Hackettraut.

68] *Pasque-flower (Anemone pulsatilla)*; woodcut
from Otto Brunfels' herbal *Herbarum vivae eicones*.

These drawings must be looked upon as the forerun-
ners of the modern scientific botanical drawing, which
may be said to date from around 1530 when Otto
Brunfels' herbal *Herbarum vivae eicones* was first pub-
lished. It contained outstanding woodcuts full of vitality
(illus. 68). The artist has relied entirely upon nature for
his inspiration.

As printing improved, illustrated books began to put
on record the well-known plants of the day. Technical
advances such as the copper plate, introduced towards
the end of the sixteenth century, made it possible for the
artist to record the minute differences between species.
The increasing range of travel in the seventeenth century
also stimulated botanical illustration. Collectors could
venture far outside Europe collecting and recording the
plants from distant lands.

In the eighteenth century scientific illustration began
to reach new heights, thanks largely to such giants in the
botanical field as Linnaeus (b.1707), whose binomial
system of genus and species brought a complete revision

of plant names. Publications such as the *Botanical
Magazine* also began to appear, containing drawings by
such Irish-born artists as WILLIAM KILBURN
(1745–1818),[4] who was to make a vital contribution to
scientific botany. With the introduction of the micro-
scope in the second half of the seventeenth century it
became possible for books dealing purely with plant
structure to be introduced. The artist's work was
eventually superseded by photography.

Running alongside the work of the botanical artist
went the decorative art of the flower painter. Towards
the close of the sixteenth century came the introduction
of the *florilegium* or picture-book of garden flowers.
Here practicality begins to make way for beauty, the
useful plant having as its rival the decorative flower
grown in the gardens of the wealthy solely for its
exquisite appearance. This was very much the age of the
flower painters who flourished throughout Europe, as is
instanced in the work of such well known artists as
Simon Verelst (1644–1721), Jan Brueghel (1568–1625)
and his followers, Pierre-Joseph Redouté (1759–1840)
and James Sowerby (1757–1822).

An Irish connection with the *Botanical Magazine*,
founded in 1787 by William Curtis and still in public-
ation, is to be found in the work of Irish-born WILLIAM
KILBURN (1745–1818), who worked with such British
artists as James Sowerby (1757–1822) and Sydenham
Edwards (1768–1819). Together they were responsible
for the large majority of drawings contributed to the
magazine in the first twenty-eight years of its existence.

Kilburn[5] was born in Capel Street, Dublin, the son of
an architect, and at the age of about fourteen was
apprenticed to a calico-printer, Jonathan Sisson, at
Lucan on the outskirts of the city. After his father's
death, and owing to financial pressures, he travelled to
London around 1766.

When he and his mother and sister had settled
permanently in London, he began to sell his designs to
calico-printers and 'drew and engraved flowers from
nature' for print shops. He lived close to the nursery
gardens of William Curtis, who persuaded him to
contribute as a draughtsman and engraver to Curtis's
Flora londinensis, which illustrated and described plants
to be found within a ten-mile radius of London.

Meanwhile, Kilburn's designs for calico were also
beginning to attract attention and he accepted an
opportunity to manage a calico-printing establishment
at Wallington, near Croydon in Surrey. He was highly
successful and seven years later, in 1784, was in a position
to purchase the entire concern. He became wealthy and
influential, even going so far as to persuade Edmund
Burke to introduce a bill to Parliament to secure calico-
printers the copyright of their original designs.

Kilburn was responsible for at least twenty-five plates
appearing throughout the three published volumes of
Flora londinensis. The first volume appeared in 1777
(illus. 69), the remainder about twenty years later. He
also executed a large number of designs in watercolour
for wallpaper, a bound volume of which, entitled
'William Kilburn's working designs for textile printing',
is in the Victoria and Albert Museum, London. These
show Kilburn's high standards of design, colour and
execution as a 'pattern-drawer'.

As already mentioned, there was no continuous

69] Title-page for William Curtis's
Flora londinensis, 1777.

tradition of either flower painting or botanical ill-ustration in Ireland. Indeed, in the late sixteenth century Irish botanical studies had reached a low ebb. Caleb Threlkeld's work *Synopsis stirpium hibernicarum*, pub-lished in 1726, was the only real attempt made to produce an Irish flora – that is, until the magnificent, decorative flower books[6] began to make their ap-pearance, helped and encouraged by the new engraving processes. At first in Ireland, such works received little or no encouragement due to lack of any real patronage, but Irish authors including Dr Walter Wade, MD, FRS (1760–1825) referred their readers to these books for illustrations of the species described, such as the *Bee Orchis* in *Flora londinensis*.

Kilburn's *Bee Orchis* (illus. 73) is a superb example of a strict botanical drawing. The flower painter on the other hand succeeds in conveying an impression of the flowers before him. It is strange that, in a country with such a strong tradition in the graphic arts, artists seemed relatively uninterested in portraying the flowers and

natural vegetation to be seen all around them. This can be observed in Irish illuminated manuscripts dating from the seventh and eighth centuries. The Book of Kells (*c*.800) contains an intricate form of decoration made up of many abstract forms, including fierce-clawed animals and humans but, strangely, floral and leaf forms are rarely found. However, in the page portraying the symbols of the Four Evangelists, a panel filled with different examples of petal forms runs diagonally through the page and flowers are shown face-on, occupying a circular space. The tendency towards using animal rather than plant forms for embellishment in later Irish illuminated manuscripts might perhaps be explained by the fact that in early Celtic society wealth was counted in cattle, and heroes known for daring encounters in cattle raids rather than for their interest in the gentler forms of nature.

In the decoration of Irish churches and high crosses during the Romanesque period, flower and leaf forms are strangely absent in any great abundance, with only one or two exceptions. Equally, in later Norman periods, plants and flowers are used only as decorative insertions in design and for no other serious purpose.

The designs of SAMUEL DIXON (*fl*.1745–1769)[7] were

70] ABOVE Design for chintz.
William Kilburn (1745–1818).

71] OPPOSITE, ABOVE *A Flower Piece*.
Samuel Dixon (*fl.* 1745–1769).

72] RIGHT *A Flower Piece*.
Samuel Dixon (*fl.* 1745–1769) .

highly decorative and charming. Well known as a flower painter, he worked in Dublin. While Dixon could never be looked on as a strict botanical artist, he was responsible for drawing the flowers and their foliage for his highly popular 'Flower Pieces' (illus. 71 and 72), while miniaturists such as Hamilton, O'Keefe and Reily (see chapter 1) completed the process by colouring the flowers and foliage in gouache by hand. Dixon was the third son of Thomas, a hosier of Cork Hill, Dublin, and was probably a pupil of Robert West at the Dublin Society Drawing School. On 26 April 1748, an advertisement appeared in Faulkner's *Dublin Journal*: 'Samuel Dixon, at his Picture-shop Capel-Street. . . . Said Dixon having now completed his Set of Flower Pieces in Basso Rilievo. . . . These Flower Pieces, which are a new Invention are not only ornamental to Lady's Chambers, but useful to paint and draw or imitate in Shell in Needle Work. . . .' Other items for sale included 'Flowers drawn on Canvas for Needlework, with many Particulars relating to Gentlemens' & Ladies' Amusements'. Each 'Piece' was formal, showing an arrangement of mixed flowers tied with a variety of coloured ribbon. These included columbines, convolvulus, bluebells and auriculas, though roses and tulips were the flowers most frequently portrayed. Executed on sheets of rough grey paper, the required sections of Dixon's designs were made to stand out in relief. This was probably achieved by means of moulds impressed from the back with a screw. Hand colouring in gouache completed the process.

Dixon's 'Flower Pieces' proved so popular that in 1749 he produced a 'Sett of curious Foreign Bird Pieces' in a similar style. In all, his efforts resulted in three sets of twelve embossed pictures. The last two sets he dedicated on the reverse to a notable person to prevent forgeries. The pictures were sold in 'gold, peartree and japanned frames'.

In September 1755 Dixon left Ireland, but he returned again in the summer of 1758 to set up a linen-printing industry at Leixlip, Co. Kildare, which proved to be artistically, though not financially, successful. Seven years later he sold out his interest and moved to London to open a picture shop. The last few months of his life were spent in Dublin, where he tried to revive interest in his 'Pieces' by inserting a notice in Sleator's *Public Gazetteer* on 23 April 1768: 'Samuel Dixon, Painter . . . hath Just opened Shop at the Golden Head in Capel-street, opposite where he formerly lived. Where he is making several New Improvements in his Flowers, Birds, etc., etc., And as the Polite Art of Drawing and Painting is daily increasing etc., among the young Ladies and Gentlemen, and many are dispirited for want of Proper Materials, Mr Dixon assures them, that he hath every Article in That Way, accurately prepared, such as Water-Colours, Crayons, fine Vellums. . . .'

Irish-born JOHN ELLIS, FRS (c.1705–1776) was an acute and accurate observer. Unlike Dixon, he was a strict botanical artist, and was described by Linnaeus as 'The main support of natural history in England'. Ellis worked from an early age in London as a merchant,

73] *Bee Orchis (Ophrys apifera)*; for William Curtis's *Flora londinensis*. William Kilburn (1745–1818) .

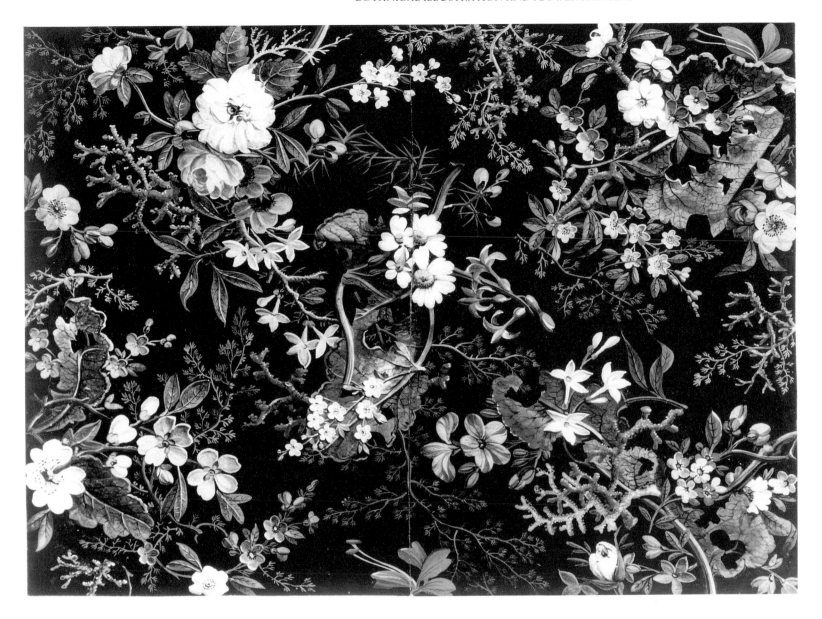

74] Design for chintz.
William Kilburn (1745–1818).

which brought him little success until, in 1764, he became an agent for West Florida and six years later for Dominica. These appointments brought him opportunities to import a wide variety of American seeds. In 1754 he was made a Fellow of the Royal Society, and the following year published *An Essay towards a Natural History of the Corallines*, which established the animal nature of this group of organisms and for which he was awarded the Copley Medal in 1768. His drawings are preserved in the Linnean Society, London.

After Caleb Threlkeld's *Synopsis stirpium hibernicarum* of 1726 no real attempt was made to produce an Irish flora until the appearance of DR WALTER WADE, MD, FRS (1760–1825) in Dublin in the 1780s. Wade, an energetic and industrious man, spent a large proportion of his spare time plant-hunting in the West of Ireland, hoping to collect a sufficient number of living specimens to complete his work, but unfortunately he did not succeed. His illustrated *Flora dublinensis*, published

around 1788,[8] contained a number of exquisite coloured plates but did not prove nearly as popular as his *Plantae rariores in Hibernia* of 1804, which contained the results of his travels in Kerry and Connemara, including his exciting discovery of the pipewort, *Eriocaulon aquaticum*, a water plant.

A dynamic speaker, who obviously possessed the gift of inspiring his many students, it was said that after his lectures 'they were seen in all directions exploring the treasures of their native land'. He became lecturer and professor in Botany to the Dublin Society, was elected an Associate of the Linnean Society, and became the first Curator of the National Botanic Gardens, Glasnevin, whose establishment in 1795 he helped to bring about. Although Wade did not complete his Irish flora he hoped that the work might be finished by his friend, JOHN TEMPLETON (1766–1825).

Templeton was to become one of the more interesting contributors to botanical illustration in the second half of the eighteenth century. His family had settled in the North of Ireland in the early part of the seventeenth century. John Templeton was born at Cranmore, close to Belfast, and educated privately. Before he was twenty

he had become interested in the cultivation of plants, and after his father's death in 1790 he began to embark on the scientific study of botany – more, it was said, from a desire to get rid of the weeds on his farm than from anything else. On his first visit to London in 1794 he met Thomas Martyn (1735–1825), Professor of Botany at Cambridge. He later contributed useful information on cultivation for Martyn's edition of Miller's *Gardener's Dictionary*.

It was on his second visit to London that Templeton encountered such well-known botanical artists as William Curtis and James Sowerby, and the highly respected botanist Sir Joseph Banks. Sir Joseph offered him large sums of money and a parcel of land if he would set sail for New Holland (Australia), but he declined the tempting offer. Instead, he set about collecting material for a complete natural history of Ireland, at the same time making important contributions to such works as Sir J. E. Smith's *English Botany* and *Flora britannica*. Devoted to collecting lichens, mosses and liverworts and frequently dissatisfied with many of the published drawings, he made careful pencil studies of a very high standard, shading them with ink or colour. A regular contributor to the *Belfast Magazine* (begun in 1808) on natural history and meteorology, he became a founder member of the Belfast Natural History Society in 1821 and was a strong supporter of the movement to promote a Botanical Garden for Belfast.

Templeton never completed his *Flora hibernica*, which was to include not only flowering plants but also a number of cryptogamic (non-flowering) ones; but he described a large number, which were accompanied by his own very beautiful watercolour drawings.

His Journal and *Flora hibernica* are now in the Ulster Museum,[9] Belfast. Judging by the contents of the Journal, it would appear that after 1815, when Templeton was forty-nine, his health was on the decline, as notes of excursions and of plants discovered ceased to appear. His pen-and-ink drawings of Irish plants mentioned in his catalogue of native *Plants of Ireland* are preserved in the Library of the RIA.[10]

ANDREW NICHOLL, RHA (1804–1886), is perhaps best known today for his watercolour views of Irish coastal towns seen through a border of wild flowers. His exquisite watercolour drawings of the plants of Ceylon are, however, not so well known. These were executed around 1846 when Nicholl was appointed by the Governor of Ceylon as Master of Drawing and Painting at the Colombo Academy. Shortly after his arrival he became friendly with Northern Ireland-born Colonial Secretary, Sir James Emerson Tennent (1804–1869), who commissioned the drawings. In the summer of 1848 Nicholl, accompanied by Tennent, set out on a tour of the interior of the island,[11] a journey that was not without its hazards. Writing on 10 August, Nicholl mentions that he arrived back at his house 'nearly barefooted; my shoes having been worn out, and my clothes hanging in shreds, completely exhausted'.

However, the physical difficulties encountered did not affect his drawing ability, as can clearly be seen from

75] *Pheasants in a Bank of Flowers.*
Andrew Nicholl (1804–1886) .

the appendix, entitled 'Notices', contains eight pages devoted to botany and animal fossils, including a grass, a sedge and marine algae, all of the illustrations, which are in watercolour, carried out by du Noyer. From his work with such an eminent botanist as David Moore (1807–1879) his knowledge and understanding of plant life deepened, as can be clearly seen from these remarkable paintings. They possess a high degree of technical skill, showing his awareness and appreciation of their natural forms. Both form and colour are true. Strict botanical details are adhered to with no attempt at embellishment, and always his feeling for texture is meticulously conveyed. All are shown life-size. His paintings of Irish apples (illus. 79) collected in and around Belfast in the year 1837 again show his superb skill as a draughtsman and artist. The forms are boldly conveyed, with the varying degrees of russeting care-

77] *The Talipot Tree.*
Andrew Nicholl (1804–1886).

such charming watercolour studies as *The Talipot Tree* (illus. 77), *Chilli Plant and Pods* and *Areka Nut and Plantain Trees* (illus. 76), all of which are drawn with a high degree of accuracy. His watercolours such as *Galle Harbour, Ceylon* or *Mountain Lake, Ceylon* show that Nicholl did not confine his painting to the studies of the indigenous shrubs, plants and trees of that country. Exactly how long he remained in Ceylon has never been firmly established, but he was still there in February 1849 according to one of his studies of *The Clove*, which is thus dated. Nicholl's paintings in other genres are mentioned in chapter VI.

An artist whose name has already been mentioned in chapter II, and whose artwork has been described as representing 'an early contribution to botanical studies', was GEORGE V. DU NOYER (1817–1869).

A geologist, he was attached to the Geological Survey of Ireland from 1848 until 1869. In 1824 a survey was carried out by Ordnance officers, the project covering a wide range of subjects including botany. The latter led to the inclusion of David Moore as botanist and George du Noyer as artist. Their work, illustrating the text of the survey data gathered by the various field parties, is contained in a *Catalogue of Plant Paintings*[12] now at the National Botanic Gardens, Glasnevin, Dublin.

In du Noyer's *Memoir*,[13] dated 1837, there are a number of plant illustrations by du Noyer himself; but

76] *Areka Nut and Plantain Trees.*
Andrew Nicholl (1804–1886).

78] *A Ripe Cotton Pod, Ceylon (Sri Lanka).*
Andrew Nicholl (1804–1886).

fully depicted, indicating his love of minute detail. To enhance their appearance he employs a glazing medium.

Landscape, marine, genre and flower painter SAMUEL McCLOY (1831–1904) was born in Lisburn and at an early age was apprenticed to Belfast engravers J. & T. Smyth, at the same time studying in the evenings at the School of Design. Leaving Belfast for London, he studied at the Central School at Somerset House, returning to Ireland in or before 1853 to become Master of the Waterford School of Art. He spent over twenty years in that city, returning to Belfast in 1875, but then settling permanently in London in 1881.

During his lifetime McCloy worked in both oil and watercolour and appeared to prefer the latter. He built up a reputation with rather overworked sentimental portraits in oil but at the same time was capable of beautiful and delicate work in watercolour, as seen in his rendering of *Éspalier Apple Blossom* (illus. 80) or *Dog Daisies and Clover*, both of which are now in the Ulster Museum. Two further examples of his work, this time in gouache, are in the V&A, London, and show his excellence as a painter of still life.

79] From *Irish Apples Collected at Belfast in 1837.* George V. du Noyer (1817–1869).

Like Andrew Nicholl and Samuel McCloy, WILLIAM HENRY HARVEY, MD, FRS (1811–1866), became a keen traveller. Born in Limerick to a Quaker family who had long-established roots with Youghal, Co. Cork, he attended Newtown School in Co. Waterford and was then sent to the well-known Quaker school at Ballitore, Co. Kildare. There the influence of the headmaster, James White, himself a keen naturalist and writer on Irish botany, had a profound effect on the young boy. From an early age Harvey avidly collected butterflies, shells, lichens, mosses and algae around the family's holiday home at Miltownmalbay.

After his father's death he moved to South Africa, where he succeeded his brother as Colonial Treasurer and once again settled down to collecting with energy and enthusiasm. During his final year in South Africa he produced the first of a series of works concerned with seaweeds, by which he was to become well known. His *Manual of the British Algae*[14] was issued by the Ray Society in 1840, and followed six years later by *Phycologia britannica*.[15]

At the Cape, Harvey had worked with zeal and enthusiasm collecting plants in the early morning, carrying out his duties as Colonial Treasurer during the day and then in the evening arranging his collections. The work and the hot climate proved too much for his

80] *Espalier Apple Blossom.*
Samuel McCloy (1831–1904).

health and he left South Africa in 1841 never to return. Back in Ireland, he applied for the Chair of Botany in Trinity College, pointing out to a friend that there was 'a moderate salary and comfortable college rooms attached. It is an old bachelor pad and would in many ways suit me very well. The only thing on the face of it disagreeable is the lecturing but I don't think I should mind that much as it is lawful to have the subjects for the class written down'. His application was, however, unsuccessful and instead he was made Keeper of the University's Herbarium, becoming Professor of Botany to the RDS in 1848.

In August 1853 he set out on a three-year expedition round the world investigating the seaweed flora of the Indian Ocean and Australasia, sometimes gathering up to 700 species in a day. On arrival in Fiji he applied to the local mission for a responsible guide and was allocated a man called 'Koroe' which, it appeared, was akin to an honourable title such as CB in England and only bestowed upon one who had committed at least five murders. Harvey returned to Europe via the Panama Canal, reaching home in October 1856. He again applied for the post in Trinity College, where the vacancy had been renewed by the departure of Professor G. J. Allman, and this time he succeeded in being elected to the Chair of Botany.

Two years after his return to Ireland he began working on the publication of his findings in Australia, his *Phycologia australica*[16] (published in 1859) running to

five volumes, with each volume containing sixty plates and descriptions executed by himself.

Harvey's best-known works are his *Flora capensis*[17] and his *Thesaurus capensis*.[18] The former was written with the help of Dr O. W. Sonder of Hamburg. It deals with the phanerogamic (flowering or coniferous) flora of South Africa. Unfortunately, Harvey did not live to see it completed. His *Thesaurus capensis* is in two volumes, containing line drawings of some plants in the South African flora. The figures, beautifully drawn and lithographed by Harvey, depict details of floral anatomy and foliage, and contain 100 plates which are a very useful and excellent supplement to the text. A third work, *Phycologia britannica*,[19] was also illustrated by himself.

Just as Harvey had spent a large proportion of his life in Australia so too did ROBERT DAVID FITZGERALD FLS (1830–1892), his family emigrating from Tralee, Co. Kerry, in 1856. Fitzgerald had studied engineering in Queen's College, Cork, and therefore found it relatively easy to gain employment on arrival, rapidly rising to the position of Deputy Surveyor-General of New South Wales. He was described not only as a civil engineer but also as an ornithologist, conservator, geologist, botanist and a very capable artist. His first love seems to have been ornithology, though later he developed a keen interest in orchids and ferns. From 1864 onwards Fitzgerald devoted all his spare time to these subjects, becoming a skilled draughtsman able to depict not only parts of plants but living plants as they grew wild in their natural environment. The first volume of his *Australian Orchids*,[20] published in 1875 and beautifully illustrated by his own hand, he dedicated to

Charles Darwin. The two volumes eventually published contained some 200 drawings with careful enlargement of the floral detail. The hand-coloured plates were all taken from living specimens.

Fitzgerald also described 173 orchids for the *Handbook of the Flora of New South Wales* (1893)[21] by Moore and Betcher. He died at Hunter's Hill, Sydney, before the work was finished. He left a considerable number of drawings and notes concerned with orchids and from these Henry Deane, assisted by A. J. Stopps, prepared the last part of the second volume of *Australian Orchids*, which was published in 1882. One of the most beautiful Australian epiphytes (plants growing on other plants), the Ravine Orchid (*Sarcochilus fitzgeraldii*), was named after him.

In Ireland, the Dublin botanical scene in the nineteenth century was dominated by Scotsman, JAMES

TOWNSEND MACKAY (1775–1862), who in 1806 had been appointed Curator of the newly-established Trinity College Botanic Gardens, where he was to remain for the rest of his life. It was Mackay who finally succeeded in publishing the *Flora hibernica*[22] which had been awaited for so long. It was a milestone in the history of Irish botany, and included all plants known during that time to be native to Ireland. Mackay was helped considerably in his work in the section on algae, or seaweeds, by the intrepid MISS ELLEN HUTCHINS (1785–1815), an energetic young botanist who lived at Ballylickey, Co. Cork. She not only supplied information for Mackay's work but also contributed seven drawings of seaweeds (illus. 85) to Dawson Turner's well-known *Fuci*[23] (published between 1808 and 1819). Dawson Turner thought highly of her work. Writing to her, he praises one of her seaweeds and states that it was 'one of the most beautiful plants I ever saw, either this (no. 21), or no. 5 or no. 7 must be called *Conferva hutchinsiae* – Choose which you please'. She also helped to gather valuable information for J. Sowerby and J. E. Smith's famous *English Botany*.

During her lifetime Miss Hutchins corresponded about her discoveries with such well-known figures as Joseph Hooker, a friend of Darwin, an adventurous explorer and the founder of the study of plant distribution. Described by Robert Lloyd Praeger as being a 'botanist of great promise', she died at the early age of thirty. Not only Dawson Turner's seaweed but several other algae and lichens were named after her.

By the early nineteenth century there was a host of artists creating flower paintings. Botany had become a highly popular recreation, and flower painting in watercolour or gouache now enjoyed a firm place among the elegant accomplishments of every fashionable young lady. The HON. KATHERINE PLUNKET (1820–1932) was a notable example. She died at her home at Ballymascanlon, Dundalk at the remarkable age of 112 years, having lived through the reigns of five British monarchs. Daughter of the second Baron Plunket, Bishop of Tuam, Killala and Achonry, she was related to the Foster family, one of whom, the Rt. Hon. John Foster, became Speaker of the Irish House of Commons and one of the founders of the Botanic Gardens, Dublin.

Katherine travelled all over Ireland, including her home county of Louth, Co. Cork and Killarney, as well as abroad to such places as Zermatt in Switzerland, constantly collecting and recording. In a letter to the Keeper of the Herbarium at Dublin she wrote: 'I shall be pleased to present [my illustrations] to a collection in my own country rather than to any Botanical Society in England.'[24] She was true to her word. In 1903 the Museum of Science and Art (now the National Museum of Ireland) received a gift from her sister and herself of an exquisitely-bound leather volume of botanical watercolours. The label on the inside cover read: 'Wild Flowers painted from Nature by the Hon. Katherine Plunket and the Hon. Frederica Plunket'. The illustrations range from buttercups to orchids; they are decorative but at the same time each plant portrait is botanically correct, the character of the individual species being quite clearly conveyed. All 400 specimens are painted on card paper and are mounted eight per page. Apart from their beauty, the illustrations are of

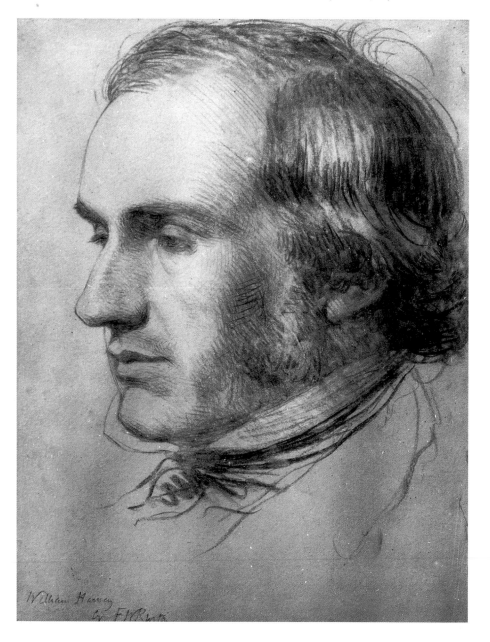

81] *William Henry Harvey (1811–1866), Botanist.* Sir Frederic William Burton (1816–1900).

82] *Orchids (Dendrobium delicatum)* .
Robert David Fitzgerald (1830–1892) .

H. niger angustifolius. Mr Brockbank's plant 1887.

84] Photograph of Lydia Shackleton (1828–1914).

value scientifically in that several related plants can be compared at a glance.

Little is known about her sister Frederica (d.1886) except that she assisted Katherine not only in her paintings, but also in gathering specimens in the high Alps and Pyrenees.

LYDIA SHACKELTON (1828–1914) was born into a large, energetic Quaker family in Co. Kildare. Later, going to live in Lucan on the western edge of Co. Dublin, she opened a small school at which many of her pupils were her own numerous nephews and nieces.

Like Katherine Plunket she was a remarkable flower painter but, unlike Katherine, she did not look on it merely as a fashionable and absorbing hobby; she took it very seriously. She was commissioned by Sir Frederick Moore (1857–1950),[25] then Curator of the Royal (now National) Botanic Gardens at Glasnevin, Dublin, to paint the numerous specimens of orchids and other plants at Glasnevin. Sir Frederick had succeeded his father as curator in 1879 and had an absorbing interest in tropical orchids, expanding the collection so that it became one of the most distinguished in the British Isles. Moore wished to have a permanent record of his collection, to which he was constantly introducing an enormous variety of new species. Between September 1884 and December 1907 she executed in watercolour over 1,400 paintings for Sir Frederick, 1,041 of them of orchids, as well as roughly 100 other studies of both introduced and native plants.

83] *Helleborus niger* cultivar (*Helleborus niger angustifolius* Mr Brockbank's plant)
Lydia Shackleton (1828–1914).

85] *Fucus fruticulosus*; from Dawson Turner's *Fuci*, vol. IV, 1819. Ellen Hutchins (1785–1815).

Her painting technique was relatively free and therefore best suited to the depiction of large flowers. When painting smaller subjects her technique did not adapt itself so well to the tight, concise botanical style required and therefore her work is not quite so successful, as seen for example in the *Lachenalia* studies. In each case she has carefully mounted the dried specimen beside her work. Most of the orchid paintings depict individual blossoms.

When Lydia Shackleton retired from her work at Glasnevin in 1907 she had made a unique contribution to botany and horticulture. She lived for another seven years but, sadly, none of her work was published in her lifetime.

The task was carried on by another Quaker, ALICE JACOB (1862–1921). Equipped with a highly sensitive

86] *Sarracenia × catosbaei* (*Sarracenia* (hybrid) *Patersonii*) .
Lydia Shackleton (1828–1914) .

87] *Coelogyne valida*.
Alice Jacob (1862–1921) .

88] OPPOSITE *Iris – Xiphion kolpakowskianum*;
from William Curtis's *Botanical Magazine*, vol. XXXVI, 1880.
Frederick William Burbidge (1847–1905) .

eye, and having trained and received a sizeable number of prizes and scholarships at the Dublin Metropolitan School of Art in the 1880s, Alice was well qualified to continue the series, which she did until 1920.

Alice was also a teacher of elementary design at both Cork and Dublin Schools of Art and in later years at Rathmines Technical School. She was perhaps principally known for her delicate lace designs, several of which are in the collection of the National Museum of Ireland.

LADY EDITH BLAKE'S (née OSBORNE; 1845–1926) watercolours reveal her keen interest in plants and insects, and provide valuable scientific information, with her portrayal of both subjects being acutely accurate. The watercolour illustrated here (illus. 89) forms part of a series which is in the British Museum (Natural History), and was executed while Lady Blake lived in Jamaica from 1889 to 1897. Her husband, Henry Arthur Blake, whom she married in 1874, was Governor of the Colony. Born at Newtown Anner, Clonmel, Co. Tipperary, her sister, Grace Osborne later became the Duchess of St Albans. Around the age of twenty, Edith became keenly interested in painting plants and insects. Throughout her life she travelled widely – largely due to the fact that her husband served as Governor of the Bahamas, Newfoundland, Jamaica, Hong Kong and Ceylon – recording the plant and insect life which she saw around her. She continued to paint until well into her seventies.

Sir Frederick Moore, who was knighted in 1911, had taken over the directorship of the gardens at Glasnevin in 1879 in the same year as another botanist, FREDERICK WILLIAM BURBIDGE (1847–1905), arrived in Dublin. Although an Englishman, born in Leicestershire, Bur-

6489

F.W.Burbidge del. J.N.Fitch lith.

Vincent Brooks Day & Son Imp.

L Reeve & Co London.

bidge was to spend the greater part of his life in Ireland, in 1879 becoming Curator of the Trinity College Botanic Gardens, where he remained until his death.

He had studied horticulture in the Royal Horticultural Gardens at Chiswick and in the Royal Gardens at Kew, acting as writer and artist on the staff of the *Garden* magazine and travelling in Borneo and elsewhere, avidly collecting plants. In Dublin he continued to contribute Irish material to the *Garden*, at the same time turning his hand to such publications as *The Art of Botanical Drawing*,[26] (illus. 90) in which he offers such hints to his students as not 'mixing their colours with either spring or mineral waters, both being injurious to whites and delicate vegetable colours', and other ideas for the aspiring botanical illustrator.

89] A Jamaican Moth and *Prunus myrtifolia*.
Lady Edith Blake (1845–1926).

On the night of April 13th the caterpillars fed, after this they retired permanently into their purse-like nest, in which they assumed the chrysalis stage. Moth emerged 15th May 95.

PASSION FLOWER.

90] *Passion Flower*; from *The Art of Botanical Drawing*, 1873
Frederick William Burbidge (1847–1905).

FANNY CURRY (d.1912) was born in Lismore, Co. Waterford, and as the owner of the Warren Nursery, Lismore, became well known as a leading horticulturalist. It is therefore not surprising that one of her main interests in the area of watercolour lay in depicting flower pieces. She exhibited at the Royal Institute of Painters in Watercolour between 1880 and 1896, at the Grosvenor Gallery, London, and at the RHA between 1877 and 1896. She also played an active role in all activities relating to the Water Colour Society of Ireland. As far as is known, Miss Curry received no formal art training.

To many people the work of DAVID WILSON, RI, RBA (1837–1935), is represented by his brilliant caricatures of famous politicians and other notable figures of his day; but to others he is a painter of flowers and landscapes, delicate and light in feeling but at the same time conveying an underlying powerful sense of draughtsmanship. David Wilson was born in Minterburn, Co. Tyrone. When he was ten the family moved to Belfast, where he completed his education at the Royal Belfast Academical Institution. Working in the Northern Bank in Belfast by day, he spent the evenings drawing at the Government School of Design, developing his obvious gift for caricature. Eventually he left Belfast for London and became one of the leading black-and-white artists in Fleet Street. He exhibited his caricatures at the Burlington Gallery, London, in 1921 and a year later showed his flower paintings at another London gallery. A member of the British Institute of Painters in Watercolour and of the Royal Society of British Artists, he also exhibited at the RA and in the

91] *Flowers on a Windowsill*.
David Wilson (1837–1935).

Paris Salon. In 1938, three years after his death, the Belfast Museum and Art Gallery (now known as the Ulster Museum) held an exhibition of his watercolours. His flower paintings are cool, harmonious compositions and convey great mastery of tone. They are painted with an exquisite delicacy and possess a harmonious, balanced composition, as seen in his watercolour of *Flowers on a Windowsill* (illus. 91), now in the V&A, London.

As already mentioned, flower painting was one of the favourite pursuits of fashionable young ladies. MILDRED ANNE BUTLER, RWS (1858–1941), was no exception. Described as 'a young lady who knows how to look at her subjects with the eyes of a well-trained artist',[27] she came from a talented and artistic family, her father, Captain Edward Butler (1805–1881), being a skilled watercolourist and draughtsman. Born near Thomastown, Co. Kilkenny, Mildred Anne obviously enjoyed painting and sketching from an early age as her work in scrapbooks reveals but, in the words of Crookshank and The Knight of Glin, 'She was still a schoolgirl in style copying romantic subjects, bulls fighting, army and hunting scenes, with a tight, dry brush ... These show no evidence of any training and little promise'.[28] However, once she was in London and studying under the Guernsey-born drawing-master Paul Jacob Naftel, RWS (1817–1891), her work began to improve considerably. The proud possessor of four Naftel watercolours, she always maintained throughout her life that her first real insight and training in art came from him. Interested in animal painting, she also spent a term in the studio of William Frank Calderon,[29] whose school of animal painting had attracted painters such as Lionel Edwards[30] and Sir Alfred Munnings.

In 1888 she began exhibiting her watercolours in the Dudley Gallery in Piccadilly, and two years later showed them in the Water Colour Society of Ireland. She was a faithful contributor to the latter for the greater part of her life. In the summer of 1894 she left Ireland to join two other artists, the Limerick-born Norman Garstin (1847–1926) and Dublin-born Stanhope Forbes, RA (1857–1947), in Newlyn, Cornwall. She became an enthusiastic and lively pupil of Garstin. The influence of both of these men on her style was considerable, as is particularly visible in her later watercolours, where she employs perspectives and viewpoints beloved by both her teachers. Examples may be found in the paintings of long stretches of coastline, or viewpoints from high chimney tops to slanting narrow streets seen in two examples in watercolour in the NGI, *A View across Rooftops to Newlyn Harbour, Cornwall* and *Rooftops, Thomastown, Co. Kilkenny*. She was able to handle strong colours competently, and frequently worked on a large scale. She specialized in garden scenes such as *The Lilac Phlox, Kilmurry, Co. Kilkenny* (illus. 92), *Flowerbeds, Kilmurry* and '*A Hasty Sketch*', *Hollyhocks and Poppies* (exhibited in the RWS Winter Exhibition of 1936), and watercolour studies of birds and animals. She died at her beloved home, Kilmurry, where she had spent the greater part of her life.

Like Mildred Butler, S. ROSAMUND PRAEGER,

92] *The Lilac Phlox, Kilmurry, Co. Kilkenny.*
Mildred Anne Butler (1858–1941).

93] *Flower-Head of a Spear Thistle*; a line drawing from *Weeds, Simple Lessons for Children*, 1913, by Robert Lloyd Praeger.
Sophia Rosamund Praeger (1867–1954).

HRHA, MA, MBE (1867–1954) was a trained artist, attending the Slade School of Art for four years. Primarily known as a sculptress – her work is represented in the Ulster Museum – she executed a number of botanical illustrations for her brother, Robert Lloyd Praeger, a man with a strong interest in plants and who was editor of the *Irish Naturalist* for thirty-three years. Several of her drawings were contained in a work published in 1913, which was written by her brother for children.[31] These simple line drawings, including the *Flower-Head of a Spear Thistle* (illus. 93) and *The Great Bindweed*, show her strong feeling for line and accuracy. Many of Rosamund's line illustrations can be found in

94] *Rhododendron Cuffeanum (Burma)*; from William Curtis's *Botanical Magazine*, vol. XIII, 1917.
Lady Charlotte Isobel Wheeler Cuffe (1867–1967).

C. J. W. 1897

95] Photograph of Charlotte Isobel Wheeler Cuffe (1867–1967).

the collection of the National Botanic Gardens, Glasnevin. In 1927 she was elected HRHA, and in later life an honorary MA was awarded by Queen's University, Belfast. In 1939 she received an MBE.

'As the pupil advances, the teacher should draw attention more and more to the form of the flowers, petals, leaves, etc. At first colour is the almost exclusive interest. The next step is the study of form.' So wrote ELIZABETH (LOLLIE) CORBET YEATS (1868–1940) in one of two manuals written and illustrated by her on the art of painting flowers, fruit and animals in watercolour (1895 and 1898).[32] She was the daughter of artist John Butler Yeats, RHA (1839–1922), who is discussed in chapter VI. Born in London, she taught art at a Froebel school in Bedford Park before she moved to Dublin. Elizabeth, no less than the other distinguished members of her family, possessed an inherent creative urge, becoming not only a painter of flowers, landscapes and portraits but also devoting a sizeable proportion of her time to teaching painting in watercolour, without preparatory drawing.

In the autumn of 1902 she joined the Dun Emer Industries, founded by Evelyn Gleeson, and established the Dun Emer Press. Six years later, with her sister, she also founded the Cuala Press. With her brother, the poet William Butler Yeats, acting as editor, the Dun Emer Press during its thirty-seven years established a high reputation publishing not only W. B. Yeats's work but also that of writers such as Louis MacNeice and Frank O'Connor. Despite depressions, wars and other adversities, Elizabeth managed to keep the press alive, publishing hand-coloured prints, Christmas cards and the

96] The National Botanic Gardens, Glasnevin (1849), founded 1795.

famous *Broadsides*, a collection of ballads and poems illustrated by her brother Jack Butler Yeats, each one being hand-coloured. (Her brother is discussed in chapter VII.) Equipped with a fine sense of draughtsmanship and possessing a pen and ink style which was 'vigorous, and pictorial, sometimes influenced by her brother's work in that medium, but occasionally more decorative and stylized',[33] she executed designs for Christmas cards and a Christmas stamp,[34] Cuala cards from her own press, ornamental poems and embroidery designs.

CHARLOTTE ISOBEL WHEELER CUFFE (1867–1967) was a granddaughter of the Revd Sir Hercules Langrishe, Third Baronet of Knocktopher, Co. Kilkenny. Although she was born in London, where her father William Williams was President of the Law Society, Charlotte's Irish connections were strengthened when in 1897 she married Sir Otway F. L. Wheeler Cuffe, the heir of Sir Charles Wheeler Cuffe of Kilkenny. Immediately after the marriage, the couple went to live for the next twenty-four years in the East, Sir Otway holding a number of posts both in Burma and in India. Charlotte's hobbies were painting and gardening, both of which led her to explore the botany of the various regions in which she lived. Descriptions of many of her expeditions, generally undertaken on horseback, are to be found in the interesting correspondence between herself and Sir Frederick Moore, Director of the Botanic Gardens at Glasnevin, particularly with reference to her exciting botanical finds.

Full of enthusiasm and energy, Charlotte thought nothing of marching eighty-four miles to spend April 1911 in the mountains 'between the Irrawaddy and the Bay of Bengal at a tiny Military Police outpost called Kampetlet on the flanks of the great mountain known as Mt. Victoria, which is over 10,000 ft high'. Charlotte described the exciting discoveries by her friend and

herself in letters to her cousin the Baroness Pauline Prochazka, who lived at Lyrath, the Cuffe family seat. She writes about the white sweet scented-rhododendron which grows epiphytically on other trees, never in the ground; a yellow rhododendron; and whole forests of the crimson tree variety. She excitedly describes the 'blue buttercups'. On the summit itself she found a magnificent crimson rhododendron 'brandishing defiance to the four winds of heaven'. Many of these discoveries she recorded in her paintings (including a sketch of the scarlet rhododendron on the summit of Mt. Victoria), which she presented to the National Botanic Gardens at Glasnevin when she and her husband retired in 1921 to live at Lyrath near Kilkenny.[35]

Unlike Charlotte Wheeler Cuffe, KATHLEEN FOX (1880–1963) was born and brought up on the outskirts of Dublin. She belonged to an Anglo-Irish family. While she was a pupil at the Metropolitan School of Art her work attracted the attention of Sir William Orpen (see p. 165). She studied under him in London and eventually became his assistant at the Dublin Art School. An extraordinarily versatile artist, she expressed her creativity in many ways, including carved wood, silver, costume design, stained glass and painted china.

After exhibiting with the RHA in 1911 she left to paint in Paris and Bruges. A large oil on canvas, *The Fish Market, Bruges*, now in Limerick Art Gallery, is evidence of this. At the outbreak of war she moved to London, where she married. Her husband, Lt. Cyril Pym, was later killed in action. She exhibited her work regularly at the RA, RHA, New English Art Club and the National Portrait Society. In the mid-1920s she returned to Dublin to live at Brookfield, Milltown, Co. Dublin, a house she inherited on the death of her mother. During the 1940s and '50s she produced some of her best work, most notably the flower studies by which perhaps she is best known today.

SIR JOHN LANGHAM (1894–1972) was born in the North of Ireland and educated at Rugby and Sandhurst, later becoming land agent to a number of large estates in Ireland. Eight small bound volumes containing exquisite

examples of his botanical work in watercolour (illus. 97) have been preserved by his widow, Lady Rosamund Langham, at his family home, in Co. Fermanagh. A unique collection, it demonstrates his accurate knowledge of botany together with his love of the countryside which was to remain with him throughout his life.

MOYRA A. BARRY'S (1886–1960) speciality was flower painting. Born in Dublin, she trained at the Schools of the RHA, receiving a number of prizes while still a student, most notably the Taylor prize. After further training at the Slade, she went to Quito in Ecuador to teach. On her return to Dublin she became a regular exhibitor at the RHA between 1908 and 1958, and also at the Water Colour Society of Ireland exhibitions throughout the 1940s and '50s. She also contributed to group exhibitions in America, Canada, England and Holland, and held several one-man shows in Dublin.

WILLIAM EDWARD TREVITHICK (1900–1958) was, like Rosamund Praeger, keenly interested in botanical illustration. His friend John Hutchinson (1884–1972), author of *The Families of Flowering Plants*,[36] the first

volume of which Trevithick illustrated describes him as a 'cheerful and jolly companion with a strong sense of humour ... applying his great talents wholeheartedly and unselfishly to whatever he undertook'. Trevithick also executed several colour plates for the *Botanical Magazine* between 1924 and 1928.

Born on Lord Headford's estate at Kells, Co. Meath, he left school at thirteen to work with his father, a gardener on the estate, and then gardened for the Duke of Rutland at Belvoir Castle in Leicestershire. He enlisted as a 'pupil gardener' at Glasnevin in 1918 while Sir Frederick Moore was Director, with the fortunate result that he had a succession of able botanists and horticulturists as his tutors.

When he had completed his training he left for London and gained employment at the Royal Botanic Gardens at Kew. It was not long before his ability and skills as an artist began to be recognized and he was busily employed working for such publications as *The Families of Flowering Plants* and the *Flora of West Tropical Africa*.[37] Trevithick was just one of a number of talented artists who contributed plates to Curtis's *Botanical Magazine*. He left Kew to study full-time at the Chelsea School of Art, doing freelance work to support himself. Eventually he set up his own successful commercial art business.

97] *Rosa spinossissima*.
Sir John Langham (1894–1972).

ROSA SPINOSISSIMA. BURNET ROSE & DIME.

The work of FATHER JACK P. HANLON (1913–1968) is in a very different style from that of the artists previously described. His best work is in his pastel-coloured watercolours of flowers. There are several examples in the NGI, one of which is illustrated here.

Born on 6 May 1913, the eldest son of James and Kathleen Hanlon of Fortrose, Templeogue, Co. Dublin, he was educated at Belvedere College, Clonliffe College and Maynooth College. He was ordained and served during his life as a curate in many Dublin parishes. From an early age he showed his considerable talent as a painter, attending Mainie Jellett's classes and winning the Taylor Art Scholarship and the International Hallmark Prize for Watercolour. Because of his vocational commitments he was not able to devote himself full-time to art. However, he did find some time to study in Paris under André Lhote with other Irish painters such as Norah McGuinness (see p. 188) up to the 1950s. Lhote was an inspired and gifted teacher, imparting his approach and Cubist techniques to his students. This had a profound and lasting influence on the young Irish priest. Watercolour was the medium over which he appears to have had the most control, his style being highly sophisticated and decorative as seen in his *Fiery Leaves* (illus. 98), or *Virgin and Child*. However, his early sketch books (now in the NGI) show highly finished watercolours and pencil studies which are believed to date from the period between 1935 and 1938. Here he displays his love of meticulous detail, which is in sharp contrast to the later period from the early 1940s onwards where there is a freer, more fluid approach to the medium. Cubism was an important influence, particularly in his later work, but he appeared to follow the Fauvist idea of pure colour and shared the group's affinity for light palettes.[38]

Hanlon also travelled and studied in other European cities such as Brussels and Madrid. A founder member of the Irish Exhibition of Living Art – he remained a committee member until his death in 1968 – he held many one-man shows during his lifetime, in Dublin, Paris, London and Brussels. His work was also represented in a number of exhibitions of contemporary Irish art both in the United States and on the Continent.

In this chapter some indication of the work of both the flower painter and the botanical illustrator has been given. Watercolour played a vital and constructive role, lending itself well to the intricate beauties of colour, texture and rhythm which make up each flower.

98| *Fiery Leaves.*
Father Jack P. Hanlon (1913–1968).

Cartons Raphael Urbin Pinx. Cav! Chezze del. Annibal Charraci inv! Leonard da Vinci Pinx.

3 CHARACTERS. 4 CARICATVRAS.

for a farthar Explanation of the Difference Betwixt Character & Caricatura See y Preface to Jos Andrews.

W Hogarth Fecit 1743

99] *Characters and Caricatures.*
William Hogarth (1697–1764) .

V

CARICATURISTS AND
BLACK-AND-WHITE ILLUSTRATORS

CARICATURE is derived from the Italian word *caricare*, meaning 'to load'. Its origins are to be found in that country where, largely through the efforts of the leading Baroque painter of the Bolognese school, Annibale Caracci (1560–1609), people began to realize that the not-always-too-flattering features of an individual were quite often more true to life than the conventional portrait study. Caracci's work and that of Italian artists such as Pier Leone Ghezzi (1674–1755)[1] whose pen-and-ink caricatures of Irish peers, *Joseph Leeson Junior and Lord Charlemont* (now in the Philadelphia Museum of Art), or of *An Englishman Studying Roman Ruins* (illus. 100; Metropolitan Museum of Art),[2] were to become more widely known in both England and Ireland through the work of an Englishman, Arthur Pond (1705–1758). Between 1736 and 1742 Pond published two sets of prints after caricatures by Caracci, Ghezzi and several other artists which were of great importance in familiarizing both the English and Irish public with the style.

Dublin-born Hugh Howard (1675–1737), a keen collector of prints and drawings and later to become Keeper of the State Papers and Paymaster of the Royal Palaces in England, was one of many who collected caricatures with zeal and energy on his travels in Italy, occasionally indulging in caricature drawing himself as his *Caricature of an old Ecclesiastic* (after Ghezzi) reveals (illus. 102).

The century in which Pond published his volume of etchings also saw the Grand Tour getting into its stride, with the artistically-inclined, wealthy and influential travelling around Europe and inevitably returning not only with old master paintings but also with collections of caricatures. The art attracted such champions of high art as Sir Joshua Reynolds. His own unique output of caricatures, executed in oil, while he was in Rome as a young man, now form part of the National Gallery of Ireland's collection. They include such delightful depictions as that showing *Sir Thomas Kennedy, Lord Charlemont, Mr Ward and Mr Phelp* (illus. 101). His well-known *Parody of Raphael's School of Athens* (oil) is also included in the collection; it is a humorous presentation of English and Irish visitors in Rome around 1750. These include James Caulfield (1728–1799), Fourth Viscount and later to become the First Earl of Charlemont (1723–1796), owner of the Casino at Marino; Joseph Leeson, First Earl of Milltown; and Thomas Patch (1720–1783), a caricaturist and view painter.

100] *An English Gentleman Studying Roman Ruins.*
Pier Leone Ghezzi (1674–1755) .

101] *Sir Thomas Kennedy, Lord Charlemont, Mr Ward and Mr Phelps*; (oil on canvas) . Sir Joshua Reynolds (1723–1792) .

Along with this growing interest in caricature was the age-old fascination of the portrayal of type. This was given an added boost during the eighteenth century by the powerful character draughtmanship of William Hogarth (1697–1764), who revelled in portraying character through the face, as is brilliantly conveyed in his *Characters and Caricatures* (illus. 99). Thomas Rowlandson (1756–1827), another English artist, not only excelled as a watercolourist but also possessed an extraordinarily sensual response to his subject matter. A superb caricaturist, he succeeded in recording with great vitality and humour the numerous aspects of the age in which he lived.

Caricature was fast becoming a distinct art form and in many cases a sharp political weapon, a far cry from the sketches of the dilettante. Artists such as Irish-born JAMES BARRY, RA (1741–1806), who was best known for his historical paintings, did not hesitate to use it, for

example when making the case that civilization and the arts would grind to a halt in a morally corrupt England. In his opinion they could only be reborn in the United States, where a 'new people of manners simple and untainted' flourished. His *The Phoenix or the Resurrection of Freedom* (illus. 105) conveys this message. Here Liberty is born again over a temple in North America while a group of mourners gather together in the foreground with supporters of the Commonwealth, a group in which Barry includes himself. This liberal, anti-establishment print was etched in response to the American Declaration of Independence of 4 July 1776.

FRANCIS GROSE, FSA (1731–1791), whose contribution to topography in Ireland has already been outlined in chapter II, issued in 1788 a pamphlet entitled *Rules for Drawing Caricatures* (illus. 104) in which he advises the reader on such delicate matters as mouths which, in his opinion, 'may be arranged under four different genera or kinds. Of each of these there are several species. The under-hung, the pouting or blubber, the shark's mouth and the bone box.' Grose gives us some idea of what he means in his group of nine caricature heads (illus. 104), a brush drawing in the V&A, London.

A landscape painter, book illustrator and caricaturist who was a close friend of Grose and who accompanied him on many occasions to Ireland was JOHN NIXON (c.1750–1818). He worked as merchant in Basinghall Street, London, where he was very much at the centre of a lively group of actors and wits; he was also a captain in the Guildhall Volunteers and a juryman at the Guildhall. Apart from making numerous topographical sketches of seats throughout the British Isles and contributing several illustrations to Grose's *Antiquities of Ireland*, he also became a genre painter, specializing in humorous watercolours full of well-grouped figures and filled with life, as his large and rather splendid watercolour of *The Cove, Cork*, so aptly demonstrates. After 1800, and

102] *Caricature of an old Ecclesiastic* (after Ghezzi) . Hugh Howard (1675–1737) .

103] *A Meeting of Connoisseurs.*
John Boyne (*c.* 1750–1810) .

under the influences of leading caricaturists such as Isaac
R. Cruikshank (1789–1856), and Rowlandson, in whose
company he visited Bath in 1792, Nixon became highly
skilled in depicting the more humorous aspects of life.
Many of his caricatures were worked up and engraved
by Rowlandson.

Not as good a draughtsman as the latter, he was
fortunate to possess Rowlandson's bravura and feeling
for small caricature groups, as seen in his amusing *Interior
with a fat woman reading aloud from Jane Shore* (illus. 106),
which forms part of a collection of caricatures by Nixon
in the British Museum. It was said of him that 'He could
sketch a portrait, with a few scratches of his pencil, of a
party whom he had not seen for twenty years and with
such marked traits of resemblance, as to be known at a
glance.'[3]

104] *Nine caricature heads*; from *Rules for Drawing Caricatures.*
Francis Grose (1731–1791) .

Drawn by Captain Grose 1789.

Another follower in the style of Rowlandson and Nixon was Co. Down-born JOHN BOYNE (c.1750–1810), the son of a joiner, who at an early age was apprenticed to London engraver William Byrne (1743–1805). According to Strickland, 'owing to his idle and dissipated habits, he was not successful'.[4] He joined a company of strolling players and played a number of Shakespeare's characters. In 1781 he returned to London, becoming a pearl-setter in the employment of a Mr Flower of Chancery Lane. Later he became a master in a London drawing school in Holborn and later in Gloucester Street, off Queen Square. His amusing pen-and-watercolour drawing entitled *A Meeting of Connoisseurs* (illus. 103) is in the V&A, London, and shows the influence of Rowlandson. Here the scene takes place in the artist's garret, light coming from a window on the left. Four gentlemen, all dressed in coats, are grouped around Boyne's easel whilst a tall black man stands on the right. The painter stands by his easel holding his palette and looking somewhat apprehensive as a junior

member of the group of visitors, a young fop, is being actively encouraged to commission a painting. Drawn with somewhat less emphasis are the painter's wife, his children and animals.

Irish illustrators such as HENRY TRESHAM (1715–1814), WILLIAM NELSON GARDINER (1766–1814), NICHOLAS BLAKEY (c.1752–1778) and RICHARD A. MILLIKEN (1767–1815) all contributed to the explosion of caricature which was to come in the nineteenth century. This was to be a golden period for caricaturists and illustrators; neither politics, social misdemeanours, fashions, nor any other aspect of society escaped the sharp, witty eye of these keen observers of the human condition. The explosion was heralded by the arrival in London of the founder of the famous family of Doyles from Ireland. JOHN DOYLE ('HB') (1797–1868) was to become a distinguished contributor to the pages of *Punch*, founded in 1841, one of the greatest comic chronicles of all time, and the longest-running humorous paper in existence today. Through its pages the art of the caricaturist began to take on a distinct respectability, which would have been unheard-of in the days of Rowlandson or Hogarth. The word 'cartoon' came into the language in its modern sense of a

105] *The Phoenix or the Resurrection of Freedom.*
James Barry (1714–1806) .

106] *Interior with a fat woman reading aloud from 'Jane Shore'.* John Nixon (*c.* 1750–1818) .

humorous, if sometimes cruel drawing.

John Doyle was the forerunner in a long tradition of distinguished caricaturists beginning with his son RICHARD ('DICKY') DOYLE (1824–1883), whose facetiousness and whimsicality fitted in well with the principles of the founders of *Punch* that this comic chronicle should be above all a 'new work of wit and whim, embellished with cuts and caricatures'.

John Doyle was born in Dublin, and received his training under the Italian landscape painter Gaspar Gabrielli (*fl.*1803–1833) and the miniaturist John Comerford (see p. 20) before coming to live in London, where he soon gained a firm reputation as a political caricaturist under the *nom de plume* 'HB'.

His interpretation of caricature differed somewhat from that of his predecessors, being unlike that of the satirical and often savage style displayed by Rowlandson. His was a much more straightforward technique, his humour being obtained not through exagger-

107] *'The Catholic Triumvirate'*, *'Honest Jack' Lawless, Daniel O'Connell and Richard Lalor Sheil.* John Doyle ('HB') (1797–1868) .

ation but by portraying in the faces of his figures the stresses and strains of their various vocations. Above all, he strove to convey a truthful artistic account of what he actually saw. He passed on his artistic talents to his gifted children, in particular to his second son Richard.

There were two essentials in Richard's work: a search for truthful artistic expression delicately counterbalanced with forays into the realms of a fantasy world. We get an indication of this in his delightful *Dick's Journal of 1840*, drawn by Richard for his father. This is an attractive account in words and pictures of daily family life in the Doyle household. Every page demonstrates his exceptional talent for capturing ordinary events with objectivity while injecting wit and humour into the situation, a gift which was to feature later in such works as *Bird's-Eye Views of Society* (1861–1863), an acute observation of the social scene which highlights all the absurdities of fashionable society. His *The Foreign Tour of Brown, Jones and Robinson* (1854), a record of the comic antics of three young bachelors let loose on the Continent for the first time, is summed up in his delightful, *They 'do' Cologne Cathedral.*

But Richard's genius was given full reign in the fantasy world of fairyland which he created. Here his originality is at its most striking, as seen for example in *The Fairy Tree* or *Fantasy on* The Tempest *by William Shakespeare.*

In 1870 he published *In Fairy Land*, considered by many to be his masterpiece. Here the artist was left entirely free to produce his own fascinating fairy world while the Irish Pre-Raphaelite poet William Allingham (1829–1889) – husband of well-known watercolourist Helen Allingham, RWS (1848–1926) – was asked to carry out the somewhat formidable task of submitting verses to accompany Richard's plates. Through his interest in fairytales Richard became a keen collector of folk legends of witches, trolls and, not least, dragons, of which a fascinating picture by him can be seen in the National Gallery of Ireland.

Richard's fantasy world of the fairies, seen here in his delightful *Under the Dock Leaves: An Autumnal Evening's Dream* (illus. 108) and *The Triumphal Entry. A Fairy Pageant* (illus. 111), was in marked contrast to the more biting and satirical world of the caricaturist, but here again his genius never deserted him. In the seven years during which he contributed to *Punch* he established himself as the master of social satire, his cartoons combining a concern for portrait detail along with his own comic inventiveness.

Richard's connection with *Punch* began in 1843 when he was introduced to the editor, Mark Lemon, by his uncle, the journalist and critic Michael Conan. The relationship was to last seven years, Doyle resigning finally in 1850. But his influence lived on in his design for the cover (illus. 109), which remained in use for over a century, until 1956.

After his resignation from *Punch* Doyle spent long periods away from London, becoming a much sought after house-guest at country-house parties. This determination to bury himself in society was later to damage

108] *Under the Dock Leaves: an Autumnal Evening's Dream.* Richard ('Dicky') Doyle (1824–1883) .

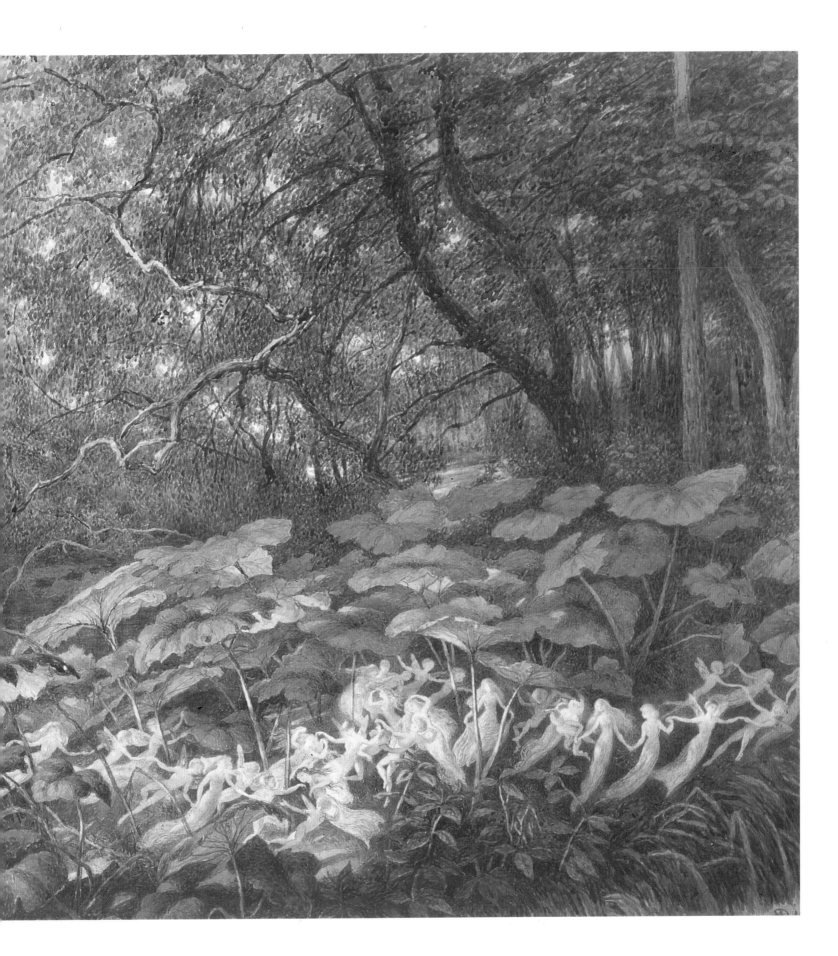

his artistic career, as he tended only to seek work when he needed the money. It was on these occasions that he frequently turned his hand to painting landscapes in watercolour, such as *Studley Park, Yorkshire*. These paintings did not appeal to his patrons or critics nearly as

much as his masterpieces of the fairy world.

Richard's brother, CHARLES ALTAMONT DOYLE (1832–1893), was also a keen observer, as may be seen in his watercolour *Bank Holiday*. This jolly holiday scene makes an interesting comparison with his rather gloomy, introspective self-portrait entitled *Meditation* (now in the V&A, London), revealing two very different sides to his character. The second child of his marriage to a strong-minded woman, Mary Foley (commonly

109] The cover for *Punch*; wood engraving after the artist's design. Richard ('Dicky') Doyle (1824–1883) .

known in the family household as 'The Ma'am'), whom he had married in Edinburgh in 1855, was the famous author Sir Arthur Conan Doyle, born in 1859.

John Doyle's third son, HENRY EDWARD DOYLE, RHA, CBE (1827–1892), was also a caricaturist, portrai-

tist and religious painter, one of his outstanding achievements being the decoration of the Chapel of the Dominican Convent, Cabra, Dublin in 1864. He became director of the National Gallery of Ireland five years later, succeeding G. F. Mulvaney. He held this post until his death in 1892. In 1880 he was awarded a CBE for his work on the improvement of the Gallery's collection, particularly in the field of portraiture. His own portraits, executed in pencil, watercolour, chalk or

110] Decorative frontispiece to a Christmas edition of *Punch*; wood engraving after the artist's design. Richard ('Dicky') Doyle (1824–1883) .

EVEN as the farmer's wife, shaking in her apron the cereal grains, bringeth all sorts of fowl about her—now calling to cocks and hens, and now with her supper-voice charming doves and pigeons from cot and roof,—now making some distant goose give forth a hopeful gaggle, and now evoking even from ducks a hilarious quack,—even so hath PUNCH, shaking his purse of a hundred guineas to all men with pens—a Hundred Guineas, the reward of a Prize Preface to this his Sixth Volume — brought around him every sort of quill, now fluttering with hope, now tremulous for gold !

Alas ! why cannot the resemblance continue ? Why, like the aforesaid farmer's wife, cannot PUNCH shower liberal handfuls to all ? Why hath he no more than One Hundred Guineas for one successful bird ? In truth, if PUNCH, as his old friend *Brutus* once hinted, could

" Coin his heart and drop his blood for drachmas,"—

he would have more than enough to satisfy all comers. His sympathies are unfathomable ; but though deep, his pocket has a bottom.

Otherwise, how would he cast about him the golden grain to the quills stained to attempt the Prize Preface ! He would throw

111] *The Triumphal Entry. A Fairy Pageant.*
Richard ('Dicky') Doyle (1824–1883) .

crayon, demonstrate a competent standard of achieve-
ment, as seen in his black chalk and crayon portrait of
John Ruskin (1819–1900), or of the patriot *Robert Emmet*
(1778–1803) (illus. 114) executed in watercolour.

A keen satirist and an acute observer CAROLINE
HAMILTON (1771–1861) mentions in her diary that she
'chose Mr. Hogarth for my model ... Sometimes
delighted with the effect of light and shade by candle-
light, I attempted it, and sometimes observing in com-
pany that muscles of the face were set in motion by such
and such feelings, I came to express them, by recourse
occasionally to Le Bruns Passions to convince me I was
right'.[5] Her watercolours are clever and witty as seen in
The Kingstown to Holyhead Packet (illus. 116), where she
amusingly depicts the embarkation of passengers at

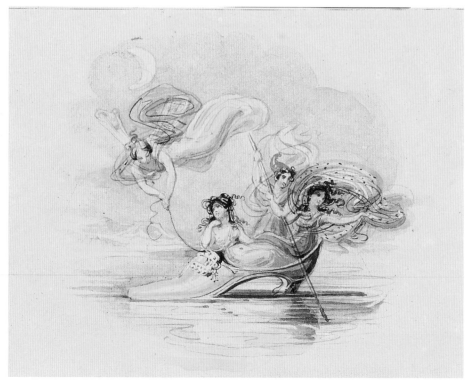

112] *Three Fairies Punting in a Shoe.*
William Henry Brooke (1772–1860) .

113] *Portrait of Richard ('Dicky') Doyle (1824–1883)*; (oil on canvas) . Henry Edward Doyle (1827–1892) .

114] *Robert Emmet (1778–1803)*, Patriot. Henry Edward Doyle (1827–1892) .

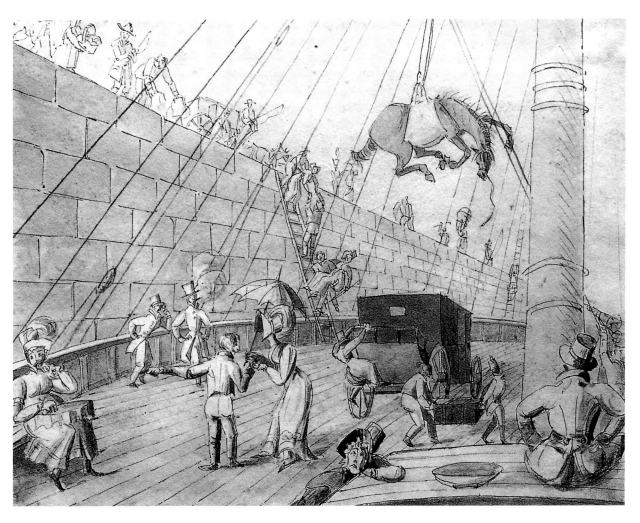

115] *The Kingstown to Holyhead Packet*. Caroline Hamilton (1771–1861) .

Kingstown for their trip to Holyhead. Caroline was the daughter of William Tighe of Rosanna, Co. Wicklow, and her mother, Sarah, was the daughter of Sir William Fownes of Woodstock, Co. Kilkenny. In 1801 she married Charles Hamilton of Hamwood, Co. Meath and the majority of her drawings and watercolours are still at Hamwood.

LADY ALICIA PARSONS (1815–1885), daughter of the 2nd Earl of Rosse, also possessed a keen and witty outlook on life. From an early age, she recorded with spirit the goings-on in her local town of Birr, Co. Offaly, between the officers of the militia garrisoned there and the local ladies, frequently adding her own amusing captions. Also a topographical watercolourist, she was capable of painting in a straightforward style using clear washes of colour as seen in her detailed view of the town of Birr or *The harbour at Kingstown, County Dublin*, both in her family's collection at Birr Castle, Co. Offaly.

William Henry Brooke, Mathew James Lawless and Paul Mary Gray are just some of the broad base of talented Irish illustrators who worked in London during this period.

WILLIAM HENRY BROOKE, ARHA (1772–1860), frequently used the pseudonym 'Paul Pry'. The grand-

116] *Self-portrait*; frontispiece to O'Driscoll's *A Memoir of Daniel Maclise RA*. Daniel Maclise (1806–1870) .

117] An illustration to *Le Morte D'Arthur* by Alfred, Lord Tennyson. Daniel Maclise (1806–1870) .

son of Robert Brooke (*fl.* 1748), a portrait painter from Co. Cavan, he became a watercolourist and caricaturist and worked in the style of the well-known book illustrator, Thomas Stothard, RA (1755–1834). Brooke's illustrations are sincere and simple, in direct contrast to the grand manner adopted by historical painters wor-

king in this field, as can be judged by his illustrations for T. Keigthley's *The Fairy Mythology*. His ability to turn out charming and delicate work is beautifully demonstrated in his watercolour *Three Fairies punting in a Shoe* (illus. 112).

Brooke had been an admirer of DANIEL MACLISE, RA (1806–1870), executing a number of etchings after Maclise's drawing for Crofton Croker's *Fairy Legends and Traditions of the South of Ireland* (1826). Croker, writing in the preface to the 1826 edition, remarks: 'The

118] *The Fraserians*.
Daniel Maclise (1806–1870).

etchings which have been added to this edition are from sketches by Mr Maclise, a young Irish artist of considerable promise who I trust will receive that patronage which he so justly merits.'

Maclise was well read in the classics and in contemporary romantic literature. His contact with intellectual and literary society stimulated his imagination and served to imbue him with a lifelong passion for books. *Wren Boys* (engraved from his original by E. Landells), was executed for Mr and Mrs S. C. Hall's *Ireland: Its Scenery and Character* (1841), and shows the traditional Christmas procession of the Wren Boys who travel from house to house carrying dead wrens attached to holly bushes and soliciting money. The author, Samuel Hall (1800–1889), was a close friend of Maclise. They had met in Cork and when the young artist first came to England, Hall went out of his way to help him. As Hall was editor

of the *Art Journal* and influential in literary and journalistic circles, he proved of considerable assistance in advancing the young painter's career.

Amongst the many works to which Maclise contributed was a new edition of Alfred Tennyson's poems published in 1857. This edition numbered among the distinguished list of illustrators many of the young Pre-Raphaelites, including Holman Hunt, Rossetti and Millais. Two pictures of Maclise decorated the poem *Le Morte d'Arthur* (illus. 117).

Maclise's considerable powers as a caricaturist are revealed in the elegant and witty series of caricatures which he produced for *Fraser's Magazine*. A fine example is his pencil portrait of *Thomas Carlyle* (illus. 119), a preliminary drawing for the caricature which appeared in 1833 in *Fraser's Magazine*.[6] According to Carlyle, the artist finished it in twenty minutes. His

119] *Thomas Carlyle*.
Daniel Maclise (1806–1870).

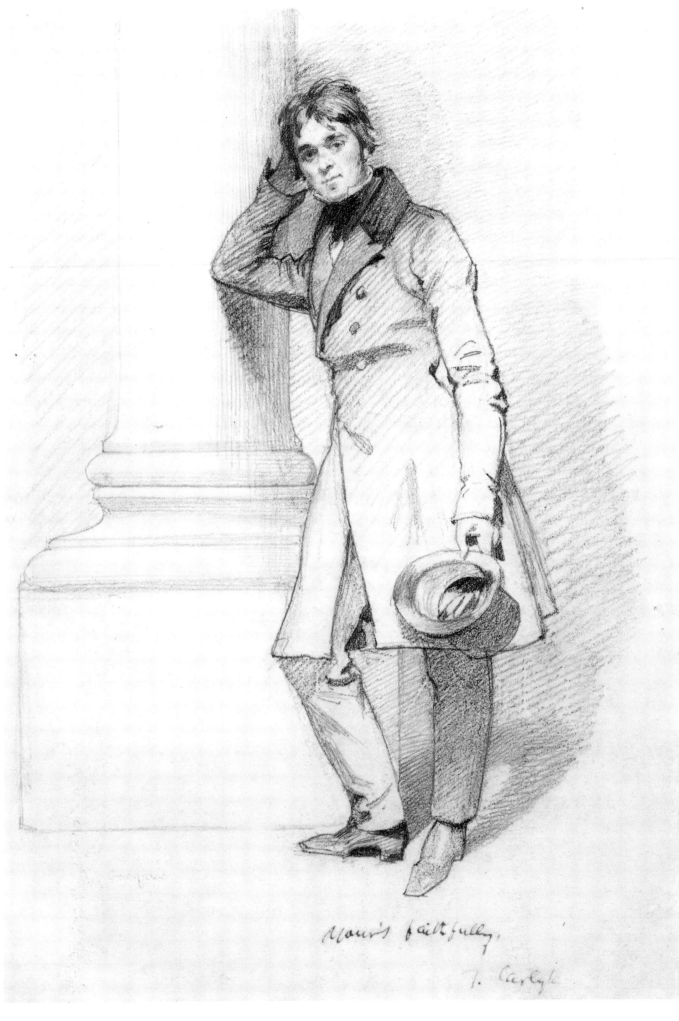

Yours faithfully,

T. Carlyle

preliminary pencil drawing for the group caricature of *The Fraserians* (illus. 118) shows the leading contributors at that time dining together in Fraser's back parlour in Regent Street.[7] Many of them were Irish. Several heads of the figures depicted in this group caricature are based on existing caricatures which had already been published in the magazine as part of Maclise's *Gallery*.

Maclise was also prominent as a 'respectable' portraitist, as will be made clear in chapter VI.

MATHEW JAMES LAWLESS (1837–1864) had a tragically short career. It spanned only five years and, owing to his ever-deteriorating health, his output was relatively small. The son of a Dublin solicitor, he was born in Harcourt Street, his family moving to London in 1845. Deafness and ill health led to his education being constantly interrupted. After he left school he studied painting at an art school in Bloomsbury and began exhibiting regularly at the RA, his paintings showing a preference for historical scenes, and in particular illustrations from Shakespeare. After art school, further training followed with J. M. Leigh (1808–1860), founder of the Newman Street drawing school and an artist who encouraged his students to illustrate scenes from Scott and Shakespeare. Completing his training with Leigh, Lawless moved to the Langham School where he was remembered for his 'studies . . . remarkable for their high finish, possessing as they did the minute perfection of the French School'.[8] The completion of his art training took place under Henry O'Neill, ARA (1817–1880), who advised him that he should 'devote himself to illustration rather than to picture painting'.[9]

The first venture of this artist, who worked primarily in pen and ink, into the publishing world appeared in *Once a Week* in December 1859. This periodical was one of the most popular of its kind during the 1860s, describing itself as 'A Miscellany of Literature, Art, Science and Popular Information'.[10] It numbered among its contributors Sir John Tenniel, RI (1820–1914) and Sir John Everett Millais, Bt., PRA (1829–1896). In *The Headmaster's Sister* (illus. 120) by Lawless, which appeared in *Once a Week*, he delineates his figures with great care and conveys his love of detail, particularly in the treatment of the shirt of the young boy on the right. Some of his best work appeared in Catherine Winkworth's *Lyra germanica* (a book of hymns translated from German, first published in 1855). His illustration *Pure Essence* shows a solitary young girl, obviously suffering. It is one of his most gifted illustrations.

Lawless loved to place his figures and settings within a period context, as seen for example in his *The Player and The Listener*. In this delicate and beautifully-balanced composition we see a young man dressed in period costume seated at the harpsichord, the artist's love of detail and the influence of French painting being obvious features. His well known *A Sick Call* in the National Gallery of Ireland demonstrates his skill as an oil painter, and also his interest in the work of such seventeenth-century Dutch artists as David Teniers (1582–1649) and Nicholas Maes (1634–1693). A visit by the artist to Bruges in 1860 also served to strengthen this interest. In the background of this work is a town whose spires and towers rise in the utterly still evening air, while in the foreground the calm, still water is reminiscent of many Dutch paintings.

This 'truly gifted young artist whose drawing was refined and accomplished'[11] died in Bayswater at the age of twenty-seven. But his fellow Irishman, PAUL MARY GRAY (1842–1866) died even younger. He was described as 'a young artist of very considerable promise who displayed much fine feeling for black and white work'.[12] Like that of his contemporary, his work possesses a melancholic streak, as if he had a premonition of an early death.

The son of a professor of music at an academy in Camden Street, Dublin, Gray was educated by the Jesuits at Tullabeg. After becoming a member of a Dominican Noviciate in Gloucester, he found he had no vocation for the ministry and took up the teaching of drawing at his old school in Tullabeg. Moving to Dublin, he determined to establish himself as a painter, and exhibited figure and genre subjects at the RHA from 1861 to 1863. But then, realizing that he needed a far wider market for his artistic talents, he moved to London and began contributing illustrations to *Punch*. As he was rather weak on humour, his relationship with the journal did not last very long. In the word of M. H. Spielman, his work lacked 'backbone'.[13]

However, he was not put off and began contributing to *Fun*, one of *Punch*'s major rivals of that time. He proved that he possessed real talent where draughtmanship and a sense of line were concerned, as may be seen in his *The Choice of Hercules*, which appeared in the edition of 22 July 1865. In this cartoon, Palmerston and Disraeli look decidedly foolish as they try to seduce the necessary vote from a somewhat confused and bewildered John Bull. While still contributing to *Fun*, in 1866 Gray also began supplying illustrations to *The Quiver*, which

120] *The Headmaster's Sister*; from *Once a Week*; engraving by J. Swain after the artist's drawing. Matthew James Lawless (1837–1864).

121 | Original drawing for an illustration for *Ally Sloper's Half-Holiday*. William Giles Baxter (1856–1888).

prided itself on being an 'illustrated Magazine of Society's Intellectual and Religious, Progress'. In his little preparatory sketch for *Cousin Lucy*, which has survived and may be seen in the V&A, his style is characterized by swift, controlled strokes and clear outlines. His charming illustrations for *Jingles and Jokes for Little Folks* are of a very high standard, but his work could vary considerably, being on occasions too vague and gentle to be effective. This may be seen in some of his work submitted to such periodicals as *Once a Week* and *Good Words*.

WILLIAM GILES BAXTER (1856–1888) could never be described as vague. A 'powerful draughtsman',[14] he was one of those caricaturists working in London in the nineteenth century 'who were to raise humorous drawing to a much higher level of artistry than formerly'.[15] Because of reduced reproduction costs, comic papers were being published at cheap, attractive prices. One such, *Ally Sloper's Half-Holiday*, gave Baxter the perfect opportunity to develop a character who eventually became a national institution. Ally Sloper, the sloven of

the East End of London slum with his scrawny figure, bulbous red nose and Micawber hat, appeared regularly on the front page, drawn with meticulous skill and care by Baxter.

Baxter was born in the south of Ireland, but later moved to America after his father's small business had failed. The family returned to England after his father died, and he was apprenticed to a Manchester architect. Not too anxious to pursue architecture as a career, he turned his talents towards black-and-white work and early in 1879 established in Manchester a satirical weekly called *Comus*, the title of which was later changed to *Monus*. It featured an extraordinary series of life-size heads, *Studies from Dickens*.

Not having much success, the young cartoonist moved to London and met Charles H. Ross, the owner of *Ally Sloper's Half-Holiday* and himself a journalist. Baxter now transformed Ross's somewhat feeble character into a loveable person, totally recognizable by the adoring British public. In the words of Simon Houfe,[16] Baxter's work 'foreshadowed twentieth-century cartoons. His cartoons were amongst the most original of the period.'

Among the Irish illustrators and caricaturists working in London during the nineteenth century was Dublin-

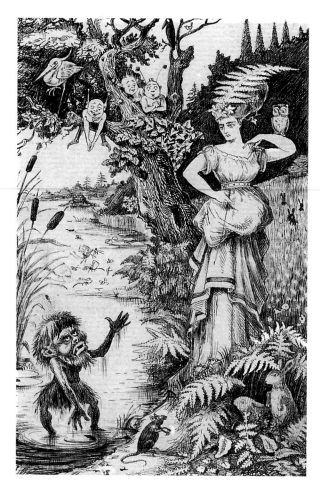

122] An illustration for *Moonshine Fairy Stories* by
E. Knatchbull. William ('Billy') Brunton (1833–1878) .

born WILLIAM ('BILLY') BRUNTON (1833–1878), a
young Irishman full of 'racy humour and odd fancies'.[17]
After studying at the RDS and exhibiting at the RHA,
Brunton was in London by 1861. Like Gray he contri-
buted to *Fun*, exaggerating the features of his figures to
provide humour and employing a tight, linear techni-
que. Obviously influenced by the work of 'Dicky'
Doyle, in particular his long-lasting cover for *Punch*,
Brunton's cover for *Fun* (1866) is full of hordes of figures
tumbling about.

Brunton also contributed to *London Society* and
among his first illustrations was *Respectable People*
published in January 1863. It is immediately reminiscent
of Hogarth's *Characters and Caricatures*. Like several
artists already mentioned in this chapter, he died young.
Strickland remarks that he 'never did justice to his
undoubted talents',[18] but his work did provide humour
and much enjoyment.

Less well known than Brunton was WILLIAM
MCCONNELL (1833–1867), the son of an Irish tailor. As
far as is known he did not receive any formal art training.
He sent a number of uncommissioned drawings to Mark
Lemon, editor of *Punch* who, over a period of ten
months in 1852, invited him to submit several drawings.

A prolific illustrator, in the space of three years
McConnell produced illustrations for thirty-one books,
among them a sizeable number of children's books for

the publishers Routledge. These children's publications
were a very profitable business in the 1860s. They were
cheap to buy, costing only sixpence or one shilling, and
were made particularly attractive by their coloured
illustrations, a novelty at such a low price.

McConnell then went on to become cartoonist for the
Illustrated Times, founded a few years earlier in 1855.
One of the aims of this publication was to capture part of
the market belonging to the *Illustrated London News*.
McConnell's first illustration was *Sunday Riots in Bel-
gravia*. Eventually he became well known for this type of
crowd scene and his ability to capture fashionable and
often controversial events in and around London.

Between 1862 and 1866 McConnell illustrated a
number of articles dealing with the theatre for *London
Society*. A character illustrator, he had no difficulty in
using theatrical gestures to convey his effects, as may be
seen in *Four Public Characters in Private Life*.

123] *Drawing him a little aside*; original drawing for an
illustration for *Sense and Sensibility*, 1896, by Jane
Austen. Hugh Thomson (1860–1920) .

124] *The Gods. The Vaudeville Gallery.*
Hugh Thomson (1860–1920)

Like McConnell, HUGH THOMSON (1860–1920) had little formal training. Born in Coleraine, he first sprang to prominence with a number of drawings which appeared in the *English Illustrated Magazine* of 1883, illustrating eighteenth-century ballads and stories. Son of a tea merchant, he had worked for a linen manufac-

turer before being employed by a firm of chromolithographic printers and publishers. There he received help and advice from John K. Vinycomb, LRIBA (*fl.* 1894–1914), an architect, illustrator and heraldic draughtsman. He also attended (but not on a regular basis) classes at the Belfast School of Art.

By 1883 he was in London and working for the *English Illustrated Magazine*, a position which he held for eight years. In constant demand as an illustrator, he provided these for works by such authors as Jane Austen,

125] A book-cover illustration for *School for Scandal*.
Hugh Thomson (1860-1920).

T. S. Eliot, Stephen Gwynn and Richard Brinsley
Sheridan (illus. 125). With its sensitive pen line, his work
was delicate and charming, as seen in such drawings as
Off we drove and *Drawing him a little aside* (an illustration

126] *An African Fable; the Hare and the Lion*.
George Morrow Junior (1870–1955).

to an edition of Jane Austen's *Sense and Sensibility* (illus.
123) published in 1896) or *Bringing him to the Point* (for
Stephen Gwynn's *An Irish Horse Fair*, 1898).

The Morrow family also came from the North of
Ireland, no fewer than five of the eight sons of George
Morrow becoming illustrators. GEORGE MORROW
JUNIOR (1870–1955) is perhaps the best known of the
family. He became a regular contributor to *Punch*,
joining the staff in 1924 and remaining there for eighteen
years, serving as art editor from 1932 to 1937. He
continued his relationship with the paper until a month
before his death in January 1955. Described in *The Times*
as 'the most consistently comic artist of his day', he also
exhibited at the RA and Royal Society of British Artists.
Examples of his work include *An African Fable*; *The Hare
and the Lion* (illus. 126) and *The Fall of Eutychus*, both of
which are in the Ulster Museum; together with a large
number of book illustrations executed around 1900.

Both his brothers, Edwin and Jack, are represented in
the NGI, whilst Albert's work is represented in the
British Museum and the V&A, London. Norman's
work can be found in the Ulster Museum's collection.

In nineteenth-century Dublin the outlook for
weeklies comparable with *Punch* or *Fun* was fairly
dismal. The small city simply did not possess sufficient
readers to sustain a wide circulation. The lives of such as
were launched were short, never lasting much more
than two years without changing ownership or folding
altogether.

A weekly that made a serious attempt to become the
Irish *Punch* was *Zozimus*, which cost one penny. It was
launched in May 1870, and remained in business until
August 1872. A highly inventive draughtsman who
began contributing cartoons to its pages at the age of
seventeen was HARRY FURNISS (1854–1925). He was
born in Wexford, the son of a Yorkshire engineer
working in Ireland. At twenty-six he joined the staff of
Punch and remained there for fourteen years, contribut-
ing in all a vast output of 2,600 drawings. Possessing a
marvellous sense of fun, Furniss must be one of the prime
examples of a newspaper cartoonist. He himself once
described a caracaturist as 'an artistic cartoonist. He is
grotesque for effect... The good points of his subjects
must be plainly apparent to him before he can twist his
study into the grotesque.'

Shortly after he joined *Punch* Furniss began illustrat-
ing a series written by the journalist Henry W. Lucy,
who was known as 'the Pepys of Parliament'. For a
number of years the two men collaborated to produce
the popular commentary entitled *The Essence of Parlia-
ment, Extracted from the Diary of Toby MP*. It was full of
innuendo and barbed allusion to the daily events taking
place at Westminster. Frequently their work caused
much friction between themselves and Members of
Parliament, as in the case of Furniss's *A House of Apollo-
ticians – As seen by Themselves*, which appeared in *Punch*
on 23 September 1893.[19] Here Harry Furniss turns the
Home Rulers led by Swift MacNeill into almost perfect
angels, after they have been physically abused by a
number of Irish nationalists in the lobby of the House of
Commons. The cartoonist includes himself in the left
corner, and has reduced his figure to simian proportions
to complete the effect of this reversal of images. A master
of political caricature, his pen line looked effortless and

127] '*Imitation the sincerest form of flattery*'; original drawing for an illustration for *Punch*. Harry Furniss (1854–1925) .

was worked up from pencil. However, when he introduced washes he was less successful.

Another able illustrator and political cartoonist who began in Dublin working for *Zozimus* was JOHN FERGUS O'HEA (1850–1922), who became master of the colour cartoon. By the 1880s many of Dublin's larger newspapers had begun to publish these weekly colour cartoons, which were printed on separate sheets and placed inside the Saturday edition. The standard of draughtsmanship and colour was of a high quality, as can be seen from O'Hea's illustration *Oiling his Locks*.

128] Cover illustration for *The Jarvey*,
26 January, 1889.

Amongst Dublin's many distinguished comic artists working in the 1880s was landscape, genre and portrait painter RICHARD THOMAS MOYNAN (1856–1906), who generally signed his work 'Lex'. He was employed as principal cartoonist of the *Unionist*, a Tory newspaper which was published each week in Dublin. Moynan's drawings concentrated on political issues and events. Before embarking on a career in art Moynan had studied medicine for several years at the Royal College of Surgeons of Ireland, abandoning it in order to become a student at the Royal Dublin Society's School and the RHA. Awarded the Albert Prize at the RHA in 1883, he and fellow student RODERICK O'CONOR (1860–1940)[20] enrolled at the Academy in Antwerp in October of the same year. Moynan continued as a student until 1885, and in that year he is recorded as sending six pictures back to Dublin to be exhibited at the RHA. Having moved to Paris in 1885 or 1886, he returned to his native city towards the end of the 1880s. According to Strickland, he 'had every prospect of a brilliant career; but unfortunately he gave way to intemperance which gradually affected his powers and his health, and ultimately wrecked his career.'[21]

Penny weeklies flourished briefly in Dublin during the 1880s. *The Jarvey* (illus. 128) began its life in January 1889 and was the first editing adventure of WILLIAM PERCY FRENCH (1854–1920). It was largely through his efforts that the paper was kept alive for two years. A reviewer in the *Freeman's Journal*, commenting on its arrival, remarked: 'We have before us the first number of a journal devoted to art and humour. Some of the jokes we have seen before – some we haven't yet'. A friend of French who later joined him and became principal cartoonist of the weekly was RICHARD CAULFIELD ORPEN, RHA, FRIAI (1863–1938), a younger brother of the painter Sir William Orpen (who is discussed in chapter VI). Before Richard Orpen became a successful Dublin solicitor, he and Percy French teamed up to produce illustrations not only for *The Jarvey* but also for such publishing ventures as *Racquetry Rhymes* (1888; a humorous commentary on the new craze for tennis) and *The First Lord Liftinant* (1890). French and Orpen took pains to avoid illustrating or commenting on political events, but rather turned their attention to jokes about life in Irish castles and cabins and light-hearted happenings of the day. When *The Jarvey* failed, French commented: 'In a country famous the world over for its wit and humour, no comic paper had the remotest chance of ever paying its way.'[22]

Richard Orpen's elder brother William's sense of humour, coupled with his superb powers of draughtsmanship, are instantly recognizable in such amusing drawings as *The Amateur Chucker-Out: Lane at the First Night of Synge's 'The Playboy of the Western World' at the Abbey Theatre, Dublin* (1907) (illus. 130). This shows the elegant Sir Hugh Lane, both arms high above his head, holding a troublemaker whom he is obviously just about to eject from the Abbey Theatre. This was an allusion to the 'Playboy Riots': Synge's play had its opening night in January 1907, and 'received a hostile and stormy reaction resulting in riots for a week'.

DR EDITH ŒNONE SOMERVILLE (1858–1949) throughout her long life was to prove herself a humorous and compassionate observer of the human condition.

After *Zozimus* closed in 1872 O'Hea found employment in Dublin's many comic weeklies, including *Ireland's Eye* (1874) and the *Irish Figaro* (originally called the *Dublin Figaro*; 1898–1901). He also contributed illustrations to *Pat*, a humorous weekly which cost the princely sum of threepence, its objectives being 'Artistic, Literary, Humorous and Satirical'. Providing cartoons for the weekly *Pat's Diary*, O'Hea in his *Reciprocity* supplied a suitable image for 'the representative Englishman' to counterbalance the equally-distorted Irish 'Paddy' of many of London's comic weeklies.

Also working for *Pat* in the 1880s was the political cartoonist THOMAS FITZPATRICK (1860–1912), a Cork man born in 1860, who served his apprenticeship in a printing and publishing firm. After working for *Pat* he left for London in the hope of improving his career. Not very successful, he returned to Dublin several years later and branched out into design and photoengraving, going on to produce illuminated addresses with the assistance of his daughter Mary. Employed as principal cartoonist for the *National Press*, Fitzpatrick continued in that position when it merged with the *Weekly Freeman* in 1892. 'Fitz' as he was known, continued to draw for the weekly supplement. He also worked for the *Irish Figaro* and eventually realized his cherished ambition by launching his own humorous paper, the *Leprechaun*, a monthly publication of satire and topical views and news. His dislike of 'Paddy' jokes, together with his warmth of personality and humour, won the *Leprechaun* many readers and admirers, so that until 'Fitz' died in February 1912, it was a major success in the precarious world of publishing in Dublin.

HINTS TO ANGLERS.

The Pose.

The Photograph.

LANE THROWING A MAN OUT OF THE ABBEY.

129] *Hints to Anglers*; illustration for *The Jarvey*, 21 September, 1889. Richard Caulfield Orpen (1863–1938).

Born in Corfu, a long way from her family home of Drishane House, Castletownsend, Co. Cork, Edith came from a distinguished Anglo-Irish family, being the great-granddaughter of a Lord Chief Justice of Ireland and daughter of Col. Henry Somerville, one-time High Sheriff of Cork. Determined to combine 'the practices of Painting and Literature with what seemed an equal enthusiasm', she persuaded her reluctant parents in 1881 to let her travel to Düsseldorf to attend a studio run by her artist cousin, Egerton Coghill (1851–1921). Prior to her visit to Germany Edith had been a successful student at the South Kensington Art School. Determined to pursue her career, she later moved on to Paris around 1885, studying at Colarossi's studio. Finding it to be too 'ladylike' for her taste, she moved to his more 'serious, professional studio' in the Rue de la Grande Chaumière. *An Artist and a Model*, a delightful wash drawing dating from about 1884, shows a fellow student of Edith at Colarossi's. The artist later incorporated this with her many articles on the ladies' ateliers in Paris, published in *Cassell's Magazine of Art* in 1885. Between 1886 and 1894

130] '*The Amateur Chucker-out' Lane at the First Night of Synge's 'The Playboy of the Western World' at the Abbey Theatre, Dublin*. Sir William Orpen (1878–1931).

131] *Portrait of Paley Dabble*; from an album
The Rev. Paley Dabble's Adventures.
Dr Edith O. Somerville (1858–1949).

Edith returned to Paris for a few months each year for a welcome change of atmosphere.

She was experiencing a certain degree of success as a professional illustrator and now, together with her cousin and lifelong friend, Violet Martin of Ross, Co. Galway, she began in the 1890s to make numerous excursions in Europe on behalf of the *Lady's Pictorial* and *Black and White*. Many of the articles in these magazines were the result of this and were illustrated by Edith in pencil, ink and wash. In her wash drawing *She Drifted Rudderless* (illus. 132) the young Martin is seen adrift in Hamburg, having become accidentally separated from Edith. A humorous and delightful portrait of Paley Dabble (illus. 131) taken from an album of eleven drawings done by Edith entitled *The Rev. Paley Dabble's Adventures* underlines her highly-comical view of Irish life. In such watercolour portraits as *The Potato Digger*, or her charcoal sketch of *A Priest*, she proves that she is well able to tackle the more serious side, revealing a compassionate streak in her character. Her pictorial humour was largely aimed at her own class, the treatment of local people always being handled with understanding and sensitivity. After her first one-

132] *'She Drifted Rudderless'*.
Dr Edith O. Somerville (1858–1949).

woman show in London in the 1920s she set out on a tour of the United States, which proved to be highly successful. She was seventy-four when Trinity College, Dublin conferred on her the degree of Doctorate of Letters. She was a talented horsewoman, and, together with her brother Aylmer, founded the West Carberry Hounds. She was also a competent musician, but will be best remembered for her marvellously humorous view of the life she saw around her. This is perhaps best exemplified in her ever-popular *Irish RM* stories written in collaboration with Violet (who used the *nom de plume* 'Martin Ross') and which Edith illustrated. She died in her beloved Castletownsend in her ninety-first year.

A strong, humorous personality characterized GRACE GIFFORD'S (1888–1955) witty cartoons. Her book *To hold as 'twere*, satirizing leading Irish personalities, was published in 1919 and two further collections in 1929 and 1930. A grand-niece of Sir Frederic William Burton (see p. 21 and p. 147) she became Sir William Orpen's pupil at the Metropolitan School of Art and also attended the Slade.

With her two sisters she was an active member of Sinn Féin, and in May 1916 married Joseph Plunkett, one of the leaders in the Rising. Becoming a member of the Provisional Republican Government, she utilized her art training by helping to promote the nationalist cause through designs of banners and posters. In March 1922 Grace made her opposition to the treaty known in an article published in *The Republic*. Both she and her sister were imprisoned in Kilmainham Jail. Her amusing pen and ink caricature *Edward Martyn 'having a week of it' in Paris* (illus. 133) shows Edward Martyn (1859–1923) struggling to resist the female temptations of Paris. Martyn, one of the founders of the Irish Literary Theatre with Yeats and Lady Gregory, was a shy and retiring man who lived at Tullyra Castle, Co. Galway, and was instrumental in encouraging many leading contemporary artists to contribute designs for stained glass, sculpture and banners for the new Cathedral in Loughrea at the beginning of the century.

HARRY CLARKE, RHA (1889–1931), made a glittering, distinguished and substantial contribution to illustration.[23] By the age of eighteen he had had an opportunity to see for himself the work of such artists as Beardsley, Burne-Jones, Rossetti and Watts at the huge 1907 Irish International Exhibition held in Dublin, an experience which must have made a deep and lasting impression on this gifted student.[24] Dr Bowe states that Clarke's earliest illustrations 'are eclectic in their reflection not only of Aubrey Beardsley, but also of Nielsen, Hoppe, Alastair, George Sheringham, Sime, Annie French, Jessie King, the MacDonald sisters, Erté and Bakst'.[25]

In order to earn some money to supplement a Travelling Scholarship which had been awarded to him by the Department of Agriculture and Technical Instruction, Dublin, Harry Clarke compiled a portfolio of some of his illustrations[26] and began to show them to London publishers, including George Harrap. Harrap gave him a commission for twenty-four black-and-white illustrations, sixteen colour pictures and ten decorative tailpieces for twenty-four of *Hans Andersen's Fairy Tales*.

In his exquisite pen-and-ink drawing *The Tinder Box*,

133] *Edward Martyn 'having a week of it' in Paris.* Grace Gifford (1888–1955).

the titlepiece to the first story in the selection, the King and Queen look into each other's eyes in disbelief as the magic tinder box trickles through their outstretched fingers. This illustration was reproduced in the prospectus for the book. When the book itself was published in October 1916, the illustrations received wide approval and much publicity. The Christmas issue of the *Studio* for that year remarked that Harry Clarke was 'a clever draughtsman and possessed a fine sense of colour as well as a good deal of imagination'. However, it referred to his affected emulation of Beardsley, a remark which upset the young artist. Thomas Bodkin, on the other hand, noted 'his superb . . . technical accomplishment', and praised him for his 'rare poetic feeling'.[27]

Further success followed when Harrap again commissioned him to execute twenty-four full page coloured illustrations and about a dozen black-and-white drawings for an edition of Edgar Allan Poe's *Tales of Mystery and Imagination*. Harrap remarked that this was in his view 'Clarke's greatest book and the one by which he

was so great that by December 1919 it had gone into a number of plates and vignettes and carried an extra full-page line illustration in two new bindings.

During the winter of 1927 and early 1928 Harry Clarke worked on ten full-page illustrations (nine of which were to be reproduced by Nickeloid photogravure) together with nineteen decorative line illustrations for an edition of the *Selected Poems of Algernon Charles Swinburne*. This was published in November 1928.

Not content to confine his talent to book illustration Harry Clarke was also responsible for designing letterheads, Mass and Christmas cards (illus. 134), magazine covers, bookplates, Church Directory inserts and covers for theatre programmes – including a pen-and-ink design for the cover of Lennox Robinson's *Plays* (1923), which is now in the Hugh Lane Municipal Art Gallery, Dublin. Two of his designs, one of which was executed in pencil and wash and the other in pen and ink, were submitted for the Corporate Seal competition for the National Gallery of Ireland in 1918 (illus. 136). Harry Clarke's entries showed St Luke poised in a vesica, and were highly thought of by committee members Richard Caulfield Orpen and Thomas Bodkin. However, they were not accepted.

At the age of forty-one, Harry Clarke died at Coire in Switzerland. Among the many moving tributes paid to this remarkable artist was one by S. G. Lockett, HM Consul in Davos:

There were two sides to Clarke's artistic imagination...
The religious side, which found expression in stained
glass; and another side that found expression in black and
white... Clarke was a great reader of books as well as an
illustrator of them... He was one of those genial givers of
the greatest things, who enrich our lives with spiritual
wealth. We may be thankful to have had him.[29]

MICHEÁL MAC LIAMMÓIR (1899–1978), best known as an actor, playwright and poet, also bestowed his creative genius on other aspects of art. Born in Cork, he played many distinguished and leading roles in the Irish theatre between 1928 and the 1960s, and founded the famous Gate Theatre in Dublin with his great friend, Hilton Edwards (1903–1982). Mac Liammóir's extraordinary versatility showed itself in highly-imaginative book illustration, as demonstrated by several cover designs executed in watercolour such as *All for Hecuba* (1946) (illus. 137), *Woman at the Window* (1932) and for a collection of his own poems published in 1964. Colour and line are again keenly felt in costume designs for Chekhov's *The Seagull*, produced at the Abbey Theatre, Dublin in 1971. Mac Liammóir had been influenced during his early studio days spent at the Slade by such artists as Aubrey Beardsley, William Blake and Arthur Rackham:

As a child I was obsessed by the uncertainty of what I
wanted to become. My chief ambition was to become a
painter or an actor... Then I toyed with the idea of
becoming a writer, and I suppose I ended up by being a
little of all these things – to my great sorrow and detriment
it may be, for the Muses of course are women and he who
would possess one must be as faithful to her as husbands

134] *Christmas card, 1917.*
Harry Clarke (1889–1931).

will be longest remembered'.[28] Pen-and-ink illustrations for this work included *Landor's Cottage* (used as the frontispiece), *The Pit and the Pendulum* and *Ligeia* (now in the Crawford Art Gallery, Cork). *Ligeia*, in the view of Dr Bowe, was the most memorable and dramatically effective of the set. The success of the book

*are supposed to be to their wives . . . Whatever talent I
have in the visual art is decorative. It can take the form of
illustration of books, or of décor for the theatre, but it is not
painting in the true sense of the word.*[30]

Throughout this chapter, it has been seen how the
contents of caricature can range from exploring greed,
folly and lechery to humour of a more simple, straight-
forward kind, the henpecked husband, the drunkard or
the fat wife. Frequently the caricaturist has been capable
of original and passionate statements. His biting talents
can add dimensions to areas such as portraiture, or
expose corruption in the respectable professions of law,
medicine or the army. The art of the caricaturist will and
must continue to flourish as a constant and healthy
reminder of all our human failings.

136] RIGHT A Competition Design for the Seal of the
National Gallery of Ireland. Harry Clarke (1889–1931).
137] BELOW RIGHT Cover design for *All for Hecuba*.
Micheál Macliammóir (1899–1978).
135] BELOW *Caricatured Self-Portrait*.
Harry Clarke (1889–1931).

VI

THE VICTORIAN PANORAMA

The event of the Rebellion (1798) and the Union diverted the public kind from the cultivation of the Fine Arts

So wrote Strickland[1] about the neglect of patronage of Irish art by fellow Irishmen in the opening years of the nineteenth century. Several factors had contributed to this sorry state of affairs. The Act of Union in 1800 had led many wealthy patrons to leave Ireland, and during the famine years of the 1840s the trend was to accelerate even further. Ireland, unlike Britain in the nineteenth century, did not have a class whose wealth relied totally on industry, so it took time to attract the rising middle-class Irishman to the cultivation of the arts, something which many tended to associate with the Ascendency. The Church, with its considerable powers of patronage, still clung to the idea that Italian, French or German art was nearly always to be favoured in place of native artists' work, no matter how hard the latter might strive to improve their standards. Despite these drawbacks, a large proportion of Irish artists working either at home or in England achieved prominence in the nineteenth century. Of these William Mulready and Daniel Maclise, although they spent a sizeable amount of their time in England, kept up a connection with Ireland by sending their work to the RHA in Dublin, or by accepting local commissions.

The 'Victorian Panorama' tended to extend from roughly 1860 to 1920 and covered a wide range of subjects such as genre, landscape, marine painting and portraits. The sheer range, richness and diversity of these Irish Victorian painters, whether working in oil or watercolour, was quite amazing. The patronage of those whom Disraeli described as 'the lords of the suburban villas' was beginning to make itself felt, so that the demand for works of high quality was constantly increasing. Added to this, education was becoming more widespread. The discipline of learning to paint became fashionable with gifted (and not so gifted) amateurs, who tried their hands in large numbers.

The great surge in marine painting (to which the RHA catalogues testify) occurred during this period, and had its roots in Dutch marine painting of the seventeenth century. The Dutch methods of composition and understanding of the sea and sky in all its moods had influenced many Irish and English artists over the course of the previous centuries. Works by such Dutch émigré painters as William van de Velde the Younger (1653–1707) began to find their way into English and Irish collections in the second half of the eighteenth century and became an example and inspiration for many artists.

During the nineteenth century the number of academy-trained professional marine painters increased enormously, as did that of amateurs of varying degrees of skill. The ship portrait was in fashion; the professional artist would offer sailors and owners, for a modest sum, an accurate portrayal of the vessel they loved.

Every branch of painting requires certain basic skills in composition, draughtsmanship or handling of the medium, but the marine artist also required an intimate and thorough knowledge of the sea. It is interesting to note that many marine painters spent a large proportion of their lives working and living on the water.

EDWIN HAYES, RHA, RI (1820–1904), possessed a profound knowledge of ships and seamanship, his experience being gained from sailing in Dublin Bay and around the coast of Ireland. Born in Bristol, the son of a hotelier, he arrived in Dublin at the age of thirteen and attended the Royal Dublin Society Schools. So strong was his love of the sea that it drove him to serve as a steward's boy on a ship bound for America. On his return he worked for ten years in Dublin, exhibiting at the RHA from 1842, then moving to London to become for a short period a pupil of William Telbin, NWS (1813–1873), the scene-painter, painting scenery at the Adelphi and elsewhere. He showed at the RHA for nearly fifty years, rarely missing an exhibition, and was elected a member in 1871. He also contributed works to the New Society of Painters in Watercolours. An intrepid traveller, he visited Spain, Italy and France, which helped to broaden his subject matter considerably. His work was described in the *Dublin University Magazine*,[2] in August 1874, as 'full of life, truth to nature and conscientiousness'. He painted in a traditional manner, with an accurate eye and love for detail, producing many extremely delicate and attractive works which have since become much sought after. Many of these qualities can be seen in watercolours such as *Six Vessels in Rough Seas* (illus. 139), in the collection of the National Maritime Museum, Greenwich, or *Towing a Vessel into Harbour*, in the Ulster Museum. His son Claude, a landscape painter, is discussed later.

The Marriage of Princess Aoife (Eva) and the Earl of Pembroke (Strongbow) .
Daniel Maclise (1806–1870) . (Detail of illus. 172)

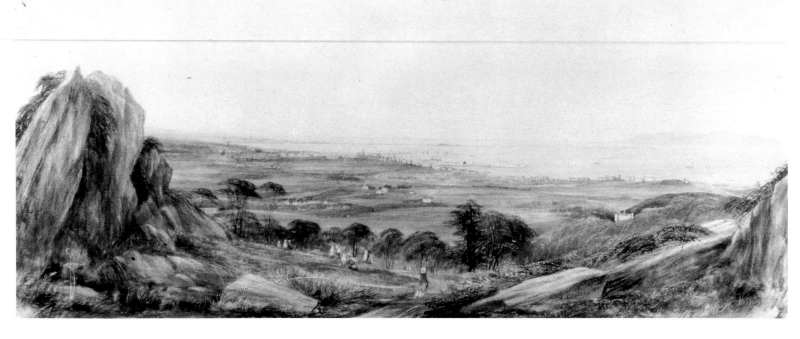

138] *View of Kingstown Harbour* (now Dun Laoghaire) *Co. Dublin*. Andrew Nicholl (1804–1866)

ADMIRAL RICHARD BRYDGES BEECHEY (1808–1895) a gifted painter of marine subjects, and GEORGE MOUNSEY WHEATLEY ATKINSON (*c.*1806–1884) together with his three sons, George, Richard and Robert, were all at some time in their careers marine painters but, unlike Hayes, they seem to have preferred to paint in oil rather than in watercolour.

ANDREW NICHOLL, RHA (1804–1866), has already been mentioned in Chapter IV and will be mentioned again in this chapter (see p. 153). An attractive aspect of his work may be seen in his watercolour seascapes, such as his *View of Kingstown Harbour* (illus. 138). It was painted from Killiney Hill, looking down on Kingstown,[3] with Dublin seen across the bay and Howth Head in the distance on the right. Other watercolours such as *The Long Bridge, Belfast* (illus. 141) or *Choppy Sea with Sailing Ships off a Harbour* indicate Nicholl's love and interest in subjects relating to the sea.

ROBERT LOWE STOPFORD (1813–1898) was born in Dublin and grew to maturity within the Victorian age. His marine work is a microcosm of the taste of the time, exemplified in his chalk and watercolour entitled *The Experimental Squadron in Cork Harbour 8th September, 1845, Cobh, Co. Cork* (illus. 140), or his attractive watercolour view of the *East Ferry, from Upper Agada, Cork Harbour* which shows a Lee paddle steamer and other shipping in the distance. From his earliest years he displayed a talent for drawing. Eventually he settled in

Cork where he 'enjoyed a considerable reputation as a painter of landscapes and marine subjects in watercolour'.[4] He also gave drawing lessons, at the same time exhibiting at the RHA. For many years he was art correspondent of the *Illustrated London News* and also contributed to the *Illustrated Times* in Ireland.

Like so many Irish marine painters, FREDERICK CALVERT (*fl.*1815–1844) was a native of Cork. He began exhibiting with the Dublin Society of Artists and Hibernian Society in 1815, moving to London shortly afterwards. During his years there he contributed antiquarian articles and illustrations to the *Archaelogical Journal*. His simple, straightforward approach to painting makes his watercolours immensely attractive, as can be seen from his *Ryde, Isle of Wight* (illus. 142).

The fluid technique called for by marine paintings shows particularly clearly the effect of an innovation in technique that had been made towards the end of the eighteenth century. Where earlier watercolours had essentially been tinted drawings, with thin washes of colour applied to an almost completely monochrome outline, now there was the pure watercolour, with colour applied boldly and directly to the paper over the lightest of preliminary sketches or none at all. Tonal variations could now be created in a wide variety of

139] OPPOSITE ABOVE *Six Vessels in Rough Seas*. Edwin Hayes (1820–1904) .
140] OPPOSITE BELOW *The Experimental Squadron in Cork Harbour, 8th September, 1845, Cobh, Co. Cork*. Robert Lowe Stopford (1813–1898) .

R: L: Stopford.
20. Great Georges St.

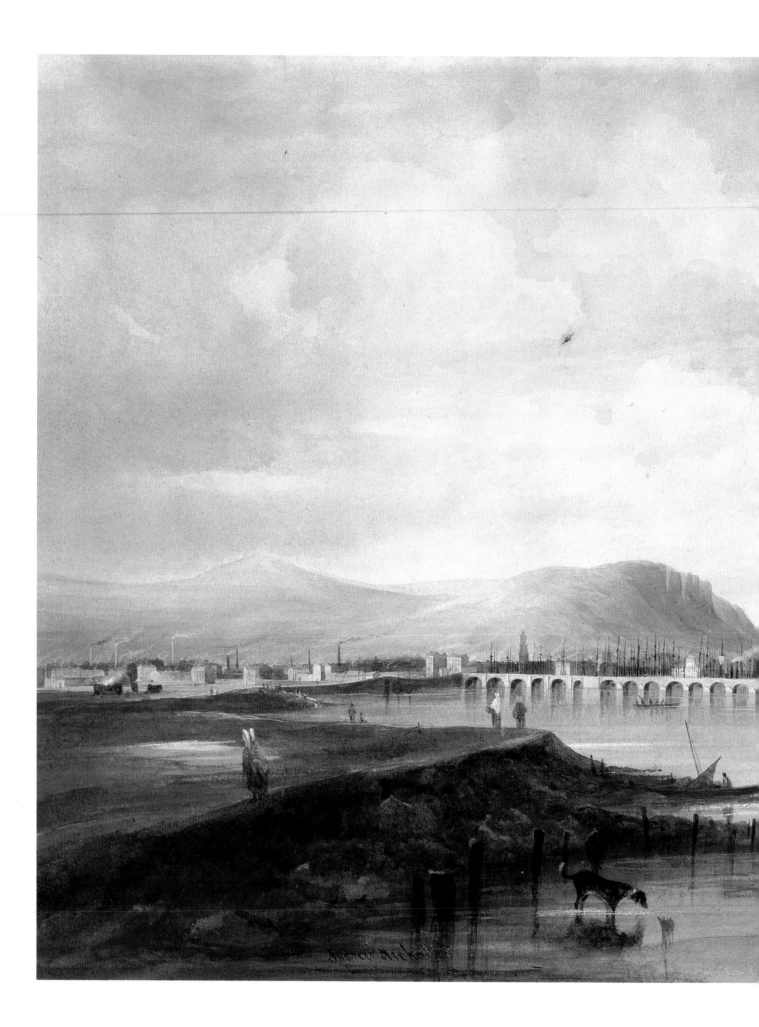

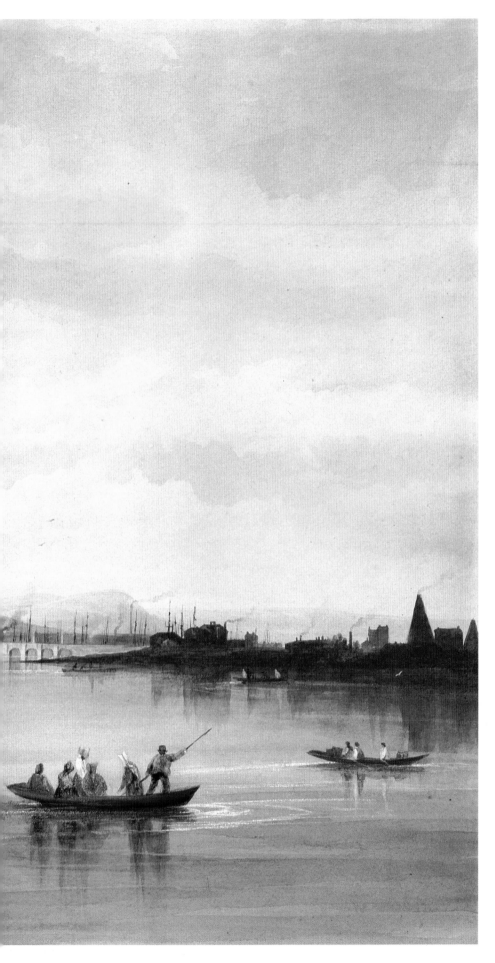

ways, the great English watercolour painter, J. M. W. Turner (1775–1851) being one of the most imaginative exponents of the new method.

The subject matter of the Victorian marine artist was also wider and more varied than that of his predecessors. Artists found picturesque qualities in estuaries, harbours and groups of fishing boats, not always relying on the traditional storms and shipwrecks which had been so much the stock-in-trade of marine artists of the seventeenth and eighteenth centuries.

THOMAS CHARLES LEESON ROWBOTHAM, NWS (1823–1875), a Dublin painter who moved to England while still quite young, had an instinctive grasp of the essence of these tranquil estuary scenes. Painting in a manner similar to that of the well-known watercolourist Richard Parkes Bonnington (1802–1828), he communicates his technical mastery in such watercolours as *The Lake of Lugano* and *The Bay of Naples*, now in the Ulster Museum. Studying under his father T. L. S Rowbotham (1783–1853), also a landscape and marine artist, he succeeded him as drawing-master at the Royal Naval School, Greenwich. A prolific painter, he contributed over 450 watercolours to the Royal Institute of Painters in Watercolours and collaborated with his father on such works as *The Art of Landscape Painting in Watercolours*.[5] Towards the end of his life he concentrated on painting Italian lake views, although he is believed never to have visited that country. Ruskin, reviewing his work, remarked that he had the makings of a good painter in spite of his tendency towards 'artificialness'.[6]

Unlike Rowbotham, JAMES GLEN WILSON (1827–1863) had his roots in the North of Ireland, being born in Co. Down in 1827. Little is known about his early life, but he spent some time studying at the Belfast Government School of Design and is recorded as exhibiting at the RHA in 1850 and again in 1853, using a Belfast address. His watercolour *Herald and Torch, off a Rocky Coast* (in the Ulster Museum) dates from that year. In the winter of 1852 he joined an expedition to the South Seas as a draughtsman. The object of the journey was to survey and explore such areas as New Zealand, New South Wales and Fiji. Wilson made 150 paintings and watercolours of the birds, fish, landscapes, natives and 'manners and customs of the people', of which *Fijian and Tongese Canoes at Levuka, July 28th, 1855* (illus. 144) is but one exciting example. Many of his views are still shown on Admiralty Charts and used in Admiralty Sailing Directions. A watercolour entitled *Marine Surveying in the South Pacific* (illus. 143) shows how directly involved the artist was in the serious business of marine survey. After spending six years in the Navy, he decided to settle permanently in Australia and was appointed Surveyor by the New South Wales Department of Lands. He spent his last years in Molong, a town then in its infancy near Sydney. Unfortunately he died at the age of thirty-six.

Another marine painter who travelled as far as Wilson was WILLIAM ALEXANDER COULTER (1849–1936). Although born in Glengariff on the rugged north-east coast of Co. Antrim, where his father was a captain in the

141] *The Long Bridge, Belfast.*
Andrew Nicholl (1804–1866).

142] *Ryde, Isle of Wight.*
Frederick Calvert (*fl.* 1815–1844).

Coast Guard, he spent the main part of his working life painting in and around San Francisco Bay. Although largely a painter in oil, he did produce a considerable number of pen-and-ink sketches illustrating maritime news for the *San Francisco Call* during his ten years with

143] *Marine Surveying in the South Pacific.*
James Glen Wilson (1827–1863).

the paper. An ink-and-graphite drawing entitled *Glorious Home-Coming of the Santiago Squadron, August 20, 1898* (illus. 145) is an example. Coulter 'covered' the Spanish-American War from his drawing-board at the *Call*. Events were telegraphed to him and he used his considerable imaginative powers to provide the missing details.

Coulter had spent most of his life at sea until, as a young man of twenty, he arrived in San Francisco in 1869. The colour and excitement of the waterfront proved irresistible to him. He quickly found work as a sailmaker, painting and sketching in his free time. He first exhibited his work at the San Francisco Art

144] *Fijian and Tongese Canoes at Levuka, July 28, 1855.* James Glen Wilson (1827–1863).

Association's Sixth Exhibition in 1874. Two years later he started travelling and studying in Europe, visiting Antwerp, Brussels and Copenhagen. Returning to San Francisco, he began exhibiting once more in 1880, and two years later travelled to Hawaii, spending seven months there sketching and painting amongst the islands. In 1896 he joined the staff of the *San Francisco*

145] *Glorious Home-Coming of the Santiago Squadron, August 20, 1898.* William Alexander Coulter (1849–1936).

146] *Cliffs at the Base of Slievemore, Achill Island.*
John Faulkner (*c.* 1830–*c.* 1888) .

Call. His pen-and-ink drawings of vessels or maritime events reveal a high degree of accuracy and a love of detail, combined with a fine sense of draughtsmanship. A prolific artist, he spent the latter years of his life painting for his many one-man shows. He returned to Ireland with his wife Hariette in 1928, a journey that took them five weeks from the west coast of America to Belfast. Two years before he died he held an exhibition of seventy-five marine canvases.

Like a number of talented marine artists working in the nineteenth century, JOHN FAULKNER, RHA (*c.*1830–*c.*1888) had trained in the RDS Schools, but, according to Strickland, 'His life and habits were however irregular and in 1870 he left Dublin under circumstances which brought about his removal from membership of the Academy.'[7] In fact he left Dublin for America, later returning to London where he earned a living painting watercolours for dealers. In 1880 he returned to his native Dublin, where he exhibited at the RHA until 1887. A watercolour entitled *Cliffs at the Base of Slievemore, Achill Island* (illus. 146), dating from 1879 and now in the Whitworth Art Gallery, Manchester, shows Faulkner's capable handling of water and light. This also applies to his watercolour *Coastal Harvest Scene* which, in a quieter vein, shows his ability to inject an atmospheric quality into his watercolours.

Unlike so many of the Irish marine painters, ANTHONY CAREY STANNUS (*fl.*1862–1909) spent his student days neither in Cork nor Dublin, but in Belfast. Here he attended the Royal Belfast Academical Institution and the Belfast Government School of Design between 1850 and 1854 before going to the Training School of Masters in London. His watercolours, such as *Quiet Evening at Bangor* and *Beating into Port*, show that on the whole he tended to be a somewhat dull, pedestrian painter lacking in imagination and versatility. However, early watercolours such as his *Launch at the Queen's Island*, or *The Old Ballast Office, Belfast* (illus. 147), provide a fascinating insight into the early days of Belfast's shipbuilding industry. He was an honorary member of the Belfast Art Society and President of the Belfast Ramblers' Sketching Club. His work is also represented in the V&A, London.

JOSEPH WILLIAM CAREY (1859–1937) also loved to record the shipbuilding industry of his native Belfast, as his lively watercolour *Belfast Shipyard (Ritchies)*, dating from 1917, illustrates. Primarily a painter of landscapes in watercolour such as *Dundrum, Co. Down* in the Ulster Museum, Carey was largely self-taught. A member of the Belfast Ramblers' Sketching Club and an active member of the Belfast Art Society, he became an Academician of the Ulster Academy of Arts in 1930. Marine painting was an area in which he excelled. His marine watercolours such as *Sailing Vessels at Evening* and *Sailing Boat off a Rocky Coast* display a sound knowledge of ships and their rigging, combined with the painter's sensitivity for the moods and movements of sea and sky. He very rarely worked in oil.

The Victorian passion for the seaside with its bathing machines, promenades and pony and donkey rides is

147] *The Old Ballast Office, Belfast.*
Anthony Carey Stannus (*fl.* 1862–1909) .

marvellously captured by ERSKINE NICOL, ARA, RSA (1825–1904) in his large watercolour *The Seafront at Bray, Co. Wicklow* (illus. 148). Nicol's insight into everyday Irish life and character was frequently conveyed with a strong sense of humour. This is shown, for instance, in his *Paddy at Versailles* and *The 'Merican Difficulty* (illus. 149), two watercolours which are now in the Ulster Museum and both of a high standard. He was born in Leith, Scotland. Undeterred by his father's disapproval of his determination to become a painter, he began in 1838 at the Trustees' Academy, Leith, as a pupil of Sir William Allan (1782–1850) and Thomas Durcan (1807–1845), becoming a drawing-master in the High School, Leith, before he had finished his training.

No exact reason has been put forward as to why Nicol

148] *The Seafront at Bray, Co. Wicklow.*
Erskine Nicol (1825-1904) .

149] *The 'Merican Difficulty*.
Erskine Nicol (1825–1904).

150] *Relentless Time*. Louisa Anne Stuart
(Marchioness of Waterford; 1818–1891).

came to Dublin in 1846 – perhaps it gave him more opportunities for patronage – but he remained there for five years, recording some of the finest studies of the famine of the 1840s. Nicol never severed his links with Ireland but returned each year, despite the fact that he had settled permanently in London and was contributing annually to the RA. As a colourist he is of a high standard, the details of his genre scenes in watercolour always being very carefully worked out and finished, as seen in *A Card Party*. Much of his work was somewhat similar in style to that of his fellow Scotsman, Sir David Wilkie (1785–1841).

Nicol's *The Card Party* is a typical genre scene. In many cases such a scene relates a story. Genre painting was already a distinct category in the Netherlands in the seventeenth century; in the nineteenth century it again became very popular in several countries and a number of recurrent themes developed, one being that of childhood. Painters were frequently criticized for treating the subject in a somewhat sentimental, mawkish way, but in many cases they drew a compassionate response from the public, often arousing interest in the serious areas of child neglect and poverty which existed so widely at the time.

Dublin-born GEORGE BERNARD O'NEILL (1828–1917) was one of the most successful painters to deal with this theme sympathetically, as can be seen from his many genre scenes. A member of the 'Cranbrook Colony' of artists who, together with their relatives and close friends, had settled in and around the village of Cranbrook in Kent, O'Neill, like the other members of the group, did not share the intellectual aspirations of his contemporaries the Pre-Raphaelite Brotherhood, but rather pursued, with painters such as Thomas Webster, RA (1800–1866), an interest in scenes from rural life and

151] *My Mother's Coming of Age.*
Grace, Duchess of St Albans (1848–1926) .

childhood. A prolific and charming painter, he possessed a style close to that of Webster.

An attractive watercolour executed in 1840 by GRACE, DUCHESS OF ST ALBANS (1848–1926) depicts an outdoor genre scene which records the coming of age of the artist's mother, Catherine Isabella Osborne (1819–1880) (illus. 151). Grace was the daughter of Sir Thomas Osborne (1757–1821) of Newtown Anner, Clonmel, Co. Tipperary, MP for Carysfort and Sheriff of Waterford. Her mother encouraged her daughters to

draw and paint (the work of Grace's sister, Edith, later Lady Blake, is discussed in chapter IV) and invited artists such as English watercolourist, Thomas Shotter Boys, NWS (1803–1874) to stay. Her strong feeling for genre scenes reveals itself in her watercolours of local people at work. A competent and highly gifted artist who, perhaps because of her social commitments (she later married William, Duke of St Albans in 1874 becoming his second wife), could not devote herself wholeheartedly to her art.

Childhood was also one of the main themes preoccupying amateur lady artists of the Victorian era. One such was CHARLOTTE AUGUSTA, DUCHESS OF LEINSTER (1793–1859). Her album of drawings and

watercolours, now in a private collection, show her skill at transforming complicated arrangements of figures (in this case children) into convincing rhythmical compositions. The details are well-handled and very precisely executed. Third and youngest daughter of the 3rd Earl of Harrington, Lady Charlotte Stanhope married the 3rd Duke of Leinster in 1818. She entertained many artists and friends in their magnificent house, Carton, Co. Kildare. In the little shell cottage on the estate are two small stained-glass panels signed *C A Leinster pinx' 1834*, the drawings for which are believed to have been executed by the Duchess.

At Carton, she and her husband encouraged a wide circle of women artists which included her sister-in-law, ELIZABETH (née STILL) COUNTESS OF HARRINGTON (*c.*1819–1912). The latter spent much of her time recording in watercolour the activities of her many children, the garden and places where she lived and visited. The HON. FRANCES CHARLOTTE DE ROS (d.1851) was also a frequent visitor to Carton. Daughter of William, 23rd Baron de Ros, of Oldcourt, Strangford, Co. Down, her watercolour of *Jane Repton at a writing table* came from an album of drawings and watercolours which belonged to Charlotte, Duchess of Leinster.

Another amateur lady artist was LOUISA ANNE STUART (1818–1891),[8] later to become the Marchioness of Waterford. She was an outstandingly beautiful girl. Ruskin, seeing her work, remarked, 'She undoubtedly would have been a great painter were she not such a stunner!' Her early life was spent in France and England until, in 1839, she married the dashing young Marquis of Waterford and came to live at his house at Curraghmore, Co. Waterford. Deeply shocked by the appalling poverty in the nearby village, she set about introducing schemes for improvement while sketching the villagers indefatigably. After the death of her young husband in a hunting accident she went to live at Ford Castle, Northumberland, a somewhat grim northern fortress bequeathed to her by her mother. Eminent Victorians such as Ruskin and Rossetti encouraged her work despite the fact that she had never received any formal training. Her watercolours are full of brillliance and warmth, as seen in *The Forge* and *Relentless Time* (illus. 150). Fortunate to enjoy patronage at a high level, Lady Waterford was at the time of her death one of the best-known amateur watercolourists of her day.

In the early years of the nineteenth century painting concerned with literary subjects also provided many narrative watercolour painters with lucrative themes. Popular authors for pictorial treatment included such literary giants as Shakespeare, Goldsmith, Dickens and Scott. *Quentin Durward Meets Isabella de Croye*, which is in the NGI, is a scene taken from Scott's novel and was painted in watercolour by illustrator and artist JAMES MAHONEY, ARHA, NWS (*c.*1810–1879). It is a good example of the Victorian painter's manner with literary subjects.

Mahoney was born in Cork, the son of a carpenter, and left his native city to study at Rennes, travelling widely on the Continent before returning to live in his father's house at 24 Nile Street (now Sheares Street), Cork. In 1843 he began exhibiting at the RHA watercolour views of his wanderings through Paris, Rome,

Venice and Rouen. In 1846 he left Ireland to spend five years abroad, chiefly in Spain. His name appears again as an exhibitor in the RHA catalogue of 1856, when he was made an Associate. Three years later he severed his links with Ireland and settled in London, finding employment as a draughtsman on the *Illustrated London News*. He soon became one of the leading draughtsmen in the publishing world. Hardie[9] described Mahoney's illustrations and his work for other periodicals such as the *Sunday Magazine* (1866) as being that of 'a very capable craftsman with a sure command of his medium'. His most important work was his series of illustrations for the 'Household Edition' of Charles Dickens's novels *Oliver Twist*, *Little Dorrit* and *Our Mutual Friend*. The National Gallery of Ireland possesses no fewer than twenty-six of his watercolour landscapes and drawings. They include *Queen Victoria and Prince Albert Opening the 1853 Dublin Great Exhibition* (illus. 152), which forms part of the Taylor Collection bequeathed in 1855.

Italy had exerted a strong influence on foreign artists through the centuries, and the nineteenth was to be no exception. A recurrent theme running through Victorian genre was the 'Vision of Italy', a wide variety of this country's themes offering painters a fruitful field from which to draw their ideas.

ALFRED ELMORE, RA (1815–1881), the son of a retired army surgeon, was born in Clonakilty, Co. Cork. A contemporary assessment of him is that he 'follows no beaten track; thinks for himself and works out his ideas in a spirit of independence affording us great pleasure in the novelty of the subject he places before us, as by the skilful and effective manner in which they are treated'.[10] In the summer of 1840 Elmore set out for Rome, visiting the galleries of Dresden and Munich along the way. After spending two years studying the works of such painters as Tintoretto, Titian and Veronese, all of whose work helped to shape and enhance his considerable sense of rhythmical design and strong feeling for richness of colour, he returned to London, exhibiting many of his Italian works at the RA. He became an ARA in 1857, and an Honorary RHA in 1878. Primarily looked upon as an historical painter, he was also regarded by many as being a superb watercolourist. Martin Hardie went so far as to compare his work with that of Delacroix as well as that of the leading watercolourist Richard Parkes Bonington (1801–1828), the latter's influence frequently being found in the treatment of Elmore's figures. This can clearly be seen in Elmore's *Two Women on a Balcony* (illus. 153) which is strikingly similar to R. P. Bonnington's figure style. William Sandby,[11] in a tribute to Elmore, wrote: 'He groups his figures with ease and grace. Draws with great correctness and force and colours richly.'

Animal genre was another popular theme with the Victorians. Sir Edwin Landseer's sentimental renderings of shaggy dogs with wet noses are well known, a Victorian critic writing: 'The pathos of these poor creatures is that they are entirely doggy ... the dog losing his master loses his all.'

Birds, rather than dogs, were the main fascination of Cork-born painter RICHARD DUNSCOMBE PARKER (*c.*1805–1881), an Anglo-Irish farmer who lived at Landscape House, Sunday's Well, Cork. William Thompson, the eminent naturalist and author of the

152] *Queen Victoria and Prince Albert Opening the 1835 Dublin Great Exhibition.* James Mahoney (*c.* 1810–1879) .

153| *Two Women on a Balcony.*
Alfred Elmore (1815–1881).

Natural History of Ireland remarked: 'His splendid collection of coloured drawings of native birds, mostly life-size and all executed by himself, attracted great admiration in the National History Section of the British Association at Cork, in 1843.'[12] Influenced by the engravings of birds in the books of Thomas Bewick

(1753–1828) and John Gould (1804–1881), and by the vast colour plates of the famous ornithological artist John James Audubon (1780–1851), Parker produced, between 1833 and 1868, 170 large watercolour paintings of nearly 260 Irish birds. As well as being a keen ornithologist and sportsman, he corresponded with many leading naturalists of the day, including William Thompson. Thompson obviously had a high opinion of Parker's work, placing it on an equal footing with Audubon's *Birds of America* (1827–38).

Parker never married, and so on his death his huge book of bird paintings in watercolour was left to his niece, Miss Eleanor Parker of Carrigrohane Lodge, Cork, who died in 1932. She in turn bequeathed her uncle's work to the Belfast (now Ulster) Museum. There the collection lay almost undisturbed until 1976. Protected from the light for over a century, the watercolours were found to be in first-class condition and were placed on view to the public in a major exhibition at the Ulster Museum in 1980.

Parker's approach to the depiction of birds was to paint each bird and then to add the landscape. While he had obviously studied each bird's habitat in great detail, the birds in many instances seem to perch unconvincingly in their surroundings; their feet quite frequently do not grip the branch, as seen in his somewhat comical portrait of the *Great Grey Shrike with a fieldmouse*. It is more than likely that Parker, as was the custom at the time, painted from skins or mounts, the standard of taxidermy occasionally being somewhat doubtful. His work in painting large birds, such as the herons and eagles, is strikingly good, decorative and highly successful. However, when working on a smaller scale his harsh vignetting convention is not so convincing.

Animal painter MICHAEL ANGELO HAYES, RHA, ANWS (1820–1877), demonstrated his interest in horses in a paper read at the RDS in November 1876, entitled 'Animals in Rapid Motion'. Throughout his life Hayes specialized in painting these beautiful creatures. He was also capable of tackling military subjects, as in his large watercolour *16th Queen's Lancers breaking the Square at the Battle of Aliwal in the Sikh Mutiny, India, 26th January, 1846*. Indeed, he was appointed Military Painter-in-Ordinary to the Lord Lieutenant in 1842. The first and only time he exhibited at the RA in London was in 1848, and in the same year he was made an Associate of the new Society of Painters in Watercolours. After he had been elected RHA in 1854 (he became Secretary two years later) he set about reforming the Academy, refusing to recognize George Petrie (see p. 43) as a member on the grounds that he had contravened the regulations by not exhibiting for two years. This, however, resulted in Hayes himself being replaced as Secretary by BERNARD MULRENIN, RHA (1803–1868). However, Hayes refused to hand over the keys and books and was expelled the following year. It was not until the RHA received a new charter in 1860 that he was reinstated and the following year was re-elected Secretary, a post he held until his resignation in 1870. Trained by his father Edward Hayes, RHA (1797–1864), himself a painter who had taught drawing at Clonmel, Kilkenny, and Waterford, Michael Angelo is perhaps best remembered today for his four famous engravings of *Bianconi's Famous Cars*.

The choice of themes such as age, youth and young love preoccupied WILLIAM MULREADY, RA (1786–1863) throughout his long and successful career. He was born in Ennis, Co. Clare, the son of a leather-breeches maker. Soon after his birth the family moved to London. Mulready started drawing at the tender age of three. His first formal art training began in 1799 under the well-known sculptor, Thomas Banks, RA (1735–1805). The following year he entered the RA Schools to study with Johann Heinrich Fuseli (1741–1825). By the time he was eighteen he was already contributing to the annual RA Exhibitions. Although he was primarily a painter in oil, Mulready's early water-colours, largely of landscape or topographical views, reveal the influence of watercolourist John Varley, OWS (1778–1842), whose sister he was later to marry. This marriage was to fail tragically.

154] *Charles Brindley Riding to Hounds.*
Michael Angelo Hayes (1820–1877) .

By the middle of the nineteenth century genre was flourishing, the painter Sir David Wilkie (1785–1841) stating in his *Remarks on Painting* that 'the taste for art in our time is of a domestic rather than an historical character'. Potential Victorian purchasers were not too fussy about size, but subject did matter. Writing to Mulready, a collector stresses that he 'should like something humorous, an outdoor scene I would prefer, I will not dictate the size that is to rest with yourself and if I like the subject, I will go 100 gns but not more'.

Mulready's genre works are simple, straightforward episodes taken from everyday life, such as his pencil-and-red-chalk study (illus. 157) for his famous painting *The Sonnet* (1838). This finished study is in the NGI collections and was a cartoon for his oil of the same title which is in the V&A, London. It was painted for his benefactor and patron John Sheepshanks, and became one of his most successful and influential works. An art critic writing in the *Athenaeum*[13] commented: 'Mr Mulready proved yet again that he could invest a subject drawn from scenes of humble life with the attributes of

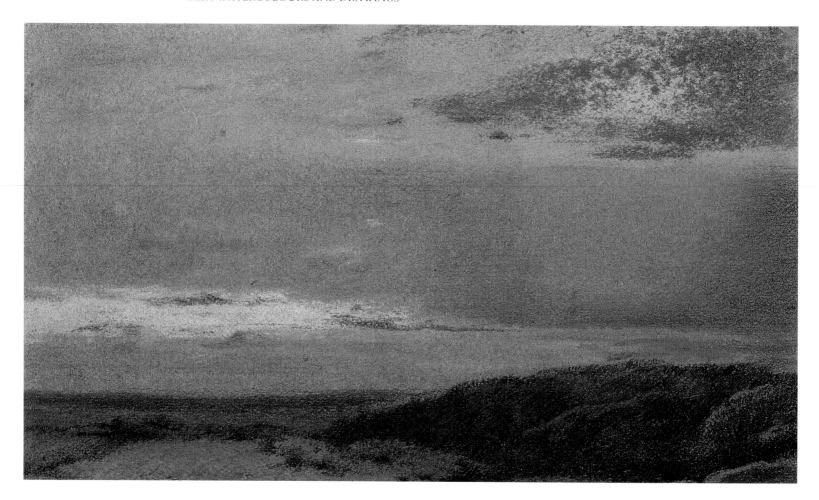

155] *Moor at Sunrise*.
William Mulready (1786–1863) .

the highest walks of his art – A Poetic spirit breathes through his presentment of first love.' His exquisite study in pen and brush in brown ink of a young girl falling asleep over her lessons (illus. 159) again highlights this, and also demonstrates his superb powers of draughtsmanship. His delicate portrait in watercolour of *Miss Elizabeth Swinburne* shows the painter's ability to excel in the informal type of child portrait.

Mulready was a consistent contributor at the RA for over fifty years, always showing high standards of discipline and perfectionism. As a person he seems to have commanded much admiration and respect on both a social and a professional level. In all aspects of his work – which included book illustrations, nature and history studies, academic studies of nudes and portraits – and indeed in his social life, Mulready seems to have been consistent, cautious and conscientious. It therefore comes as something of a surprise to find his practices and principles being used by revolutionaries such as the Pre-Raphaelite Brotherhood. His oil painting *The Sonnet* shows his reliance on contemporary subject matter and his love of minute detail. The use of bright colour painted on a white ground gives a brilliance of tone to his reds, greens and blues. The knowledge gained from his teaching sessions at the RA warmly endeared him to the movement which was to come into existence ten years after this work was painted.

The Pre-Raphaelite emphasis on 'studying nature' was not new. Mulready himself underlines the importance of it in a sketch book (now in the V&A, London) where he remarks: 'Never dispute about principles of art and the laws of nature – try them in your works – watch them in art and nature. The things most praised that have stood the test of ages are overrated, and a sound code of laws cannot, in a direct manner, be deduced from them.' His 'truth to nature' meant a detailed study of every blade of grass and leaf which, when interpreted by members of the Pre-Raphaelite Brotherhood, often resulted in absurd extremes.

Mulready died a much-loved man in 1863, having lived through the Pre-Raphaelite movement, although he seems to have remained remarkably uninfluenced by its innovations.

What were these innovations? In technical terms they were a love of detail the use of bright pure colours, and working over a white ground. Coupled with this technique was a determination to record each fact (sometimes with startling honesty), as may be seen in the works of such celebrated supporters as Sir John Everett Millais and Dante Gabriel Rossetti. Although members of the movement probably thought of themselves as being primarily painters in oil, much of their expressive painting was executed through the medium of watercolour. The movement itself was short-lived. It was

156] *Bathers Surprised*.
William Mulready (1786–1863) .

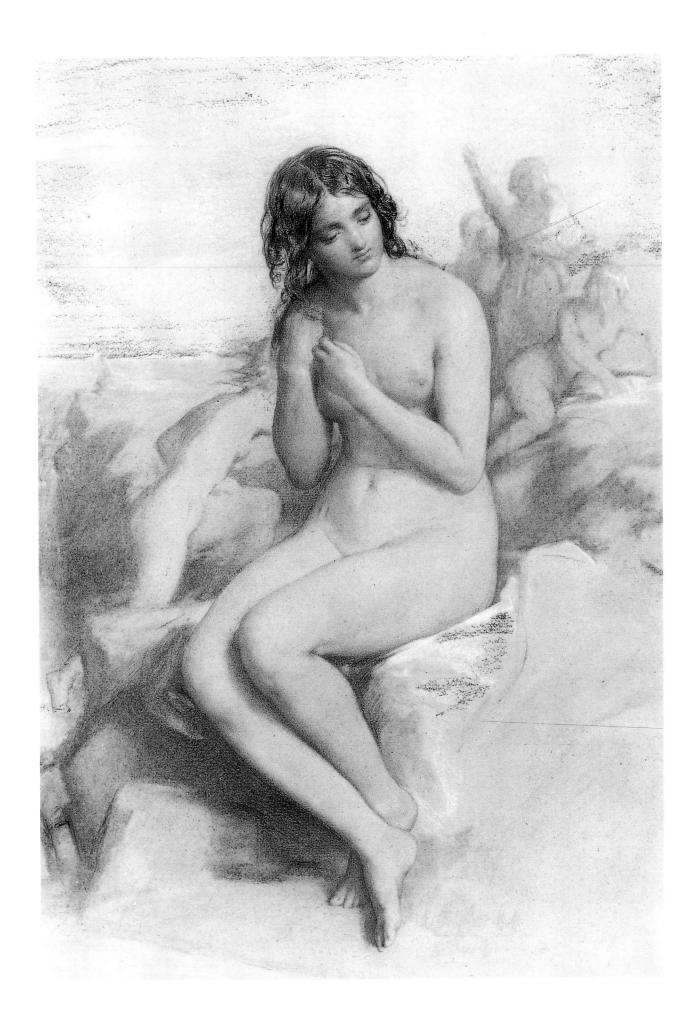

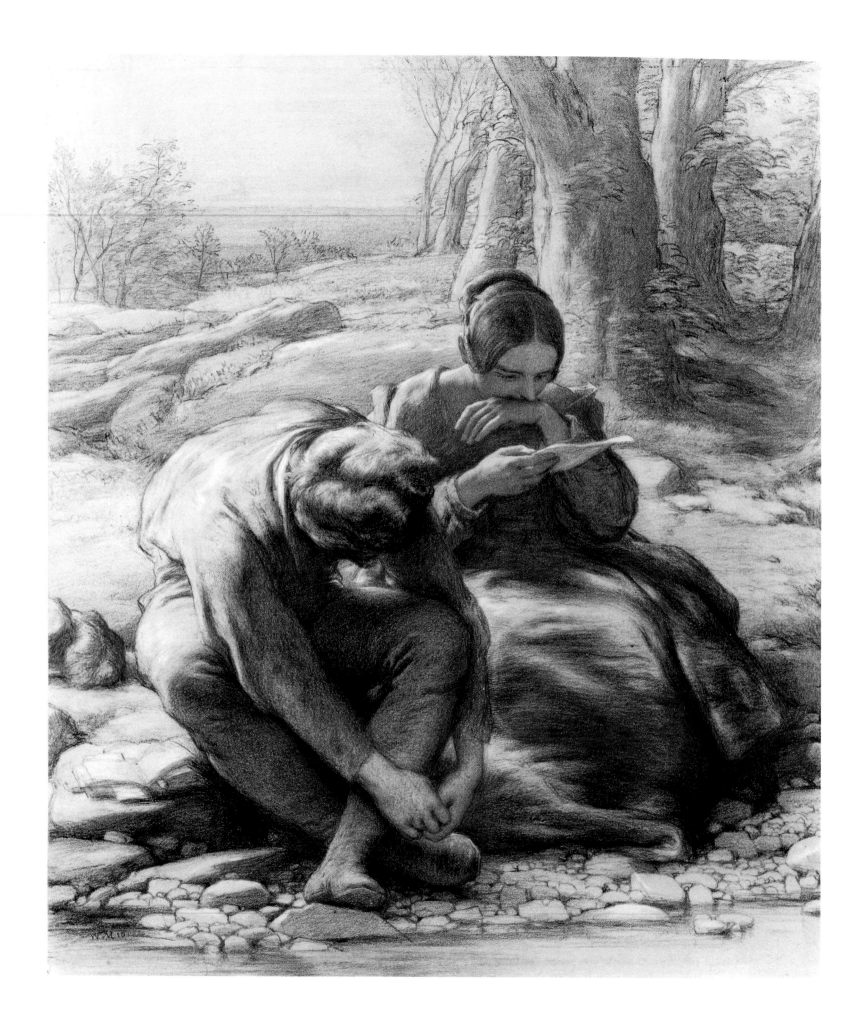

founded in the winter of 1848, and the first works were exhibited a year later. After Millais agreed to become an Associate of the RA in 1856 several members, including Rossetti, regarded his acceptance as the end of the secret Brotherhood, and many of its members went their separate ways.

Why was the name 'Pre-Raphaelite Brotherhood' chosen? Although none of the members had actually visited Italy, the name was decided upon because it reflected their respect, love and admiration for Italian painters before the sixteenth century, whose honesty and simplicity they themselves wanted to emulate. They were also determined to revolt against the traditional, conservative attitudes which prevailed in such bastions of the establishment as the RA, and in particular in the work of one of its most distinguished past members, Sir Joshua Reynolds, who was scathingly referred to by the Brothers as 'Sir Sloshua'. However, when it came to Ireland, the movement's influence was to be very slight indeed.

One of its best known exponents was Irish-born WILLIAM DAVIS (1821–1873), later to be known as 'Davis of Liverpool'. He was born in Dublin, son of a solicitor. Davis embarked on a law career, but soon abandoned it in favour of becoming a pupil at the Dublin Society Schools. After a short and unsuccessful period practising as a portrait painter in Dublin – Davis seems always to have experienced difficulty as a figure draughtsman – he set out for Liverpool, which at that time had one of the largest concentrations of Pre-

158] *The Penny Postage Envelope*. William Mulready (1786–1863) .

157] OPPOSITE *The Sonnet*; a cartoon for the oil in the V & A, London. William Mulready (1786–1863) .

159] *Girl dozing over her lessons*. William Mulready (1786–1863) .

Raphaelite painters in England. By 1856 he had risen to the rank of Professor of Drawing at the Liverpool Academy and, encouraged by his friend the artist Robert Tonge (1823–1856), he specialized in landscapes: beautifully-observed scenes full of vigorous colours and clear detail, and containing the subtlest effects of light and shade. A fine example entitled *Ploughing* (illus. 161), is in the Walker Art Gallery, Liverpool. His work was admired by Pre-Raphaelites such as Rossetti and Ford Madox Brown. In fact Rossetti was so impressed by Davis's work that he brought it to the attention of Ruskin, who later wrote a letter of advice to the young artist: 'Your work . . . cannot become popular unless you choose subjects of greater interest. . . . It seems to me that you might have sought over most landscapes for miles together, and not stumbled over anything so little rewarding your pains and skill as that 'ditch and wheatfield'.'[14] Davis never received the letter. This preference for the commonplace in landscape, rather than the picturesque or sublime was, as Ruskin inferred, a significant factor in setting the conventional body of the RA against his work, thus debarring Davis from greater public recognition.

Characteristic of this Irish painter's work was his joy and love of nature as he found it, together with a determination not to rearrange the natural details of the scene before him – which almost all artists of the time found it necessary to do. Small details filled him with curiosity. A story told of Davis by a Pre-Raphaelite member relates how, having placed the painter in front of an enchanting view, his companion returned and found the artist with his back to the scene happily sketching instead the brick opening of a drain. Very much part of the Pre-Raphaelite scene in both Liverpool and London, Davis was one of a few members of the Liverpool Academy who had the distinction of being asked to join the Old Hogarth Club, which had been founded in the 1850s to promote Pre-Raphaelite ideals and which included such distinguished members as the two Rossettis and Burne-Jones.

After the break-up of the Liverpool Academy, Davis settled in London in 1870, his style of painting landscapes becoming broader. He never lost his skill as a first-rate colourist and conveyer of poetic effect. His dissatisfaction with the hanging of one of his works submitted to the International Exhibition of 1873 brought on an attack of angina pectoris from which he was to die shortly afterwards. Such was his reputation in Liverpool that when an exhibition of forty-six of his works was held at the gallery in Old Post Office Place shortly after his death, all were sold without any difficulty, the proceeds going to help his widow and large family – two of whom, Joseph and Val, themselves became landscape painters.

One of the most interesting and best-known watercolourists working around this period was SIR FREDERIC WILLIAM BURTON, RHA, RWS, RSA

160] *In Joyce's Country, (Connemara, Co. Galway)*. Sir Frederic William Burton (1816–1900).

161] *Ploughing*. William Davis (1821–1873).

(1816–1900) whose work in miniature has already been mentioned in chapter 1. Although he could not be accounted solely a Pre-Raphaelite, many of his ideas were similar to those of his English counterparts. His love of brilliant colouring is beautifully conveyed in his well-known watercolour *Helelil and Hildebrand, or The Meeting on the Turret Stairs* (1864). The subject is taken from a Danish ballad.[15] George Eliot, a close friend and admirer of Burton's work, having seen this striking watercolour in the OWS exhibition of 1864 wrote to the artist: 'You must let me tell you something of the great happiness your great picture has given me this morning. . . . Only through a great deal of suffering could anyone have worked his way to such a height as you have gained in the picture.'

Throughout his long life, Burton, according to Strickland, 'confined himself solely to watercolour and to chalk, never exhibiting in oil'.[16] Indeed, it was said that the smell of oil paint offended him. He was born at Clifden House, Corofin, Co. Clare, the son of an amateur artist, and was sent to Dublin at an early age. Entering the Dublin Society Schools in 1826, he received his training from Henry Brocas (see p. 41) and Robert Lucius West. The latter, besides being a fine draughtsman, was also an enthusiastic art historian and encouraged his young students to pursue both the practical and the academic arts. This, together with Burton's lifelong friendship with archaeologist, painter and musician, George Petrie (see p. 43), encouraged his interest in Irish archaeological studies. Burton became a founding member of the Archaeological Society of Ireland and was elected Fellow of the Society of Archaeologists in 1863. Petrie did not, however, influence his technique, or style; as Strickland remarks, 'Even in his earlier drawings, Burton showed a perception and sense of colour much beyond Petrie's limited range.'[17] During the early part of his career Burton practised as a miniature painter, being much influenced by that accomplished miniaturist, songwriter, illustrator and novelist Samuel Lover (see p. 20).

Travelling in Ireland, particularly in the west and frequently in the company of Petrie, Burton recorded much of the landscape in watercolours such as *The Upper End of Lough Corrib, Co. Galway* and *In Joyce's Country (Connemara, Co. Galway)* (illus. 160). He also began to collect material for some of his well-known works such as *A Connaught Toilette* (1841)[18] and the watercolour *The Aran Fisherman's Drowned Child* (1841). He made many drawings for such compositions. Margaret Stokes, commenting on this, wrote there are 'at least fifty [she approximates] preparatory drawings in pen or pencil for the picture of the *Aran Fisherman's Drowned Child*, which show how the subject grew in the painter's brain till he found the true arrangement and grouping by which to concentrate all feeling on the parent's sorrow. . . .'[19]

Burton belonged to many societies including the Royal Irish Art Union, and was a member of the 'Irish Academy of Science, Antiquities and Belles Lettres'. He was also a member of the Zoological Society. Energetic and enthusiastic, he designed a seal for St Columba's College which was accepted; also the Grecian heads for the Bank of Ireland notes. Devoting a good deal of his time to portraiture, both in chalks and watercolours, he produced in the 1840s such delightful works as that of

the very beautiful *Helen Faucit as Antigone* (1849), a full-length study (Helen Faucit, 1817–1898, later became Lady Martin) and *Annie Callwell* (illus. 162), painted a year earlier, which shows a young girl seated on a bank in a sunny, woodland glade surrounded by tall trees and flowers. Attracted by early Celtic art, he showed this influence in a series of designs and sketches in ink and pencil for the Mace in the Royal College of Physicians, Ireland in 1850 (illus. 163).

Burton did not confine his many activities to Ireland, but made several visits in the 1840s to Germany and eventually decided to take up residence there in 1851. He had been invited by King Maximillian II of Bavaria to paint and copy works of art in the collection accumulated by Ludwig I. Originally, he had intended to stay for two years, but in fact he remained for seven. Energetic as ever, he spent a great deal of his time sketching and painting in watercolour: architectural studies, landscape and peasant life. His delicate and

charming watercolour-and-pencil study of a young *Bavarian Peasant Girl*, whose face catches the sunlight, possesses striking luminosity and sensitivity. Determined not to sever his links either with Ireland or England, he paid a number of visits to London, and in 1855 was made an Associate of the Old Watercolour Society; a year later he became a full member, contributing annually until 1870. In 1886 he was awarded an honorary membership.

In 1858 Burton left Bavaria to live permanently in London, where he was to spend the rest of his life. Setting up his studio, he produced refined and highly-coloured watercolours such as *The Child Miranda*, exhibited at the OWS exhibition in 1864, and *La Romania* dated 1871. A highly conscientious and diligent worker, he applied watercolour layer upon layer, slowly and painstakingly, which placed a considerable strain upon his eyesight. This had never been very strong, and the effort of painting became increasingly taxing. At the age of fifty-eight he was appointed Director of the National Gallery by Mr Gladstone. His new post offered him little or no time for his favourite pursuit: 'I hoped and had been assured by Boxall [his predecessor] I would have time to go on with painting, but I've never been able to touch a brush. . . .'[20]

Determined to improve the gallery's collection of Old Masters, he was able to make a considerable number of worthwhile acquisitions. Purchases included Leonardo's *Virgin of the Rocks*, the gallery's only Hals and its first Vermeer. In the words of Homan Potterton, former Director of the NGI, 'It is difficult to fault his judgement in the pictures that he bought for the Gallery; but apparently that judgement was not matched by an equally good sense when it came to price.'[21] On his retirement in 1894 he was knighted and returned to Ireland, settling in Kingstown on the outskirts of Dublin.

Landscape was, along with genre and marine painting, very much part of the Victorian watercolourist's

162] LEFT *Portrait of Annie Callwell (d. 1904)*. Sir Frederic William Burton (1816–1900).

163] A Design for the Crown of the Mace of the Royal College of Physicians of Ireland. Sir Frederic William Burton (1816–1900).

164] *Sheep on the Moor.*
Claude Hayes (1852–1922).

oeuvre, the sheer quantity produced in the nineteenth century being overwhelming. CLAUDE HAYES, RI, ROI (1852–1922), 'a supreme watercolour painter',[22] was the son of the well-known Irish marine painter Edwin Hayes (see p. 127), and was born in Dublin. Edwin Hayes was determined that his son should not follow him, but rather enter the world of business, something his offspring was equally determined he would not do. A clash of wills ensued and the young Claude ran away to sea, becoming involved in the Abyssinian expedition in the 1860s. Before returning to London he spent a winter in the United States, earning a living by selling his drawings. Back in England, he found his father somewhat more amenable to the idea that he might pursue a career in art, and so it was at the age of twenty-two that he finally entered the RA schools, completing the three-year course in 1876. He then continued his studies in Antwerp. Although watercolour had not officially been taught in the art schools, it soon became Hayes's favourite medium. He began to exhibit in watercolour at the Royal Institute of Painters in 1884, being elected a member two years later.

Some of his most successful scenes in watercolour, such as *Sheep on the Moor* (illus. 164), *An Estuary* and *Across the Common* show wide open spaces with large expanse of sky and distance making full use of the transparency of the medium, so that the white paper can reflect light through the washes. This accomplishes a purity and strength of tone not arrived at by any other means. Hayes's work was very much the envy of his contemporaries, two distinguished members of the Royal Society of Painters in Watercolour confessing their admiration of his sky technique, one of them remarking: 'He can produce amazing cloud effects with a mere turn of the brush, quite indescribable.' A successful and popular painter in his day, he was influenced by such landscape artists as his brother-in-law, W. C. Estall (1857–1897), and established water-colourists like David Cox, OWS (1783–1859) and Thomas Collier, RI (1840–1891), painting in their breezy, open-air style, but at the same time never imitating them. Towards the end of his life Hayes tended to turn out 'hasty and indifferent' work, largely owing to a shortage of money and failing health.

In the 1870s, an increasing number of Irish painters turned towards the Continent for their artistic training, with Paris, Antwerp, Brittany and Grez-sur-Loing becoming the artists' focal points. Artists such as Richard

Thomas Moynan, (1856–1906), Walter Osborne (see p. 159) and Rose Barton (see p. 155) were to become part of a large group of Irish men and women who were drawn to the Continent by such factors as the Taylor prizes set up in 1877, which gave them an opportunity to travel and study abroad. It is also probable that they were encouraged by such Irish-born landscape painters as NATHANIEL HONE THE YOUNGER (1831–1917) who spent seventeen years in France. Hone – a descendant of the painter Nathaniel Hone the Elder (see p. 15), who was a founder member of the RA in the eighteenth century – had begun his career not in the art world but in the field of engineering, having graduated from Trinity College, Dublin, in 1850 with a degree in Engineering and Science. He spent a period working on the Midland Great Western Railway, but his enthusiasm for yachting and country pursuits helped to develop his leanings towards achieving an art training. This was to last three or four years, towards the end of which he settled in the little village of Barbizon, just beyond Fontainebleau. Here he lived close to Millet and Rousseau and mingled frequently with other artists such as Corot and Harpignies. But with the exception of Thomas Couture (1815–1879), in whose atelier he worked in Paris, the influence of French painters on his work is believed to have been slight. George Moore, in an introductory note to a joint exhibition of the work of John Butler Yeats and Nathaniel Hone held in 1901 and entitled 'Modern Landscape Painters', noted that 'the influence of France is not apparent in his work'. However, on his return to Ireland in 1872, the painter's effect on young and aspiring painters through his teaching was to have far-reaching results, many artists in the 1870s looking to the Continent for their training.

Hone's watercolours, which were never signed, were mostly small in size and painted from a palette of not more than three or four tints, revealing a preference for

166] *The Last Ray of Evening, Shannon Bridge.* Henry Albert Hartland (1840–1893).

165] *Dinghies on a Normandy Beach.* Nathaniel Hone the Younger (1831–1917).

tonal values that were more characteristic of Ireland than France – or of Egypt, which he and his wife visited in 1892. Watercolours such as *The River Nile, Egypt, at Evening; Dinghies on a Normandy Beach* (illus. 165) and a *House and Salita near Nice, S. France* are comparable in tonal terms with Irish watercolours such as *Lismore Castle, Co. Waterford* or *A Road through the Woods at Malahide, Co. Dublin*. Hone also painted in Greece, Constantinople and Corfu and may even have visited Palestine.

In the view of Dr Thomas Bodkin, his biographer and friend 'the germ of all his pictures is to be found among

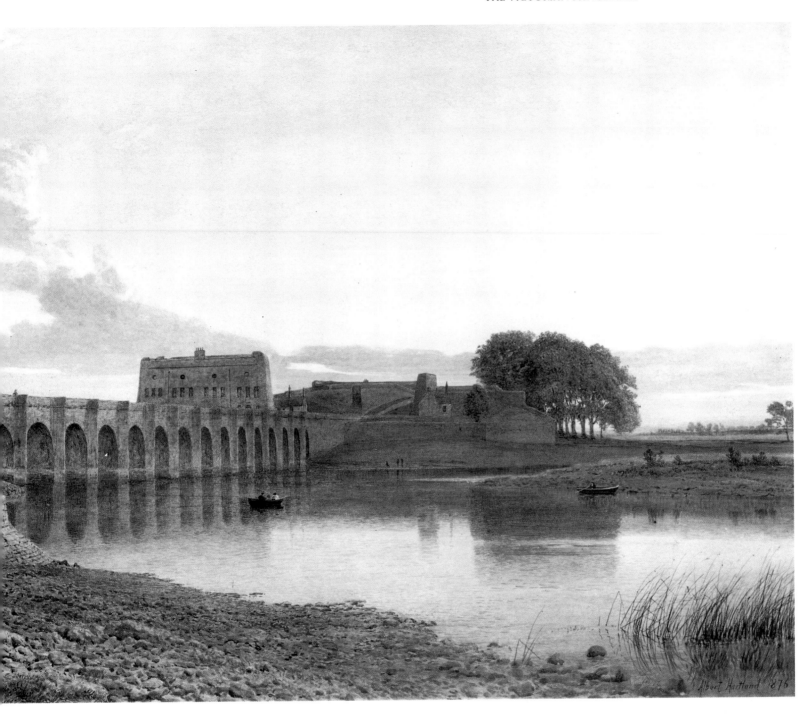

these sketches; they were the vital sparks that set on fire the memory and imagination which he brought to making his large oil paintings.'[23]

Dermod O'Brien, then President of the RHA, in a catalogue for an exhibition of Hone's watercolours which formed part of a bequest made by the artist's wife to the NGI and exhibited there in 1921, wrote:

The brilliant example of Hone's work in watercolours will come as a surprise to the public for I believe he never exhibited any work in that medium and himself looked on them as mere working notes. They raise the prestige of this great Irish landscape painter to a higher plain even than has been accorded to him hitherto and place him on a parity with De Wint, Cox, Cotman and the makers of watercolour painting.

Unlike Nathaniel Hone, HENRY ALBERT HARTLAND (1840–1893) never worked in France. He presents a charming, altogether conservative vision of the country-side in his *Country Lane* and *The Last Ray of Evening, Shannon Bridge* (illus. 166). The son of a landscape gardener, Hartland trained in the Cork School of Art, and was a scene-painter at the Cork Theatre and Theatre Royal before coming to Dublin, where he first exhibited at the RHA in 1865. He settled in Liverpool in 1870, where he was elected to the Liverpool Academy. His landscapes became highly popular and he remained in England for the rest of his life, with only occasional visits to his native country.

EDWARD LEAR (1812–1888) was, in Huon Mallalieu's opinion, 'saddened that his fame as a nonsense writer should overshadow what he considered his real achieve-

167] *Wicklow Head from Glen of the Downs, Co. Wicklow.*
Edward Lear (1812–1888) .

Glendalough was perfect. . . . The guide [Lear] was, however, sufficient to drive away all sentiment. He began by shouting Moore's poem on Glendalough at the top of his voice . . . and nearly broke my legs by trying to make them meet round a stone cross, which is necessary to secure a beautiful wife and a good fortune. . . . Ascending shoeless with Mr Lear along a narrow ledge, we were helped round the corner by an old woman surnamed Kathleen, who popped us into the hole [St Kevin's Bed] . . . saying all the time, 'Don't be fearful, my dear.'[25]

Lear's interest in landscape stemmed from the early 1830s, landscape executed in watercolour forming the backgrounds to his ornithological studies. Before coming to Ireland his style had been tight and concise with great attention to detail, very necessary for his ornithological work. However, in the little drawing, *Wicklow Head from Glen of the Downs* (1835) (illus. 167), Lear reveals an altogether different approach. The handling is quite free with use being made of dark, soft pencil lines heightened with white chalk.

Lear travelled extensively throughout his life, assembling a vast collection of drawings and watercolours and becoming a 'watercolour draughtsman in the school of Towne rather than a typical Victorian watercolour painter'.[26] At the time of his death in 1888 in San Remo, he had produced more than 10,000 sheets of sketches.

ments as an artist'.[24] Lear came to Ireland in 1835 in the company of the Bishop of Norwich, Edward Stanley and his son, Arthur Penrhyn Stanley, later to become Dean of Westminster, the latter giving an amusing account of their travels:

168] *A Waterfall in a Wood.*
Alfred Downing Fripp (1822–1895) .

169] *In the West 1914.*
William Percy French (1854–1920) .

The watercolours of ANDREW NICHOLL, RHA (1804–1866), have already been mentioned in connection with his portrayal of the plants of Ceylon and of marine subjects. Nicholl was also a landscape painter. He began his artistic career without any formal art training, being born in Belfast, the son of a boot and shoe maker. He was apprenticed to a painter, F. D. Finlay, who founded the *Northern Whig* in 1824, a paper on which Nicholl worked as a compositor for seven years. Encouraged by his elder brother, William – himself an amateur painter whose work may also be seen today in the Ulster Museum, Belfast – he embarked on a series of watercolours of the Antrim coast around 1828. His watercolours of *Ballygally Head, near Larne* and *Black Cave, near Larne* and his two views of *Carrickfergus Castle* all contain such features as colours laid on in flat washes over pencil outlines, which give his paintings a 'hard edge' effect; later he abandoned this method. But characteristic techniques such as the introduction of sgraffito (the scraping out of details in dark areas) were employed by Nicholl throughout his career.

Before leaving for London in 1830 he had already gained a good deal of local recognition with his Antrim views. In London he continued to teach himself, largely by copying pictures in such places as the Dulwich Picture Gallery.

After his return from London to Dublin in 1832 he began to contribute drawings to the *Dublin Penny Journal* and also to submit work for the first time to the RHA, becoming a full member by 1860. In 1840 he returned to London, exhibiting at the RA. Six years later he accepted the teaching post in Ceylon. He died in London.

Nicholl's well-known landscape watercolours, such as his attractive *View of Wild Flowers with the Mussenden Temple in the Background*, or *A Bank of Flowers, with a View of Bray and the Valley of the Dargle, Co. Wicklow*, show how far he had moved away from the hard-edge style seen in those early watercolour views of the Antrim coast. Here he places land and sea in the background, using instead the delicate and very beautiful wild flowers – daisies and poppies – in the foreground, all of which contributed to creating highly attractive, romantic and original compositions in watercolour.

Shortly after his death in May 1886, a large exhibition containing over 200 examples of his work was held at 55

170] *The Main Staircase at 80 St Stephen's Green, Dublin.*
Rose Maynard Barton (1856–1929) .

Donegall Place, Belfast, the object being to 'vindicate the reputation of the late Mr Nicholl as an artist of no mean order'.

A less well-known watercolourist than Andrew Nicholl was MARY HERBERT (1817–1893). Her depiction in watercolour of *The lakes of Killarney from the slopes of Mangerton* displays a confident style despite her lack of formal art training. Born at Whittinghame, East Lothian, Scotland, the second daughter of James Balfour of Whittinghame and Lady Eleanor Maitland, daughter of the 8th Earl of Lauderdale, she married Henry Arthur Herbert of Muckross House, Killarney, Co. Kerry in 1837. From 1857 to 1858 he was Chief Secretary for Ireland. Examples of his wife's work may be seen at Muckross House and in the National

Library of Ireland.

A frequent visitor to Ireland in the 1840s was ALFRED DOWNING FRIPP, RWS (1822–1895), grandson of the well-known English watercolourist Nicholas Pocock, OWS (1740–1821). Fripp recaptures the intrinsic beauty of the Irish countryside in his watercolour *A Waterfall in a Wood* (illus. 168), as well as in the three architectural scenes executed at Clonmacnois which he showed at the OWS exhibition of 1851. These Irish scenes (with somewhat mawkish and sentimental titles such as *The Irish Mother*, or *The Fisherman's Departure*) figured prominently in Fripp's work.

Born in Bristol, he entered the RA and spent a good deal of his spare time studying in the British Museum's Sculpture Galleries. He was elected a full member of the OWS in 1846 and appointed Secretary in 1870, a position he held for the rest of his life. After the death of his first wife in 1850 he travelled to Rome and remained in Italy until 1858, painting in Naples, Capri and Venice

before finally returning to live in England. A good colourist, and a subtle chiaroscurist, Fripp – together with his brother, George A. Fripp, RWS (1813–1896) – drew 'Abundant praises from Artists of all sorts'.[27]

WILLIAM CRAIG (1829–1875) was born in Dublin, entering the Royal Dublin Society Schools in 1847 and exhibiting at the RHA in the same year. He was a founder member of the American Society of Water-colour Painters. Towards the end of his career, his work began to deteriorate as he began to concentrate on producing work for the salesrooms. He was drowned on 20 August 1875.

I was born a boy and have remained one ever since. Friends and relatives often urge me to grow up and take an interest in politics, whiskey, race meetings, foreign securities, poor rates, options and other things that men talk about, but no – I am still the small boy messing around with a paint-box, or amusing myself with pencil and paper while fogies of forty determine the Kaiser's next move.

WILLIAM PERCY FRENCH (1854–1920), who spoke these words, was a talented watercolourist fortunate to possess a cheerful disposition, which was displayed in his humorous penny weekly, *The Jarvey*. Extraordinarily versatile, he excelled not only as a painter, specializing largely in landscape watercolours, but also as a conver-sationalist, musician, actor and storyteller.

He grew up in Cloonyquin, Co. Roscommon, from whence his father, detecting his young son's obvious intelligence, sent him to Trinity College, Dublin, to follow a course in engineering. The young Percy summed up his experiences of university life thus: 'I think taking the banjo, lawn tennis and watercolour painting instead of chemistry, geology and theory of strains must have retarded my progress a great deal. But eventually I was allowed to take out my CE. They were obviously afraid that if I stayed at Trinity much longer, I might apply for a pension.' He was a gifted artist; his watercolours such as *In the West, 1914* (illus. 169) and *Purple Twilight* are laden with atmosphere. He very rarely introduces figures into his landscapes.

From the mid-1860s on, the Impressionists began to have an effect. One painter influenced by them was ROSE MAYNARD BARTON, RWS (1856–1929), who tended to concentrate on watercolour townscapes (see front jacket) which are extremely appealing. The second of two daughters of solicitor Augustine Barton of Rochestown, Co. Tipperary, and Elizabeth Riall, she was strictly brought up by her parents, being educated privately at home by a German governess who instructed the girls in drawing and music. Rose, we are told by her nephew, Raymond F. Brooke,[28] became a skilled horsewoman and also loved betting. In the Royal Watercolour Society's Members' Book is an entry in longhand which records the fact that on the day of her death she backed two winners. She and her sister were presented at Dublin Castle in 1872, Rose recording this prestigious annual event in her delightful watercolour *Going to the Levée, Dublin Castle*. Two years later her father died, and her mother and the two girls set out for Brussels where they spent most of the winter, Rose taking lessons in painting and drawing, and then travelling up the Rhine to

Switzerland. She also studied in France under Henri Gervex (1852–1929), and indeed it was in France that many of the characteristics such as the obvious influence of Impressionism, her liking for bright colours, the love of *plein-air* sketching and her skill at depicting the commonplace, everyday subject began to make them-selves felt in her work. These features were to remain with her for the greater part of her painting career.

Returning to Dublin, she entered into a hectic social life, going to dinner parties, dances and hunt balls, as recorded in such watercolours as *The Main Staircase at 80 St Stephen's Green, Dublin* (illus. 170). It was not until after an unhappy love affair that she finally decided to work professionally at her painting. She exhibited her

171] *Kensington Gardens.*
Rose Maynard Barton (1856–1929) .

172] *The Marriage of Princess Aoife (Eva) and the Earl of Pembroke (Strongbow)* . Daniel Maclise (1806–1870) .

work in Dublin for the first time in 1878 at the RHA, and two years later in London at the Society of Lady Artists and in the Dudley Gallery. Throughout the 1880s and 1890s she continued to exhibit her work in a number of London galleries, including the Japanese Gallery in New Bond Street and the Clifford Gallery, earning considerable sums of money from the sale of her attractive watercolours. She also exhibited regularly at the RA until 1889. A contributor to the OWS, she was elected an Associate in 1893. She also had the distinction of being the first woman member admitted to the RWS prior to 1911. Like her cousin Edith Somerville (see p. 120) she was also an illustrator. She contributed to *Picturesque Dublin, Old and New* by Frances A. Gerrard (the pseudonym of Geraldine Fitzgerald) and she also published her own *Familiar London* in 1904, which she both wrote and illustrated.

The latter part of her life was largely spent in London, sketching and painting continuously and contributing work to a number of exhibitions. She loved entertaining her Irish relatives when they came to stay: '. . . they can recall the kindly old lady, who entertained them in her untidy artist's flat, which they used to visit on their way back to school, having travelled over from

Ireland. . . .'[29] Rose Barton died in Knightsbridge, London, in October 1929.

In a watercolour such as *The Embankment* (1897) it is not too difficult to observe how closely Rose was influenced by artists such as Whistler. In fact she herself remarked that '. . . on one still November afternoon, when I went out for a stroll at dusk along the Chelsea Embankment . . . as I walked along I meditated on how truly Whistler had interpreted the scene. . . .'[30] A keen observer of the social scene too, she obviously enjoyed studying the citizens and the children of London, her pictures of children being particularly delightful as seen in *Kensington Gardens* (illus. 171).

In a Dublin watercolour such as *St Patrick's Close*, executed in 1885, it is clear how much her technique had progressed since her early French-influenced pictures. In the words of Rebecca Rowe,

There are two planes, the lower, darker marketplace and above it the brighter lit building with the steeple of the cathedral dominating the skyline. It is untypical of Rose to highlight the background of her work and darken the foreground, but in this watercolour the technique helps to evoke a squalid, marketplace atmosphere. . . . We have come to Rose's developed style; small generalised figures against large forbidding buildings, with the hint of a world beyond such as a street disappearing around the corner.[31]

A competent flower painter, as her attractive water-colour of *The Gardens at St Anne's, Clontarf* demonstrates, she also painted a number of topographical scenes.

Painting in a similar watercolour style to that of Rose Barton was LADY KATE DOBBIN (1868–*c*.1948). Her soft, loose, almost impressionistic style was immensely attractive and lent itself well to views of the City of Cork and surrounding countryside. She was born in Bristol, the daughter of a solicitor, and married Alfred Graham Dobbin, a Cork tobacco manufacturer. He became High Sheriff of the City of Cork in 1900. From 1894 until 1947 she exhibited regularly with the RHA.

A competent and highly professional watercolourist, HELEN O'HARA (1881–1919) was an active participant at the RHA, the RI and the Society of Women Artists between the years 1881 and 1908. Elected vice president of the Belfast Art Society in 1896, she became an honorary member in June 1904 along with Mildred Anne Butler, John Lavery and Frank Spenlove. Her work is represented in the Ulster Museum.

ROSALIE FRANKS (*fl*. *c*.1921–1929) was a consistent exhibitor at the Irish Water Colour Society from 1921. Painting in muted tones and using atmospheric washes, she reveals the influences of the Impressionists, and her style is not unlike that of Rose Barton. An enthusiastic traveller, she exhibited views in watercolour of Switzerland, Venice, Florence, France and England.

Sadly, when it came to portraiture, the Victorian era could not be said to boast a high level of artistic performance. The strong emphasis placed on the character of the sitter, which had so dominated the late eighteenth and early nineteenth century in the works of painters such as Sir Thomas Lawrence (1769–1830), began to diminish after his death. The introduction of the photograph in the 1840s meant that a likeness could now be achieved within a very short space of time. But despite this drawback, the period was extraordinarily rich from an iconographical standpoint. An intense curiosity about the past, coupled with the cult of hero-worship, began to show itself in the numerous images of famous faces, such as those of writers, poets, actors, philanthropists, explorers, travellers and clergymen, which now graced the walls of the Victorian drawing room. These replaced, to some degree, the usual pictures of the wealthy aristocrat and his noble, if often somewhat dull, family. In the case of the set-piece ceremonial portrait there was little scope for watercolour, but the portrait drawing, larger than miniature size and capturing the colour and character of the sitter, still retained its popularity, particularly in the second half of the nineteenth century.

This period saw many changes in Ireland. Dublin had ceased to enjoy its status as a capital second only to London, and a great deal of the social life which had tended to centre on the annual meeting of Parliament declined. After the temporary scare of the 1798 Rebellion Irish life had gradually become more settled, and increasing exchange between the two islands brought with it a greater awareness of what lay outside. Ireland in turn provided her neighbour with many of her leading figures, including the Duke of Wellington and Lady Conyngham. Leading Irish families, such as the Beresfords and Conynghams, frequently sat for such eminently successful English portrait painters as Lawrence.

DANIEL MACLISE, RA (1806–1870), was, as has already been outlined in chapter v, a gifted painter. His art was many-faceted, covering not only portraiture but book illustration, caricature, history and design. Charles Dickens described him as being a 'wayward fellow in his subjects, such a discursive devil and flies off at such odd tangents that I feel it difficult to convey any general notion of his purpose'.

It was in the year 1827 that Maclise moved permanently to London from Cork. During his early years in the English capital, he claimed to have drawn nearly 1,000 portraits. Although this is probably an exaggeration he did enjoy a comfortable position as a portraitist, being able to provide himself with enough money to finance his studies and eventually to become a subject painter. These early portraits were nearly all drawings

173] *Debut of Paganini*.
Daniel Maclise (1806–1870).

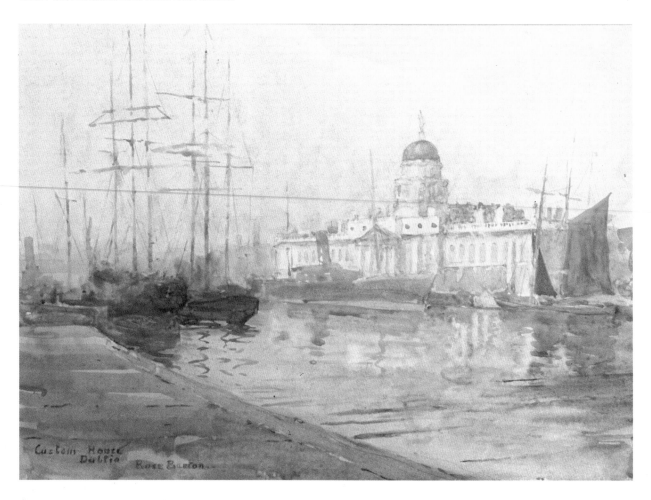

174] *The Customs House Before the Rebellion.*
Rose Maynard Barton (1856–1929) .

and show an elegant, incisive style, tightly drawn and usually on a vignette-like scale similar to the work of such artists as Ingres, or of English portrait draughtsmen such as Joseph W. Slater (d.1847). His powers as a portrait draughtsman reached a climax in the elegant and witty series of caricatures which he produced for *Fraser's magazine*; his picture of Carlyle has already been illustrated (see illus. 119).

Maclise's aptitude for accurate characterization is equally well demonstrated in his pencil portrait of Paganini (illus. 173), which shows the Italian virtuoso violinist making his appearance at the King's Theatre (known as the Opera House) in London on 3 June 1831. In the bottom right-hand corner the distinguished player is sketched in action, while the bottom left corner shows Paganini bowing to his rapturous audience.

A highly-accomplished watercolourist, Maclise was equally at home working on a large scale, as is illustrated in his vast family group portrait in watercolour depicting Sir Francis Sykes and his family. The medieval costumes and setting in this exhibition piece spring from the romantic neo-Gothic movement. The structure of the composition is somewhat unusual, with the spiral staircase providing an impressive setting for a family portrait full of vitality and originality. Maclise had been introduced to the Sykes family by his friend Benjamin Disraeli, who was enjoying a liaison with the somewhat

flighty and tempestuous Henrietta (depicted here with her long-suffering husband and their four children). Replacing Disraeli as her lover, Maclise was discovered in compromising circumstances by her husband, who set out to divorce her. The proceedings were finally dropped, but not before the affair had received much publicity, leading Queen Victoria to write amusingly in her diary: 'Talked of Maclise having run away with Lady Sykes . . . Lord M[elbourne] said 'They're a bad set; they're grand-daughters of Elmore, the horse-dealer . . . (he) trafficked with his daughters as much as he did with his horses.'[32]

Despite these amorous adventures Maclise remained a bachelor, being looked after towards the end of his life by his unmarried sister Isabella. After moving to London he very rarely visited his native country; nevertheless he remained deeply attached to it, as is revealed in his large watercolour *The Marriage of Princess Aoife and the Earl of Pembroke* (illus. 172), dated 1854. This extraordinarily complex group is a variant of the artist's large oil of the same title which today hangs in the National Gallery of Ireland. Although it is a fairly accurate recording of the larger picture the watercolour is simpler, lacking the grand, heroic quality which is so striking in the oil. Maclise's ability to capture an historic event in rich detail is well conveyed. He takes great care to see that all aspects of the architecture, metalwork, costumes and so on are entirely correct. The painter's interest in Irish antiquities is also apparent, demonstrated in such items as the richly-ornamented harp belonging to the bard, and the slab which is inscribed in Irish *orit do mac*. His ability

to portray such a vast gathering of figures while maintaining harmony and balance in his subject matter, composition and colour is all strikingly evident in this watercolour study.

Maclise was equally at home working on a small scale, as his sensitive watercolour of *Thomas Campbell* demonstrates. An admirer of the poet, Maclise contributed a caricature of him to *Fraser's Magazine* in 1830.[33]

In 1854 he began working on a commission for the huge murals in the rebuilt Palace of Westminster; these were to be the climax of his career. Rossetti, writing after their completion, said, 'He has produced a work which stands without competition in England and which no continental masterpiece could possibly put to shame.' But his health was beginning to fail and this, together with the death of his sister, forced him to withdraw from society. He declined both a knighthood and the post of President of the Royal Academy.

FRANCIS WILLIAM TOPHAM, OWS (1808–1877) first visited Ireland in 1843 in the company of the artist Frederick Goodall, RA (1822–1904), for a sketching tour in the west. Born in Leeds, he had begun his working life as an engraver, being apprenticed to his uncle. Around 1830 he moved to London, becoming an engraver of heraldic designs and an illustrator. After joining the Clipstone Street Society he decided to turn his hand entirely to painting in watercolour, and was elected NWS in 1843 and OWS in 1848.

Further visits to Ireland in 1860 and 1862 provided him with some of his favourite subject matter, country folk, as seen in his watercolour *Galway People* (illus. 177). A watercolourist who 'put on colour and took off colour, rubbed and scrubbed, sponged out, repainted, washed, plastered and spluttered his drawings about in a sort of frenzied way', Topham travelled and painted extensively during his lifetime. He died at Cordova, Spain in the winter of 1877.

A portrait painter who, despite belonging to a highly-artistic Dublin family, still managed to produce mediocre portraits was GEORGE FRANCIS MULVANY, RHA (1809–1869), son of Thomas James Mulvany, RHA (1779–1845) the Keeper of the RHA. George Mulvany's early training had included a trip to Italy in the mid-1820s. In 1835 he became a full Academician, succeeding his father as Keeper of the RHA in 1839. However, his major contribution was the role he played in the creation of the National Gallery of Ireland, which first opened its doors to the public in 1864, Mulvany becoming its first Director.

BEATRICE GUBBINS (1878–1944) was born at Dunkathel, Glanmire, not far from Cork City. Her diaries are still preserved at the house. The three volumes serve as a meticulous record of social life in Ireland during this period, and also detail her travels to such places as Italy, Corsica, North Africa and the West Indies. She received some of her early art training in Cork and was a member and honorary Secretary of the Queenstown Sketching Club at Cobh. Her portraits in watercolour include *Woman and Child in Cottage Interior* (illus. 176), *A Young Girl with a Red Bow* and *A Grey-Bearded Man*, all of which were shown in an exhibition of her works at the Crawford Municipal Art Gallery, Cork, in 1986.

WALTER FREDERICK OSBORNE, RHA (1859–1903), reveals his skill at handling watercolour in his delightful,

175] A cartoon for the '*Meeting of Wellington and Blucher 1858–9*'; a detail from the full-scale finished cartoon for the fresco in the Royal Gallery, Palace of Westminster, London. Daniel Maclise (1806–1870).

informal portrait of his four-year-old godchild *Aubrey Gwynn* in the NGI. In later life watercolour and pastel were to play an increasingly important part in this artist's work. His watercolour *The House Builders*, dating from 1902, provides a charming example.

Osborne's career had begun in Dublin, where he attended the RDS Schools, being awarded the Taylor Scholarship in April 1881. He set out for Antwerp that autumn, registering at the Académie Royale and enrolling in Charles Verlat's painting-from-life classes. His early work dating from this period is generally tightly and carefully painted with great attention being given to detail, as may be seen in such pencil sketches as *A Woman Sewing*, *a Seated Man and a Seated Child* and *Woman with a Basket* and *A Labourer*, three sketches dating from around 1882, which are now in the NGI. After completing his final year in Antwerp in 1883, he went to Brittany,[34] where he spent a year painting at Quimperle, Pont-Aven and Dinan. This part of France had

176] *Woman and Child in Cottage Interior.*
Beatrice Gubbins (1878–1944) .

177] BELOW *Galway People.*
Francis William Topham (1808–1877) .

become popular in the 1870s and 1880s with such painters as Bastien-Lepage and Stanhope Forbes, so it is more than likely that the young Osborne had an opportunity to meet them and to view their work. Certainly his own paintings show influences of these artists.

By 1884 he had left France for England to paint in small villages. He exhibited regularly in Dublin as well as at the Royal Birmingham Society of Artists and the New English Art Club, never losing touch with Dublin's art world. He became a member of the Dublin Sketching Club (founded in 1874) in 1884, and was elected a full member of the RHA in 1886. In England he began to introduce a new medium into his *oeuvre*, pastel, as seen in such works as *In a Berkshire Village* (1887), *Gossip* (exhibited in the RHA in 1888) and a portrait of his father, *William Osborne, RHA* (c.1888).

Returning to Ireland in 1891, he taught at the Academy Schools, and such was his influence as a teacher that he inspired one of his pupils, Beatrice Elvery (1883–1968), to travel on the top of a tram, so that she, like her beloved teacher, might catch pneumonia! Artist W. J. Leech was also a pupil, stating that Osborne taught him 'everything I needed to know'.[35] (Leech is discussed in chapter VII.)

During his career, Osborne executed a considerable number of preparatory sketches generally in pencil for a number of his oils, whether the subject was landscape, genre or portraiture. Jeanne Sheehy writes:

> In the autumn of 1892, after his sister's marriage, he began to work on Milking Time, one of the most important series of the later part of his career. The sketches are worth looking at in detail, as they give a very good idea of Osborne's method of work. The finished picture has an uncontrived, spontaneous look, and yet the amount of preparatory work put into it is in direct contradiction to this. To begin with, there are several pages of sketches in pencil, studies of cows being milked, a farm cart, and various details of the picture. Some of the sketches have colour notes – there are elaborate ones for the woman milking cows in the foreground: Old brown dress, blue apron, olive body to dress, purple wool shoulder shawl, old black hat, metal bucket.
> Next, there are two small oil sketches, one showing the setting of the picture, with an indication of cattle under the trees, another with house, cattle and cart. Finally in the finished composition all the details in the sketches are drawn together into a convincing whole. In spite of appearances to the contrary, the preparation of the picture

178] OPPOSITE ABOVE *The Dolls' School.*
Walter Frederick Osborne (1859–1903) .

179] OPPOSITE BELOW *The House Builders.*
Walter Frederick Osborne (1859–1903) .

works, there were 100 portraits, about 66 of them commissioned. The idea that he was primarily a painter of portraits had been derived from the fact that he tended to submit portraits rather than genre or landscape scenes to important exhibitions. Sheehy regards Whistler, together with Sir William Quiller Orchardson (1832–1910), as the lasting influences on the way Osborne handled his sitters. Other outside influences included painters of the eighteenth-century English school such as Gainsborough and Reynolds, and of the Spanish school, notably Velazquez and Goya.

Less well known is the work of HARRIET OSBORNE O'HAGAN (1830–1921). The charcoal portrait with white highlights of his sister, Eugénie (illus. 180), shows a finely modelled yet sensitive portrait revealing possible influences of Realist French painter, Thomas Couture, with whom she studied in Paris between 1866 and 1878. Other teachers included Robert-Fleury and Cogniet. Born in Dublin, she exhibited at the RHA in 1849 (aged nineteen) a lithograph portrait of Mrs Hone. In 1851 she is recorded as submitting four portraits to the RHA and *c*.1854 one portrait to the RA. Primarily a painter of

180] *Eugénie O'Hagan.*
Harriet Osborne O'Hagan (1830–1921) .

was about as spontaneous as that of Seurat's Grande Jatte. . . .*What Osborne has done, in fact, is to work out a compromise between studio painting, Impressionism, and Bastien-Lepage pleinairism.*[36]

From about 1889 Osborne began to take his portrait painting seriously, seeking out commissions and not merely confining his pictures to those of friends and relatives. His portraiture may be divided into two distinct groups, formal and informal, with the media of pastel, watercolour and pencil generally being used for the latter – as seen, for example, in his delightful *Mother and Child* sketches executed largely in pencil. These were generally preliminary studies for his oils. Capable of the informal, relaxed portrait, as his charming pencil study of a *Dublin Flower Girl* reveals, he also executed some attractive watercolour studies of children such as *The House Builders* (illus. 179) or *The Dolls' School* (illus. 178), where the watercolour medium is heightened by the introduction of coloured chalks. *At a Child's Bedside* shows a sleeping child in bed with a woman seated in a chair at the bedside. Again *The High Chair*, a watercolour with pastel highlights, shows Osborne's marvellous ability to capture children in a delightfully relaxed, informal way. On a more sophisticated level, his very fine pastel portrait of his mother, *Annie Jane Osborne at the Age of 67 with her Black Cat, Hecate* shows a high level of technical competence and achievement.

When he died in 1903 Osborne had become Ireland's leading and most fashionable portrait painter but, as Jeanne Sheehy points out, his output in this area had been small. Out of a total documented output of about 600

181] *Isaac Butt Yeats (1848–1930), the Artist's Younger Brother.* John Butler Yeats (1839–1922) .

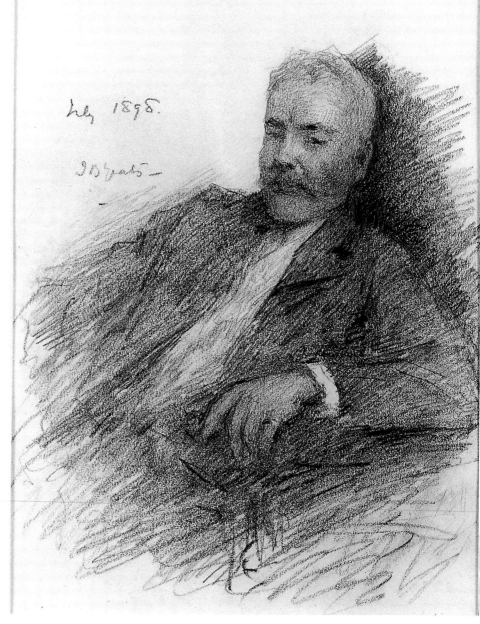
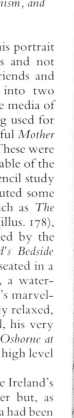

portraits, she worked largely in charcoal and oil. Harriet died in Paris in 1921.

JOHN BUTLER YEATS, RHA (1839–1922) was born at Tullyish, Co. Down, the son of a Church of Ireland rector, the Revd W. B. Yeats. Educated at a preparatory school in Liverpool and then in the Isle of Man, he graduated at the age of twenty-three, with honours and a prize in Political Economy, from Trinity College, Dublin. At twenty-four he married Susan Pollexfen, the daughter of a Sligo shipowner, whose family originated in Cornwall. Soon after his marriage he began to study for the Irish Bar, to which he was called in 1866, but his

182] *Dr Douglas Hyde (1860–1949), Scholar and 1st President of Ireland.* John Butler Yeats (1839–1922) .

efforts to earn a living in this field proved difficult and he decided to become a professional painter instead.

To this end, Yeats set out for London armed with an introduction to 'Dicky' Doyle of Punch (see p. 103), who may have suggested to him the idea of enrolling at the famous Heatherley's Art School. A warm, humane, and unselfish man, Yeats was also gifted as a conversationalist. Witty and artistic, the young painter included in his wide circle of friends in London the artist J. T. Nettleship (1841–1902), whose career as a Pre-Raphaelite included such pieties as *Jacob Struggling with the Angel* and *God Creating Evil*; the Hon. John Collier (1850–1934), whose 'problem pictures' achieved enormous popularity at the RA; and George Wilson – the shy and gifted neo-Pre-Raphaelite. With this group, together with Edwin Ellis (1841–1895), he formed a brotherhood devoted to the Pre-Raphaelite ideal. This is revealed in one of his earliest and most important works in gouache, *Pippa Passes* (illus. 184), dating from 1871 and illustrating an episode in Browning's poem. The painting possesses many of the movement's salient characteristics.

During the 1880s Yeats worked as an illustrator, his drawings being published in *Good Words* and *The Leisure Hour*. He also produced thirty-two wash drawings, reproduced in photogravure, for the complete edition of Defoe's work published in 1894 by Dent.

From 1868 onwards he moved backwards and for-

wards between England and Ireland devoting more and more of his time to portraiture and setting out to capture everyone who interested him, particularly the leading political figures, writers and talkers of the day. He finally settled at Howth, Co. Dublin. A joint exhibition of his work and that of Nathaniel Hone (see p. 15) was mounted in 1901 at 6 St Stephen's Green, Dublin. (It was organised by Sarah Purser, who will be discussed shortly.) Forty-three out of the total of seventy-two works shown were by Yeats.[37] The catalogue included a preface by George Moore and Prof. York Powell. Yeats's work sold well and was so successful that art dealer and collector Sir Hugh Lane (see p. 169) commissioned him to do a series of pencil portraits of distinguished Irishmen which included the future first President of Ireland *Dr Douglas Hyde (1860–1949)* (illus. 182), playwright John Millington Synge (1871–1909) and journalist John O'Leary (1830–1907), together with members of his own family, as demonstrated in his portrait of *Isaac Butt Yeats, the Artist's Younger Brother* (illus. 181).

These pencil portraits demonstrate John Yeats's outstanding ability to observe with warmth and compassion not only the crucial facial characteristics of his sitters but also to seek out and convey the mind behind the face. He accentuates the sitter's characteristics, such as the warmth and geniality of Douglas Hyde or the seriousness and intensity of O'Leary, at the same time conveying the sitter's personality with sympathy. His pencil portraits cover a wide range of sitters drawn from all walks of life, but they are brought together with an outstanding sense of dignity and a strong, unifying style.

183] *Sarah Purser Reclining.*
John Butler Yeats (1839–1922) .

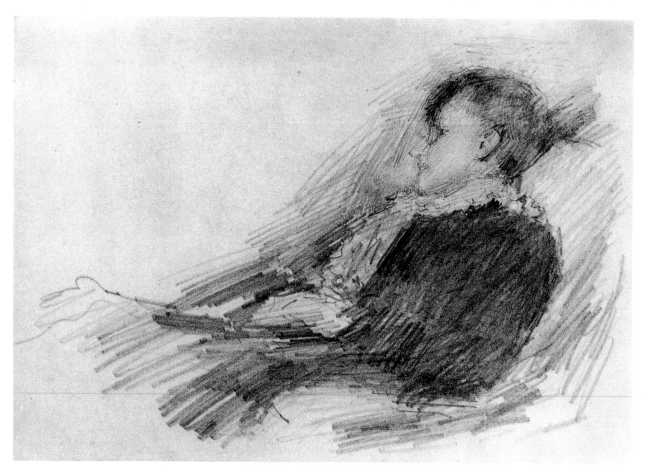

These were to become his best-known works.

In 1908 Yeats set sail for the United States to attend an exhibition of embroidery being given by his elder sister. He was never to return to Ireland, for he died in New York on the 2 February 1922. Dr James White, summing up his work remarked: 'He was a portrait painter. All his life he was engaged in an encounter with the personality of the sitter. He knew exactly what he wanted to do. It was to capture the moment of humanity in a smile; to enlarge experience by showing us a living being in a pencil sketch or an oil painting.'[38] Yeats's famous children are discussed in chapter IV and chapter VII.

An informal sketch by John Butler Yeats of his friend, JOSEPHINE WEBB (1853–1924), is in the NGI. Josephine was part of a lively circle of artists and writers who surrounded Yeats. She grew up in Dublin as part of a large Quaker family and attended Alexandra College and the Queen's Institute. She was awarded two silver medals for drawing in 1875. In 1877–8 she studied in Paris at the Académie Julian under M. Robert-Fleury, Professor of Drawing. Later she travelled to Holland, painting and recording what she saw in watercolour. She exhibited her work at the Water Colour Society of Ireland in 1889, '92 and '93, signing her work in monogram.

SIR WILLIAM ORPEN, RHA, RA (1878–1931), who has been described as an 'Irish prodigy of the early twentieth century',[39] was one of the leading society portrait painters of his day. He was also one of the wealthiest, earning large sums each year from portrait commissions. An exceptional and precocious student, he went to the Metropolitan School of Art when only eleven. Later he studied at the Slade, where he was able to meet and absorb the influences of such men as Professor Tonks and fellow students Augustus John (1876–1961) and Percy Wyndham Lewis (1884–1957). Orpen's genius was thus summed up by one of his contemporaries: 'It was a one-man show; that man was Orpen.' He was elected ARHA in 1904, RHA in 1908 and RA in 1921.

The drawings in Orpen's sketch-books show his superb powers of draughtsmanship. The carefully preserved sketch-books of his Slade and pre-Slade days testify to the assiduousness and determination with which he set out to master the elements of style of all periods and races. Assyrian reliefs, Egyptian furniture, the classic Greek orders of architecture, Roman mosaics, Byzantine enamels, Persian glass, medieval French ivories, Jacobean wood-carving, Gothic fan-vaulting . . . every conceivable object of artistic craftsmanship, Western and Eastern, are to be found in these exercise books, set down, not only with infallible accuracy, but with a deftness of touch and with a taste in the selection of accents and labour-saving omissions of non-essentials that suggest a mature master's hand.

Unfortunately the sketch-books are undated, with the exception of a solitary page on which is a blackberry branch with inimitable delicacy of line and sensitive accentuation. It bears the date October 25th, 1895, and thus stands as proof that, so far as drawing was concerned, Orpen had nothing to learn at the age of seventeen. . . . Continual practice of drawing, in leisure as well as in school hours, as may be gathered from the numerous

184] *'Pippa Passes'*, from Browning's poem. John Butler Yeats (1839–1922) .

portrait sketches of his friends, which alternate with the life studies in his sketch-books, sharpened Orpen's power of observation and gave sureness and authority to his hand.[40]

The artist's pencil drawing of a *Seated female nude* taken from one of these sketch books demonstrates the painter's ability to portray the nude figure in a totally natural and relaxed manner, a strong sense of style being portrayed by the carriage of the model's head. In his delicate red chalk drawing of his friend *Sir Hugh Lane* the style is again thoroughly confident, free and relaxed, showing his flair for portraying his figures in unusual poses. Again this point is aptly demonstrated in his *The Draughtsman and his Model* (illus. 185).

Orpen's oil portraits, such as his superb full-length

185] *The Draughtsman and his Model.*
Sir William Orpen (1878–1931).

painting of the fashionable and elegant *Mrs Howard St George*, show his ability to paint in the grand manner, his magnificent draughtsmanship, together with his depiction of light and colour, being handled with supreme confidence and mastery.

An official War Artist, he produced in 1917 a remarkable collection of drawings and paintings which earned him the title of 'the Samuel Pepys of the Western Front'. Right through the 1920s, Orpen continued to dominate the English portrait scene, his approach being always professional, but, as Bruce Arnold points out,

> [He] had to overcome the inborn reticence and hesitation he felt with people, and construct a professional sympathy and understanding that would make a success of portrait painting. It might seem a strange contradiction to pursue an end in life for which the psychological sympathies, as opposed to the technical means, were apparently so limited. And yet there is a certain value in the cold and objective application of technical brilliance to a given task that offered scope and a future.[41]

Orpen's younger brother, Richard Caulfield Orpen, is discussed in chapter V.

After the death of portrait painter Walter Osborne in 1903, it fell to painters such as Dublin portraitist SARAH PURSER, HRHA (1849–1943), to pick up his portrait practice. She was born into a family of nine boys and two girls. Her father had been a prosperous flour miller in Dungarvan, Co. Waterford until, in 1873, the flour mills failed, probably owing to American competition. Fortunate to have had a good education in Switzerland, Sarah moved with her mother[42] to Dublin and set out to equip herself to earn a living as a professional portrait painter.

After studying at the Dublin School of Art under R. E. Lyne, who was its head between 1874 and 1876, she set out unaccompanied for Paris, becoming a student at the Académie Julian in the 'ladies' section'. Desperately short of money, she managed to subsist for six months on a gift of thirty pounds from her brothers, sharing accommodation with a Swiss student, Louise Breslau (1854–1927), a gifted painter, and the Italian singer Maria Feller. At thirty, older than her fellow Greek, Russian and Swiss students, Sarah spent her days copying from the antique, drawing still life, or capturing the human figure. She received a thorough practical

grounding in drawing which was to stand her in good stead for the rest of her life.

On returning to Dublin she rented a little studio in Leinster Street and first exhibited at the RHA in 1880. Her first real success came when she was commissioned to paint the beautiful *Frances L'Estrange*: 'A very good portrait and everybody liked it.' Then followed an introduction by the L'Estrange family to the Gore-Booths. 'Lady Gore-Booth's brother being at the Vice-regal Lodge, I was called in there and he got me a few commissions for portraits in London. They were hung in the Royal Academy and from that I never looked back – I went through the British Aristocracy like the measles.'

A hard worker, she established herself as Ireland's foremost painter of faces. With her exceptional energy and intelligence she was always in the forefront of Irish intellectual activities. She and Sir John Purser Griffith[43] were responsible for setting up and financing the Purser Griffith Scholarship and History of Art lectures, which still continue. In 1914 she was appointed to the Board of the National Gallery of Ireland and was largely responsible for the foundation of the Friends of the National Collections of Ireland. She also had the distinction of being the first woman to be accepted into the ranks of the RHA, becoming a full Academician in 1924 at the age of seventy-six.

Her portraits, executed in pencil, crayon or charcoal, are competent, academic and attractive. Determined and indomitable to the end, she showed remarkable spirit when, in her eighties, she was still painting and drawing such celebrated figures as Jack B. Yeats and Thomas McGreevy,[44] not, as she was quick to point out, for the money, but rather for the love of good company.

186] *William Butler Yeats (1865–1939)*. Sarah Purser (1849–1943).

August
1905

J B Yeats

TWENTIETH-CENTURY PORTRAITS AND LANDSCAPES

A gallery of Irish and modern art in Dublin would create a standard of taste, and a feeling of the relative importance of painters. This would encourage the purchase of pictures, for people will not purchase where they do not know.

Such a gallery would be as necessary to the student if we are to have a distinct school of painting in Ireland, for it is only contemporaries that teach one the most. They are busy with the same problems of expression as oneself, for almost every artist expresses the soul of his own age. . . .

I and my friends look forward to having in Dublin sooner or later a gallery where such works, and, if possible, the works of all great contemporaries may be hung. . . .

THESE were just some of the main aims expressed by Sir Hugh Lane (1875–1915) in his introduction to an exhibition of works by Irish painters organized by himself and held at the Guildhall, London, in 1904. Lane wanted nothing less than to provide Ireland's capital city with her own gallery of modern art because, as he stated,

There are so many painters of Irish birth or Irish blood in the first rank at this moment, that extreme interest is being taken in this bringing together of sufficient specimens of their work to enable students of art to discover what common or race qualities appear through it. There is something of common race instinct in the work of all original Irish writers today, and it can hardly be absent in the sister art.

Lane had been born at Ballybrack House, Co. Cork, the son of a Church of Ireland clergyman. His mother was a member of the well-known Persse family of Co. Galway. He was the only one of the seven children of the marriage actually to be born in Ireland, and he spent his childhood and teenage years both in Ireland and England, returning frequently to stay with his aunt, Lady Gregory, at Coole Park, Co. Galway.

He was intensely interested in art and art collecting, but it was only after he had paid a visit, in October 1901, to a joint exhibition of the works of John Butler Yeats and Nathaniel Hone organized by Sarah Purser at 6 St Stephen's Green, Dublin (see p. 164) that, in the words of

Thomas Bodkin, 'the little show proved to be the spark which fired Lane's imagination with the idea of working for Ireland'.[1]

A series of events, including Lane's appointment as Director of the National Gallery of Ireland in 1914, eventually led to the opening on 18 June 1908 of the Municipal Gallery of Modern Art in Clonmel House, Harcourt Street, Dublin.

The cover of the handsomely-bound green catalogue contained notes written by the artist Sarah Cecilia Harrison (see p. 172) and carried on the cover a striking silhouette of Rodin's statue *The Age of Bronze*, a hint of the quality of the outstanding collection of three hundred items listed in the catalogue and included in the exhibition to mark the opening of this gallery of modern art in the heart of Dublin. Lane had generously collected and presented to the Irish nation drawings, sculptures and paintings which included a formidable array of works by French artists such as Fantin-Latour, Harpignies, Degas and Manet. The English school was also represented by watercolourists such as David Cox (1783–1859); and Irish painters by John Butler Yeats, his son, Jack Yeats, Walter Osborne and Sir William Orpen.[2]

Thus, at the turn of the century, thanks to the generosity of one man, Dublin possessed a flourishing, if somewhat conservative, centre of modern art. Artists such as DERMOD O'BRIEN, PRHA, HRA, HRSA (1865–1945), who became President of the Royal Hibernian Academy in May 1910, were expected by Lane to help to lay down the foundation of modern Irish painting.

O'Brien was born at his uncle Lord Monteagle's house, Mount Trenchard, which stood near Foynes, Co. Limerick. His grandfather was the Fenian leader William Smith O'Brien. When he was three O'Brien's mother Mary (née Spring Rice) died, and his father did not remarry until 1880.

Young Dermod was sent to a preparatory school and, in 1879, to Harrow, from where he matriculated to Trinity College, Cambridge, to read Political Economy and Literature. He left, however, without taking his degree. In 1886 he went to Paris, spending a good deal of his time studying the old masters in the Louvre, and thence to Italy in the following year. It was around this period that Dermod decided to take painting seriously, his father encouraging him to become a student at the Royal Academy in Antwerp. Many Irish painters studied there, including Walter Osborne (from 1881; see

187] *Sir Hugh Lane (1875–1915)*.
John Butler Yeats (1839–1922).

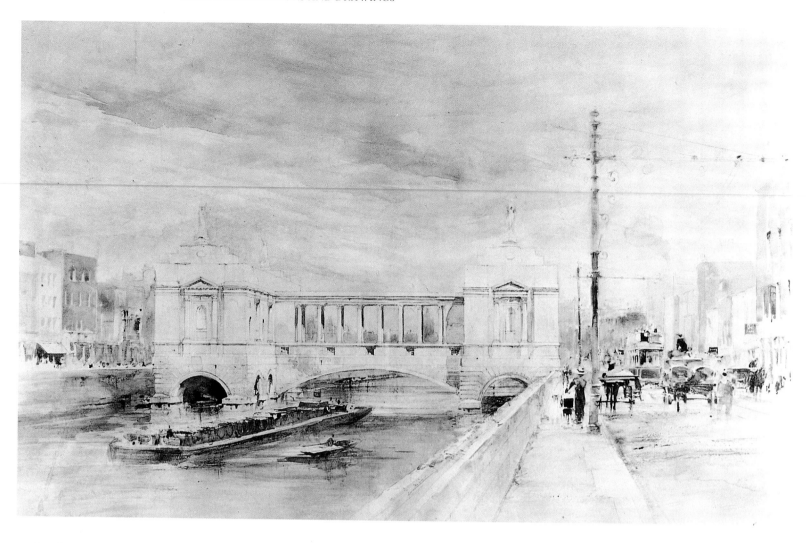

188] A design for a proposed bridge and gallery over the River Liffey as seen from Bachelor's Walk, near O'Connell Bridge, Dublin. William Walcot (1874–1943).

p. 159 and Roderick O'Conor (1884; see p. 120). Under the direction of Charles Verlat, O'Brien worked hard, being awarded first prize in life drawing in 1890. Deeply attracted by Rembrandt, he spent a good deal of time studying the great Dutch artist's work, whose influence on his style is obvious.

His Antwerp portraits dating from this period reveal him as a competent academic painter relying on a traditional use of chiaroscuro and possessing an accurate sense of draughtsmanship, all of which is beautifully demonstrated in his pencil sketch of author and director, *Lennox Robinson (1886–1958)* (illus. 191) and *The White Dress* (illus. 190), a preliminary study for a portrait of *Lady Farrer* (oil on canvas) in the National Gallery of Ireland.

To complete his training in 1891 he moved to Paris, becoming a student at Académie Julian under Robert-Fleury and Flameng. O'Brien was not too happy there despite becoming friendly with fellow students such as the English artist William Rothenstein (1872–1945): 'Paris was not his milieu. . . . Artist though he was, he was also an Irish gentleman and he could never feel at his ease in the Bohemian crowd.'[3]

189] Right wing of the bridge and galleries designed by Sir Edwin Lutyens.
William Walcot (1874–1943).

By 1893 O'Brien had moved to London, and after a short period of study at the Slade School he set up as a portrait painter, his approach to this area of painting being in general fairly formal and academic. He now had a wide selection of friends, both artistic and literary, including the Leslie Stephens and their two daughters Vanessa Bell and Virginia Woolf; Sargent; Sickert; Sir John Lavery; and Henry Tonks with whom he shared a studio. But his portrait practice was not flourishing as he had hoped and eventually in 1901, O'Brien made the decision to return to Dublin and his boyhood friends, with whom he had always kept in touch.

Within a few months he had made many new acquaintances: 'Dublin is just the right size for a city. Everyone can know everyone else, it's small enough for that but large enough to avoid the people you don't want to meet and yet you need not be alone. In Dublin there can always be friends in the evenings.'[4]

When his father died in 1909 he inherited the family home at Cahirmoyle in Co. Limerick, and decided to give up his studio in Mountjoy Square. Now engaged in farming, he found the landscape around him a constant source of inspiration and, as many of his watercolours from this period demonstrate, he painted his beloved Irish countryside in a style and manner similar to that of

190] *The White Dress*; preliminary study for a portrait of *Lady Farrer* (oil on canvas) in the NGI. Dermod O'Brien (1865–1945) .

191] *(Esmé Stuart) Lennox Robinson (1886–1958), Author and Director*. Dermod O'Brien (1865–1945) .

Nathaniel Hone. However, in 1920, he decided to sell Cahirmoyle and move back to Dublin with his family. They took up residence in Fitzwilliam Square. During this period in the 1920s, O'Brien spent a good deal of his time painting in France, as several watercolours such as *Cassis* and *Gorge du Loup* testify. The latter composition shows a high degree of technical achievement and is full of vitality and spontaneity. However, he found the technique of watercolour difficult to handle and certainly it was not suited to his usually slow, relaxed and even deliberate approach to his work.[5]

Throughout his life O'Brien was a constant source of help and encouragement to young artists, particularly during his years as President of the RHA. He also took a keen interest not only in the graphic arts but also in music, his lifelong hobby. He was made an honorary RA in 1912, a member of the Royal Scottish Academy in 1914, of the Royal Society of British Artists in 1919, of the Belfast Art Society and later of the Ulster Academy of Arts. O'Brien's death in 1945 marked the end of an era in Irish cultural life.

One of Lane's less well-known contemporaries was SARAH CECILIA HARRISON (1863–1941), who had been responsible for compiling the excellent notes contained in the catalogue drawn up to celebrate the opening of Lane's gallery in 1908. Sarah was later to work continually and indefatigably for the return of Lane's pictures to Dublin.[6]

Descended from Ulster stock, she had been born the third child of Henry Harrison, JP, of Holywood House,

193] *'I Have Trodden the Winepress Alone'*. Mainie Jellett (1897–1944) .

Ardkeen, Co. Down, and his second wife, who was a great-grandniece of Henry Joy McCracken.[7] After the death of her father the family settled in London, where Sarah attended the Slade School, studying under Alphonse Legros (1837–1911).

Contrary to the trend of teaching in his native France during this period, Legros insisted on 'impeccable drawing as the sure foundation of all good painting'[8] and, belonging to the tradition of Ingres, he placed strong emphasis on accurate draughtsmanship, his students being encouraged to 'draw with the point and by the character of the contour rather than by the mass in tone'.[9]

Much of her teacher's influence reflects itself in Harrison's work, particularly with regard to her portraiture, where her style is competent and firm if a little conservative at times. This is well displayed in her pencil portrait of musician Edith Best (née Oldham; 1865–1950) in the NGI. Again, in two pen-and-ink studies taken from her sketchbooks, *A Country House* and *Farm Buildings*, the influence of Legros is quite evident.

Sarah Harrison had taught for a period at the Dublin Metropolitan School, one of her most distinguished pupils being MAINIE JELLETT (1897–1944) who throughout her life was to remain a close friend of the stained-glass artist EVIE HONE HRHA, LLD (1894–1955).

Mainie Jellett was the daughter of a Dublin barrister, William Morgan Jellett, who married a musician, Janet

192] *Achill Horses*; pencil drawing for an oil painting in the NGI. Mainie Jellett (1897–1944) .

Stokes. Some of her earliest painting lessons in water-colour were given by Elizabeth (Lolly) Yeats, sister of W. B. and Jack Yeats (see p. 196). From the age of seventeen she was a full-time student at the Metropolitan School, where William Orpen (see p. 165) was then acting as a visiting teacher in charge of the life class. After two years she travelled to London where, at the Westminster School under Walter Sickert, she studied for two and a half years: 'For the first time drawing and composition came alive to me, and with Sickert's help, I began to understand the work of Old Masters, Sickert being in the direct line of French Impressionist painting was an excellent stepping stone to my next revolution, Paris and Lhote's Studio.'[10]

Mainie's early watercolours, such as *The Sea at Wimereux*, dating from 1911 when she first visited France with her mother, had shown considerable promise. Her watercolour *Betty at Fintra*, executed eight years later, dates from the Sickert period and shows a fluency and understanding of light combined with a confident grasp of colour and composition which clearly point towards a rich awakening of her talent and energy.

This was to bear fruit in Paris where she and Evie Hone became pupils of André Lhote. For the first time, Mainie was introduced to a relatively modified version of Cubist art based on realistic forms – that is to say, a style of Cubist painting which stood midway between the academic, adapted by artists who tended to copy natural objects, and the non-representational, adopted by artists who completely discarded their subject matter.

To Mainie, this seemed a compromise: it did not go far enough. She sought a fuller understanding of non-representational art. Therefore, after two sessions she left Lhote's studio and knocked on the door of the atelier of Albert Gleizes,

> *... one of the original members of the Cubist groups and one who had produced the purest and most austere form of non-representational work. I went right back to the beginning with him, and was put to the severest type of exercise in pure form and colour, evolved on a certain system of composition. I now felt I had come to essentials and though the type of work I had embarked upon would mean years of misunderstanding and walls of prejudice to break through, yet I felt I was on the right track.*[11]

Within a year of moving from Lhote's studio to Albert Gleizes, Mainie had begun to master pure Cubism, producing abstract works in both oil and gouache such as the gouache painting illustrated here. In this work the abstract forms and colours are treated with a boldness and simplicity which adds a new dimension of strength and solidity. From now on the artist tended to work in gouache, and only rarely returned to the medium of watercolour.

When Mainie Jellett exhibited two Cubist paintings at the Dublin Painters' Exhibition in 1923 she had to bear the brunt of hostile criticism which in some cases degenerated into derision. But with courage and fortitude she took on the role as a pioneer of Cubist abstract painting in Ireland, lecturing and broadcasting on non-representational art and publishing, in 1926, her first essay on Cubism. Not content to abandon herself to pure abstraction, she returned from time to time throughout the remainder of her career to realism and semi-abstract work, as seen in her gouache study of *Water-Lilies*, or her outstanding gouache and pencil '*I Have Trodden the Winepress Alone*' (illus. 193), a study for a larger work in oil.

Throughout her career she made numerous pencil drawings (illus. 192), generally working them into gouache studies for larger works in oil. At the same time she also produced a number of finished pencil drawings, particularly nude studies, which again demonstrate her sound draughtsmanship.

An enthusiastic traveller, she visited Lithuania in 1931, then Amsterdam and Antwerp with Evie Hone in 1933. In 1938 Séan Lemass, then Minister of Industry and Commerce, invited her to design some murals for the Irish Pavilions at the Exhibitions of 1939 in Glasgow and in New York. These murals are now in the NGI.

A designer of carpets, textiles, rugs, sets and costumes for plays produced at the Gate Theatre by Hilton Edwards and Micheál Mac Liammóir (see p. 124), she was one of the founders of the Irish Exhibition of Living Art in 1943. She died in Dublin a year later and is buried at Howth, Co. Dublin.

Some of the early paintings of EVIE SYDNEY HONE, HRHA (1894–1955) are hard to distinguish from those of Mainie Jellett. A direct descendant of Joseph Hone (the brother of the well known eighteenth-century painter, Nathaniel Hone the Elder (1718–1784), who is discussed in chapter 1), Evie Hone was born on 22nd April at Roebuck Grove, Co. Dublin. Her father was a

194] Photograph of Mainie Jellett (1897–1944) in her early forties.

Italy and was much impressed by the work of such painters as Giotto (126/7–1337) and Fra Angelico (c.1387 or possibly c.1400–1455). In London she studied under Walter Sickert (1860–1942) at the Westminster School of Art, and attended evening classes which were being given by Byam Shaw. Dividing her time between receiving medical treatment from her physicians, and having lessons from Bernard Meninsky at the Central School of Art, she was encouraged by the latter to study in Paris.

In the Autumn of 1920 she joined André Lhote's studio in Paris. His cubist-divisionist style and masterly feeling for composition and construction had been much influenced by Cézanne (1839–1906). After she and her life-long friend, Mainie Jellett, had spent two winters with Lhote, they moved to the studio of Cubist painter, Albert Gleizes (1881–1953), who had been one of the earliest exponents of the movement and one of its most ardent supporters. For the next ten years Evie was to spend four or five months of each year working in Paris with Gleizes. Here she produced Cubist works such as her magnificent abstract *Maternité* and *The Adoration of the Magi* (c.1925), using one of her favourite mediums, gouache. She worked hard striving to master 'the powerful basic rhythms of Italian Primitives . . . in study after study intended eventually to yield a meaning as direct and pregnant as in the work of a Giotto or a Fra Angelico. All questions of atmosphere, movement or literacy content were to her irrelevancies standing in the way of direct communication of feeling'.[12] During this period she had an opportunity to visit Spain and study for herself the work of artists including El Greco (1541–1614).

Her work in the early thirties, such as her gouache *Abstract* (1933) – a cartoon for the baptistry in St Naithi's Church, Dundrum, Co. Dublin – or her gouache *Entombment* (c.1935), reveal the influence of George Rouault (1871–1958), an artist who remained apart from all groups and systems of aesthetics, but yet went on to develop one of the purest forms of Expressionism. It has been suggested that Rouault awakened in her the possibility that stained glass might contain the opportunity to combine formal statements of religious art with the underlying abstract design which she was always anxious to incorporate into her work.

Towards the end of the 1930s the influence of Rouault began to fade, and in her magnificent gouache cartoon *My Four Green Fields* (see illus. 195) – a provisional design for a glass panel for the Pavilion at the New York World's Fair – Evie shows, in a strong, confident, representational manner, the Four Provinces of Ireland standing out against an abstract pattern, which clearly lends support to the structure and integral unit of this thoroughly satisfying composition.

The artist's *Christ & Apostles* – a two-light Ascension window at Kingscourt Church, Co. Cavan, 1947–1948 – is believed to have been one of her favourite works. The cartoon for this is also in gouache. The painter's strong feeling for abstract makes itself particularly clear in the treatment of the landscape background. This work at Kingscourt attracted the attention of Lord Crawford and Sir Jasper Ridley, who put forward her name for the Eton College Chapel commission.

Evie began working on this commission, described by

195 | '*My Four Green Fields*'; Provisional design for a glass panel. Evie Sydney Hone (1894–1955).

malster and a director of the Bank of Ireland, and her mother was the daughter of Sir Henry Robinson, KCB. Tragically, early in her life she contracted infantile paralysis, the course of which was to condition much of her artistic career.

Evie Hone's work may be divided into three main periods. The first stage springs from Cubism learned in Paris, which was substantially to influence her work until the early 1930s. Prior to this, in 1915, she had visited

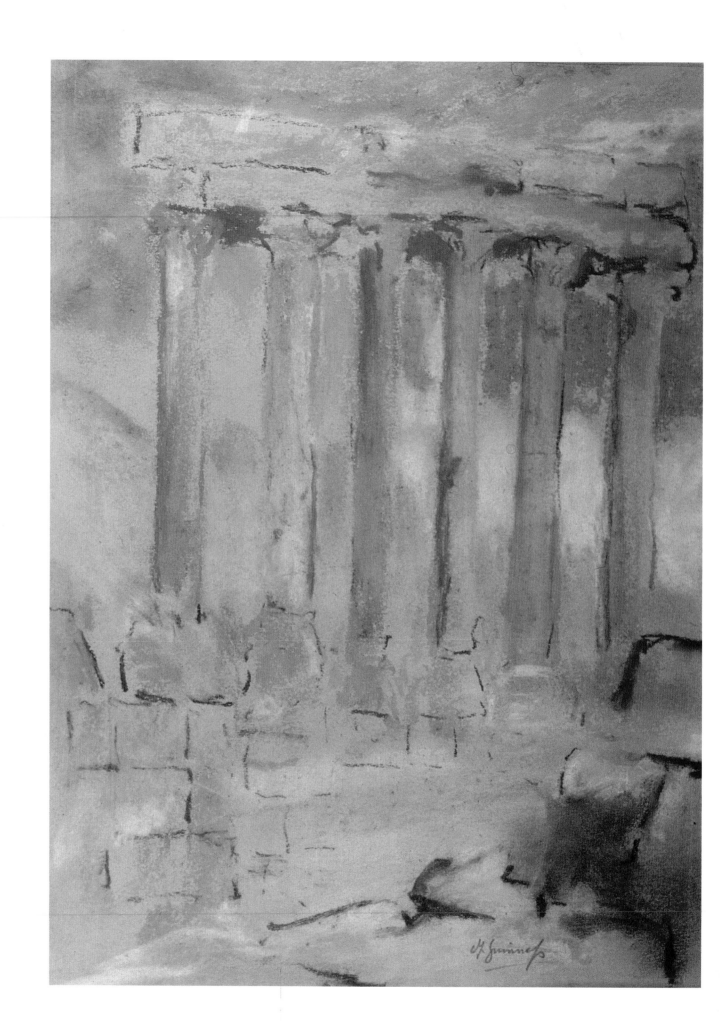

Michael Wynne as a 'monumental consummation', in the year 1959. She was not helped by the fact that she was in poor health and had only the assistance of a small number of glaziers. The cartoon in the NGI for this work was executed in watercolour, not gouache, and shows the design divided into two great sections: the upper space is occupied by *The Crucifixion* and spectators, while below it lies *The Last Supper*, flanked by the figures of Melchisedech and Abraham which are in turn surrounded by numerous symbolic images. To help her with her descriptive imagery, Evie had studied late medieval Irish carving, making several drawings of early stone carvings as can be seen in her drawing of a crucifixion after a sixteenth-century carved stone in Cashel (*c*.1941). In the words of Wynne: 'The images of Medieval Irish carvings in Evie Hone's stained glass are not slavish copies, but rather free "translations" of the line and form of the earlier craftsmen-sculptors.'[13]

During the last few years of her life her style tended to soften. Her choice of colours became somewhat more muted and their range was reduced, as may be seen in a cartoon executed in gouache for a three-light window for the Cathedral Church, Blackrock, Co. Dublin, (1954/1955). Combined with this last phase in stained glass came a further series of abstract designs both in gouache and oil.

Evie Hone collapsed and died just as she was about to enter her Parish Church at Rathfarnham, Co. Dublin, on 13 March 1955. In a moving tribute to her, Dr C. P. Curran said: 'Yet I imagine that all who knew her however justly they prize her genius, think of her not solely as the modern master of stained glass, but as an heroic figure whose art was enclosed in her spiritual heroism and was fed and sustained by it.'[14]

MAY GUINNESS (1863–1955) was a friend of Mainie Jellett and Evie Hone and fellow student of André Lhote in Paris. She studied with Lhote from 1922 to 1925, having developed late as an artist. The third child of seven children born to Thomas Hosea Guinness and Mary (née Davis) of Tibradden House, Rathfarnham, Co. Dublin, she studied painting in Paris from 1910 onwards, returning nearly every year until 1931.

Attracted by the work of such painters as Matisse and Dufy, she announced in 1925 that she had been 'through all the phases, and had now settled down to "stylisation" ... the flat and rhythmic arrangements of line and colour'.[15] A keen traveller, she painted in Sicily and Greece, as two watercolours indicate: *Byzantine Church, Greece* (1936) and *Harbour of Palermo, Sicily* (1939).

From an early age she showed a fondness for working in pastel, as displayed in such works as *On the Terrace* and *In the Garden*, both of which she exhibited in 1893, and *Athenian Evening* (illus. 196). Two later watercolours, *Girl Reading* (1945) and *Girl with Flower*, demonstrate how she had still not shaken off the French influence of such painters as Dufy.

EVELYN GLEESON (1855–1944) used watercolour to a lesser extent than May Guinness, preferring instead to specialize in pastel. She used this latter medium for portraiture as seen in her *Self-Portrait* dating from *c*.1890.

Born in Knutsford, Cheshire, she moved with her parents to Athlone when she was fifteen. Evelyn studied under Ludovici in London and then in Paris. Having spent some years in London where she studied design, she returned to Ireland *c*.1895. She became closely involved in setting up the Dún Emer Guild in Dundrum, Co. Dublin between 1902 and 1904. A well-known portrait painter, she tended to use the medium of watercolour largely for landscape and design only.

A highly competent portrait in pastel entitled *Winter* demonstrates HARRIET HOCKLEY TOWNSHEND'S (1877–1941) confident and accomplished style. A student at the Metropolitan School of Art in Dublin in 1910, she may have been influenced by William Orpen (see p. 165) who was teaching at the school between *c*.1908 and 1912. The daughter of Major General Walter Weldon and Annie Homan Molloy, she was born in Ireland. After her marriage to Thomas Loftus Uniacke Townshend on 8 June 1910, she continued to exhibit under her married name at the RHA between 1903 and 1935.

Described by Sir William Orpen as 'a young lady with many gifts, much temperament and great ability',[16] BEATRICE ELVERY (LADY GLENAVY), RHA (1883–1966), at the age of sixteen, received a scholarship to study at the South Kensington School of Art in London for three weeks. A bright and gifted pupil, she later studied sculpture under John Hughes (1865–1941) and at the Metropolitan School of Art. She was also successful in obtaining the Taylor Art scholarship in three successive years (1902–1904) and exhibited with the Young Irish Artists at the Arts and Crafts exhibition in 1904. Around this time, Beatrice decided to study in Paris with her sister, Dorothy (who had been a pupil of Walter Osborne), and two other students, ESTELLA SOLOMONS (1882–1968) and 'Cissie' Beckett (see below). They spent their mornings 'drawing from life in Colarossi's and in the afternoons wander about sightseeing, find Paris very hot and exhausting'.[17] On her return to Dublin, Beatrice joined An Túr Gloine, Sarah Purser's Tower of Glass (stained glass co-operative). According to her account of her career in stained glass, she never seemed totally at ease working in this field: 'I never got the right feeling for glass or the detached, austere quality necessary for ecclesiastical art.'[18] Two cartoons, executed in watercolour, ink and pencil, that do seem to have pleased her, however, are her designs for a tiny church on Tory Island, *St. Columba with the white horse that foretold his death* and *St. Columba arriving at Tory island* (for a three-light window), and her cartoon of the *Good Samaritan* for her local parish church at Carrickmines, Co. Dublin.

A book illustrator[19] and a designer of prints for the Cuala Press, she returned in 1910 to London to study at the Slade School under Tonks and Steer. Two years later she married Gordon Campbell, later to become Lord Glenavy. She was elected RHA in 1933, and held her first one-man show in Dublin in 1935.

As has already been mentioned above, FRANCES ('CISSIE') BECKETT (1880–1951) was a close friend of Beatrice Elvery. She also studied at the Metropolitan School of Art, exhibiting at the Young Irish Artists exhibition in Dublin in 1903. A year later she went to Paris with Beatrice and Estella Solomons, attending life

196| *Athenian Evening.*
May Guinness (1863–1955) .

197| *Cherry Ripe*.
Jessie Douglas (1893–1928) .

classes at Colarossi's. She exhibited at the RHA in 1897 and then from 1901 to 1908, her main subject area becoming portraits. After her marriage in 1908 to the art dealer, William Abraham Sinclair, she lived at Baily, Howth, Co. Dublin and painted little.

HELEN COLVILLE (d.1953) of Howth, Co. Dublin was a prominent member of the Water Colour Society of Ireland. She began exhibiting with the Society as early as 1892 and continued to do so almost every year until her death. She also exhibited her work at the RHA (1920–1947), the Royal Society of Artists and the Society of Women Artists. Her landscapes in watercolour are competent and attractive and can be found in the Hugh Lane Municipal Gallery, Dublin and in many private collections.

JESSIE DOUGLAS's (1893–1928) portrait in water-colour entitled *Cherry Ripe* (illus. 197) shows a painter of outstanding promise. Sadly, only one work by her is known. A member of the Belfast Art Society, in 1896

she was elected one of the four vice-presidents. Her exhibits show her to have been a keen traveller: Donegal, Connemara, Holland, the South of England and France. In 1918 she became an honorary member of the British Art Society.

An 'Irish beauty' who was very much involved in both the artistic and political life of her country was CONSTANCE, COMTESSE DE MARKIEVICZ, (née GORE-BOOTH; 1868–1927). She studied painting at the Slade in London and then at Julian in Paris. There she met and eventually in 1900 married fellow artist Comte Casimir de Markievicz, returning at the turn of the century to live in Dublin. Soon she became involved with political life, being elected in 1909 to the Council of Sinn Féin. Five years later she became a member of the Citizens' Army. In 1916 she commanded a group of insurgents in the Royal College of Surgeons, Dublin. After they had surrendered she was sentenced to death. However, her sentence was commuted to life imprisonment. During her days in Holloway Gaol she painted a number of watercolours which were of a visionary, romantic nature and show the influence of an artist she greatly admired, 'AE' (the pseudonym of George Russell; see p. 196). Earlier, around the turn of the century, she, 'AE' and Comte Markievicz had exhibited together in Dublin, the Comtesse contributing no fewer than twelve watercolours to the exhibition.

After the amnesty in 1917 she was released from prison. She continued to play an active role in Irish political life and in 1918 was the first woman to be elected as a Republican to the British Parliament, though she did not take her seat. Until her death in 1927 she was a member of Dáil Éireann.

Her drawings, mainly executed in charcoal, show her to be a competent and technically-accomplished draughtswoman in this medium. *Miss Purser* (illus. 198), dating from 1898 (possibly Elinor Purser, a niece of Sarah Purser – see p. 166), is just one of six crayon drawings executed by the Comtesse and is now in a private collection in Ireland.

PATRICK JOSEPH TUOHY, RHA (1894–1930), de-scribed himself as a 'portrait painter and painter of decorative compositions and genre subjects'. His work hangs in the Hugh Lane Municipal Gallery of Modern Art, where his portrait in watercolour entitled *The Little Seamstress* demonstrates his superb skill and ability to portray and capture a likeness through this medium.

He was born in Dublin at 15 North Frederick Street. His father was a doctor and his mother was a skilled short-story writer. Tuohy was educated by the Christian Brothers until the age of fourteen, when he became one of the first pupils to be admitted to Scoil Eánna, which was founded by Patrick Pearse in 1908.

There, under the guidance of the sculptor William Pearse (1881–1916), and despite having a withered left hand, Tuohy quickly showed his skill and aptitude as a draughtsman, as may be seen in for example an early study of twelve faces executed while he was still a pupil at Scoil Eánna.

A conscientious and eager worker, he began exhibiting his painting at the Small Concert Room in Dublin in 1911, where three of his canvases were described as being 'remarkable as coming from the brush of a boy artist'.[20] A group portrait executed in water-

198] *Miss Purser*.
Constance, Comtesse de Markievicz (1868–1927).

colour dating from around this period, *Supper Time*, shows his considerable skill at depicting a wide range of character, age and personality. His first serious commission, however, came in 1913 when he executed ten ceiling paintings in Rathfarnham Castle, Co. Dublin. These were followed by further ceiling paintings for the

La Scala Theatre (later the Capitol Cinema), Dublin.

In 1916 he lent support to Patrick Pearse in the GPO in Dublin, and after the Rising escaped to Spain, gaining employment as a teacher in Madrid, where he remained for eighteen months. This gave Tuohy the opportunity to study the works of such masters of Spanish painting as Zurbaran and Velazquez. These began to influence his approach to portraiture in particular, his academic style changing into a more individual and more personal approach.

199] *The Model*; (oil on canvas).
Patrick Joseph Tuohy (1894–1930).

Returning to Dublin in 1918, he began teaching at the Metropolitan School of Art, his most famous pupil being Norah McGuinness (see p. 188). He also began exhibiting his work in the RHA, showing his well-known oil *A Mayo Peasant Boy* in that same year. He became ARHA in 1926.

Tuohy kept up his links with the Continent, returning frequently to Paris where some of his work was shown at the Galéries Barbazanges in the winter of 1922, alongside that of Sarah Purser (see p. 166), Albert Power (1883–1945) and sculptor Oliver Sheppard, RHA, RBS (1864–1941). He was a close friend of the Joyce family in Paris and painted the writer and his family.

After receiving a gold medal in 1926 at Aonac Tailteann for *The Baptism of Christ* (oil on canvas), which revealed his considerable imaginative and decorative powers, he left Ireland the following year for Columbia in South Carolina, settling afterwards in New York. There he helped to organize the city's first exhibition of contemporary Irish art, held at the Helen Hackett Gallery in 1929. This included works by Irish stained-glass artists such as Harry Clarke, and painters Margaret Clarke, Charles Lamb and Dermod O'Brien (see pp. 123, 169 and 191).

Described by Bodkin as 'a man of sensitive feeling and careful judgement, introspective and rather aloof by temperament but quick to put himself in another's place and generous in his appreciation of his fellows',[21] Tuohy died in his studio on Riverside Drive, New York in August 1930.

Tuohy is largely remembered for his remarkable pencil studies and portraits in oil as illustrated here in his full-length nude study (illus. 199). His pencil portraits of *Pádraic Colum, F. R. Higgins* (illus. 200), *Seán O'Casey* and *Sarah Allgood* show his power to produce a true likeness of his sitter combined with a remarkable and illuminating insight into character which never bordered on caricature. His ability as a landscape artist never reached the same level as that of his portraiture, or his religious works, but a number of watercolours dating from the 1930s such as *The Boyne* and *Clouds* or *Millwheel Bridge* proved him to have qualities of imagination and sensitivity outside his scope as solely a painter of portraits. He also drew a number of book illustrations, among others for books by Standish O'Grady and Katherine MacCormick.

'Introverted, self-conscious, shy, dominated by his mother, over-shadowed by his brother, unsuccessful in selling his work, increasingly bewildered about the direction in which he was going, yet with a firm and lasting belief in his basic skills and his vision, CHRISTOPHER CAMPBELL presents himself as an enigmatic figure in Irish Art.'[22] So wrote Bruce Arnold in his introduction to an exhibition of the work of CHRISTOPHER CAMPBELL (1908–1972), held in 1977. This exhibition proved Campbell to be a competent

TUOHY 26

200] *F. R. Higgins.*
Patrick Joseph Tuohy (1894–1930).

portraitist and artist, particularly when it came to designing cartoons in watercolour and crayon for stained glass in Irish churches. He was also successful in carying out a number of secular works in stained glass. His cartoons in watercolour for glass included *Brendan, the Navigator* for Tiráun Church, Belmullet, Co. Mayo, *The Holy Trinity*, a centre design for a three-light window, and *The Flaying of Jesus*, a watercolour and crayon cartoon which was exhibited at the Royal Dublin Society's National Art competition in 1930, winning first prize. Brother of the well-known Dublin sculptor, Laurence Campbell, he attended the National College of Art and became a devoted follower and student of Patrick Tuohy. He exhibited at the RHA between the years 1928 and 1945. A fine painter of portraits, nudes and imaginative studies, he became an art teacher at Kilkenny Technical Schools in 1947, a post he was to hold for four years.

An artist who used watercolour as an essential part of his creative and artistic process was the somewhat shy

201] *The White Shadow* (Self-Portrait).
Christopher Campbell (1908–1972).

202] *Moore Street Market, Dublin*.
Michael Joseph Healy (1873–1941).

Moore St. Dublin

and retiring MICHAEL JOSEPH HEALY (1873–1941). He was seldom to exhibit throughout his life and never belonged to an academy, but his work in cathedrals and churches, both in Ireland and abroad, bears a living and brilliant testimony to his skilled workmanship.

Healy was born at Bishop Street in the heart of Dublin in 1873 and attended the Metropolitan School of Art in 1897, where he concentrated on book illustration. He left for London a year later hoping to find work as an illustrator, but the visit was brief and unsuccessful. Healy returned to Dublin and entered the RHA School where he won first prize for a drawing from life. In September 1898 the editor of the *Irish Rosary*, Father Glendon, advertised for an illustrator. Healy applied and was successful. Thus began a long and fruitful friendship, which was to last throughout the artist's life.

203] *Self-Portrait.*
Seán Keating (1889–1977) .

Healy's early drawings and watercolours for the *Irish Rosary* display a technical competence and grasp of character very remarkable in such a young painter. With Father Glendon's encouragement, he set out for a two-year period of study at the Instituto di Belle Arte in Florence, also studying at Arezzo and Sansepolcro. He took a particular interest in the paintings of the Quattro-cento artist, Piero della Francesca (1410/20–1492). He also had the opportunity of studying under Florentine artist and teacher, de Bacci-Venuti. Healy's period in Italy resulted in his strong sense of draughtsmanship and almost sculptural treatment of the human figure, which remained an integral part of his style for many years.

On his return to Ireland in May 1901, he continued to contribute to the *Irish Rosary*, while at the same time making hundreds of watercolours which eloquently portray the life of the Dublin City streets. Examples may be found in his delightful *Moore Street Market* (illus. 202), or in his little watercolour portrait *Lighting the Way*. It is interesting to note that these watercolour studies were to become better known than his subsequent contribution to stained glass. But Healy had to support himself. He therefore took on the task of art teacher at the Dominican College, Newbridge, Co. Kildare, and supplied illustrations for the college magazine. However, teaching did not suit his temperament, and he was glad to accept Sarah Purser's invitation to join her co-operative stained-glass studio, known as An Túr Gloine, in 1903. He remained there for the rest of his life. Healy found his strong sense of line had a worthwhile opening in stained glass. This is seen in such early works as an angel, painted for *The Annunciation* window in Loughrea Cathedral in 1903, or his pencil and watercolour cartoon of *St John the Baptist*, which he produced the following year for Gorey Cathedral, Co. Wexford.

The acme of Healy's career was reached in 1940 with the completion of his magnificent *Last Judgement* for Loughrea Cathedral. It is a glittering achievement of splendour and magnificence: 'one of the crowning masterpieces of the Irish stained glass revival.'[23]

SEÁN KEATING, PRHA (1889–1977) was one of a group of painters 'concerned with recording the outer image of the new generation of Irishmen, conscious of the need to manifest a distinct national characteristic of face and costume'. His portraits of *Robert Erskine Childers*, *John Devoy* and *Terence MacSwiney*, all worked in charcoal, show his high degree of technical competence when using this medium. Keating was a superb draughtsman, and after winning a scholarship from the technical school in Limerick to the Metropolitan School of Art in Dublin, became a pupil of William Orpen (see p. 165), who taught him directness and precision, constantly stressing its importance: 'There is only one place for it – the right place. There is only one line which describes a shape, not three.' After finishing at the Metropolitan School of Art in Dublin, Keating went to London and worked as a student in Orpen's studio during 1915. In that year he had a work accepted at the RHA. He returned to Dublin and began teaching at his old art school, and was elected RHA in 1919. He became President of the RHA in 1948, a position he was to hold for fourteen years.

He relied largely on oil, charcoal and pencil rather than watercolour as media in which to express himself.

204] *Austin Clarke (1896–1974)*; (oil on canvas) .
Lilian Lucy Davidson (d. 1954) .

His art, in the words of art critic and author Bruce Arnold, tended to be governed by an 'intense nationalism, love of the language, a belief in the purity of the simple peasant life which, for Keating, was epitomised by the Aran Islands, and a repudiation of modernism in all its forms'.[24] His works in later years tended to become less dramatic, as can be seen from his *The Matriarch* (illus. 205), or indeed, from his *Self-Portrait* (illus. 203) executed in pastel and now in the National Self-Portrait Collection, Limerick.

A regular and consistent contributor to the Watercolour Society of Ireland and the Munster Fine Art Club, LILIAN LUCY DAVIDSON, ARHA (d.1954), was born in Wicklow. She studied at the Metropolitan School of Art, Dublin, and exhibited her work for the first time at the RHA in 1914. From her studio in Earlsfort Terrace she taught drawing in the 1920s, particularly drawing for illustration. Intensely interested in the theatre, she designed and painted scenery for the Torch Theatre and wrote a number of plays. Though primarily a landscape painter, as her watercolours such as *Clouds, Lough Conn* (1930), *The Road to the Sea* (1938), *The Back Strand* (1946) and *Olive Trees, Lake Garda* (1948) demonstrate, she was also a competent portraitist, as may be seen in her oil study of writer and poet Austin Clarke (c.1954) (illus. 204). Painting in Belgium, Swit-

zerland and Italy, she exhibited her work not only in Ireland but also in Amsterdam, Paris and London.

'One of the defects of mankind is its failure to recognise genius until it has been removed. He was a man of the deepest intelligence, with an extraordinarily cultivated mind yet a strong sense of real humour.'[25] So wrote Maurice MacGonigal, PRHA, in a note of appreciation of the work of SEÁN O'SULLIVAN, RHA (1906–1964), a prolific creator of portraits in crayon, pencil and oil.

His excellence as a draughtsman led this Dublin-born artist to achieve rapid success in both England and Ireland soon after he left the Metropolitan School of Art, where he had been successful in winning a teacher-in-training scholarship. After studying lithography in London[26] he went to Paris where, as he remarked somewhat wryly, 'I had all the facilities for painting without the ignorant intervention of unskilled "teachers".' A student with Colarossi and La Grande Chaumière, he also received some tuition from Henri Morriset. He lived for a period in a studio in Montparnasse above that of the sculptor Bourdelle, Rodin's

former pupil. Back in London, he married an English girl, borrowing for the purpose a ten-pound note from the President of the Scottish Academy. Three years later they left London to make their home in Ireland.

Seán's outstanding talents as a draughtsman were quickly recognized and soon led to numerous commissions, one of these being for the design of postage stamps commemorating Douglas Hyde, Rowan Hamilton and Ignatius Rice. Included in the collection of charcoal and pencil studies in the NGI are portraits of many distinguished sitters such as *James Joyce, Jack Butler Yeats* (illus. 207), *Éamon de Valera* and his wife *Sinéad de Valera, Patrick Kavanagh, Thomas McGreevy* and *Maud Gonne McBride* (illus 206). All are executed in charcoal or pencil or a combination of both, and all express his facility and excellence as a superb draughtsman, combined with his gift of capturing a likeness without losing sight of the sitter's essential character: 'Once he commenced with pencil or pen, he could describe the turn of a head, the angle of nose or chin, the poise of *The Lady of the Mantilla* and the roguishness of an Irish girl with the kind of accomplishment reserved for the real masters of art.'[27]

One of the youngest artists ever to be elected to the RHA (aged twenty-one), O'Sullivan became a full Academician in 1931. He exhibited extensively, and to

205] *The Matriarch.*
Seán Keating (1889–1977) .

206] *Maude Gonne McBride (1866–1953), Actress and Revolutionary.* Seán O'Sullivan (1906–1964) .

earn money toured the United States making portrait drawings. Also a painter of interiors and landscapes, he supplied illustrations for M. J. MacManus's *So this is Dublin* (1927).

HARRY KERNOFF, RHA (1900–1974), painted Dublin and its citizens from so many unexpected angles that it is possible to overlook his landscapes, genre painting and bold, dramatic woodcuts. 'As Dublin as Leopold Bloom and in his work as timeless',[28] Kernoff was the son of a Russian furniture maker, Isaac Kernoff, and his Spanish wife Catherine (née Barbarella). The family had emigrated to Dublin from London in 1914 and Harry was apprenticed to his father when he left school. Somehow he managed to find the time to attend night classes at the Metropolitan School of Art, and in 1923 was awarded the Taylor Art Scholarship in both watercolour and oil painting. After he left art school he became friendly with many literary figures of the day, including Liam O'Flaherty and his brother Tom, founders of the Radical Club. Kernoff was also a member of the Studio Club, which was eventually to become known as 'Toto Cogley's Cabaret', in Harcourt Street. It was here that he had the opportunity to meet and to sketch many people from all walks of life. His pictures ranged from a delicate ink and pencil portrait of *A Woman Holding a Flower* (illus. 208) to a pastel of playwright *Brendan Behan*. He also painted theatre sets and designed costumes, generally working in ink, pencil and watercolour, as seen in his design for a costume for a *Female Atlantian*, or a collection of costumes for *Five Gentlemen in Black*. Watercolour adapted itself well to his designs for theatre sets, which included sets for Lord

207] *Jack Butler Yeats (1871–1957)* . Seán O'Sullivan (1906–1964) .

Dunsany's *The Glittering Gate* and Seán O'Casey's *Shadow of a Gunman*.

He captured them all, whether it was the 'Toucher' Doyle (who gained his title from having actually 'touched' King Edward VII at Fairyhouse for a fiver), or Endymion, or the Lavender Man (an Englishman named Clifford who sold artificial lavender and real French letters), or the librarian who could only speak Irish when he was drunk, or more universally acclaimed characters like the 'Pope' O'Mahony and Oliver Gogarty.[29]

A prolific artist, Kernoff painted all his life in Dublin with the exception of a summer spent in Nova Scotia. He exhibited his work as an illustrator at the Arts and

208] *A Woman Holding a Flower.*
Harry Kernoff (1900–1974) .

Crafts Society in 1925 and frequently had his work hung in the RHA from 1926 onwards, being elected a member in 1936. In the 1940s, he produced a series of striking woodcuts, and the Three Candle Press published books of his woodcuts in 1943 and 1945. He also assisted the Yeats family with the production of illustrations for books, broadsheets and ballad sheets for the Cuala Press. But mainly, he spent some sixty years capturing the landscape and characters of his beloved city of Dublin.

Portraiture was, of course, not the only theme occupying artists in the first half of this century. Landscape was to play an important role in the lives of a great number of Irish painters, working both at home and abroad.

The school of landscape painting which emerged in Ireland in the first sixty years of this century tended to be dominated by academic realism, the majority of Irish painters standing apart from international trends. Until the mid-1960s Irish artists were to a large extent unaffected by what was happening in other countries such as America, and this hesitancy in seeking and accepting outside influences can be put down to a number of factors. One of them was the country's isolation, particularly during and immediately after the Second World War. Another was a basic conservatism which ran right through Irish art. Outside influences occupied a subordinate position, and the latest trends on the international scene only began to make an impact in the late 1950s. A passionate concern with their past and their agricultural roots, combined with a deep mistrust of change, all helped to shape the style of these early

twentieth-century Irish landscape painters.

Land was of enormous significance and it remained the dominant theme. Painters were acutely affected by Irish light and Irish scenery, with their use of colours tending to be generally soft, subdued and atmospheric and possessing a mildness that was entirely in keeping with the Irish scene. The urban world seemed very far away. Painters were determined to remain true to their traditional media of oil and watercolour. The intense naturalism of Super-Realism, so prevalent in artists who worked, for example, in the United States during this period, did not make any great impact in this country, the Irish painter preferring an abstractly poetic interpretation of nature rather than the direct and straightforward approach. This allusion to something of significance beneath the outer surface was of vital importance. The poet and writer Seán O'Faolain, referring to works by twentieth-century Irish painter Nano Reid, noted: 'She indicates, hints, suggests, but once we get the hang of her private code, she is just as lucid as painters who speak openly through things made recognisable at a glance.'

MAURICE MACGONIGAL, PRHA (1900–1979) was very much part of this landscape school which emerged in the first sixty years of the century. He was a painter who possessed an acute sense of the Irish reality, basking in the silence of Connemara, in its green-and-grey countryside, and in the enormity of its skies well conveyed in such watercolours as *Morning Tide, Roundstone* or *Clouds over Mount Brandon, Co. Kerry* (illus. 209). In a watercolour such as *Fair Day, Clifden, Connemara,* he shows how he is one of the few Irish landscape painters who could also portray an exciting anecdote at the same time as a lively characterization of the scene before him.

His early training had begun in the stained-glass studio of his uncle Joshua Clarke, to which he was later to return after a period of internment in Kilmainham Gaol, a result of his political activities. While in prison he continued to paint frequently in watercolour. *Republican Prisoners on the Roof, Kilmainham* (illus. 211) dates from this period. Returning to his uncle's studio, MacGonigal received help and encouragement from his cousin Harry Clarke (see p. 123). Watercolours and drawings continued to feature prominently in this early stage of his career, early examples being *Howth Village, Farm near Rush* and *Rathlin from Ballintoy.*

In 1923 Maurice MacGonigal was awarded a scholarship at the Metropolitan School of Art, where he studied under Patrick Joseph Tuohy and Seán Keating. After a study period spent in The Hague he returned to Dublin and was appointed visiting teacher to the RHA School and also at the Metropolitan School of Art, a post he was to hold until his retirement in 1968. Elected RHA in 1933, he became President of the Academy in 1962 and was also an honorary member of the RA and the Royal Scottish Academy.

209] OPPOSITE ABOVE *Clouds over Mount Brandon, Co. Kerry* Maurice MacGonigal (1900–1979) .

210] OPPOSITE BELOW *Ramelton, Co. Donegal.* Norah McGuinness (1903–1980) .

From 1924 onwards MacGonigal painted in Connemara and on the Aran Islands, as well as executing a substantial number of watercolours of the north Down and Antrim coast with Bulmer Hobson (1927–1930). During the war years he moved to Carraroe and Inverin and then, until the late 1970s, painted around Roadstone and Clifden.

Colour and light were of paramount importance to him in his work, their subtle nuances constantly fascinating him. Painting in watercolour on a fairly large scale using big brushes, he was able to control the medium with confidence and ease.

However, as his son Ciarán points out: 'he regularly destroyed paintings, drawings, watercolours and seri-

graphs over his life-time.'[30]

MacGonigal was also interested in stage design and book illustration. He designed the sets for the first Dublin production of Seán O'Casey's *The Silver Tassie*, as well as creating during the late 1920s a number of panels in gouache for the first Irish Sweepstake.

NORAH McGUINNESS, HRHA (1903–1980), unlike MacGonigal, tended to rely more on line than on colour, delineating and articulating her shapes in what the writer Elizabeth Bowen has described as her 'architectural instinct in livingness',[31] with her zoning of distances and the broadening existence of space and light creating landscapes larger than, as canvases, they in fact are. Her colours in oil, watercolour or gouache are frequently muted and almost masculine in tone but, largely through her powerful sense of movement, whether it be in the broad flat, contours of hills seen in her *Landscape, Rathfarnham*, or in her harbour and sea pictures *Dunmore East*, *New York Harbour* and *Barges at Hammersmith*, to name but a few, her work never becomes melancholy or depressing.

Unlike many of her contemporaries, Norah in her early period revealed leanings towards Cubism, and traces are still to be found in her later work, with shallow space and characteristic flatness being constant features. Like MacGonigal she was also a student of Harry Clarke and Patrick Tuohy. Born in Derry, she came to Dublin in 1921 and entered the Metropolitan School of Art, spending a brief period in London before returning to Dublin in 1925 to design stage sets and costumes for the Abbey and Peacock Theatres.

Again, like MacGonigal, she was interested in book illustration, and here her style is clearly influenced by that of Harry Clarke. In 1929, on the advice of her friend and fellow artist, Mainie Jellett (see p. 172), she decided to work in Paris under André Lhote. In 1939 she held her first one-woman exhibition in London. Several months later she showed in America. She exhibited at the RHA in 1940 and was elected an Honorary Member in 1957. A founder member of the Exhibition of Living Art, she became President after Mainie Jellett's death. In 1977 she had the distinction of having an honorary degree of D.Litt. conferred on her by Dublin University.

Norah avoided soft, atmospheric effects in her paintings, preferring a sense of movement, clarity and firmness, creating a sharp formal order. Everything is crisply controlled; the emotional response is held firmly in its place. Her compositions in gouache, including *Ramelton* (illus. 210), *Still Life on the Thames*, *Flower Study* and *Dieppe*, all show an underlying sense of elegance and decoration.

NANO REID (1905–1981), like her contemporary Norah McGuinness, was strongly influenced by Harry Clarke. 'It was a joy to watch him work' she said, and her early illustrations at the RHA (from around 1925) reveal his influence quite clearly. She, like Norah, spent a period studying at the Metropolitan School of Art, where she became a pupil of Keating, Tuohy and Whelan. She also studied in Paris, working with three fellow Irish students, Doreen Dickie, Molloy Maguire and Kathleen Fox in La Grande Chaumière, but she found the standard of teaching not to her liking. In London, she enrolled at the Central School of Art under

211] *Republican Prisoners on the Roof, Kilmainham.*
Maurice MacGonigal (1900–1979) .

Bernard Meninsky, who gave her a good deal of encouragement and confidence. She held her first one-woman show in the Dublin Painters' Gallery in 1934.

As her career progressed she began to make greater use of watercolour, as seen in such works as *The Little Waterfall, London Garden, Churchyard by the Sea* and *The Crabapple Tree*, all of which date from around 1949. During the 1940s, her watercolours often outnumbered her works in oil, one critic remarking: 'In watercolour, she is particularly happy, they are bold and direct colourful statements clearly and unhaltingly expressed.'

Her work has been frequently described as being 'utterly Irish', yet that Irishness is difficult to pin down. Her native region – the Boyne Valley, Achill, Connemara and Donegal – supplied her with a good deal of her subject matter. Nano's first priorities would appear to be an emphasis on line and movement. Space is in many works completely flattened and colours are in a low, sombre, dark key, as seen in two examples in watercolour: *Mud Banks* and *River's Edge*. In 1950 she and Norah McGuinness had the joint distinction of being selected to represent Ireland at the Venice Biennale. A retrospective exhibition of Nano Reid's work took place in Dublin in 1974 at the Municipal Gallery of Modern Art, and at the Ulster Museum in the following year.

WILLIAM JOHN LEECH, RHA (1881–1968), like Nano, had painted in Paris but, unlike her, he loved unusual perspectives, and had a decorative feeling for nature. He was educated at St Columba's College, Rathfarnham, Co. Dublin, and in Switzerland, later studying at the Metropolitan School of Art in Dublin and at the RHA, where he became a pupil of Walter Osborne (see p.159). In 1903 he enrolled at Académie Julian, Paris, for a further two years and had the distinction of being taught by Boulanger, who had been mentor to painter Sir John Lavery (1856–1941). Towards the end of 1905 Leech moved to Brittany and settled in Concarneau, a small town on the Bay of Biscay where he 'retained to the end of his life an enduring love for the landscape and nostalgia for the happiness he had there with youthful friends'.[32]

There he painted *en plein air*, sunlight and shadow flooding his scenes as for example in *Sunny Afternoon in Concarneau*, an oil painting which was exhibited at the RHA in 1909 and described by Thomas Bodkin as being 'charming for its atmospheric clearness, good perspective and other artistic points, which almost make the spectator think he is looking at a real scene instead of a picture'.[33] As his career progressed he became more and more fascinated with his contrasts between light and shade, and in design. This may be seen for example in his *Aloes* series.

Leech was also interested in exploring exciting perspectives, frequently (as in landscape) flattening the picture surface, viewing it from above as in his watercolour *A Snow-Covered Field*, or flattening his shapes as in another watercolour, *Mountain Town* (or *Monastery*). Several of his watercolours seem to be totally unplanned, painted in a moment; a view through a window, or a sunny corner of the garden, as his watercolour *Sunflowers* (illus. 212), now in the Ulster Museum, charmingly demonstrates. Here Leech marvellously captures the sensation of sunlight, using bright colours combined with a broad handling of the medium which

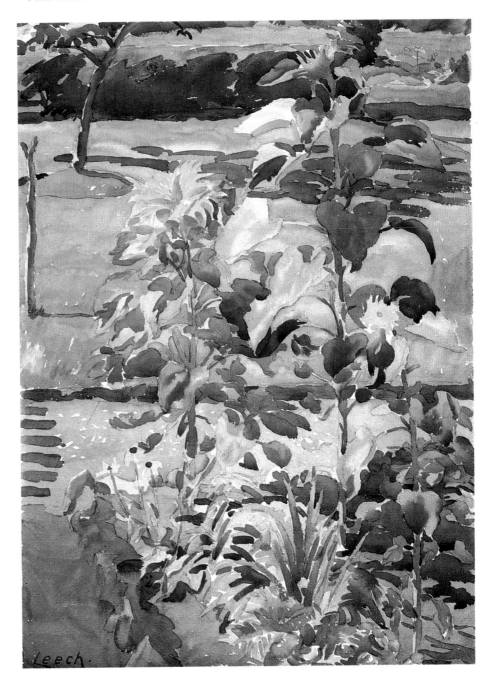

212] *Sunflowers.*
William John Leech (1881–1968) .

all contribute to a 'direct atmospheric impression of nature'.[34]

He travelled all over the Continent to paint, including Switzerland and Italy, and exhibited in Dublin, London and Paris. After his second marriage in 1953 Leech moved from London to Surrey, where the last few years of his life were spent in almost total obscurity. His work varied enormously from small atmospheric impressions of nature to large, carefully thought-out canvases. As he rarely dated his pictures, his chronology is difficult to follow.

Born five years earlier than Leech, PAUL HENRY, RHA (1876–1958) studied at the Belfast Academical Institute and School of Art and spent a short period in

Paris attending classes under Jean-Paul Laurens at the Académie Julian and later in Whistler's new studio, where the great master made it clear: 'I do not teach art, I teach the scientific application of paint and brushes.' Henry, however, was deeply impressed by his teacher's style and technique, as his works were later to reveal. He was also influenced by artists such as Cézanne, Seurat, Gauguin an van Gogh. About van Gogh's painting he records in *An Irish Portrait*: 'It seemed crude and meaningless to me, but in a few months, I would have walked halfway across Paris to look at a new thing by him, for then the revolutionary in me had developed.'[35]

Around 1900 Henry settled in London and three years later married the artist Grace Mitchell (1868–1953). He was working largely in the medium of charcoal and pencil, as his drawings of the Surrey countryside reveal, and beginning to discover his ability to portray landscape. He was also busily illustrating such books as John Davidson's poem *Ballad of a Nun*, a charcoal drawing for which is in the NGI. Some of his finest drawings in this medium, such as *Storm over the Bog* and *Water Meadows*, derive from this fruitful Surrey period.

In the summer of 1921 Henry and his wife went to Achill in the west of Ireland for the first time, and both liked it so much that they remained there for the next seven years. His early Irish landscapes show influences besides that of Millet and Whistler. Henry, like his French counterpart Millet, was more preoccupied with the people who actually worked the land than with the landscape before him. His charcoal portrait of a *Connemara Peasant* and his pencil sketches *The Village Gossip* (illus. 214) and *A Man on a Telegraph Pole* (illus. 215) bear witness to this, being full of richness of personality. The gentleness of the Surrey watermeadows is in complete contrast to these portraits, which capture so well the rugged and hard life of the west of Ireland. Henry's ability to change and adapt his style to his surroundings was one of his outstanding characteristics.

Back in Dublin in the late 1920s, he was producing some of his best work. He and his wife founded the Dublin Painters, whose membership included such well-known artists as Mainie Jellett and Charles Lamb. They held their annual exhibitions in the studio on St Stephen's Green, which had once been owned by the painter Walter Osborne (see p. 159). Around this period, Henry was also designing and producing paintings for posters which included one for Bord Fáilte (the Irish Tourist Board) and others for the London, Midland & Scottish Railway (1925). He was elected RHA in 1929.

In Henry's later landscapes, Whistler's delicate influence begins to creep back, his use of light tones of blues, greys, purples and greens replacing the dark tones of his earlier period. Figures are no longer essential; in many cases he dispenses with them altogether. Balance of colour and composition become all-important, while his attention to the design, shape and pattern of the scene before him is paramount. In fact, in some of these later works, his lakes, mountains and trees possess an almost architectural solidity about them, as exemplified in *The Tree*, which is in a private collection.

MABEL YOUNG (c.1890–1974) was born on the Isle of Wight, coming to work in Dublin as an assistant to her sister, who was manageress of the Shelbourne Hotel. While on holiday in Enniskerry, Co. Wicklow, she met Paul Henry, with whom she lived and painted until his death in 1958. She exhibited at the RHA from 1928 to 1961 and contributed to the 1932 Aonach Tailteann Exhibition of Irish Art. She and Paul Henry eventually married after Grace Henry's death in 1953. Her watercolours are in the Hugh Lane Municipal Gallery, Dublin and many private collections.

Her close friend was FLORA H. MITCHELL (née JAMESON: 1890–1973) whose quiet city scenes of Dublin in ink and watercolour are well known (these views were reproduced or repainted for her book *Vanishing Dublin*, published in 1966). An American by birth, she came to live in Ireland after her marriage, studying at the

213] *Self-Portrait.*
William John Leech (1881–1968) .

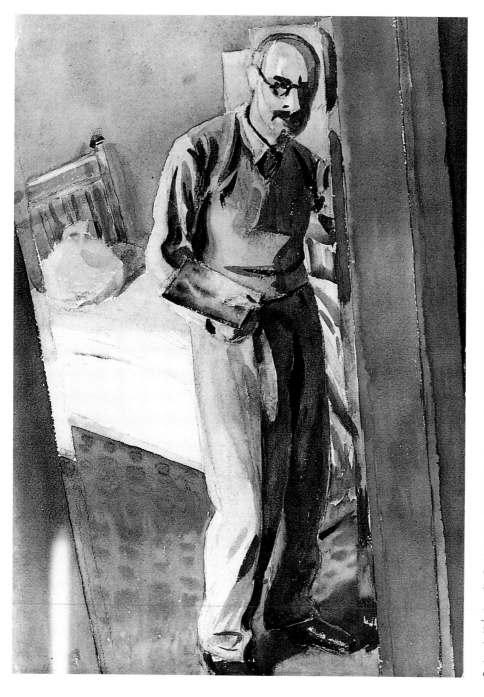

214] *The Village Gossip.*
Paul Henry (1876–1958) .

Metropolitan School of Art. Her watercolour views of
Dublin serve as a valuable pictorial record and a
substantial collection of them (over 300 watercolours
and drawings) are in the NGI.

CHARLES LAMB, RHA (1893–1964), was a close friend
of Paul Henry and also became deeply attracted to the
Connemara landscape. He settled permanently there at
Carraroe in 1935:

> *In Carraroe he found a life which fitted his ideas of
> contemplation, which left time to measure the place of man
> in the landscape, or the fishing boat on the ocean. Above
> all, it gave him the opportunity to describe the joy of song
> and dance and in general to celebrate factors ever present
> amongst simple people living simply. These come across
> boldly in his paintings which sometimes give one to think
> that he could have designed for ballet or theatre, so
> powerful are his elemental outlines and his bold colours.*[36]

Charles Lamb was born in Portadown, the eldest of
seven children. His father was a painter and house-
decorator. Following his father's footsteps, he attended
Portadown Technical School and in 1913 was awarded a
gold medal for being the most outstanding house-
painter of the year. He also found the time to attend the

215] *A Man on a Telegraph Pole*; from a sketch book.
Paul Henry (1876–1958) .

Belfast School of Art in the evenings and, in June 1917,
won a scholarship to the Metropolitan School of Art in
Dublin. During his four years in the capital he made
many friends, including Paul Henry and Arland Percy
Ussher (1899–1980). He eventually left Dublin to paint
full-time in the west of Ireland, where he found the
'national essence' and the time to paint 'those who are of
the earth and who are the seed, root and branch of this

country, and from whom everything proceeds and to whom it seems now everything must return'.[37]

In 1922 Lamb began exhibiting at the RHA, and from then on contributed on a regular basis. He was also elected a member of the Ulster Academy of Arts. Between 1928 and 1934 his work was shown in exhibitions in London, Boston, New York and Chicago, and at the Los Angeles Olympic Art Exhibition of 1932. In 1938 Lamb was elected an Academician of the RHA, and in that same year showed his work at the RA in London.

Lamb's approach to his work was strictly objective. He had little or no interest in trends or developments in painting after French Impressionism. Although he was a pupil of Seán Keating, RHA (1889–1977) there is little influence of his teacher to be found in his painting. Not particularly interested in the subtleties of draughtsmanship or in the detailed finished drawing, Lamb settled down to painting in the Carraroe district, showing every facet of his beloved Connemara landscape, as his watercolour *Lakeside, Connemara* (illus. 217) demonstrates. His delightful pencil and charcoal drawings, such as *The Bishop Leaves the Mainland for the Aran Islands* (illus. 216) or *Bringing Home the Seaweed*, again capture every mood of this rural community.

Unlike Lamb, WILLIAM CONOR, OBE, MA, RHA, PRUA, ROI (1881–1968), found inspiration not in a peaceful country community but in the bustling streets of his native Belfast. He was born in the Old Lodge Road, the son of a wrought-iron worker. His talent for drawing revealed itself at an early age. Louis Mantell, a teacher of music, recognized this and arranged for the young boy to attend the Government School of Design, after which he became an apprentice poster designer at David Allen & Son Ltd. In 1912 he managed to save enough money to study in Paris where 'he learned representation' from old masters. In 1921 he succeeded in having his work hung at the Paris Salon. During the First World War he was appointed by the Government to make official records of munition workers and soldiers. He lived in London after the war, becoming part of the Café Royal set, and was friendly with Lavery and Augustus John. The latter's work in Conor's view was not sufficiently 'Presbyterian, lacking the "Fundamentals"'.

In 1923 he showed his work at the Goupil Gallery in London, and in 1925 in Dublin at 7 St Stephen's Green. A year later he was in New York painting portraits and exhibiting at the Babcock Galleries. Enormously successful, Conor had the distinction of being the first Irish artist to become a member of the Royal Institute of Oil Painters. His work was exhibited at the RA and in a number of exhibitions organized by the Society of Portrait Painters of the Royal Portrait Society. In 1946 he was elected an Academician of the RHA, and also exhibited his works at the Oireachtas. An honorary Master of Arts degree was conferred on him by Queen's

218] *Self-Portrait.*
William Conor (1881–1968) .

University, Belfast, in 1957, and in the same year he was elected President of the Royal Ulster Academy.[38]

His favourite medium seems to have been crayon, in which he excelled: 'He first draws with greasy crayons, and then scrapes away the greater part of the colour with a razor blade in a most ingenious manner and with impressionistic effect shows us a poor but smiling and not unhappy people.'[39] Examples of his work in crayon include *Shipyard Workers Crossing the Queen's Bridge Belfast* (illus. 220), *Children at the Building of a Shelter* and *The Lost Child* (illus. 219), all of which are in the Ulster Museum. Other aspects of Conor's work included watercolours, of which *Ferry Boats, River Lagan* and *Colin Glen, Belfast* and *Antirrhinums* are but three examples. 'He loved above all others watercolour and has made us feel the poetry in a whole series of drawings, watercolours and oil paintings treated with an expert and vigorous hand and with a serious and powerful art, I hope that this remarkable painter will share his success between Ireland and France and that he will soon give us a more complete exhibition of his work.'[40]

Unlike William Conor, VIOLET McADOO (*fl.*1925–1965) rarely used crayon. Her strong, confident watercolour *Tiled Roofs (Spain)* shows a thorough grasp of the medium. Trained at the Belfast School of Art, she exhibited at the Society of Watercolour Artists, Ulster Academy, RHA, and the Royal Ulster Academy.

LETITIA MARY HAMILTON, RHA (1878–1964), was born at Hamwood, Dunboyne, Co. Meath and, like her

216] *The Bishop Leaves the Mainland for the Aran Islands.*
Charles Lamb (1893–1964) .

217] *Lakeside, Connemara.*
Charles Lamb (1893–1964) .

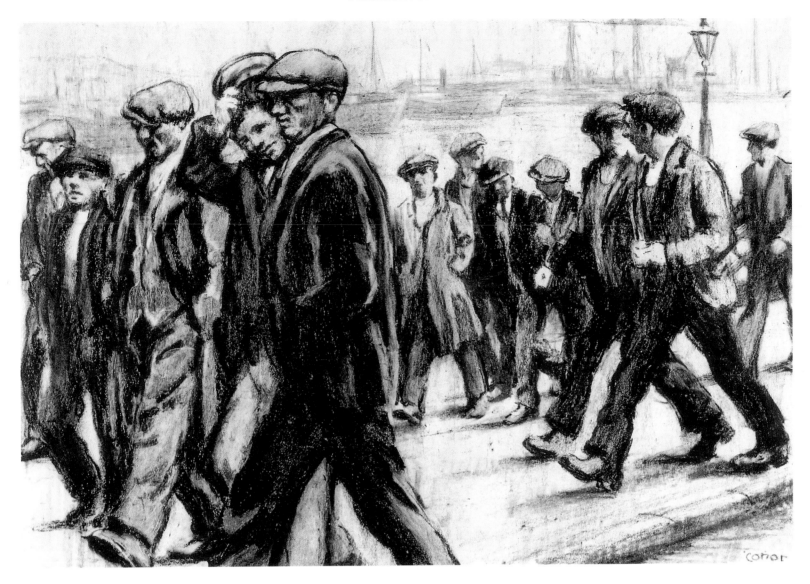

220] *Shipyard Workers Crossing the Queen's Bridge, Belfast.*
William Conor (1881–1968) .

sister Eva (1882–1968), was a student of William Orpen
(see p. 165) at the Metropolitan School of Art. She went
on to study at the London Polytechnic and in Belgium
under Frank Brangwyn.

With Paul Henry, she was one of the founders of the
'Dublin Painters' in 1920, and indeed to some extent her
style reflects his influence, particularly in her use of
colour and handling of light in some of her watercolours
such as: *View of Chapelizod*; *Summer on the Liffey*; *Beech
Trees, Winter*; and *Trees on the Liffey* (illus. 221). These
all display a genuine feeling for the Irish country-
side, with an emphasis on light and reflections. It is
possible that she may have met the Irish painter Roderick
O'Conor (1860–1940) whilst she was working in Paris;
some of her oils portray his 'impressionistic' brush
strokes. Her landscapes have proved very popular with
the buying public over a long period. A year before her

death a Dublin gallery held an exhibition of her work
and every painting was sold.

Thomas McGreevy recalls a day when 'in a huge
gallery in Kensington Gardens, London, I came upon an
Irish landscape by Letitia Hamilton and without glanc-
ing at my catalogue instinctively rejoiced in the feeling
of Ireland and Home!'

GLADYS WYNNE (1878–1968) was born in the same
year as Letitia Hamilton, and was the daughter of the
Archdeacon of Aghadoe. She was related to the Wynne
sisters of Tigroney House, Avoca, Co. Wicklow. Her
early watercolours display a strong sense of feeling for
space coupled with a confident feeling for colour and
light as seen in the example illustrated here (illus. 222).
Her later work tended to lose its sense of freedom and
spontaneity, becoming more tight and concise. She
began exhibiting at the RHA as early as 1889, submitting
two flower studies. Later she completed her art educa-
tion in Rome and Florence. She was a member of the
Irish Water Colour Society and the Dublin Sketching
Club. She settled at Lake Cottage, Glendalough, Co.
Wicklow, where she spent the greater part of her life.

Also a landscape painter in watercolour, JANE
SERVICE WORKMAN (1873–1943) exhibited at the RA
and at the Ulster Academy, and frequently painted in

219] OPPOSITE *The Lost Child.*
William Conor (1881–1968) .

Donegal with John Workman, grandfather of the watercolourist Tom Carr. She was born at Craigdarragh, Helen's Bay, Co. Down, and studied in Belfast with a Miss Douglas who specialized in *chiaroscuro* watercolour studies. Together with her sister, Ellen, she visited the Low Countries when she was sixteen and also had the opportunity of studying in Paris. Her sister, Ellen, worked in Whistler's studio. In 1896 her father's publication, *Malaysian Spiders* (2 vols) was published. She and another sister, Margaret, were responsible for the highly finished and detailed coloured drawings. She married James Yeames in 1901, a nephew of the artist W. F. Yeames, RA, who painted the famous *And when did you last see your Father?*. After her marriage she continued to paint, exhibiting largely in Belfast.

GEORGE WILLIAM RUSSELL ('AE') (1867–1935) was a man of many parts. He was best known as a writer, poet, playwright, and philosopher but was also an amateur painter. Involved in many aspects of Irish life, he studied at evening classes in the RHA Schools and also at the Metropolitan School of Art. Unlike the work of his contemporary Paul Henry, his landscapes nearly always included the presence of figures. These are usually ethereal, visionary creatures, the visual counterpart perhaps of the Celtic Twilight in literature.

Towards the end of his career he began to rely more on the medium of pastel, as two pictures, *A Warrior of the Sidhe* and *Lady with a Lamp*, testify. He was also competent in pen and wash; his *Parent and Child* and *The Traveller* (both in the Armagh Museum) show that his style could equally well be neat, non-visionary and attractive.

A member of the Theosophical Society and active in the Co-Operative movement, he was Vice-President of the Irish National Theatre Society from 1902 to 1904. In 1932 he drew up the rules of the Irish Academy of Letters. Editor of the *Irish Homestead*, he continued in that post when the periodical merged with the *Irish Statesman* and carried on until its last issue in 1930.

JACK BUTLER YEATS, RHA, D.LITT. (1871–1957), was the son of the distinguished portrait painter, John Butler Yeats (see p. 163) and brother of the poet William. Unlike many of his contemporaries he enjoyed a considerable reputation during his lifetime, breaking

221] *Trees on the Liffey.*
Letitia Mary Hamilton (1878–1964) .

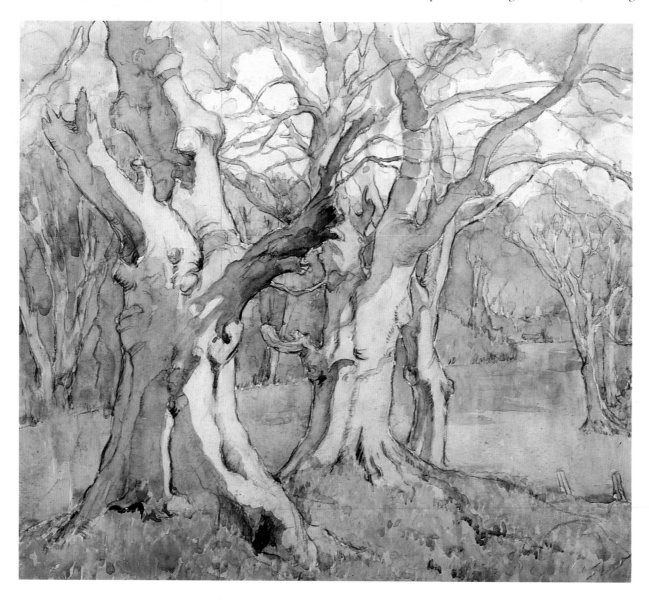

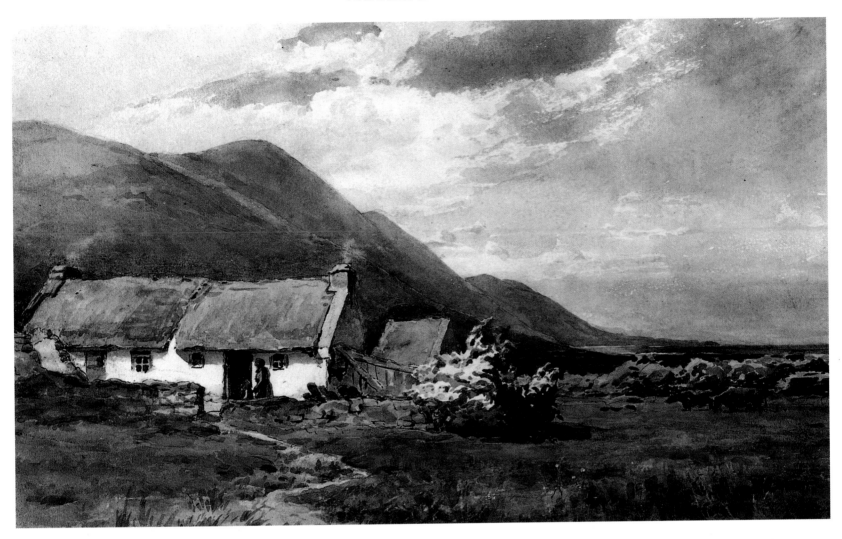

222] *Glenbeigh, Co. Kerry.*
Gladys Wynne (1878–1968).

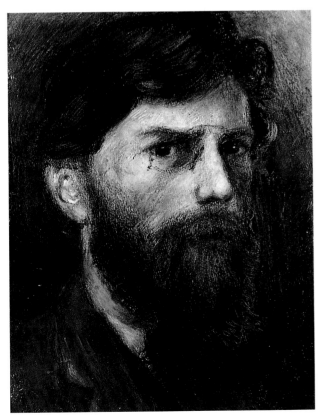

with panache and vigour into the timid world of the 'English and Irish imitators of the Leightons and Ponyters with his troop of tinkers, magic-men, jockeys, clowns, drivers and purse-proud horse-dealers'.[41]

Jack Yeats was the youngest of the four surviving children of the family. Mrs Yeats's health was delicate and her husband's professional career as a portrait painter in London precarious, all of which eventually led to their latest child being sent to live with his Pollexfen grandparents in Sligo. There the young Yeats attended the local school and spent much of his free time drawing and sketching the region that he came to love, and which was later to become the source of imagery and inspiration for so much of his mature work.

In 1887 he joined his family in London and a varied art training followed, which included periods spent at the South Kensington School of Art, under Thomas Armstrong; the Chiswick School of Art; and the Westminster School of Art, where – through Fred Brown's influence and possibly that of Legros – he was

223] *Self-Portrait.*
George William Russell ('AE') (1867–1935).

introduced to and eventually became influenced by the New English Art Club. It was Legros who introduced Yeats to his own type of memory drawing, memory becoming a vital feature in Yeats's later works.

Some of his earliest work in the field of illustration was executed at the age of sixteen, when his first illustrations appeared in the *Vegetarian* (1888). For the next nine years, his work appeared in such black-and-white magazines as *Chums* and *Judy*, Yeats meeting and working alongside such black-and-white artists as Harry Furniss (see p. 148).

In 1896 he decided to settle in Strete in Devon, and began working almost entirely in watercolour. A work in this medium entitled *Memory Harbour*, painted after the death of his mother, shows his reliance on memory, which was now beginning 'to impress him as an artistic implement'.[42]

224] *Singing 'Haul Away Oh'*;
Jack Butler Yeats (1871–1957) .

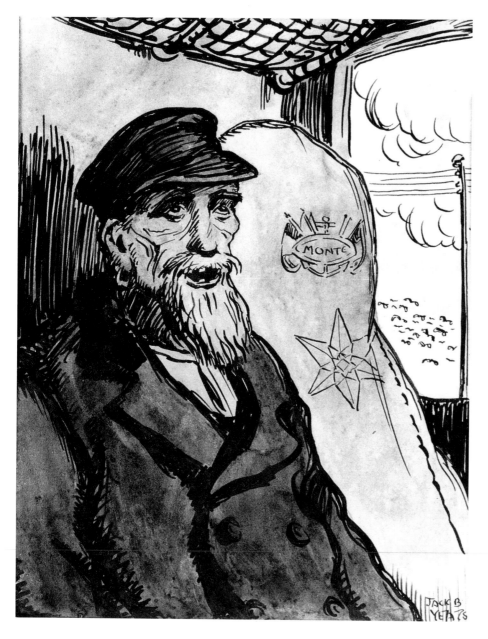

After a visit in the summer of 1905 with the playwright J. M. Synge to the Gaeltacht[43] areas of South Galway, Yeats painted his famous chalk-and-watercolour *The Man from Aranmore*. Here we see the artist's ability to place his figure with ease in a landscape setting, and also his success in imbuing that figure with such pride and arrogance that he completely dominates and diminishes the landscape around him. This work also reveals Yeats's superb qualities of draughtsmanship, his strong feeling for line probably stemming from his work as an illustrator. Throughout his long life he was to find himself continually supplying drawings to accompany the written word, a fact which not only enhanced his drawing ability but also created in his work a strong desire to record a happening or a daily event, as seen in his delightful pen-, ink-and-watercolour *The Country Shop* (illus. 226), one of several drawings executed for *Life in the West of Ireland*, published in 1912.

During his period in Devon he also took the opportunity to exhibit his work on a regular basis, and held his first one-man show in London in 1897; he had already shown his work in Dublin at the RHA two years earlier. In 1904 his work went on view at the Clausen Galleries in New York, and in that same year he contributed to Hugh Lane's exhibition at the Guildhall, London, presenting Lane with a painting for his proposed Gallery of Modern Art in Dublin.

The second period of his career, extending from about 1905 to 1940, saw Yeats beginning to make the gradual change from a superb draughtsman to a colourist – with colour no longer being merely descriptive but rather employed to capture atmosphere and mood, as seen in his watercolour of *Lough Gill, Co. Sligo* (illus. 227), executed in 1906. Here the misty grey atmosphere of a typically 'soft' day in the west of Ireland is marvellously captured.

From his youth and early years spent in Sligo, Yeats had been consistently fascinated and drawn to the excitement and tensions generated by the circus, capturing all aspects of the travelling show through the medium of oil or watercolour. His watercolour *The Circus Chariot* (illus. 228) executed in 1910, recalls for the painter: 'chariot races in a circus tent under a long glass roof, and the way the outer wheels used to spray up the sand and dust when the driver spun his team at the turn'.[44]

It was not until around 1905 that Yeats began painting seriously in oil, but in 1910 he decided to devote himself almost entirely to working in this medium.[45] In that year Yeats left Devon to live at Greystones, Co. Wicklow. He began to take up the threads again as an illustrator, resuming his cartoon work for *Punch* in November 1910 under the pseudonym 'W. Bird'. He continued to contribute until 1941. Gradually he moved 'from being an Edwardian illustrator and genre artist – a kind of Sickert with an Irish accent – into an advanced and daring original, a figure who has no parallel in Irish or British art of his time'.[46]

He received numerous public honours, including a D.Litt. conferred by Dublin University in 1946; a Diploma of the Academia Culturale Adriatica, Milan, in 1949; and in 1950 he was made Chevalier de la Légion d'Honneur. But Yeats was essentially a very private person, taking no pupils and never discussing his works.

225] *A Courtroom Scene.*
Jack Butler Yeats (1871–1957).

226] *The Country Shop*; an illustration for *Life in the West of Ireland*, 1912.
Jack Butler Yeats (1871–1957).

In his own words, 'It doesn't matter who or what I am, people may think what they will of the pictures.'

During the 1930s and '40s Northern Ireland was to produce many fine painters, among them Belfast-born JOHN LUKE (1906–1975), an artist who not only painted landscape and figure subjects but who was also to become a fine sculptor.

Luke's introduction to art began after he had worked as a riveter in the Belfast shipyards and in a flax-spinning company. It was there that he heard about the School of Art, where he eventually enrolled. After distinguishing himself by gaining several prizes, including the Dunville award in 1927, he arrived in London where he became a pupil of Henry Tonks at the Slade, and on occasions attended the Westminster School under Walter Bayes (1869–1956). On his return to Belfast at the end of 1931 Luke began to exhibit at the RHA and in Belfast. He was described as a painter 'who, with his clothes brushed, his hair short, was not at all close to the romantic stereotype of the artist'.[47] Despite the fact that he was keen to paint rather than to hold down a full-time job, Luke obtained employment as an art teacher in Milford while living at Killylea, Co. Armagh, where he had moved in 1941 to avoid the air raids in Belfast.

In his successful career he executed several enormous works, including a 150 ft frieze for the Northern Ireland Government pavilion at the Glasgow Empire Exhibition held in 1938, and a vast mural painting inside the dome of Belfast City Hall, depicting the life and history of the citizens. Two sketches for this mammoth undertaking, one in pencil and the other in bodycolour, are now in the Ulster Museum. It was commissioned to celebrate the Festival of Britain in 1951. Equally at home in tempera, ink and oil, as his studies for *The Rehearsal* (executed both in tempera and pencil) demonstrate, he was also a

227] ABOVE *Lough Gill, Co. Sligo.*
Jack Butler Yeats (1871–1957) .

228] BELOW *The Circus Chariot.*
Jack Butler Yeats (1871–1957) .

229] *The Old Callan Bridge.*
John Luke (1906–1975) .

capable performer when it came to watercolour, as his *Road to the West* amply testifies. Two examples employing both oil and tempera together are *Shaw's Bridge* (1939) and *The Old Callan Bridge* (1949) (illus. 231), both of which reveal a style which is highly rhythmical, decorative and imaginative. He has been described as 'Expressionist' by John Hewitt; 'more precise labels than Romantic are impossible to affix'.

An Ulster 'individualist', COLIN MIDDLETON, RHA, MBE (1910–1983), described his feelings with regard to the painting of landscape:

> *When you get there, you know you belong . . . it gets at you, it eats you. It's as though you've been there always and always been there. When I go to a place there's got to be something in the bloodstream to belong to and . . . to get the old machine ticking . . . there's got to be some sort of place, particular places, holy places. Once you get there, you know you're kith and kin. The stones start to talk.*

Middleton was a born painter. Head of no particular group or school, he was, like Luke, born in the Northern capital, and was the son of a damask designer. He joined his father as an apprentice, at the same time studying at the Belfast School of Art. After his father's death it fell to him to carry on the business, and later he was to attribute his feelings for texture and material to this early training. In 1935 he was made an Associate of the Royal Ulster Academy. He exhibited for the first time at the RHA in 1941 and was elected a full member in 1970. When he was forty-seven he abandoned his damask business and instead devoted himself full-time to painting, spending a year in England before finally settling in Ardglass, Co. Down. Many of his works of the 1940s and '50s were painted in an 'expressionist' style, revealing his superb technical skills and grasp of whatever medium he happened to be working in. Middleton lived in many parts of Northern Ireland, including Bangor, where he moved in 1953 when he was appointed art master at Coleraine Technical School.

In the summer of 1972 he spent a period of two months in the suburb of Rossmoyne, Perth, Western Australia as part of a world trip. Painting in watercolour,

230] *The Mournes from Portaferry.*
Maurice C. Wilks (1911–1984) .

his compositions such as *Landscape after Rain* or *Wattle Bird and Fuchsia* evoke the moods, emotions, colours and contours of his Australian surroundings which he willingly and expertly accepted and articulated into his work. Between 1972 and 1975 he visited Spain, producing his Barcelona notebook series, the majority of drawings such as *Madre y nene, Barcelona* and *Line Drawing, Barcelona* being executed in ink.

Returning to Ireland, Middleton continued to exhibit regularly in both Belfast and Dublin. Writing an introductory note for a catalogue of his paintings, Middleton explained what he was striving to achieve:

These paintings are the product of the interaction of two basic concerns of the painter; with the moods and qualities evoked in him by certain places; by the intimate nature of the rocks, pebbles, trees and plants as much as by the configuration of the mountain, mud flat or cockle strand – and with the essential nature of the materials which he uses, namely chalk, glue, wax and stains.

The keynote is simplicity. . . . Contrary to the more readily accepted notion that images are abstracted or reduced from objects or groups of objects, here the dominant archetypes are coaxed from the amorphous materials and move towards realisation in much the same way as the elements work upon wood and stone; a process of erosion; the polish of wind and rain, the action of sand or the trace of a thorn. . . .[48]

In 1969 Colin Middleton was awarded an MBE. There was a restrospective exhibition of his work in 1976, jointly organized by the Arts Council of Northern Ireland and An Chomhairle Ealaion (Irish Arts Council). Nearly 300 of his works were included.

MAURICE C. WILKS, RUA, ARHA, BWS, UWS (1911–1984), was a Northerner born in Belfast, the son of Randal Wilks, a linen designer. He received his education at Malone Public School, Belfast, and at the Belfast College of Art. After he had been awarded the Dunville Scholarship to the day school he began exhibiting at the age of nineteen in the RHA and also at the Oireachtas. A portraitist as well as being a landscape painter, he sketched and painted all over Ireland, spending his early years living in Cushendun in the Glens of Antrim. A prolific exhibitor, he held one-man shows in Dublin, Belfast, Toronto, Montreal and Boston. Elected an Academician of the Royal Ulster Academy, he spent the later years of his life painting at Sutton, Co. Dublin, where he had a summer studio. Watercolours such as *The Mournes from Portaferry* (illus. 230) and *Rough Seas, N.W. Donegal* show him to be a skilled performer in this medium.

'Like most painters, George Campbell had an intuitive control over his talent. He senses when there is danger of indiscipline, of the lack of formal structure in his painting and perhaps prescribes for himself a momentary reconsideration of the Cubist concepts that informed the work of men like Braque for whom he had a great admiration.'[49] Born in Arklow, Co. Wicklow, GEORGE CAMPBELL, RHA (1917–1979), was fortunate to come from an artistic family. His mother Gretta (née

Bowen) was a primitive painter, and his grandfather had been a sculptor. After he received his education in Dublin, the family moved to Belfast. Following a period as a commercial artist, he decided to opt for full-time painting. Almost entirely self-taught, he and his friend and fellow painter Gerard Dillon spent a good deal of time painting together in Connemara. In these early years both had to struggle to make a living. Then Campbell was awarded first prize in the Open Painting Exhibition sponsored by the Arts Council of Northern Ireland in 1962, and the Douglas Hyde prize for the best historical painting four years later. He was also the recipient of the Irish Landscape prize in the Oireachtas Exhibition in 1969. Campbell's works have been shown in many countries including Spain, where he lived for part of each year for the last twenty-five years of his life, becoming a competent flamenco guitarist. In 1978 he received from the Spanish Government the Order of Merit in the degree of Knight Commander.

His drawings are full of a literal, and in many cases quite specific, imagery. He is extraordinarily aware of the archetypal. Drawings such as *Two Gypsies, Palo* show peasants who are peasants for all time; they could equally be the people of Connemara or Galway. The influence of music played an important part in his work. Acutely aware of the 'unseeing quality of music', he symbolizes this in his drawings of blind street musicians,

guitarists or the members of a *Symphony Orchestra, Carol Singers, El Palo* or *Woman Singing, Malaga Cathedral*.

GERARD DILLON (1916–1971) liked to feature local people in his watercolours, as can be seen from his *Village in the Valley* and *Italian Village*. Here they are conveyed in a simple, straightforward, unsophisticated manner, surrounded by their familiar fields and homes. He ignores conventions such as space and atmosphere and instead concentrates on creating a strong pictorial rhythm, one that is essentially lively and exciting. At the same time he places his figures with great care within the confines of the picture frame itself.

Dillon, like Campbell, spent a substantial proportion of his life in Belfast, being born just off the Falls Road. He left school at fourteen to become a house-painter. Living in London between 1934 and 1939, he took odd jobs so that he could devote most of his time to painting. His first one-man show was held in 1942 at the Country Shop, Dublin. His work was, like that of Campbell, exhibited on a wide scale, notably in the 1958 Pittsburgh International, two years later at the Guggenheim and in 1963 at the Marzotto International in Rome. However, he always retained his strong connections with both Dublin and Belfast, and in 1966 the Arts Council of Northern Ireland mounted a one-man show of his work.

KITTY WILMER O'BRIEN, RHA, UWA (1910–1982), was a distinguished past President of the Water Colour Society of Ireland and was elected an honorary member of the Ulster Women Artists. Daughter-in-law of artist Dermod O'Brien (see p. 169), she was born in Quetta (then in India) where her father was attached to the

231| *Westport, Co. Mayo.*
Kitty Wilmer O'Brien (1910–1982).

232] *Mount Shannon.*
Bea Orpen (1913–1980) .

233] *Girls Making Brushes.*
Mary Swanzy (1882–1978) .

234] *Seated Figures, Samoa.*
Mary Swanzy (1882–1978) .

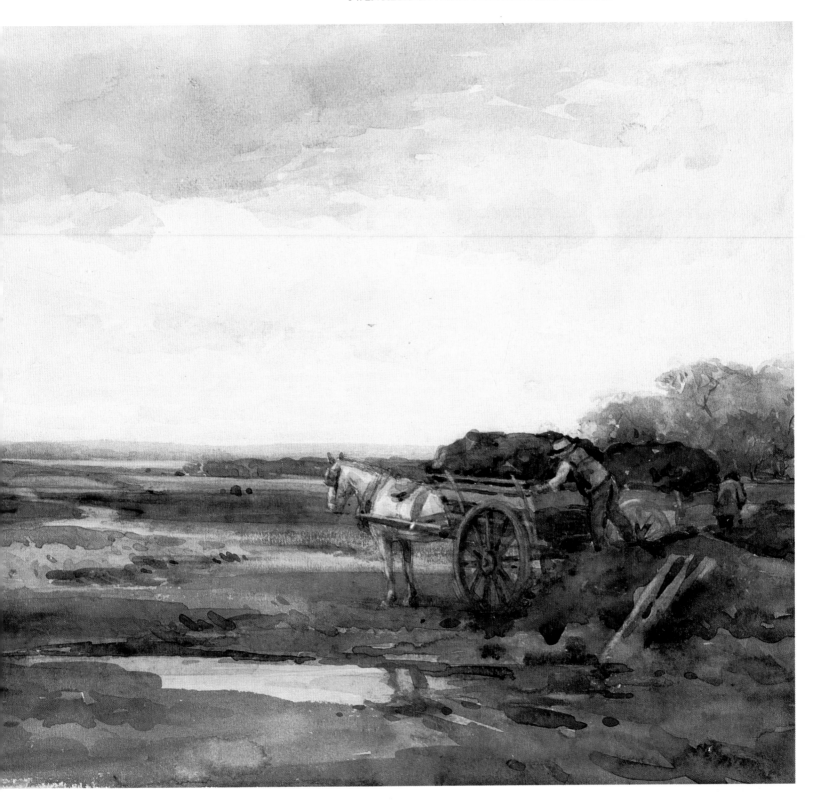

235] *Loading the Turf.*
Frank McKelvey (1895–1974).

Indian Army, her mother coming from Dublin. She was brought home from India during the First World War and vividly remembered travelling across war-torn France. The family settled in London, but soon her father was killed and her mother, brother and herself moved to Dublin. Kitty was sent to school in Kent and by the time she was sixteen was determined to go to art school. She entered the RHA Schools under Dermod O'Brien, and also studied at the Metropolitan College of Art with Maurice MacGonigal (see p. 208). In 1933 she was awarded the Taylor Art Scholarship. A year later, on the strength of this award, she went to the Slade in London. Every summer was spent painting in Connemara. After her marriage she and her husband went to Germany for their honeymoon, where they visited a number of galleries. Much of what she saw there –

particularly works by van Gogh – left a lasting impression on her. She held her first one-woman show in 1938 in the United Arts Club, Dublin. It was opened by the artist Jack Yeats (see p. 196).

More at home painting landscapes than portraits, she worked not only in watercolour but also in gouache. Watercolours from summers spent in the west of Ireland include *View of Killary Harbour*, *Below Kings*, *Errif River*, *The Kileen Road, Co. Mayo* and *The Mall, Westport, Co. Mayo* (illus. 231). In 1964 she was awarded the Douglas Hyde Gold Medal and Prize and the Arts Council Award.

Like Kitty Wilmer O'Brien, BEA ORPEN, HRHA (1913–1980) had a long association with the Water Colour Society of Ireland, exhibiting every year without a break between 1936 and 1980. Related to the painter Sir William Orpen (see p. 165) and Richard Caulfield Orpen (see p. 120), Bea trained at the Metropolitan School of Art and at the Life Schools of the RHA, where she became a prize-winning student. Between 1935 and 1939 she attended the Slade, where she was awarded a Diploma in Design in 1939. While in London she also attended the School of Typography and took a number of courses in textile design and commercial design in the LCC Central School of Arts and Crafts.

Deeply involved in art education, she was appointed a member of the Governing Body of the National Institute for Higher Education, Dublin. Elected Honorary Member of the RHA in 1980, she exhibited consistently with them between 1934 and 1980, and also in the annual Oireachtas Exhibition beginning in 1944.

Generally working in the medium of gouache, watercolour, pen or pencil in preference to oil, Bea was primarily a landscape painter, highly professional in her approach and particularly good at depicting atmospheric effects, as seen in such works as *Mount Shannon* (illus. 232), *Le Mont, Lausanne*, or *Gorteen Strand*. A strong sense of style and draughtsmanship characterized her pen drawings such as *Slane Mill* or *Béguinage Doorway, Bruges*.

A Northern painter who was to make a reputation far outside his native province of Ulster in the field of portraiture before he had reached the age of thirty was FRANK MCKELVEY, RHA, RUA (1895–1974). A highly skilful artist, McKelvey painted landscapes in a manner between that of Constable and the Impressionists, his ability to capture evening light falling over vast expanses of low, level estuaries or plains being one of the major characteristics of his work, as seen in his watercolour *Loading the Turf* (illus. 235). Also a well-known portraitist, he could present his sitter accurately and observantly. This resulted in his becoming an Associate of the RHA before he was thirty and a full Academician in 1930.

A distinguished career at the Belfast School of Art, which included prizes for figure drawing,[50] led him to set up his own studio in Royal Avenue, Belfast, in the early 1930s. His work had already been exhibited at the *Irish Portraits by Ulster Artists* exhibition held at the Belfast Museum and Art Gallery in 1927. In 1936 three of his Irish landscapes were purchased by Dutch people living in Ireland as a wedding present for Princess (later Queen) Juliana of the Netherlands. A year later he held his first one-man show in Dublin. An Academician of the Royal Ulster Academy, McKelvey was a regular contributor to the RHA.

HENRY HEALY, RHA (1909–1982), was for many years President of the Dublin Painters' Group, and his work in watercolour is well known. After graduating from the National College of Art in 1934 he studied in both London and Paris. Over a period of thirty-five years he travelled and painted in such places as Lapland, the islands of the Aegean, the Algarve and Istanbul. Elected to the RHA in 1960, he became one of the best-known figures on the Irish art scene. His works have been shown in many exhibitions abroad, and at home he was a regular contributor to such exhibitions as the Living Art Exhibition and the Oireachtas Exhibition. In 1931 he was elected to the Board of Governors and Guardians of the National Gallery of Ireland. His watercolours of the Irish landscape such as *Rain Over Boffin*, *Howth Harbour* or *Doega, Achill* display a genuine feeling for the country and the life of the people.

MARY SWANZY, HRHA (1882–1978), recognized by many as a living legend, was still exhibiting at the age of ninety-two. A Dubliner, born in Merrion Square and the daughter of a leading oculist, Sir Henry Swanzy, she had the 'privilege of growing up in a completely Georgian city. Everything was in proportion, the size of the squares related to the width of the streets and the heights of the houses, even to the balustrades and the doors. Everything was in complete proportion.'[51]

As a child she attended painting and drawing classes given by a Miss Underwood and a Miss Webb: 'I wanted to know how to draw. That was my chief interest at first.'[52] After finishing her education at Alexandra College and having spent a period at the Lycée in Versailles and in Freiburg, Germany, she returned to Dublin and enrolled at Miss Mary Manning's where J. B. Yeats, whose art she greatly admired and respected, became for a time her teacher. Further tuition followed in the evenings at the Metropolitan School of Art, where she received lessons in modelling from sculptor John Hughes (1865–1941).

Determined to study painting in Paris, and encouraged by Miss Manning, who herself had painted there around the same time as Sarah Purser (see p. 166), in 1905 she became a pupil at Delacluse's, where a studio was provided especially for women. Mary Swanzy describes the scene: 'You went in and the model posed and you just drew and drew. Nobody taught you. You learned by doing it and somebody came round once a week and told you how bad your things were – which you knew anyway.'[53] A second visit to Paris followed around 1906, when she became a pupil of portrait painter, La Grandara, and also worked at Colarossi's studio and at La Grande Chaumière.

On her return to Dublin she was encouraged by her father to follow in the footsteps of Sarah Purser and become a successful portrait painter, and this she did for some time. However, she did not become a full-time professional. Instead, she turned her hand to teaching: 'But I did not like it. You can't teach painting, you can only learn by doing it.'[54]

After the death of her parents within three years of each other Mary decided to travel extensively, visiting the United States, as well as Czechoslovakia and Yugoslavia just after the First World War. Also included

were visits to the lush tropical landscapes of Hawaii and Samoa. The influence of the Tahitian pictures of Gauguin inevitably reflected itself in her work. When she returned from Santa Barbara, California, where she had exhibited her paintings, her art began to enter a Cubist phase, which was not always very successful. It is difficult to pin down her work to periods and subjects. She came under the influence of a number of Continental schools, so that the mood created in her paintings varied considerably. Brian Fallon, art critic of the *Irish Times*, commenting on her work summed it up this way: 'A unique original, quite outside any movement or fashion. From being a straightforward almost realist painter in her earlier phase, she has become poetic and imaginative, very painterly.'

Reluctant to comment on her work, she justified herself by saying, 'After all a picture entails expense, fatigue, trouble, knowledge, patience, tenacity. The artist should not be required to explain in words which are not his medium, what it's all about. How can he know what it's all about? That is your affair.'[55]

Primarily a painter in oil, one must not overlook Mary Swanzy's drawings, whether executed in charcoal, colour crayons or pencil, they were all essentially modern, 'quite personal in their point of view ... far removed from the freaks of the Futurist'.[56] Her travels in Yugoslavia and Czechoslovakia led her to depict the colourful way of life and dramatic landscape of these two countries in colour crayon, and of course in oil. A keen observer of everyday life, she sketched the market scenes with its stalls and groups of seated peasants, peasants in traditional embroidered costumes, or the bird-seller in the market in search of a buyer, in such drawings as *Market Scene – Pottery Seller* and *Outdoor Café Scene*. In 1922 she exhibited these charming coloured drawings at the Dublin Painters' Gallery, a reviewer commenting: 'The colour drawings are also worth attention. The crowd of peasants celebrating the Feast of Corpus Christi is no palette-made gathering, but a gay and animated group, full of vigorous life.'[57]

In Hawaii and Samoa Swanzy obviously revelled in depicting the sunny tropical world around her, as seen in three delightful drawings, *House in Honolulu*, *Seated Figures, Samoa* (illus. 234) and *Girls Making Brushes* (illus. 233). Later, in France, she brought equal zest to *A Game of Football*, or *Café Scene – Gossip*.

Swanzy's style symbolizes the energy and enthusiasm of these twentieth-century artists. Their work contributed generously to the area of watercolours and drawings down through the years, leaving us with a valuable legacy, much of which has yet to be explored.

NOTES

CHAPTER I

1. The measurements of the Book of Durrow are given in the facsimile edition of 1960, p. 3: 'As the leaves have been trimmed irregularly and the size of the writing area varies ... measurements of the writing area of the sacred text are 220–205 × 120 mm ... present measurements of the leaf are approximately 247–225 × 160 mm.'
2. The facsimile edition called this carpet page 'The Biting Animals'. It is a famous Durrow page and would be recognized by this title. The general term for this form of ornament is the 'zoomorphic pattern'.
3. The Psalter of Cormac (BM Add. MS 36929) is believed to date (according to Dr F. Henry) *Irish Art in the Romanesque Period* from AD 1150–1200.
4. Rosalba Carriera (1675–1757). Born in Venice. Both her father and grandfather were painters and as a result she received every encouragement, being also taught by Giovani Antonio Pellegrini (1675–1741). Due to bad eyesight she had to abandon painting miniatures and changed to executing pastels on a large scale; her work became well known. She travelled widely visiting France, Tuscany, Denmark, Austria and Poland. Her contribution to art was important; it was she who introduced ivory as a base on which to paint miniatures. Pasquin states that Rosalba Carriera visited Ireland. However, if she did not, her work would have been known through the collections formed in the 1740s by such Irish peers as Lord Milltown.
5. Anthony Pasquin (*nom de plume* of John Williams), *Memoirs of the Royal Academicians and an Authentic History of the Artists in Ireland*, reprinted edn, pp. 16–17.
6. Dr Michael Wynne, *Burlington Magazine*, February 1972, p. 79. According to Dr Wynne it is possible that Thomas Frye may have been the second son of John Frye (1670–1752) of Edenderry. See also W. H. P. Fry, *Annals of the late Major Oliver Fry, RA*, p. 18.
7. Walter George Strickland, born 3 June 1850, was educated at Ushaw College and London University. He travelled, spending part of his life in Australia. On his return to Ireland he became Registrar of the NGI, and on the death of Sir Hugh Lane (1915) he was appointed Director. In 1920 he was appointed Hon. General Secretary of Royal Society of Antiquaries of Ireland, and held office until 1927 when he resigned due to ill health. For further information see *A Dictionary of Irish Artists* vol. I, reprinted edn (1968), pp. v–viii.
8. W. G. Strickland, vol. I, reprinted edn, p. 385.
9. Dr Michael Wynne, *Burlington Magazine*, February 1972, p. 79.
10. John Thomas Smith, *Nollekens and His Times*, ch. VI, p. 143.
11. Anne Crookshank and The Knight of Glin, *The Painters of Ireland c.1660–1920*, ch. V, p. 86.
12. John Camillus Hone (1759–1836) is thought to have travelled to the East Indies in about 1780. The evidence of his residence there consists of two advertisements which appeared in two Calcutta newspapers. The first, dated 22 March 1784,

announced that Mr Hone had a house to let in Rada Bazar; and the second, dated 14 April 1785, announced that the miniaturist offered to instruct his pupils in drawing or painting at his house.
13. Thomas James Mulvany, 'Hugh Douglas Hamilton', *Dublin Monthly Magazine*, January–June 1842, pp. 68–9.
14. Ibid., p. 68.
15. *Firenze e l'Inghilterra, rapporti artistici e culturali del XVI al XX secolo*, cat. no. 55.
16. MSS 'Canoviani', Bassano del Grappa, Biblioteca Civica Epistolario Comune v, 3491.8.
17. See Paul E. M. Caffrey, 'The life and career of Sampson Towgood Roch, miniaturist', *GPA Irish Arts Review*, vol. III, no. 4, winter 1986, pp. 14–21.
18. Paul E. M. Caffrey, *GPA Irish Arts Review*, vol. IV, no. 3, 1986, pp. 42–7.
19. Caffrey, ibid., p. 42.
20. W. G. Strickland, vol. II, reprinted edn, p. 284.
21. W. G. Strickland, vol. II, p. 287, records the date of Walter Robertson's death as 1802. However, William Foster, CIE, in his article 'British artists in India', *Walpole Society*, vol. XIX, p. 66, states that the date given by Strickland is incorrect as a return at the India Office of Administration granted in 1801 is recorded for Charles Robertson's estate (18 December).
22. W. G. Strickland, vol. I, reprinted edn, p. 581.

CHAPTER II

1. Macauley & Hughes, *Charts coast of Ireland*, 1790–4.
2. For further information relating to Francis Place, see Patricia Butler, 'The ingenious Mr Francis Place', *GPA Irish Arts Review*, vol. I. no. 4, winter 1984, pp. 38–40.
3. The Dublin Society had originated in 1731 in Hawkins Street, Dublin, on the site of the old Theatre Royal, and was supported by a number of leading Dublin citizens for about eighteen years. The minutes of a meeting held on 18 May 1746 record that 'Since a good spirit shows itself for drawing and designing, which is the groundwork of painting and so useful in manufactures, it is intended to erect a little academy or school of drawing and painting, from whence some geniuses may arise to the benefit and honour of this Kingdom; and it is hoped that gentlemen of taste will encourage and support so useful a design'. Premises (which have long since disappeared) were obtained in Shaw's Court, off Dame Street, then in 1767 the school moved to Grafton Street; thirty years later its address was again given as Hawkins Street. In 1815 the 'little academy' finally established itself near Leinster House. In 1820 George IV bestowed upon it the title of the Royal Dublin Society. Its first teachers were the distinguished Irish-born Robert West (d.1770) and French-born James Mannin (d.1779). Mannin was appointed as assistant in 1746 to teach language and ornament while West, as Principal, taught in the Figure School. Down through the years a number of changes in the title and authority took place. In 1848 it passed from the Royal Dublin Society to the newly appointed Board of Trade, and was thereafter known as the School of Art. It became the Metropolitan School of Art in 1877, and today is

known as the National College of Art and Design, enjoying new premises in Thomas Street in the heart of the city.
4. A record of the minutes for the year 1740 are in the Society's Library, Ballsbridge, Dublin. For further information about the Society and other Irish societies, see W. G. Strickland, *A Dictionary of Irish Artists*, vol. II, reprinted edn.
5. Anne Crookshank and The Knight of Glin, *The Painters of Ireland c.1660–1920*, ch. III, p. 55.
6. W. G. Strickland, vol. II, pp. 462–65, reprinted edn.
7. 'A Philosophical Landscape. Susanna Drury and the Giant's Causeway', *Art History Journal*, vol. no. 3, September 1980, p. 265.
8. According to Mrs Delany, Susanna Drury spent three months at the Causeway. See Mrs Delany, letter to her sister dated 8 October 1758. Lady Llanover, ed. *Autobiography and Correspondence of Mary Granville, Mrs Delany*, London 1861, vol. III, p. 519. It is believed that Susanna Drury's family were also connected with the French miniaturist, Jean Petitot (1607–1691), although not the branch to which Susanna Drury belonged.
9. Anthony Pasquin (*nom de plume* of John Williams), *Memoirs of the Royal Academicians & an Authentic History of the Artists of Ireland ...*, reprinted edn, p. 40.
10. *A Catalogue of a Collection of Modern Pictures and Drawings chiefly consisting of the Works and Property of Mr Serres, Junior ... which will be sold by Auction of Mr Greenwood ... on ... 22nd of April, 1790, and following day* A copy of this catalogue is in the V&A, London.
11. T. Mulvany, RHA, *The Life of James Gandon, Esq., MRIA, FRS, etc., Architect*, ch. X, p. 142.
12. *A Picturesque & Descriptive View of the City of Dublin displayed in a Series of the most Interesting Scenes taken in the Year 1791*, by James Malton, with a brief authentic history from the earliest accounts to the present times.
13. *A Treatise on Perspective on the Principles of Dr Taylor*, 1775.
14. Martin Hardie, *Water-colour Painting in Britain*, vol. I, p. 178.
15. W. G. Strickland, vol. I, p. 344.
16. Drawn and engraved in aquatint by Jonathan Fisher, and forming an appendix to his *Scenery of Ireland*.
17. Anthony Pasquin, p. 44.
18. Revd George N. Wright, *Ireland Illustrated*. This was illustrated from original drawings by G. Petrie, W. H. Bartlett and T. M. Baynes with descriptions by G. N. Wright.
19. N. P. Willis and J. S. Coyne, *The Scenery and Antiquities of Ireland*. This was illustrated from drawings by Bartlett, the literary portion of the work by Willis and Coyne.
20. Revd William Gilpin, *Three Essays on Picturesque Beauty; on Picturesque Travel; and on Sketching Landscape; to which is added a poem, on landscape painting*.

CHAPTER III

1. The Diary of Joseph Farington. The original diary is in the Royal Library, Windsor and a copy is in the BM Reading Room, London.

2. For further information relating to R. Crone, J. Forrester, H. P. Dean and other Irish artists working in Rome during this period, see Nicola Figgis, *GPA Irish Arts Review*, vol. III, no. 3, pp. 28–36, vol. IV, no. 4, pp. 60–5 and *GPA Irish Arts Review Yearbook* 1988, pp. 125–36. I am greatly indebted to Nicola Figgis for information about these artists.

3. Edward Edwards, *Anecdotes of Painters*, p. 59.

4. Ibid., p. 59.

5. Frequently known as 'the Father of English Watercolour', Paul Sandby's, RA, (1725–1809), landscapes both in watercolour and bodycolour had a considerable influence on topographical painting in the second half of the eighteenth century. He was one of the first professional watercolourists to use aquatint, which had been introduced into England by one of his pupils and sketching companions, the Hon. Charles F. Greville (1749–1809). A Foundation Member of the RA, he was an astute and popular teacher, numbering among his pupils many influential amateurs. His brother Thomas Sandby, RA (1721–1798), was also a drawing master and a Foundation Member of the RA. Unlike his brother he was also an architect, becoming first Professor of Architecture of the RA; his best known architectural drawings are views of the Covent Garden arcades, London.

6. See Richard Brinsley Ford, 'The Letters of Jonathan Skelton Written from Rome & Tivoli in 1758 together with correspondence relating to his Death on 19 January 1759', ed. Brinsley Ford, *Walpole Society*, vol. XXXVI, 1956–58, p. 28.

7. Thomas Jones 'Memoirs of Thomas Jones', *Walpole Society*, 1946–48, vol. 32, p. 12.

8. Edwards, op. cit., p. 108.

9. Jones, op. cit., p. 12.

10. Ibid., p. 12.

11. W. G. Strickland, *A Dictionary of Irish Artists*, vol. I, reprinted edn, p. 30.

12. Registry of Deeds, Dublin, no. 223 52 146588. Also see Anne Crookshank and The Knight of Glin, *The Painters of Ireland, c.1660–1920*, ch. VII, p. 116.

13. Martin Hardie, *Water-colour Painting in Britain*, vol. II, p. 87.

14. George Petrie (1790–1866) travelled to London with J. A. O'Connor (1792–1841) and Francis Danby, ARA (1793–1861), but he quickly returned to Dublin leaving his two friends behind. He had managed to raise the money for his fare by selling a painting. Sketches relating to the outward journey, executed in 1813, are in the NGI cat. nos. 6742 & 6745.

15. David Bogue, *Men of the Time, a biographical dictionary*, p. 44.

16. John Hutchinson, *J. A. O'Connor*, catalogue, NGI., November–December 1985, p. 83.

17. John Roberts, letter dated 8 January 1779 to an unnamed correspondent.

18. James Barry, RA (1741–1806). Historical, mythological and biblical painter. Born in Cork, he was a student of John Butts (*c*.1728–1764) whom he attributed 'my first guide, and was what enamoured me with art itself'. (See James Barry, *The Works of James Barry . . . containing his correspondence . . . his lectures . . .*, ed. E. Fryer, 2 vols., London 1809, vol. I, p. 22.) Also see Anne Crookshank and The Knight of Glin, *The Painters of Ireland c.1660–1920*, ch. 6, pp. 105–10. Barry's contribution to watercolour was, as far as can be ascertained, negligible. However, he did occasionally combine pen with Indian ink washes or sepia. His drawings were strong and powerful in concept particularly when he used a broad pen.

19. John Roberts, letter dated 8 January 1779 to an unnamed correspondent.

20. Prof. Thomas J. Mulvany, RHA, 'Memoirs of National Artists', no. 11, Mr Thomas Sautelle Roberts, RHA, *Citizen*, XXXC, no. 1841, p. 243.

21. Anthony Pasquin, (nom de plume of John Williams), *Memoirs of the Royal Academicians and an Authentic History of the Artists of Ireland*, reprinted edn, p. 8.

22. W. G. Strickland, op. cit., vol. II, pp. 279–80.

23. Crookshank and The Knight of Glin, op. cit., ch. VIII, p. 137.

24. The Rt. Hon. Charles Abbot, 1st Baron Colchester, (1757–1829) became speaker of the English House of Commons on 11 February 1801 (until 1817).

25. RIA MS no. 24K 14, pp. 113–14, entry for 25 January 1802.

26. The *via militaris* was built following the rebellion of 1798 in order to allow the army easier access to the Wicklow mountains. It was constructed from Rathfarnham in the County of Dublin to Laragh in the County of Wicklow.

27. RIA MS no. 24K 14, pp. 113–14, entry for 25 January 1802.

28. Edwards, op. cit., p. 268.

29. For further information on Francis Wheatley's years in Ireland, see Patricia Butler, 'Gathering on the Green', *Martello*, spring 1985, pp. 46–50.

30. Mary Webster, *Francis Wheatley*, p. 48. According to Webster, Francis Wheatley probably returned to England 'in the later months of 1783'.

31. Alistair Rowan, 'Poor William Pars, a forgotten early English Watercolourist'. *Country Life Annual*, 1970, pp. 116–18.

32. Pasquin, op. cit., p. 53.

33. Nicholson's drawing manual. *The Practice of Drawing and Painting Landscapes from Nature in Watercolours*, was published in 1820.

34. Pasquin, op. cit., p. 53.

35. Ibid., p. 53.

36. Crookshank and The Knight of Glin, op. cit., ch. 8, p. 139.

37. See note 5, ch. III.

38. For further information on the life and work of James Gandon see Edward McParland, *James Gandon, Vitruvius hibernicus*.

39. A curious incident took place while Cornelius Varley was sketching in Killarney. A hunted fox decided to seek refuge under his stool, which was concealed by the painter's long coat. A pungent smell attracted the artist's attention and he got up, but the fox took fright and ran off. Shortly afterwards the hounds arrived, upsetting the artist's materials, and poor Varley had to take refuge in a nearby tree, much to the amusement of the hunt followers when they arrived on the scene.

40. Samuel Redgrave *A Dictionary of Artists of the English School*, p. 360.

CHAPTER IV

1. Erwin Panofsky, *Early Netherlandish Painting*, vol. I, ch. v, 'Reality and Symbolism in Early Flemish Painting: 'Spiritualia sub metaphoria corporalium', p. 146; epilogue, 'The Heritage of the Founders', p. 333.

2. Peter J. Mitchell, *European Flower Painters*, Introduction, p. 14.

3. Wilfred Blunt, with the assistance of William T. Stearn, *The Art of Botanical Illustration*, ch. III, 'The Rebirth of Naturalism', p. 29.

4. For further information on William Kilburn see Patricia Butler, 'Designers of distinction. William Kilburn (1745–1818) and Samuel Dixon (fl. 1745–1769)', *GPA Irish Arts Review Year Book*, 1990, pp. 176–189.

5. Patricia Butler, 'A Designer of Distinction', *Friends of the Royal Society of Watercolours & Drawings*, spring 1987, pp. 37–9.

6. See Sothebys *A Magnificent Collection of Botanical Books*, 1987.

7. Patricia Butler, 'Designers of Distinction . . .', op. cit., *GPA Irish Arts Review Year Book*, 1990, pp. 176–189.

8. According to Dr E. C. Nelson this was published in 1789 (see his letter to the Director, National Library of Ireland, Dublin dated 17 January 1979 attached to the fly-leaf of Walter Wade's *Flora dublinensis*. Ref: LBR 5280). Also see Dr E. C. Nelson, 'Walter Wade's *Flora dublinensis*, an enigmatic Irish botanical publication', *Long Room Bulletin of the Friends of the Library, Trinity College, Dublin*, nos. 20 and 21, spring and autumn, 1980.

9. John Templeton (1766–1825), Journal and *Flora hibernica*, Ulster Museum, Ref: L2–1939.

10. John Templeton (1766–1825), *Catalogue of the native plants of Ireland*, RIA, Ref: (SR.)3.B48. A letter dated 1897 (inside the front cover) from Frances M. More to Dr Wright, Secretary, RIA, states that the manuscript was drawn up between 1794 and 1810 by John Templeton. It was lent by his son to Alexander Goodman More when he was preparing the second edition of *Cyble hibernica* on the condition that it should be placed in the Library of the RIA afterwards.

11. A detailed account of his journey in Ceylon was given in the *Dublin University Magazine*, vol. 40, 1852.

12. M. J. P. Scannell and Christina I. Houston, 'George V. du Noyer (1817–1869). A catalogue of Plant Paintings at the National Botanic gardens, Glasnevin with aspects of his scientific life', *Journal of Life Sciences*, Royal Dublin Society, 2 (1), 1980, pp. 1–13.

13. George V. du Noyer, *First Public Memoir of the City and N.W. Liberties of London Derry, Parish of Templemore*.

14. W. H. Harvey, *Manual of the British Algae*.

15. W. H. Harvey, *Phycologia britannica, or a History of British sea-weeds*.

16. W. H. Harvey, *Phycologia australica, or a History of Australian sea-weeds*.

17. W. H. Harvey, *Flora capensis, being a systematic description of the plants of the Cape Colony, Caffraria, and Port Natal*.

18. W. H. Harvey, *Thesaurus capensis, or illustrations of the South African Plants, selected from Dublin University Herbarium*.

19. W. H. Harvey, *Phycologia britannica*, op. cit.

20. Robert David Fitzgerald, FLS, *Australian Orchids*, part 1, vol. I, published 1875 and parts 1–7 completed 1882. 4 parts of vol. II had been published before his death on August 12 1892 at Hunter's Hill, Sydney. He left a considerable number of notes and drawings relating to orchids. From these, Henry Deane, FLS, assisted by A. J. Stopps (Fitzgerald's lithographer), prepared them for publication. The plates in part 5, vol. II, were published by Deane & Stopps in 1894 but there publication ended. The Trustees of the Mitchell Library, Sydney secured the majority of the unpublished plates and unfinished drawings.

21. Charles Moore assisted by Ernst Betcher, *Handbook of the Flora of New South Wales*.

22. James Townsend Mackay, *Flora hibernica, comprising the flowering plants of Ireland arranged according to the natural system with a synopsis of the genera according to the Linnean system*.

23. Dawson Turner, *Fuci, sive Plantarum fucorum generi a botanics ascriptarum icones, descriptiones et historia*, 4 vols (In Latin and English).

24. Letter from the Hon. Katherine Plunket to Professor Thomas Johnson, Professor of Botany, College of Science, dated 21 May 1903. This, together with a collection of her letters, is in the National Botanic Gardens, Glasnevin, Dublin.

25. Sir Frederick William Moore (1857–1950). Associate of the Linnean Society (1893). Fellow of the Linnean Society (1911). Awarded Victoria Medal of Honour (1897). Veitch Memorial Medal (1932). Curator Trinity College Garden, Dublin 1877–79. Succeeded his father, David (1807–1879) as Curator of the Royal Botanic Gardens, Glasnevin, 1879–1922.

26. Frederick William Burbidge, *The Art of Botanical Drawing*, published 1873.

27. The words of a critic in the *Atheneaum*, 5 May 1897.

28. Anne Crookshank and The Knight of Glin, *Mildred Anne Butler (1858–1941)*, p. 6.

29. William Frank Calderon, ROI (1865–1943). Founder and Principal of a School of animal painting which existed from 1894–1916.

NOTES

30. Lionel Dalhousie Robertson Edwards, RI, RCA (1878–1966). Painter and illustrator. Studied under William Frank Calderon. Exhibited Royal Institute of Painters in Watercolours. Books illustrated by him and relating to Ireland include *Irish Hunting* by Muriel Bowen, ills. L. Edwards, p. xvi; *My Irish Sketchbook*, 1938, p. 68.
31. Robert Lloyd Praeger, *Weeds, Simple Lessons for Children*.
32. Elizabeth Corbet (Lollie) Yeats, *Brushwork Studies of Flowers, Fruit and Animals*, 1896, p. 6.
33. Homan Potterton, *Irish Women Artists. From the Eighteenth Century to the Present Day*, p. 195.
34. Elizabeth Corbet Yeats was responsible for designing the Women's National Health Association of Ireland Christmas stamp, 1909.
35. Only one of the sixty-six watercolours presented by Charlotte Wheeler-Cuffe to the National Botanic Gardens, Glasnevin, Dublin, can now be traced.
36. John Hutchinson, *The Families of Flowering Plants*.
37. John Hutchinson and John MacEwan Dalziel *Flora of West Tropical Africa*.
38. *Flowers* by Maurice de Vlaminck (1876–1957), who exhibited with the Fauves, was owned by Father Jack P. Hanlon and exhibited at a loan exhibition of continental paintings held in Dublin in 1944. It was later purchased by the NGI at a sale at the Dawson Gallery, Dublin.

CHAPTER V

1. Ghezzi was called *il famoso cavaliere delle caricature*, 'the famous knight of caricatures'.
2. See Cynthia O'Connor, 'The Parody of the School of Athens, The Irish Connection', *Irish Georgian Society*, vol. XXVI, 1983, pp. 5–22.
3. Henry Angelo, *Reminiscences of Henry Angelo, with Memoirs of his late father & friends*, vol. I, p. 269.
4. W. G. Strickland, *A Dictionary of Irish Artists*, vol. I, p. 75.
5. From Caroline Hamilton's diary, partially quoted in *The Hamwood Papers* by Miss Eva Bell, 1930.
6. *Fraser's Magazine*, VII, June 1833, p. 706. This was no. 37 of Maclise's 'Gallery of Illustrious Literary Characters'.
7. Ibid., XI, January 1835.
8. G. White, *In Memoriam Mathew Lawless*.
9. G. White, *Quarto*, p. 49.
10. Prospectus for *Once a Week*, May 1859.
11. George Dalziel, *The Brothers Dalziel, a record of their work*, p. 236.
12. Dalziel, op. cit., p. 307.
13. Marion H. Spielman, *History of Punch*, p. 517.
14. Dalziel, op. cit., p. 328.
15. Sir David Low, *British Cartoonists, Caricaturists and Comic Artists*. pp. 30–2.
16. Simon Houfe, *The Dictionary of British Book Illustrators and Caricaturists, 1800–1914*, p. 365.
17. Dalziel, op. cit., p. 314.
18. W. G. Strickland, op. cit., vol. I, p. 115.
19. Furniss's sketch of the South Donegal MP, the flamboyant Irish nationalist, J. G. Swift MacNeill, depicted the Member for Parliament as an ape. This was too much for the volatile MP to bear and he made plans with fellow Irish nationalists to gain his revenge. They waylaid the caricaturist in the lobby of the House of Commons and told him what they thought of him, MacNeill going so far as to commit a 'technical assault' on the artist. Furniss wisely avoided a physical response but in due course gained his revenge. On 23 September, Punch published a full page cartoon of the parliamentary party, all of whom were depicted with beautiful, sweet, angelic faces. Swift MacNeill stood in the foreground his face carrying a tranquil expression. The bottom left hand corner carried a self portrait of the artist depicted as an ape. The drawing was entitled *A House of Apollo-ticians—As Seen by Themselves* and was signed 'Lika Joko'. Furniss had succeeded in turning the tables on his assailants.
20. Roderic O'Conor (1860–1940) was born in Co. Roscommon, Ireland. He entered the Metropolitan School of Art in Dublin in 1878 remaining there for the next five years. In the autumn of 1883 he enrolled at the Academie Royal des Beaux-Arts, Antwerp under Verlat. He left the Academy in late summer 1884. Around 1866 he was in Paris studying under Carolus-Duran and exhibited at the Paris Salon in 1888, '89 and '90, where Rousseau, Toulouse-Lautrec, Signac, Seurat, Redon, Bernard and Van Gogh were also active participants, the latter's work having a profound effect on the Irish artist. O'Conor spent ten or possibly more years in Brittany, moving there in about 1890. He is said to have met Gauguin after Gauguin's return from Tahiti in 1894. In 1904 O'Conor left Brittany and returned to live and paint in Paris exhibiting at the Salon d'Automne in 1903, becoming a member of the jury in 1908. Towards the end of his life he married Mlle Renee Honta, herself a painter. He died on 18 March 1940 and was buried at Nueil-sur-Layon, (Maine-et-Loire). For further information see Dr J. Campbell, 'An Irish Expressionist'. *Irish Artists in France & Belgium*. pp. 96–103.
21. W. G. Strickland, op. cit. vol. II. p. 145.
22. *Dublin Figaro*, vol. I, 9 April 1982, p. 115.
23. For further information about this artist's graphic work see Dr Nicola Gordon Bowe, *Harry Clarke: His Graphic Art*.
24. For further biographical details relating to Harry Clarke see Dr Nicola Gordon Bowe, *The Life and Work of Harry Clarke*.
25. Dr Nicola Gordon Bowe, *Monograph of Harry Clarke*.
26. Harry Clarke had already completed a number of illustrations for Pope's *The Rape of the Lock* which had been commissioned by his patron, Laurence Ambrose Waldron.
27. Thomas Bodkin, 'The Art of Illustration: Fairy Tales from Hans Christian Anderson' illustrated by Harry Clarke, *Studies*, vol. VI, no. 22, June 1917.
28. George G. Harrap, *Some Memories 1901–1935: A Publisher's Record*. ch. II, p. 60.
29. Quoted in Bowe, *Harry Clarke: His Graphic Art*, op. cit., ch. 13, p. 102.
30. Quoted in *All for Hecuba* (ed. Richard Pine; catalogue of 1978 exhibition).

CHAPTER VI

1. W. G. Strickland, *A Dictionary of Irish Artists*, vol. II, reprinted edn, p. 135.
2. *Dublin University Magazine*, August 1874.
3. Kingstown, Co. Dublin changed its name to Dun Laoghaire in 1920. See Peter Pearson, *Dun Laoghaire Kingstown*, p. 13.
4. W. G. Strickland, op. cit., vol. II, p. 404.
5. *The Art of Landscape Painting in Watercolours* by Thomas Leeson Rowbotham.
6. John Ruskin, *Notes on the RA, 1858 and 1859*.
7. W. G. Strickland, op. cit., vol. I, p. 340.
8. For further information on Louisa Anne Stuart (1818–1891) see Patricia Butler, 'A Victorian Watercolourist' *Friends of the Royal Society of Watercolours and Drawings*.
9. Martin Hardie, *Watercolour Painting in Britain*, vol. II, p. 140.
10. *Art Journal*, 1857.
11. William Sandby, *The History of the Royal Academy of Arts*, reprinted edn, vol. II, p. 304.
12. William Thompson, *The Natural History of Ireland – Birds*, vol. I, pp. 13, 14.
13. *Athenaeum*, 10 June 1848, p. 584.
14. John Ruskin, *Notes* (ed. Cook and Wedderburn), vol. XIV, pp. 32, 33.
15. The ballad was translated by Whitley Stokes, brother of Margaret Stokes, and was published in *Fraser's Magazine*, 1855, vol. II, January, p. 89. Whitley Stokes (1830–1909) was born in Dublin, the son of Dr William Stokes (1804–1900). He was educated at Trinity College, Dublin and called to the English Bar in 1855. He travelled to India in 1862 and held several important legal posts in Madras and Calcutta. He remained in India for fifteen years and then returned to Ireland in 1882. He concentrated on studying old Irish texts and glosses together with associated languages, notably Breton and Cornish. He edited many of these texts providing translations. His library of Celtic books was presented to University College, London by his daughter, Margaret NcNair Stokes. Margaret McNair Stokes (1832–1900) was an archaeologist, illustrator, writer and artist, (exhibited at the RHA 1895). She travelled with her father and Lord Dunraven recording Irish architectural remains, sketching and recording what she saw. Many of these drawings and watercolours are now in the NGI collection. She also travelled extensively on the Continent. She was elected Hon. MRIA in 1876 and Hon. member, Royal Society of Antiquaries of Ireland.
16. W. G. Strickland, op. cit., vol. I, p. 131.
17. Ibid., vol. I, pp. 130–31.
18. *A Connaught Toilette* was exhibited in the RHA in 1841 but was burnt in a fire at the Pantechnicon, London together with another of Burton's watercolours, *The Blind Girl at the Holy Well*, which had been exhibited at the RHA in 1840.
19. Unpublished manuscript owned by a descendant of Burton and quoted in an unpublished BA thesis (Trinity College, Dublin) on Burton by Jane MacFarlane.
20. Lady Gregory, *Seventy years: Being the Autobiography of Lady Gregory*, p. 150.
21. Homan Potterton, 'A Director with Discrimination: Sir Frederic Burton at the National Gallery', *Country Life*, vol. CIV, 9 May 1974, pp. 1140–41.
22. Hardie, op. cit., vol. III, p. 158.
23. Dr Thomas J. Bodkin, *Four Irish Landscape Painters*, reprinted edn, pp. 58–9.
24. H. L. Mallalieu, *Dictionary of British Watercolour Artists up to 1920*, p. 158.
25. Rowland E. Prothero with the co-operation of G. G. Bradley, *The Life and Correspondence of Arthur Penrhyn Stanley*, ch. VI, pp. 146–47.
26. Mallalieu, op. cit., p. 158.
27. F. J. Stephens, *Magazine of Art*, 1895.
28. Raymond F. Brooke, *The Brimming River*, ch. 5, p. 83.
29. Charles Nugent in *Rose Barton (1856–1929)* (exhibition catalogue), p. 11.
30. Rebecca Rowe, in *Rose Barton (1856–1929)*, op. cit., p. 12; (quotation taken from *Rose Barton, Familiar London*, p. 87).
31. Rowe, ibid., p. 13.
32. Entry for 2 February 1839. The Royal Archives, Windsor.
33. *Fraser's Magazine*, vol. I, 1830, p. 714.
34. Walter Osborne left Antwerp in the spring or summer of 1883, according to Dr J. Campbell, *The Irish Impressionists – Irish Artists in France and Belgium, 1850–1914* (exhibition catalogue), p. 88.
35. Alan Denson, *John Hughes, Sculptor*, section I, par. 210.
36. Jeanne Sheehy, *Walter Osborne*, p. 29.
37. Prof. Frederick York Powell (1850–1904). See Oliver Elton, *Frederick York Powell: a life and a selection from his letters and occasional writings*. See Powell's letters to J. B. Yeats, vol. I, ch. IX, pp. 438–45.
38. Dr James White, *John Butler Yeats and the Irish Renaissance*, p. 7.
39. Anne Crookshank and The Knight of Glin, *The Painters of Ireland, c.1660–1920*, ch. 15, p. 269.
40. P. G. Knody and S. Dark, *Sir William Orpen, Artist and Man*, ch. I, p. 133.
41. Bruce Arnold, *Orpen, Mirror to an Age*, ch. 7, p. 106.
42. Sarah Purser's mother was Anne Mallet, who was connected to many of Dublin's engineering and brewing families.

210

43. Sir John Purser Griffith, MA (1848–1911). Civil engineer. Senator Irish Free State, 1923–36. President Institute of Civil Engineers, 1919–20. Vice-President, Dublin Society, 1922. Hon. Freedom of the City of Dublin, 1936.

44. Thomas McGreevy (1893–1967), poet, critic and director of the National Gallery of Ireland. Born Tarbert, Co. Kerry. He graduated in history and political science from Trinity College, Dublin. In 1926 he was appointed English Reader at the University of Paris. Through James Joyce's influence he became a reviewer and was Joyce's executor. In the 1930s he moved to London and became chief critic of *The Studio*, lectured on History of Art at the National Gallery, London and contributed to the *Times Literary Supplement*. He settled in Dublin in 1941 and became Director of the NGI in 1950. He was awarded a Chevalier of the Legion of Honour in 1948. He retired from the NGI in 1964 and died in Dublin on 16 March 1967.

CHAPTER VII

1. Dr Thomas Bodkin, *Hugh Lane and His Pictures*, p. 4.

2. In 1924, the Friends of the National Collections of Ireland was founded by Sarah Purser. They played a vital role in securing Charlemont House, Parnell Square, Dublin for a Municipal Gallery of Modern Art, which they finally handed over to Dublin Corporation in 1927. To commemorate Hugh Lane's generosity, the name of the gallery was later changed to the Hugh Lane Municipal Gallery of Modern Art.

3. See the biography of Dermod O'Brien by Lennox Robinson, *Palette and Plough*, p. 61.

4. Ibid., p. 75.

5. I am greatly indebted to Anne Miller for much of the information relating to Dermod O'Brien.

6. The failure of Dublin Corporation to build a suitable gallery for Sir Hugh Lane's collection, which he had assembled in the temporary gallery in Clonmel House in Harcourt Street, persuaded him to present thirty-nine of his principal masterpieces to the London National Gallery in 1913. Before departing for the United States in 1915, he wrote a codicil to his will altering this intention and stating that he wished the thirty-nine pictures to be bequeathed to Dublin. He was drowned returning from the USA in the *Lusitania*. His codicil was deemed by the courts in London to be invalid as it was not witnessed, and the pictures therefore were declared the property of the London National Gallery. The cause for the return of the Lane pictures was taken up by Yeats, Lady Gregory and others. In 1959 an historic compromise was announced in the House of Commons by the then British Prime Minister, Mr Harold Macmillan (later Lord Stockton). The thirty-nine French Impressionist pictures were to be loaned in two lots to Dublin for successive periods of five years over a twenty year period. A subsequent agreement, entered into in 1979, allowed thirty of the pictures to be loaned to the Hugh Lane Municipal Gallery, with the remaining nine staying in London until 1993.

7. Henry Joy McCracken (1767–1798), United Irishman. Born Belfast. He joined with Thomas Russell (1767–1803) in founding the first Society of the United Irishmen in Belfast. He was arrested in 1796 and imprisoned in Kilmainham, Dublin. On his release he took a leading part in planning a rising. An attack on the town of Antrim led by him was defeated. He took refuge in the Slemish mountains but whilst trying to escape to the United States he was captured, tried by court martial and hanged in Belfast on 17 July 1798.

8. Sir William Newnham M. Orpen and Frank Rutter, *The Outline of Art*, p. 650.

9. A. S. Hartrick, *A Painter's Pilgrimage through Fifty Years*, p. 8.

10. Mainie Jellett, *My Voyage of Discovery – The Artist's Vision*, p. 47.

11. Ibid. p. 48.

12. Dr James White, Introduction to an exhibition of Evie Hone's work, 29 July–5 September 1958.

13. Dr James White and Dr Michael Wynne, *Irish Stained Glass*.

14. C. P. Curran, S.C., D.Litt. Quotation taken from 'Evie Hone; Stained glass artist 1894–1955', an essay from *A Tribute to Evie Hone*, ed. Stella Frost, p. 11.

15. *Sphere*, 17 October 1925.

16. William Orpen, *Stories of Old Ireland and Myself*.

17. Beatrice Elvery, *Today we will only gossip*.

18. Ibid., ch. 2, p. 32.

19. Violet Russell, *Heroes of the Dawn*.

20. *Freeman's Journal*, December 1911.

21. Dr Thomas Bodkin, Introduction to an exhibition of works by Patrick Joseph Tuohy, RHA, Dublin 1931, p. 4.

22. Bruce Arnold, Introduction to an exhibition of works by Christopher Campbell (1908–1972). Neptune Gallery, Dublin 1977.

23. Thomas MacGreevy, *Capuchin Annual* 1946, p. 363.

24. I am greatly indebted to Bruce Arnold for allowing me to use this quotation and for information in relation to Seán Keating.

25 Maurice MacGonigal, 'Seán O'Sullivan. An Appreciation', *Irish Times*, 4 May 1964.

26. Two of Seán O'Sullivan's prints are in the British Museum's collection. Both lithographs were presented by the Contemporary Art Society in 1928 and 1934.

27. Dr James White, 'Seán O'Sullivan . . . , op. cit.

28. Ciarán MacGonigal, Introduction to the Harry Kernoff Memorial Exhibition held at the Hugh Lane Municipal Gallery of Modern Art, 1976–7.

29. John Ryan, Introduction to an exhibition of Harry Kernoff's work, Godolphin Gallery, Dublin 1974.

30. Ciarán MacGonigal, Introduction to an exhibition by Maurice MacGonigal, Dublin 1981.

31. Elizabeth Bowen, Preface to an exhibition held at the Leicester Gallery, London 1957.

32. A. Denson, *Capuchin Annual*, 1974.

33. Thomas Bodkin, *Freeman's Journal*, 31 March 1909.

34. Review of a group exhibition, 1909, in the *Irish Times*, quoted by Alan Denson in *His Life's Work – A Catalogue*, part 1, vol. 11, p. 25.

35. Paul Henry, *An Irish Portrait* (The Autobiography of Paul Henry, RHA), p. 24.

36. Dr James White, Introduction to a catalogue for a Memorial Exhibition: *Charles Lamb*, 1969.

37. Arthur Power, Charles Lamb memorial exhibition catalogue, op. cit.

38. The Ulster Folk and Transport Museum, Cultra, has a room devoted entirely to the work of William Conor known as the 'Conor Room'.

39. *Apollo*, May 1929.

40. *La Revue moderne*, October 1921.

41 C. P. Curran, S.C., D.Litt.

42. Hilary Pyle, *Introduction to Jack B. Yeats in the National Gallery of Ireland* (exhibition catalogue), p. xv.

43. Gaeltacht – an Irish or Scottish speaking area.

44. Jack B. Yeats, *Ah Well*.

45. For information on Yeats's work, the author would refer the reader to Hilary Pyle's excellent biography of the artist, *Jack B. Yeats: A Biography*.

46. Brian Fallon, review of Hilary Pyle's catalogue 'Jack B. Yeats in the National Gallery of Ireland,' in *Irish Times*, 17 May 1986.

47. John Hewitt, *John Luke 1906–1975*, p. 14.

48. Quoted by Michael Longley in an extract from *The Dublin Magazine*, Autumn/Winter 1967.

49. Kenneth Jamison, Introduction to an Exhibition of Paintings by George Campbell, RHA, Salthill, Galway 1975.

50 The Sir Charles Brett prize for figure drawing, 1911–1912, and the Fitzpatrick prize for drawing, 1913–14, were both awarded to Frank McKelvey while he was a student at the Belfast School of Art.

51. Mary Swanzy, from an interview with Una Lehane, *Irish Times*, 29 March 1974.

52. Ibid.

53. Ibid.

54. Ibid.

55. From an interview with Peta Cullen, 'Mary Swanzy, A Major Irish Painter', *Irish Times*, 28 May 1968.

56. Sarah Purser, 'Miss Swanzy's Paintings', *Irish Times*, 31 March 1915.

57. *Irish Times*, 31 May 1922.

LIST OF ILLUSTRATIONS

The publishers are most grateful to all the galleries, museums and individuals who have kindly either given their permission for their pictures to be reproduced, or supplied photographs. Every effort has been made to identify the copyright holders and to obtain their permission to reproduce illustrations, and apologies are made for any inadvertent errors or admissions. Dates, media and dimensions have been included where possible.

FRONT JACKET
Halfpenny Bridge, 1892 (detail). Rose Barton (1856–1929). Pencil and watercolour heightened with bodycolour, 295 × 510 mm. Private Collection (photo: Crawford Municipal Art Gallery, Cork).

BACK JACKET
See below (illus. 130).

ENDPAPERS
See below (illus. 39).

HALF-TITLE PAGE
An illustration to *Moonshine Fairy Stories* by E. Knatchbull. William ('Billy') Brunton (1833–1878). Pen and ink and Chinese white, average size 152 × 102 mm. By courtesy of the Board of Trustees of the Victoria and Albert Museum, London.

FRONTISPIECE
See below (illus. 70).

1] Carpet-page facing the beginning of St John's Gospel, Book of Durrow (AD 650–680), TCD MS 57, fol. 192v. For dimensions see chapter 1, note 1, p. 208. The Board of Trinity College, Dublin.
2] A page from the Psalter of Cormac (AD 1150–1200). Add MS 36926, fols 1ᵛ 2. 128 × 175 mm. The British Library Board.
3] *Self-Portrait in Elizabethan Costume*. Richard Cosway (1742–1821). Watercolour on ivory, 71 × 57 mm. National Gallery of Ireland.
4] *Simon Digby, Bishop of Elphin* (fl.1668–1720). Unidentified Artist. 950 × 825 mm. Mr Simon Wingfield Digby, Sherborne Castle.
5] *An Unknown Woman* 1767. Luke Sullivan (1705–1771). 44 × 25 mm. By courtesy of the Board of Trustees of the Victoria and Albert Museum, London.
6] *Hiliary Turriano*. Thomas Frye (1710–1762). By courtesy of the Board of Trustees of the Victoria and Albert Museum, London.
7] TOP *Sarah Sophia Banks*, 1768. Nathaniel Hone the Elder (1718–1784). Watercolour on ivory, 45 × 38 mm. National Gallery of Ireland. LEFT *Mrs Morgan*, 1788. Sampson Towgood Roch (1759–1847). Watercolour on ivory, 67 × 51 mm. National Gallery of Ireland. RIGHT *Portrait of a Lady in a Pink Dress*, 1764. James Reily (fl. c.1750–1820/88). Watercolour on ivory, 38 × 32 mm. National Gallery of Ireland.
8] *Mrs Sarah Siddons (1755–1831), Actress*, 1784. Horace Hone (1756–1825). Watercolour on ivory, 92 × 76 mm. National Gallery of Ireland.
9] *Self-Portrait*, after 1778. Horace Hone (1756–1825). Watercolour on ivory, 65 × 50 mm. National Gallery of Ireland.
10] *Edmund Burke (1729–1797), Writer and Statesman*. Nathaniel Hone the Elder (1718–1784). Watercolour on ivory, 46 × 37 mm. National Gallery of Ireland.

11] *Denis Daly of Dunsandle, MP (1747–1791)*. Hugh Douglas Hamilton (1740–1808). Pastel on paper, 240 × 200 mm. National Gallery of Ireland.
12] *Portrait of a Young Lady seated on a Sea-wall*. Adam Buck (1759–1833). Watercolour on ivory, 85 mm diam. National Gallery of Ireland.
13] *Major Conyngham Ellis (1783–1815)*. Adam Buck (1759–1833). Watercolour on ivory, 64 × 53 mm. National Gallery of Ireland.
14] *Charlotte Walpole, Countess of Dysart (d.1789)*. Attributed to George Chinnery (1774–1852). Watercolour on ivory, 77 × 61 mm. National Gallery of Ireland.
15] *Mrs Robert Sherson (1780–1858)*, 1803. George Chinnery (1774–1852). Watercolour on ivory, 155 × 122 mm. By courtesy of the Board of Trustees of the Victoria and Albert Museum, London.
16] *Self-Portrait*, c.1840; squared for the National Portrait Gallery, London. George Chinnery (1774–1852). Pencil and sepia on paper, 182 × 136 mm. National Gallery of Ireland.
17] *Henry Sheares (1752–1798), Barrister*. John Comerford (c.1770–1832). Watercolour on ivory, 124 × 90 mm. National Gallery of Ireland.
18] *Self-Portrait*, 1828. Samuel Lover (1797–1868). Black and red chalk with white highlights on buff paper, 228 × 192 mm. National Gallery of Ireland.
19] *Portrait of a Young Girl*. Samuel Lover (1797–1868). Watercolour on ivory, 85 × 75 mm. National Gallery of Ireland.
20] *Christine Noletor (née Jaffrey), the Artist's Wife*. Charles Robertson (1760–1821). Watercolour on ivory, 69 × 57 mm. National Gallery of Ireland.
21] *Walter Robertson (fl. c.1768–1801), Miniaturist and the Artist's Elder Brother*. Charles Robertson (1760–1821). Watercolour on ivory, 75 × 59 mm. National Gallery of Ireland.
22] *Charles Robertson (1760–1821), Miniaturist*. Henry Kirchoffer (1781–1860). Pencil and watercolour on paper, 446 × 307 mm. National Gallery of Ireland.
23] *Dublin from Donnybrook Bridge (now rebuilt), on the River Dodder*, 1698. Francis Place (1647–1728). Ink and watercolour on paper, 125 × 395 mm. National Gallery of Ireland.
24] *Limerick City; from the artist's Military Survey of Ireland*, 1685. Thomas Phillips (c.1635–1693). Pen and ink wash with slight colour, 406 × 1029 mm. National Library of Ireland.
25] *View of Waterford from across the River Suir*. Francis Place (1647–1728). Ink and wash on paper, 290 × 560 mm. National Gallery of Ireland.
26] *East Prospect of the Giant's Causeway, Co. Antrim*. Susanna Drury (fl.1733–1776). Gouache on vellum, 340 × 676 mm. Photograph reproduced with kind permission of the Trustees of the Ulster Museum.
27] *Portrait of Francis Grose (1731–1791)*; a plate from *A Dictionary of Irish Artists*, 1913, by W. G. Strickland, vol. 1. 64 × 76 mm. National Library of Ireland.
28] *Drumcondra Church; from The Antiquities of Ireland*, 1791–5; engraving after the drawing by Francis Grose (1731–1791). 152 × 203 mm. National Library of Ireland.
29] *The Lord Lieutenant's residence (now Áras an Uachtaráin), Phoenix Park, Dublin*. John James Barralet

(1747–1815). Ink, wash and watercolour on paper, 206 × 260 mm. National Gallery of Ireland.
30] *View of the Village of Bray, Co. Wicklow*, 1736. Letitia Bush (fl. 1731–1757). 208 × 290 mm. National Gallery of Ireland.
31] *Mount Merrion. The Lodge seen from the Lawn*. William Ashford (1746–1824). 320 × 430 mm. Fitzwilliam Museum, Cambridge.
32] *View of Castle Durrow*. James Malton (c.1760–1803). By courtesy of the Board of Trustees of the Victoria and Albert Museum, London.
33] *The Customs House, Dublin*, 1793. James Malton (c.1760–1803). Ink and watercolour on paper, 536 × 770 mm. National Gallery of Ireland.
34] *A Description of the Lakes of Killarney, Co. Kerry*; from *Scenery of Ireland*, 1796; drawn and engraved by Jonathan Fisher (fl. c.1763–1809). National Library of Ireland.
35] *View of Capel Street, Dublin, with the Royal Exchange in the Distance*, 1800. James Malton (c.1760–1803). 587 × 787 mm. By courtesy of the Board of Trustees of the Victoria and Albert Museum, London.
36] *The Post Office and Nelson's Pillar, Sackville Street (now O'Connell Street), Dublin*, 1818. Samuel Frederick Brocas (1792–1847). By courtesy of the Board of Trustees of the Victoria and Albert Museum, London.
37] *Old Bael's Bridge, Limerick* (now rebuilt). James Henry Brocas (1790–1846). Ink and watercolour on paper, 233 × 395 mm. National Gallery of Ireland.
38] *The Fountain, James's Street, Dublin*. Ascribed to George Petrie (1790–1866). Watercolour on paper, 288 × 207 mm. National Gallery of Ireland.
39] *Trinity College and College Green, Dublin*, 1818. Samuel Frederick Brocas (1792–1847). Ink and watercolour on paper, 244 × 402 mm. National Gallery of Ireland.
40] *Pilgrims at St Brigid's Well, Liscannor, Co. Clare*, 1831. George Petrie (1789–1866). Watercolour on paper, 185 × 260 mm. National Gallery of Ireland.
41] *Hanging Washing in Lord Portlester's Chapel, St. Audeon's Dublin*. George Petrie (1789–1866). Ink and wash on paper, 143 × 231 mm. National Gallery of Ireland.
42] *The Cloth Mart, Home's Hotel and Queen's Bridge, Usher's Quay, Dublin*; from *Ireland Illustrated*, 1831; engraving after the drawing by William Henry Bartlett (1809–1854). The Bodleian Library, Oxford.
43] *The Quay, Waterford*; from *The Scenery and Antiquities of Ireland*, 1844; engraving after the drawing by William Henry Bartlett (1809–1854). The Bodleian Library, Oxford.
44] *The Arbra Santa on the Bank of Lake Nemi*, c.1754–6. Richard Wilson (1714–1782). Black chalk, possibly touched up with pencil, heightened with white, on grey paper, 385 × 555 mm. Yale Center for British Art, Paul Mellon Collection.
45] *S. Agnese Fuori le Mura and S. Constanza, Rome, in a Capriccio with the so-called Sarcophagus of Constantine*, 1751/56. Richard Wilson (1714–1782). Black chalk and wash with white highlights on paper, 297 × 394 mm. National Gallery of Ireland.
46] *Landscape in the manner of Richard Wilson*. Robert Crone (c.1718–1779). Black chalk, 279 × 425 mm. Reproduced by courtesy of the Trustees of the British Museum.

117] An illustration to *Le Morte d'Arthur* by Alfred, Lord Tennyson. Daniel Maclise (1806–1870). By courtesy of the Board of Trustees of the Victoria and Albert Museum, London.

118] *The Fraserians*, 1835. Daniel Maclise (1806–1870). pencil on paper, 207 × 270 mm. By courtesy of the Board of Trustees of the Victoria and Albert Museum, London.

119] *Thomas Carlyle*; preliminary drawing for the caricature which appeared in *Fraser's Magazine*, 1833. Daniel Maclise (1806–1870). Pencil on paper, 260 × 172 mm. By courtesy of the Board of Trustees of the Victoria and Albert Museum, London.

120] *The Headmaster's Sister*; from *Once a Week*; engraving by J. Swain after the artist's drawing. Matthew James Lawless (1837–1864). By courtesy of the Board of Trustees of the Victoria and Albert Museum, London.

121] Original drawing for an illustration for *Ally Sloper's Half-Holiday*. William Giles Baxter (1856–1888). By courtesy of the Board of Trustees of the Victoria and Albert Museum, London.

122] An illustration to *Moonshine Fairy Stories* by E. Knatchbull. William ('Billy') Brunton (1833–1878). Pen and ink and Chinese white, average size 152 × 102 mm. By courtesy of the Board of Trustees of the Victoria and Albert Museum, London.

123] *Drawing him a little aside*; original drawing for an illustration to *Sense and Sensibility*, 1896, by Jane Austen. Hugh Thomson (1860–1920). Pen and wash, 276 × 184 mm. By courtesy of the Board of Trustees of the Victoria and Albert Museum, London.

124] *The Gods. The Vaudeville Gallery*, 1899; original drawing for an illustration to the *Graphic*. Hugh Thomson (1860–1920). Pen and watercolour, 290 × 248 mm. By courtesy of the Board of Trustees of the Victoria and Albert Museum, London.

125] A book-cover illustration for *School for Scandal*. Hugh Thomson (1860–1920). By courtesy of the Board of Trustees of the Victoria and Albert Museum, London.

126] *An African Fable; the Hare and the Lion*. George Morrow Junior (1870–1955). Pen, ink and white on paper, 311 × 257 mm. Photograph reproduced with kind permission of the Trustees of the Ulster Museum.

127] *'Imitation the sincerest form of flattery'*; original drawing for an illustration for *Punch*, 1890, vol. XCIX. Harry Furniss (1854–1925). Pen and wash, 244 × 187 mm. By courtesy of the Board of Trustees of the Victoria and Albert Museum, London.

128] Cover illustration for *The Jarvey*, 26 January 1889. National Library of Ireland.

129] *Hints to Anglers*; illustration for *The Jarvey*, 21 September 1889. Richard Caulfield Orpen (1863–1938). National Library of Ireland.

130] *'The Amateur Chucker-out' Lane at the First Night of Synge's 'The Playboy of the Western World' at the Abbey Theatre*, Dublin, 1907. Sir William Orpen (1878–1931). Ink on paper, 330 × 200 mm. National Gallery of Ireland.

131] *Portrait of Paley Dabble*; from an album *The Rev. Paley Dabble's Adventures*. Dr Edith O. Somerville (1858–1949). The Queen's University of Belfast.

132] *'She Drifted Rudderless'*. Dr Edith O. Somerville (1858–1949). Wash with white highlights on paper, 265 × 105 mm. The Queen's University of Belfast.

133] *Edward Martyn 'having a week of it' in Paris*. Grace Gifford (1888–1955). Pen and ink on paper, 209 × 266 mm. Hugh Lane Municipal Gallery of Modern Art, Dublin.

134] *Christmas card, 1917*. Harry Clarke (1889–1931). The collection of the artist's granddaughter (photo: David H. Davison).

135] *Caricatured Self-Portrait*. Harry Clarke (1889–1931). The collection of the artist's granddaughter (photo: David H. Davison).

136] A Competition Design for the Seal of the National Gallery of Ireland 1919. Harry Clarke (1889–1931). Ink and pencil on paper, 146 × 75 mm. National Gallery of Ireland.

137] A cover design for *All for Hecuba*, 1946. Micheál MacLiammóir (1899–1978). Watercolour, 555 × 470 mm.

Courtesy of the Gate Theatre, Dublin.

138] *View of Kingstown Harbour* (now Dun Laoghaire) Co. Dublin, 1857. Andrew Nicholl (1804–1866). Watercolour on white paper heightened with white, 593 × 988 mm. Belfast Harbour Commissioners.

139] *Six Vessels in Rough Seas*. Edwin Hayes (1820–1904). Watercolour and bodycolour, 500 × 900 mm. Courtesy of the National Maritime Museum, Greenwich.

140] *The Experimental Squadron in Cork Harbour, 8th September, 1845, Cobh, Co. Cork*. Robert Lowe Stopford (1813–1898). Chalk and watercolour, 311 × 464 mm. Courtesy of the National Maritime Museum, Greenwich.

141] *The Long Bridge, Belfast*. Andrew Nicholl (1804–1866). Watercolour on paper, 442 × 610 mm. Photograph reproduced with kind permission of the Trustees of the Ulster Museum.

142] *Ryde, Isle of Wight*. Frederick Calvert (fl. 1815–1844). By courtesy of the Board of Trustees of the Victoria and Albert Museum, London.

143] *Marine Surveying in the South Pacific, 1858*. James Glen Wilson (1827–1863). Pen, sepia and grey wash on white paper, 262 × 471 mm. Private Collection (photo: Reproduced by courtesy of the Trustees of the British Museum).

144] *Fijian and Tongese Canoes at Levuka, July 28, 1855*. James Glen Wilson (1827–1863). Watercolour on white paper, 215 × 472 mm. Private Collection (photo: Reproduced by courtesy of the Trustees of the British Museum).

145] *Glorious Home-Coming of the Santiago Squadron, August 20, 1898*. William Alexander Coulter (1849–1936). Ink and graphite, 318 × 533 mm. Sausalito Historical Society, San Francisco (Private Collection).

146] *Cliffs at the Base of Slievemore, Achill Island*. John Faulkner (c.1830–c.1888). Watercolour with gouache and surface scratching, 692 × 1200 mm. Whitworth Art Gallery, University of Manchester.

147] *The Old Ballast Office, Belfast*. Anthony Carey Stannus (fl.1862–1909). Pencil and watercolour on white paper heightened with white, 342 × 479 mm. Belfast Harbour Commissioners.

148] *The Seafront at Bray, Co. Wicklow*. Erskine Nicol (1825–1904). Pencil and watercolour, 482 × 643 mm. National Gallery of Ireland.

149] *The 'Merican Difficulty*. Erskine Nicol (1825–1904). Watercolour and bodycolour on paper, 308 × 232 mm. Photograph reproduced with kind permission of the Trustees of the Ulster Museum.

150] *Relentless Time*. Louisa Anne Stewart (Marchioness of Waterford, 1818–1891). Watercolour and bodycolour, 252 × 355 mm. Windsor Castle, Royal Library. © Her Majesty the Queen.

151] *My Mother's Coming of Age*. Grace, Duchess of St Albans (1848–1926). Watercolour on paper, 195 × 377 mm. Private Collection (photo: National Gallery of Ireland).

152] *Queen Victoria and Prince Albert Opening the 1835 Dublin Great Exhibition*. James Mahoney (c.1810–1879). Watercolour on paper, 601 × 733 mm. National Gallery of Ireland.

153] *Two Women on a Balcony*. Alfred Elmore (1815–1881). Watercolour, 219 × 133 mm. By courtesy of the Board of Trustees of the Victoria and Albert Museum, London.

154] *Charles Brindley Riding to Hounds*. Michael Angelo Hayes (1820–1877). Black chalk and wash on paper, 114 × 121 mm. National Gallery of Ireland.

155] *Moor at Sunrise*. William Mulready (1786–1863). Pastel on grey paper, 90 × 150 mm. National Gallery of Ireland.

156] *Bathers Surprised*. William Mulready (1786–1863). Black, red and white chalk and crayon on paper, 499 × 334 mm. National Gallery of Ireland.

157] *The Sonnet*; a cartoon for the oil in the V&A, London. William Mulready (1786–1863). Red chalk and pencil with white highlights on paper, 360 × 299 mm. National Gallery of Ireland.

158] *The Penny Postage Envelope*. William Mulready

(1786–1863). By courtesy of the Board of Trustees of the Victoria and Albert Museum, London.

159] *Girl dozing over her lessons*. William Mulready (1786–1863). Pen and brush in brown ink, 157 × 112 mm. Ashmolean Museum, Oxford.

160] *In Joyce's Country, (Connemara, Co. Galway)*. Sir Frederic William Burton (1816–1900). Watercolour on paper, 253 × 360 mm. National Gallery of Ireland.

161] *Ploughing*. William Davis (1821–1873). Watercolour, 192 × 352 mm. Trustees of the National Museums on Merseyside (Walker Art Gallery).

162] *Portrait of Annie Callwell (d.1904)*. Sir Frederic William Burton (1816–1900). Pencil and watercolour on paper, 591 × 406 mm. National Gallery of Ireland.

163] A Design for the Crown of the Mace of the Royal College of Physicians of Ireland, c.1850. Sir Frederic William Burton (1816–1900). Ink on paper, 156 × 195 mm. National Gallery of Ireland.

164] *Sheep on the Moor*. Claude Hayes (1852–1922). Watercolour, 368 × 537 mm. By courtesy of the Board of Trustees of the Victoria and Albert Museum, London.

165] *Dinghies on a Normandy Beach, c.1860*. Nathaniel Hone the Younger (1831–1917). Pencil and watercolour on paper, 197 × 284 mm. National Gallery of Ireland.

166] *The Last Ray of Evening, Shannon Bridge*. Henry Albert Hartland (1840–1893). Watercolour, 584 × 1029 mm. By courtesy of the Board of Trustees of the Victoria and Albert Museum, London.

167] *Wicklow Head from Glen of the Downs, Co. Wicklow*, 1835. Edward Lear (1812–1888). Pencil heightened with white chalk on feint grey paper, 108 × 165 mm. Private Collection.

168] *A Waterfall in a Wood*. Alfred Downing Fripp (1822–1895). Watercolour with white highlights on paper, 273 × 380 mm. National Gallery of Ireland.

169] *In the West, 1914*. William Percy French (1854–1920). Watercolour, 368 × 521 mm. By courtesy of the Oriel Gallery, Dublin.

170] *The Main Staircase at 80 St Stephen's Green, Dublin*, 1902. Rose Maynard Barton (1856–1929). Pencil and watercolour heightened with white, 412 × 514 mm. Private Collection.

171] *Kensington Gardens*. Rose Maynard Barton (1856–1929). Private Collection.

172] *The Marriage of Princess Aoife (Eva) and the Earl of Pembroke (Strongbow)*. Daniel Maclise (1806–1870). Watercolour on paper, 512 × 802 mm. National Gallery of Ireland.

173] *Debut of Paganini, c.1831*. Daniel Maclise (1806–1870). Pencil heightened with white, 359 × 273 mm. By courtesy of the Board of Trustees of the Victoria and Albert Museum, London.

174] *The Customs House Before the Rebellion*. Rose Maynard Barton (1856–1929). 260 × 350 mm. Private Collection.

175] A cartoon for the '*Meeting of Wellington and Blucher 1858-9*'; a detail from the full-scale finished cartoon for the fresco in the Royal Gallery, Palace of Westminster, London. Daniel Maclise (1806–1870). French chalk on paper. The Royal Academy of Arts, London.

176] *Woman and Child in Cottage Interior*. Beatrice Gubbins (1878–1944). Watercolour, 350 × 250 mm. Private Collection (photo: Courtesy of Crawford Municipal Gallery, Cork).

177] *Galway People*, 1857. Francis William Topham (1808–1877). 391 × 311 mm. By courtesy of the Board of Trustees of the Victoria and Albert Museum, London.

178] *The Dolls' School*, 1900. Walter Frederick Osborne (1859–1903). Pastel and watercolour on paper, 452 × 595 mm . National Gallery of Ireland.

179] *The House Builders*, 1902. Walter Frederick Osborne (1859–1903). Watercolour on paper, 477 × 598 mm. National Gallery of Ireland.

180] *Eugénie O'Hagan*. Harriet Osborne O'Hagan (1830–1921). Charcoal with white highlights on paper, 570 × 457 mm. National Gallery of Ireland.

181] *Isaac Butt Yeats (1848–1920), the Artist's Younger Brother*. John Butler Yeats (1839–1922). 254 × 102mm. Private Collection.

GLOSSARY

WATERCOLOUR

In the strict sense of the word, watercolour is a medium in which water is used as the 'vehicle' for the pigment together with a binding material. That binding material is generally gum arabic (a soluble gum obtained from the acacia tree) or, in the case of the medieval illuminator, glair (egg white). When dissolved in water these materials not only disperse the insoluble grains of pigment but actually increase the luminosity of the colours. A denser colour can be achieved by mixing pigment with an opaque white such as 'Chinese white' (a pigment based on zinc oxide, introduced by Winsor & Newton in 1834), and this is known as bodycolour or gouache. Bodycolour conceals what is underneath, but the transparent medium is unable to do this, the painted surface becoming a series of colour filters which allow the light to pass through them and reflect off the white surface beneath. The greater the degree of translucency achieved, the purer the colours will appear. Another term for this medium is 'pure watercolour'.

DRAWINGS

Media used in drawings.

BISTRE. A brown pigment made from beechwood soot; often referred to as pen and brown wash or pen and brown ink.

CHALK BLACK. This is a mineral which is indelible and adhesive to paper.

CHALK RED. Subtle gradations of tone may be introduced by rubbing with the finger or brush.

CHARCOAL. Easy to manufacture and cheap to buy, this was and is a popular medium in drawing.

CONTÉ (crayon). The conté crayon is a mixture of clay and refined graphite; invented in 1790 by Nicholas-Jacques Conté (1755–1805).

INK. Indian and Chinese ink are made from lampblack (soot) mixed with gum and hardened by baking. Iron-gall writing ink was used until the present century. It is made from tannin obtained from oak galls and treated with ferrous sulphate.

PASTEL. A wide variety of coloured chalks is used in pastel drawing. In eighteenth-century France another term used for pastel was 'crayon'.

PEN AND WASH. Often the quill feathers of a bird's wing were used for pens. Wash indicates an area of tone applied with the brush.

PENCIL. Piece of graphite enclosed in a cylinder of wood or contained in a metal case with tapering end.

PLUMBAGO. The Latin word for lead ore, now denoting black lead which is in fact graphite. Sharpened pieces were used for drawing.

SEPIA. A dark brown pigment derived from the black fluid of the cuttlefish. The name is frequently used as a general term for a dark brown colour.

Printing Techniques.

AQUATINT. This method involves covering the plain surface of the steel plate with sand or other grainy matter. The plate is then applied to heat, acid or other agents which cause the surface to become mottled.

ENGRAVING. The art of drawing or writing on any substance by means of an incised line. Materials usually used as the plate substance are: stone, wood, zinc, iron, silver, steel, brass, pewter and in later times man-made fibres. The line is incised on the surface by a variety of sharp tools. Scrapers with two cutting edges are also used to remove larger areas of the surface so that the paper or other material being printed receives no impression in the area in question.

ETCHING. Instead of cutting into steel plate substances with a tool, as in the case of engraving, the line is obtained by corroding or 'eating into' the plate with acid or mordant. In this technique the plate is covered with an acid-resistant surface which is then cut into by the special tools. This is then exposed to acid or mordant which eats the line where the acid-resistant surface has been removed.

LITHOGRAPHY. The process of writing or drawing on a stone with a composition of wax and lampblack (substances of a more sophisticated type were later developed). The stone is then wetted, but the drawn or written line being greasy resists the water. A roller covered with printing ink is then applied to the stone, but only the drawn or written line picks up the ink and this is then pressed on to paper in the usual methods.

MEZZOTINT. This is a process of working out light portions of ground by eating into the steel plate with a rocker or other toothed or serrated edge which breaks up the plain surfaces.

PRINT. This is an impression which can be reproduced several times, for example an engraving is a print.

PRINTING. Printers ink is laid on the prepared plate and dabbed into the lines, incisions or crevices. The superfluous ink is then removed. Paper is placed damp against the plate in a copper-plate press or other pressure method to force the paper into the hollows and so gain the impression of the ink.

STIPPLE. Work in stipple is produced by a skilful arrangement of dots pecked into the metal plate.

NB Printing techniques are complicated and technical, and these notes are given in order to communicate the basic ideas. For further information, there are many books on the subject including: *A Short History of Engraving and Etching* by A. M. Hind, London, 1908, with full bibliography.

ABBREVIATIONS USED IN THE TEXT

SELECT BIBLIOGRAPHY

ADAMS, ERIC, *Francis Danby, Varieties of poetic landscape*, London, 1973

ANDERSEN, HANS CHRISTIAN, *Fairy Tales*, London, 1917 (Illustrations by Harry Clarke)

ANGELO, HENRY, *Reminiscences of Henry Angelo, with memoirs of his late father and friends*, 2 vols., London, 1828

ANGELSEA, MARTYN, *The Royal Ulster Academy of Arts*, Belfast, 1981

ARCHIBALD, EDWARD H. H., *Dictionary of Sea Painters*, Suffolk, 1980

ARNOLD, BRUCE, *A Concise History of Irish Art*, 1977 edn, London, 1969

ARNOLD, BRUCE, *Orpen, Mirror to an Age*, London, 1981

ARNTZEN, ETTA & RAINWATER, ROBERT, *Guide to the Literature of Art History*, Chicago & London, 1980

BARRET, G., *The Theory and Practice of Watercolour Painting*, 1810

BARTON, ROSE, *Familiar London*, London, 1904

BECK, HILARY, *Victorian Engraving*, London, 1973

BÉNÉZIT, EMMANUEL, *Dictionnaire des peintres, sculpteurs, dessinateurs et graveurs*, 8 vols., 2nd ed, France, 1960; 10 vols., new edn, France, 1976

BERRY, H. FITZPATRICK, *A History of the Royal Dublin Society*, London, 1915

BINYON, ROBERT LAURENCE, *English Water-colours*, London, 1933

BLACKER, STEWART, *Irish Art and Artists*, 1845

BLUNT, WILFRED, with the assistance of STEARN, WILLIAM T., *The Art of Botanical Illustration*, London & Glasgow, 1950

BODKIN, THOMAS, *Four Irish Landscape Painters*, 1987 edn, Dublin & London, 1920 (Introduction by Dr J. Campbell)

BODKIN, THOMAS, *Hugh Lane and His Pictures*, Dublin, 1932

BOGUE, DAVID, *Men of the Time, a biographical dictionary*, London, 1857

BOWE, NICOLA GORDON, *Harry Clarke. His Graphic Art*, Mountrath, Ireland & Los Angeles, 1983

BOWE, NICOLA GORDON, *The Life and Work of Harry Clarke*, Dublin, 1989

BOWKER, *International Directory of Arts*, 1988/89

BOYLAN, HENRY, *A Dictionary of Irish Biography*, 2nd edn, Dublin, 1988

BREFFNY, BARON BRIAN DE, *A Cultural Encyclopaedia*, London, 1983

BREWER, JAMES NORRIS, *The Beauties of Ireland*, 2 vols., London, 1825–6

BROOKE, RAYMOND F., *The Brimming River*, Dublin, 1961

Bryan's Dictionary of Painters and Engravers, 5 vols., revised edn, London, 1903–5

BUCK, SAMUEL & BUCK, NATHANIEL, *Buck's Antiquities*, 2 vols., 1774

BURBIDGE, WILLIAM F., *Art of Botanical Drawing*, 1873

BURBIDGE, WILLIAM F., *A Dictionary of Flower, Fruit and Still Life Painters 1515–1950*, 2 vols., London, 1974

BURBIDGE, WILLIAM F., *The Narcissus: its history and culture*, London, 1875

BURKE, EDMUND, *A Philosophical Enquiry into the Origin of our Ideas of the Sublime and Beautiful*, London, 1767

BUTLER, PATRICIA A., *A Guide to Art Galleries in Ireland*, Dublin, 1978

COLDING, T. H., *Aspects of Miniature Painting, its Origins and Development* (with plates), Copenhagen, 1953

COLGAN, NATHANIEL, *Flora of the County of Dublin*, Dublin, 1904

COLLIS, MAURICE, *Somerville & Ross: a biography*, London, 1968

COURCY, CATHERINE DE, *The Foundation of the National Gallery of Ireland*, Dublin, 1985

COXHEAD, EILEEN ELIZABETH, *Daughters of Erin*, London, 1965

CROKER, T. CROFTON, *Fairy Legends and Traditions of the South of Ireland*, 3 vols., 1825–8

CROMWELL, THOMAS K., *Excursions through Ireland*, 3 vols., London, 1820

CROOKSHANK, ANNE & THE KNIGHT OF GLIN, *The Painters of Ireland c.1660–1920*, London, 1978 (Foreword by Dr James White)

CURRAN, C.P.S.C., D.Litt., 'Evie Hone, stained glass artist 1894–1955' from STELLA FROST (ed.), *A Tribute to Evie Hone*, Dublin, 1958

CURTIS, LEWIS PERRY JR., *Apes and Angels: The Irishman in Victorian Caricature*, Newton Abbot, 1971

DALZIEL, GEORGE & DALZIEL, EDWARD, *The Brothers Dalziel: A record of thirty years' work 1840–90* [G. & E. Dalziel], London, 1901

DENSON, ALAN, *An Irish Artist, W. J. Leech, RHA (1881–1968)*, 2 vols., Kendal, 1968–9

DENSON, ALAN, *Printed writings by George W. Russell (AE), a bibliography* London, 1961

DESMOND, RAY, *Dictionary of British and Irish Botanists and Horticulturalists, including Plant Collectors and Botanical Artists* [New edn of J. BRITTEN & G. E. S. BOULGER, *A Biographical Index of British and Irish Botanists*], London, 1977

DOYLE, RICHARD, *Bird's Eye Views of Society*, London, 1864

DOYLE RICHARD, *Dicky Doyle's Journal*, London, 1885 (Introduction by J. Hungerford Pollen)

DOYLE, RICHARD, *In Fairyland*, a series of pictures from the elf world with a poem by WILLIAM ALLINGHAM, London, 1870

DOYLE, RICHARD, *The Foreign Tour of Messrs. Brown, Jones, & Robinson*, London, 1854

DUBUISSON, A. & HUGHES, C. A., *Richard Parkes Bonington, his life and work*, London, 1924 (Translation with annotations by C. E. Hughes; illustrated with reproductions etc.)

EDWARDS, EDWARD, *Anecdotes of Painters*, London, 1808

ELLIS, JOHN, *An Essay towards a Natural History of the Corallines*, London, 1755

ELLWOOD, C. V., & HARVEY, J. M. V., *The Lady Blake Collection: Catalogue of Lady Edith Blake's collection of Jamaican Lepidoptera and Plants*, Bulletin of the British Museum (Natural History) Historical Series, vol. 18, no. 2, in press

ELMES, ROSALIND M., *Catalogue of Engraved Irish Portraits mainly in the Joly Collection, and of original Drawings*, Dublin, 1937

ELMES, ROSALIND M., *Catalogue of Irish Topographical Prints and Original Drawings, mainly in the Joly Collection*, Dublin, 1943 (new revised and enlarged edn by Dr MICHAEL HEWSON Dublin, 1975 for National Library of Ireland Society)

ELTON, OLIVER, *Frederick York Powell: a life and a selection from his letters and occasional writings*, 2 vols., Oxford, 1906

ELVERY, BEATRICE (LADY GLENAVY), *Today We Will Only Gossip*, London, 1964

ENGEN, RODNEY K., *Dictionary of Victorian Engravers, Print Publishers and their Works*, Cambridge, 1979

EVANS, MAJOR EDWARD B., *A Description of the Mulready Envelope* and of various imitations and caricatures of its design, with an account of other illustrated envelopes, 1981 edn, 1970 (Foreword by Eric Allen)

FARINGTON, JOSEPH, The Farington Diary 1793–1821, unpublished manuscript in the collection of her Majesty the Queen (typescript in the Print Room, the British Museum)

FIGGIS, ALLEN, *Encyclopedia of Ireland*, Dublin, 1968

FISHER, JONATHAN, *A Picturesque Tour of Killarney*, describing in twenty views the most pleasing scenes ... accompanied by some observations, etc., with a map of the lake and its environs, engraved in aquatint, Dublin, 1789

FISHER, JONATHAN, *Scenery of Ireland*, illustrated in a series of prints of select views, castles and abbeys, drawn and engraved in aquatint, Dublin, 1795–6

FISHER, STANLEY W., *A Dictionary of Watercolour Painters, 1750–1900*, London, 1972

FITZGERALD, EDMOND J., *Marine Painting in Watercolour*, London, 1972

FITZGERALD, ROBERT D., *Australian Orchids*, 2 vols., Australia, 1892

FITZSIMON, CHRISTOPHER, *The Arts in Ireland: a chronology*, Dublin and New Jersey, 1982

FOSKETT, DAPHNE, *Collecting Miniatures*, Woodbridge, Suffolk, 1979

FOSKETT, DAPHNE, *Miniatures and Guide*, Woodbridge, Suffolk, 1987

GILBERT, SIR JOHN T., *History of the City of Dublin*, 3 vols., Dublin, 1854–9; new edn, Dublin, 1903

GILPIN, REV. WILLIAM, *Three Essays on Picturesque Beauty, on Picturesque Travel and on Sketching Landscape; to which is added a poem on landscape painting*, London, 1792

GRANT, COLONEL M. H., *A Chronological History of the Old English Landscape Painters*, 3 vols., vols. I & II London, 1926, vol. III Leigh-on-Sea, 1947

GRANT, MAURICE HAROLD, *A Dictionary of British Etchers*, London, 1952

GRAPPA, BASSANO DEL, MSS Canoviani, Biblioteca Civica Epistolario Comune V, 3491.8

GRAVES, ALGERNON, *A Dictionary of Artists who have exhibited works in the principal London exhibitions from 1760 to 1880*, London, 1884 (new and enlarged edn, 1895)

GRAVES ALGERNON, *The Royal Academy of Arts; a complete dictionary of contributors and their work 1769–1904*, 8 vols., London, 1905–6

GRAVES, ALGERNON, *The Society of Artists of Great Britain ... the Free Society of Artists*, London, 1907 (a

complete dictionary of contributors and their work to 1791)

GREENACRE, FRANCIS, *Francis Danby*, London, 1988

GREGORY, (LADY) AUGUSTA, *Hugh Lane's Life and Achievement*, London, 1921

GREGORY, (LADY) AUGUSTA, *Seventy years: Being the Autobiography of Lady Gregory*, Gerrards Cross, 1974

GREGORY, (LADY) AUGUSTA, *The Case for the Return of Sir Hugh Lane's Pictures to Dublin*, Dublin, 1926

GRIFFITHS, ANTHONY & WILLIAMS, REGINALD, *A User's Guide – Department of Prints and Drawings*, Trustees of the British Museum, London, 1987

GROSART, REV. ALEXANDER B., *The Lismore Papers*, 10 vols., London, 1886–8

GROSE, FRANCIS, *Rules for Drawing Caricatures: with an essay on comic painting* [by F. Grose], London, 1788

GROSE, FRANCIS, *The Antiquities of Ireland* (edited and completed by E. Ledwich), 2 vols., London, 1791, 1795

GWYN, STEPHEN, *Dublin, Old and New*, London & Dublin, 1938

HALL, SAMUEL CARTER & HALL, ANNA MARIA, *Ireland: its Scenery, Character etc.*, 3 vols., London, 1841–3

HALSBY, JULIAN, *Scottish Watercolours 1740–1940*, London, 1986

HARBISON, PETER et al, *Irish Art and Architecture from Prehistory to the Present*, London, 1978

HARDIE, MARTIN, *Water-colour Painting in Britain*, 3 vols., London, 1966–8

HARE, AUGUSTUS J. C., *The Story of Two Noble Lives*, 3 vols., London, 1893

HARRAP, GEORGE G., *Some Memories 1901–1935. A Publisher's Record*, London, 1935

HARTRICK, A. S., *A Painter's Pilgrimage through Fifty Years*, Cambridge, 1939

HARVEY, JOHN R., *Victorian Novelists and Illustrators*, London, 1970

HARVEY, WILLIAM H., *A Manual of the British Algae*, London, 1841

HARVEY, WILLIAM H., *Flora capensis: a systematic description of the plants of the Cape Colony, Caffraria and Port Natal by W. H. Harvey* [and others] (edited by SIR WILLIAM THISELTON-DYER), 7 vols., London, 1894–1933

HARVEY, WILLIAM H., *Phycologia australica or A History of Australian Sea-weeds*, London, 1858–63

HARVEY, WILLIAM H., *Phycologia britannica or A History of British Sea-weeds*, 4 vols., London, 1846–51

HARVEY, WILLIAM H., *Thesaurus capensis or Illustrations of the South African Flora*, 2 vols., Dublin, 1859

HAYES, MICHAEL ANGELO, Delineation of Animals in Rapid Motion, a paper read before the RDS, Dublin, 1877

HELENIAK, K. M., *William Mulready* (Studies in British Art), New Haven, 1980

HENRY, FRANCOISE, *Irish Art in the Early Christian Period (to 800 AD)*, London, 1965

HENRY, FRANCOISE, *Irish Art in the Romanesque Period (1020–1170 AD)*, London, 1970

HENRY, FRANCOISE & MARSH-MICHELI, GENEVIEVE, *Studies in Early Christian and Medieval Irish Art Volume II: Manuscript Illumination*, London, 1984

HENRY, PAUL, *An Irish Portrait (An Autobiography)*, 1988 edn, London, New York, Toronto & Sydney, 1951 (Foreword by Seán O'Faoláin)

HERMAN, LUKE, *British Landscape Painting of the 18th Century*, London, 1973

HEWITT, JOHN, *John Luke (1906–1975)*, 1978

HEWITT, JOHN & SNODDY, THEO, *Art in Ulster Vol I: Paintings, Drawings, Prints & Sculpture for the last 400 years to 1957 with biographies of the artists by Theo Snoddy*, Belfast, 1977

HILLIARD, NICHOLAS, A Treatise concerning the Arte of Limning, at the request of R. Haydocke, who published in England a translation of Paolo Lomazzo on painting in 1598

HOFFER, PHILIP, *Edward Lear as a Landscape Draughtsman*, London, 1967

HOLMAN HUNT, WILLIAM, *Pre-Raphaelitism and the Pre-Raphaelites*, 2 vols., London, 1905

HOUFE, SIMON, *The Dictionary of British Book Illustrators and Caricaturists 1800–1914*, Woodbridge, Suffolk, 1978

HUCHISON, SIDNEY C., *The History of the R.A. 1768–1968*, London, 1968

HUTCHINSON, JOHN, *The Families of Flowering Plants*, 2nd edn, 2 vols., Oxford, 1959

HUTCHINSON, JOHN & DALZIEL, JOHN MACEWAN, *Flora of West Tropical Africa*, vols. I & II, London, 1927–36

JELLETT, MAINIE, *My Voyage of Discovery – The artist's vision. Lectures and essays on art*, DR EILEEN MACCARVILL (ed.), Dundalk, 1958

JOHNSON, J. & GREUTZNER, A., *The Dictionary of British Artists 1880–1940*, Woodbridge, Suffolk, 1976

KEIGHTLEY, T. K., *The Fairy Mythology*, 2 vols., London, 1833

KNODY, PAUL G. & DARK, SIDNEY, *William Orpen: Artist and Man*, London, 1932

KNOWLES, RODERIC, *Contemporary Irish Art*, Dublin, 1983

LAVERY, SIR JOHN, *The Life of a Painter*, London, 1940

LEWIS, GIFFORD, *Somerville and Ross. The World of the Irish R.M.*, London, 1985

LEWIS, SAMUEL, *A Topographical Dictionary of Ireland*, 2 vols., London, 1837

LLANOVER, LADY, *Autobiography and Correspondence of Mary Granville, Mrs Delany*, 6 vols., London, 1861

LOEBER, ROLF (ed.), An alphabetical list of artists who worked in Dublin during the seventeenth and eighteenth centuries, unpublished typescript, Kingston, Ontario, 1973

LOWE, SIR DAVID, *British Cartoonists, Caricaturists & Comic Artists*, London, 1942

LUCAS, S. T., *Bibliography of Watercolour Paintings and Painters*, London, 1976

MAAS, JEREMY, *Victorian Painters*, London, 1969

MACAULEY & HUGHES, *Charts coast of Ireland*, Dublin, 1790–4

MacGREEVY, THOMAS, *Jack B. Yeats*, Dublin, 1945

MacLIAMMÓIR, MICHEÁL, *All for Hecuba, an Irish Theatrical Autobiography*, London, 1946, revised, edn Dublin, 1961

MacMANUS, M. J., *So This is Dublin*, Dublin, 1927 (Illustrated by Seán O'Sullivan)

MacPARLAND, EDWARD, *James Gandon, Vitruvius hibernicus*, London, 1985

MALLALIEU, HUON I, *The Dictionary of British Water-colour Artists up to 1920*, Woodbridge, Suffolk, 1976

MALLINS, EDWARD & BISHOP, MORCHARD, *James Smetham and Francis Danby*, London, 1974

MALTON, JAMES, *A Picturesque and Descriptive View of the City of Dublin displayed in a series of the most interesting scenes taken in the year 1791* (With a brief authentic history from the earliest accounts to the present times, engraved title page & dedication. 25 plates of views, 2 maps, chart [Survey of Dublin Bay, 1795] Obl. fol., London, 1792–9

MALTON, JAMES, *The Young Painter's Maulstick: being a practical treatise on perspective*, London, 1800

MALTON, THOMAS, *A Compleat Treatise on Perspective: on the true principles of drawing*, London, 1778

MANNERS, LADY VICTORIA & WILLIAMSON, GEORGE C., *Angelica Kauffman, RA Her Life and Her Works*, London, 1924

MARILLER, H. C., *Liverpool School of Painters: an account of the Liverpool Academy, from 1810 to 1867, with memoirs of the principal artists*, London, 1904

MAYER, RALPH, *A Dictionary of Art Terms & Techniques*, London, 1969

MEENAN, JAMES & CLARKE, DESMOND, *The Royal Dublin Society 1731–1981*, Dublin, 1981

MILLER, LIAM, *The Dún Emer Press, later the Cuala Press*, Dublin, 1973 (Preface by Michael B. Yeats)

MILLER, LIAM (ed.), *Retrospect: the work of Séamus O'Sullivan & Estella Solomons*, Dublin, 1973

MILTON, THOMAS, *A Collection of Select Views from the Different Seats of the Nobility & Gentry in the Kingdom of Ireland, engraved by T. Milton, drawings by the best artists*, London, 1783–93, 24 plates

MITCHELL, PETER J., *European Flower Painters*, London, 1973

MONKHOUSE, WILLIAM C, *The Earlier English Water-colour Painters*, London, 1890

MURPHY, WILLIAM, *Prodigal Father; the Life of John Butler Yeats 1839–1922*, London, 1978

MURRAY, PETER & LINDA, *The Penguin Dictionary of Art and Artists*, 1978 edn, London

NEALE, JOHN PRESTON, *Views of the Seats of Noblemen and Gentlemen in England, Wales, Scotland and Ireland*, 6 vols., London, 1818

NELSON, DR E. CHARLES, *Some published dates for parts of William Curtis's Flora londinensis* (offprint from Taxon 29 November, 1980)

NELSON, DR E. CHARLES, *Works of Botanical Interest published before 1800 held in Irish libraries*, Glasnevin National Botanic Gardens (Occasional Papers I), Dublin, 1981

O'BRIEN, EOIN & CROOKSHANK, ANNE, *A Portrait of Irish Medicine*, Dublin, 1984

O'DONAILL, NIALL, *Fochoir Gaeilge-Bearla*, Dublin, 1977

O'DRISCOLL, WILLIAM JUSTIN, *A Memoir of Daniel Maclise, RA*, London, 1871

O'KEEFFE, JOHN, *Recollections of the Life of John O'Keeffe written by Himself*, 2 vols., London, 1826

ORMOND, RICHARD E., *Early Victorian Portraits*, 2 vols., London, 1973

ORPEN, WILLIAM, *Stories of Old Ireland and Myself*, London, 1924

OSBORNE, HAROLD, *Oxford Companion to Art*, 1979

PANOFSKY, ERWIN, *Early Netherlandish Painting, its Origins and Character*, 2 vols., The Charles Eliot Norton Lectures: 1947–8, New York, Hagerstown, San Francisco & London, 1971

PASQUIN, ANTHONY (JOHN WILLIAMS), *Memoirs of the Royal Academicians and an Authentic History of the Artists in Ireland*, revised edn with an introduction by R. W. Lightbown, London, 1970

PETRIE, GEORGE et al, *Picturesque Sketches of Some of the Finest Landscape and Coast Scenery of Ireland with drawings by G. Petrie RHA, A. Nicholl & H. O'Neill*, vol. I, Dublin, 1835, vol. II, Dublin, 1843

PEARSON, PETER, *Dun Laoghaire Kingstown*, Dublin, 1981

POCOCKE, RICHARD, *Richard Pococke's Tour in Ireland in 1752*, with an introductory note by Revd G. T. Stokes, London & Dublin, 1891

POE, EDGAR ALLAN, *Tales of Mystery and Imagination*, London, 1923 (Illustrations by Harry Clarke)

PAPHAM, A. E., *Handbook to Drawings and Watercolours in the British Museum*, London, 1939

PRAEGER, ROBERT LLOYD, *Some Irish Naturalists*, Dundalk, 1949

PRAEGER, ROBERT LLOYD, *Weeds, Simple Lessons for Children* (Cambridge Natural Study Series), Cambridge, 1913 (With illustrations by S. Rosamund Praeger and R. J. Welch)

PRICE L. (ed.), *An Eighteenth-century Antiquary. The Sketches, Notes and Diaries of A. Cooper 1759–1830*, Dublin, 1942

PROTHERO, ROWLAND E., *The Life and Correspondence of Arthur Penrhyn Stanley*, 2 vols., London, 1893

PYLE, HILARY, *Jack B. Yeats; a Biography*, 1988 edn, London, 1970

PYLE, HILARY, *Portraits of patriots*, Dublin, 1966

REDGRAVE G. I. R., *A History of Watercolour Painting in England* (Illustrated London Books of Art), London, 1892

REDGRAVE, SAMUEL, *A Dictionary of Artists of the English School*, 2nd edn, London, 1978

REDGRAVE, SAMUEL & RICHARD, *A Century of Painters of the English School*, 2 vols., London, 1866, revised edn, London, 1947

REID, F., *Illustrators of the Sixties*, London, 1928

REVETT, NICHOLAS & STUART, JAMES, *The Antiquities of Athens. Measured delineated by J. Stuart and N. Revett*, 4 vols., 1713–88, London, 1837

REYNOLDS, ARTHUR GRAHAM, *British Water-colours* (Illustrated booklet, 4) V&A Museum, London, 1958, 2nd edn, London, 1968

ROBERTS, THOMAS SAUTELLE (or SOTELLE), *Twelve Engravings in Aquatint of Views in the south of Ireland drawn by T. S. Roberts* (With descriptive letterpress), London, 1795–9

ROBINSON, ESMÉ STUART LENNOX, *Plays (1923)*, London, 1928

ROE, F. GORDON, *Sea Painters of Britain*, Leigh-on-Sea, 1947

ROGET, JOHN LEWIS, *A History of the 'Old Water-Colour Society', now the Royal Society of Painters in Watercolours. With biographical notices of its older and of all deceased members & associates, preceded by an account of English water-colour art and artists in the eighteenth century*, London, 1891, new edn, Woodbridge, Suffolk, 1972

ROSE, MARY GADDIS, *Jack B. Yeats, Painter and Poet*, Berne & Frankfurt, 1972

ROSENTHAL, T. G., *Yeats. The Masters No. 40*, Bristol, 1966

ROSS, ALEX M., *William Henry Bartlett, Artist, Author & Traveller*, containing a reprint of Dr WILLIAM BEATTIE's *Brief Memoir of the late Will. Henry Bartlett*, Toronto, 1973

ROTHENSTEIN, SIR W., *Men and Memories*, London, 1931

ROWBOTHAM, THOMAS LEESON, *The Art of Landscape Painting in Water Colours*, London, 1850

RUSKIN, JOHN, *Pre-Raphaelitism*, London, 1851

RUSSELL, VIOLET, *Heroes of the Dawn*, Dublin, 1922 (Illustrations by Beatrice Elvery)

SANDBY, PAUL, *The Virtuosi's Museum, containing select views in England, Scotland and Ireland, drawn by Paul Sandby RA*, London, 1778–81

SANDBY, WILLIAM, *The History of the Royal Academy of Arts*, 2 vols., London, 1862, new edn, London, 1970

SANDBY, WILLIAM, *Thomas and Paul Sandby, Royal Academicians*, London, 1892

SCHIDLOF, LEO R., *The Miniature in Europe*, 4 vols., Austria, 1964

SHEEHY, JEANNE, *Walter Osborne*, Ballycotton, Co. Cork, 1974

SLYTHE, MARGARET R., *The Art of Illustration 1750–1900*, London, 1970

SMITH, JAMES E., *English Botany; or coloured figures of British plants by J. Sowerby*, 36 vols., (With General Indexes to English Botany; to which is added an alphabetical index to English fungi), London, 1790–1814

SMITH, JOHN THOMAS, *Nollekens and His Times*, 2 vols., London, 1829, annotated edn London, 1920

SOMERVILLE, DR EDITH O., *The Rev. Paley Dabble's Adventures*

SPAROW, WALTER SHAW, *John Lavery and His Work*, London, 1912

SPENDER, MICHAEL, *The Glory of Watercolour. The Royal Watercolour Society Diploma Collection*, London, 1987

SPIELMAN, MARION H., *The History of Punch*, London, 1895

STALEY, ALLEN, *The Pre-Raphaelite Landscape*, Oxford, 1973

STEPHEN, LESLIE & LEE, SIDNEY (eds.), *The Dictionary of National Biography*, 66 vols., London, 1885–1901 and later edns

STEWART, ANN M., *Royal Hibernian Academy of Arts, Index of exhibitors*, 1826–1979

STOKES, SIR WILLIAM R. W., *Life and Labours in the Art & Archaeology of George Petrie*, Dublin, 1968

STORY, ALFRED T., *The Life of John Linnell*, 2 vols., London, 1892

STRICKLAND, WALTER G., *A Dictionary of Irish Artists*, 2 vols., Dublin, 1913, Shannon, 1968 (Introduction by Theo Snoddy)

STRONG, SIR ROY, *The English Renaissance Miniature*, London, 1983

TEMPLETON, JOHN, *Catalogue of the Native Plants of Ireland*, RIA, Dublin.

TENNYSON, ALFRED LORD, *Alfred Tennyson's Poems 1830–1870*, London, 1912 (With an introduction by T. H. Warren and illustrations by Maclise, Millais, Rossetti & others)

THOMPSON, WILLIAM, *The Natural History of Ireland – Birds*, vols. I, II & III, London, 1849

THORPE, JAMES, *English Illustration: The Nineties*, London, 1935

TOOLEY, R. V. (compiler), *Tooley's Dictionary of Mapmakers*, Tring, 1979

TURNER, DAWSON, *'Fuci, sive … plantarum fucorum … et historia*, 4 vols., in Latin and English, London, 1808–19

TWISS, RICHARD, *A Tour in Ireland in 1775*, London, 1776

VERTUE, GEORGE W., *A Description of the Works of W. Hollar, with account of his Life*, London, 1745

VERTUE, GEORGE, *A Dictionary of Painters, Sculptors, Architects and Engravers*, London, 1810

WADE, WALTER, *Plantae rariores in hibernia inventae*, or habitats of some plants, rather scarce and valuable found in Ireland, Dublin, 1804 (With concise remarks on the properties & uses of many of the plants)

WADE, WALTER, *Salices*, or an essay towards a general history of sallows, willows and ossiers, their uses and best methods of propagating and treating them etc., Dublin, 1811

WAKEMAN, GEOFFREY. *Victorian Book Illustration*, Newton Abbot, 1973

WALPOLE, HORACE, *Anecdotes of Painting in England*, RALPH N. WORNUM ed., 3 vols., Strawberry Hill, London, 1762–3 and 1849 edns

WARBURTON, JOHN et al, *History of the City of Dublin*, 2 vols., London, 1818

WATERHOUSE, ELLIS K., *Painting in Britain*, London, 1953

WEBB, DR J., *Guilds of Dublin*, Dublin, 1929

WEBSTER, MARY, *Francis Wheatley*, London, 1970

WEDMORE, F., *Fine Prints*, 1972 edn, London, 1897

WHITE, JAMES, *John Butler Yeats and the Irish renaissance with pictures from the Collection of Michael Butler Yeats and from the National Gallery of Ireland*, Dublin, 1972

WILDE, SIR WILLIAM ROBERT W., *Memoir of Gabriel Beranger, and his Labours in the Cause of Irish Art and Antiquities, from 1760 to 1780*, Dublin, 1880

WILLIAMSON, G. C., *Richard Cosway RA*, London, 1897

WILLIAMSON, G. C., *The History of Portrait Miniatures*, 2 vols., London, 1904

WILLIS, N. P. & COYNE, J. S., *The Scenery and Antiquities of Ireland*, London, 1844 (Illustrations [drawings] by Henry Bartlett)

WILTON, ANDREW, *British Watercolours 1750–1850*, Oxford, 1977

WINKWORTH, CATHERINE, *Lyra germanica*, London, 1855

WOOD, CHRISTOPHER, *The Dictionary of Victorian Painters with Guide to Auction Prices and Index to Artists' Monograms*, Woodbridge, Suffolk, 1971

WRIGHT, REV. GEORGE N., *Ireland Illustrated, from original drawings by G. Petrie, RHA, W. H. Bartlett & T. M. Baynes* (With descriptions by G. N. Wright), London, 1831

WRIGHT, REV. GEORGE N., *A Guide to the County of Wicklow*, London, 1822 (Illustrated engravings after the designs of George Petrie Esq.)

WRIGHT, REV. GEORGE N., *Tours in Ireland: or guides to the lakes of Killarney*, London, 1823 (Illustrated with maps and engravings after drawings by George Petrie)

YEATS, ELIZABETH CORBET, *Brushwork Studies of Flowers, Fruit and Animals*, London, 1896

YEATS, ELIZABETH CORBET, *Elementary Brushwork Studies*, London, 1900

YEATS, JACK BUTLER, *Ah Well: a Romance in Perpetuity*, 1942 and London, 1974

YEATS, JACK BUTLER, *A Little Book of Drawings by Jack B. Yeats, gathered from 'A Broadside'*, Dublin, 1971

YEATS, JACK BUTLER, *Broadside Characters, Drawings by Jack Butler Yeats*, Dublin, 1971 (Introduction by Anne Yeats)

YEATS, JACK BUTLER, *Hand-coloured Prints from Drawings by Jack Butler Yeats*, Dalkey, Co. Dublin, 1978

YEATS, JACK BUTLER, *Life in the West of Ireland, drawn and painted by J. B. Yeats*, Dublin & London, 1912

YEATS, JOHN BUTLER, *Early Memories, some chapters of autobiography*, Dublin, 1923

YEATS, JOHN BUTLER, *J. B. Yeats, Letters to his son, W. B. Yeats, and others, 1869–1922*, edited with a memoir by J. HONE, London, 1944

YEATS, WILLIAM BUTLER, *Irish Fairy Tales*, London & Leipzig, n.d. (Illustrations by Jack Butler Yeats)

YOUNG, ARTHUR, *A Tour in Ireland, with general observations on the present state of that kingdom, made in the years 1760–1780*, 2 vols., Dublin, 1880

PERIODICALS

Irish Times, 31 May 1922; 4 May 1964; 28 May 1968; 17 May 1986

'The Gallery of Illustrious Literary Characters' in *Fraser's Magazine for Town & Country*, vol. VII, June, 1833

ADAMS, RONALD, 'Andrew Nicholl' in GPA *Irish Arts Review*, vol. I, no. 4, winter, 1984

BODKIN, THOMAS, 'The Art of Illustration: Fairy tales from Hans Christian Andersen', Illustrations by Harry Clarke, in *Studies*, vol. VI, no. 22, June, 1917

BUTLER, PATRICIA A., 'A Designer of Distinction – William Kilburn (1745–1818)' in the magazine of the Friends of the Royal Society of Watercolours and Drawings, spring, 1987

BUTLER, PATRICIA A., 'The Ingenious Mr Francis Place' in GPA *Irish Arts Review*, vol. I, no. 4, winter, 1984

CAFFREY, PAUL E. M., 'The Life and Career of Sampson Towgood Roch, Miniaturist' in GPA *Irish Arts Review*, vol. III, no. 4

CROOKSHANK, ANNE O., 'Irish Landscapes with an English Air – William Ashford (1746–1824)' in *Country Life*, vol. CLVII, no. 4064, 22 May, 1975

FIGGIS, NICOLA, 'Irish Portrait and Subject Painters in Rome' in *The GPA Irish Arts Review Yearbook*, 1988

FORD, BRINSLEY (ed.), 'The Letters of Jonathan Skelton written from Rome and Tivoli in 1758, together with correspondence relating to his death on 19 January 1759' in *Walpole Society*, vol. XXXVI, 1956–8

FOSTER, WILLIAM, 'British Artists in India' in *Walpole Society*, vol. XIX

JONES, THOMAS, 'Memoirs of Thomas Jones' in *Walpole Society*, vol. 32, 1946–8

MULVANY, THOMAS J., 'Hugh Douglas Hamilton' in *Dublin Monthly Magazine*, Jan–June, 1842

MULVANY, THOMAS J., 'Memoirs of National Artists, no. 11, Mr Thomas Sotelle Roberts, RHA' in *Citizen* XXXC (no. 1841)

NELSON, DR E. C., 'Walter Wade's Flora dublinensis, an enigmatic Irish botanical publication' in *Long Room Bulletin of the Friends of the Library*, Trinity College, Dublin. nos. 20 & 21, spring & autumn, 1980

NICHOLL, ANDREW, 'A Sketching Tour of five weeks in

the Forests of Ceylon' in *Dublin University Magazine*, no. CCXXXIX, Nov., 1852

O'CONNOR, CYNTHIA, 'The Parody of the School of Athens, the Irish Connection' in the bulletin of the Irish Georgian Society, vol. XXVI, 1983

POTTERTON, HOMAN, 'A Director with Discrimination – Sir Frederic Burton at the National Gallery' in *Country Life*, vol. CIV, 9 May, 1974

ROWAN, ALISTAIR, 'Poor William Pars, a forgotten early English Watercolourist' in *Country Life Annual*, 1970

WYNNE, MICHAEL, 'Thomas Frye (1710–1762)' in the *Burlington Magazine*, vol. CXIV, no. 827, February, 1972

CATALOGUES

Catalogues of the Water Colour Society of Ireland, omitting 1892, 1895, 1896, 1900, 1903, 1905, 1907

Ireland's Literary Renaissance 20th century Portraits, Introduction by Dr James White, Sept–Oct 1980

Belfast, City of Belfast Museum and Art Gallery, *David Wilson, RI, RBA (1873–1935). Exhibition of watercolour drawings*, December, 1938

Belfast, Ulster Museum, *A Concise Catalogue of the Drawings, Paintings and Sculpture in the Ulster Museum*, 1986

Belfast, Ulster Museum (& Arts Council of N. Ireland Galleries), *Gerard Dillon 1916–1971 A Retrospective Exhibition*, Introduction by Dr James White, Foreword by Oliver Dowling, Biographies by Noreen Rice, Brian Ferran, Ted Hickey, Ethna Waldron, 1972 (travelling exhibition: Nov–Dec 1972, Belfast; Jan–Feb 1973, Municipal Gallery of Modern Art presented by An Chomhairle Ealion, Dublin)

Belfast, Ulster Museum, *Richard Dunscombe Parker's Irish Birds*, Introduction by Ted Hickey, Keeper of Art, Ulster Museum, July–Aug, 1980

Belfast, Ulster Museum, *Andrew Nicholl 1804–1886*, catalogue by Martyn Anglesea, 1973

Belfast, Arts Council of N. Ireland exhibition *William Conor*, Introduction by Denis Ireland, 1968

Belfast, Ulster Museum (Arts Council of N. Ireland exhibition with Chomhairle Ealaion), *Colin Middleton*, Preface by Brian Ferran, Assistant Director, Arts Council of N. Ireland, Introduction by Colm O'Briain, Director, An Chomhairle Ealaion, and J. Kenneth Jamison, Director, Arts Council of N. Ireland, January 1976 (travelling exhibition: Jan–Feb 1976, Ulster Museum; Mar–Apr 1976, Municipal Gallery of Modern Art, Dublin)

Cork, Crawford Municipal Art Gallery, *Rose Barton, RWS. Exhibition of Watercolours and Drawings*, catalogue by Rebecca Rose and Charles Nugent, 1987 (travelling exhibition: Jan 1987, Cork; Feb–Mar 1987, Fine Art Society, London; Mar–Apr 1987, Ulster Museum; May 1987, Butler Gallery, Kilkenny)

Cork, Crawford Municipal School of Art, *Irish Art in the Nineteenth Century: an exhibition of Irish Victorian Art at the Crawford Municipal School of Art*, Oct–Dec 1971

Cork, ROSC exhibition, *Irish Art 1900–1950*, catalogue by Hilary Pyle, 1975–6

Dallas, USA, Dallas Museum of Fine Arts, *Irish Watercolours 1675–1925 from the National Gallery of Ireland*, 1976

Dublin, Cynthia O'Connor Gallery, *Irish Topographical Pictures*, 1976

Dublin, Cynthia O'Connor Gallery, *The Studio of Dermod O'Brien, PRHA, 1865–1945*, 1983

Dublin, Department of Foreign Affairs, *Irish Art from 1600 to the Present Day*, catalogue by Anne O. Crookshank (Aspects of Ireland 4), 1979

Dublin, Hugh Lane Municipal Gallery of Modern Art, *'All for Hecuba'. An exhibition to mark the Golden Jubilee 1928–78 of the Edwards-MacLiammóir partnership & of the Dublin Gate Theatre*, catalogue edited by Richard Pine, 1978

Dublin, Hugh Lane Municipal Gallery of Modern Art, *Mainie Jellett. A retrospective exhibition of paintings and drawings*, Introduction by Dr Eileen MacCarvill, 1962

Dublin, Hugh Lane Municipal Gallery of Modern Art, *Seán Keating. Paintings and Drawings*, Introduction by Dr James White, 1963

Dublin, Hugh Lane Municipal Gallery of Modern Art, *Harry Kernoff Memorial Exhibition*, 1976–7

Dublin, Hugh Lane Municipal Gallery of Modern Art, *Charles Lamb. Memorial Exhibition*, Introduction by Dr James White, 1969

Dublin, John Taylor Galleries, Dawson Street, *Maurice MacGonigal*, Introduction by Ciarán MacGonigal, 1981

Dublin, Mills' Hall, *Patrick Joseph Tuohy, RHA (1894–1930) Paintings, drawings, sketches 1901–1930*, Introduction by Thomas Bodkin, 1931

Dublin, National Gallery of Ireland, *'The Aran Fisherman's Drowned Child' by Frederic William Burton, RHA*, Painting in Focus by Marie Bourke, 1987

Dublin, National Gallery of Ireland, *The Early Celtic Revival*, Introduction by Jeanne Sheehy, n.d.

Dublin, National Gallery of Ireland, *The Irish Impressionists – Irish Artists in France and Belgium 1850–1914*, catalogue by Dr J. Campbell (travelling exhibition: Oct–Nov 1984, NGI, Dublin; Feb–Mar 1985, Ulster Museum, Belfast)

Dublin, National Gallery of Ireland, *Irish Portraits*, catalogue by Anne Crookshank and the Knight of Glin, 1969 (travelling exhibition: Aug–Oct 1969, NGI, Dublin; Oct 1969–Jan 1970, NPG, London; Jan–Mar 1970, Ulster Museum, Belfast) Published by the Paul Mellon Foundation for British Art, 1969

Dublin, National Gallery of Ireland, *Illustrated Summary Catalogue of Drawings, Watercolours and Miniatures*, Introduction by Homan Potterton, the Director NGI, compiled by Adrien Le Harivel, 1983

Dublin, National Gallery of Ireland, *Illustrated Summary Catalogue of Prints and Sculpture*, catalogue edited by Adrien Le Harivel, compiled by Susan Dillon, Frances Gillespie, Adrien Le Harivel & Wanda Ryan-Smolin, 1988

Dublin, National Gallery of Ireland, *James Arthur O'Connor*, catalogue by John Hutchinson, 1985 (travelling exhibition: Feb–Mar 1986, Ulster Museum, Belfast; Mar–Apr 1986, Crawford Municipal Art Gallery, Cork

Dublin, National Gallery of Ireland, *Thomas Roberts 1748–78*, catalogue by Dr Michael Wynne, 1978

Dublin, National Gallery of Ireland, *Jack B. Yeats 1871–1957. A Centenary exhibition at the N.G.I.*, 1971

Dublin, National Gallery of Ireland, *Jack B. Yeats in the National Galley of Ireland*, catalogue by Hilary Pyle, 1986

Dublin, National Gallery of Ireland, *John Butler Yeats and the Irish Renaissance*, catalogue by Dr James White, with

pictures from the collection of Michael Butler Yeats and from the NGI, 1972

Dublin, Neptune Gallery, *J. H. Campbell 1757–1828 and his School. Irish Landscape Watercolour*, Introduction by Bruce Arnold, June 1967

Dublin, Neptune Gallery, *Irish Watercolours 1750–1900*, Apr–May 1972

Dublin, Neptune Gallery, *Sir William Orpen 1878–1931. Drawings 1899–1901*, Introduction by Bruce Arnold, June–July 1971

Dublin, Neptune Gallery, *Edith Œ Somerville 1858–1949. Catalogue of an exhibition of drawings*, 1968

Dublin, The Oriel Gallery, *Percy French 1854–1920. Exhibition of Watercolours*, Introduction by Oliver Nulty, June–July 1979

Dublin, 6 St Stephen's Green, *Hone, Nathaniel RHA and John Butler Yeats RHA: a loan collection of pictures*, Introduction by George Moore and F. York Powell, 1904

Dublin, Exhibition Hall, New Library, Trinity College, *Norah McGuinness. Retrospective Exhibition*, Introduction by Anne Crookshank, Oct–Nov 1968

Dublin, Douglas Hyde Gallery, Trinity College, *Paul Henry (1876–1958)*, Introduction by Prof. George Dawson, 1973

Edinburgh (Arts Council exhibition), *George Chinnery*, catalogue by Allan Carr, 1957 (travelling exhibition: Edinburgh & London)

Galway, Galway Arts Festival, *'A Century of Connemara'*, compiled by Kieran Corcoran, 1985

London, (Arts Council exhibition), *Hugh Lane and his pictures*, catalogue by Thomas Bodkin, 1956

London, Art Gallery of the Corporation of London, *Exhibition of Works by Irish Painters*, catalogue by Hugh Lane, Honorary Director, descriptive and biographical notes by A. G. Temple, FSA, 1904

London, National Portrait Gallery (Arts Council exhibition), *Daniel Maclise 1806–70*, catalogue by Richard Ormond and John Turpin, 1972 (travelling exhibition: NPG, London & NGI, Dublin)

London, Pyms Gallery, *Mary Swanzy, HRHA (1882–1978)*, Foreword by Mary and Alan Hobart, compiled by Dr J. Campbell, Nov–Dec 1989

London, Sotheby's (sales catalogue), *A Magnificent Collection of Botanical Books*, 1987

London, Tate Gallery (Arts Council exhibition with the Tate Gallery) *Evie Hone 1894–1955*, catalogue by Dr James White, 1958 (travelling exhibition: London & Dublin)

London, Victoria and Albert Museum, *Mulready 1780–1863*, catalogue by Marcia Pointon, 1986 (travelling exhibition: July–Oct 1986, V&A; then 1986/7 at NGI, Dublin & Ulster Museum, Belfast)

London, Victoria and Albert Museum, *William Mulready (Drawings)*, catalogue by Anne Rorimer, 1972

London, (sales catalogue), *A Catalogue of a Collection of Modern Pictures and Drawings chiefly consisting of the Works and Property of Mr Serres, Junior . . . which will be Sold by Auction by Mr Greenwood . . . on 22nd of April, 1970 and following day*, 1970 (copy in the Victoria and Albert Museum)

York, City Art Gallery, *Francis Place 1647–1728*, 1971 (travelling exhibition: April 1971, York; May 1971, Kenwood, The Iveagh Bequest, Greater London Council)

INDEX

Figures in *italic* refer to illustration captions.

221